Southwestern Pottery

Anasazi to Zuni

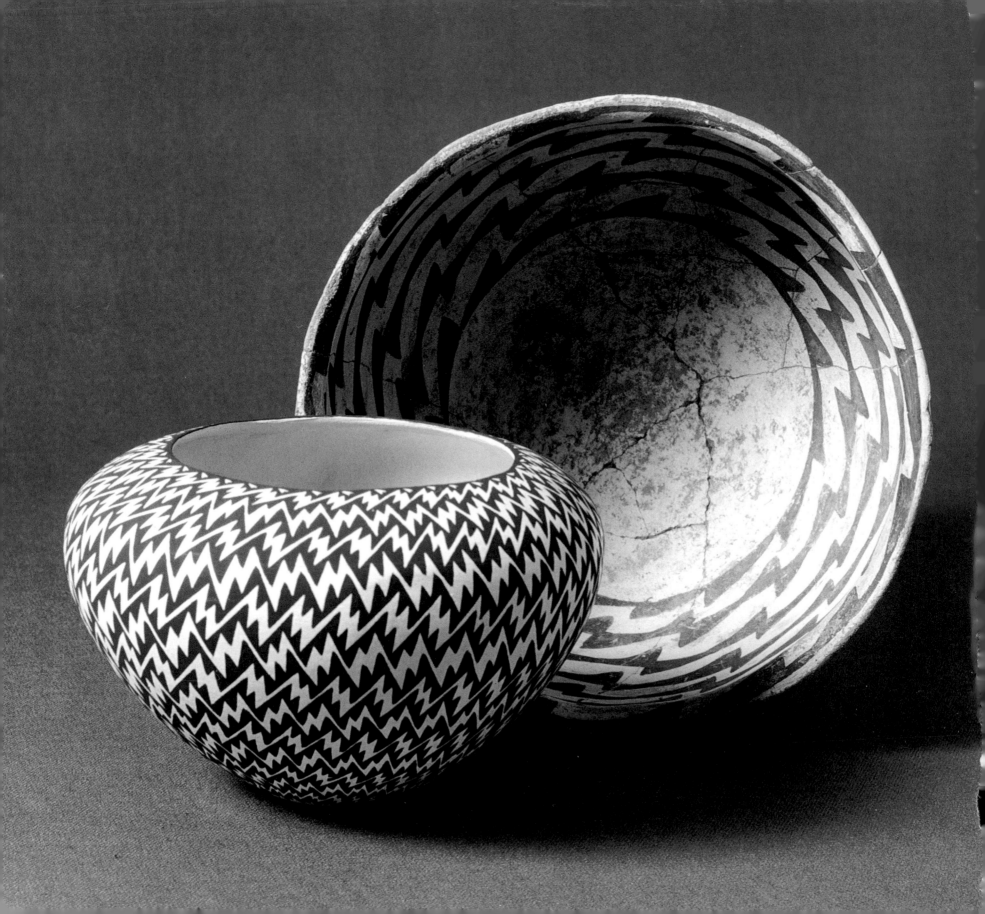

Southwestern Pottery

Anasazi to Zuni

by ALLAN HAYES AND JOHN BLOM

Photographs by JOHN BLOM

Foreword by ALEXANDER E. ANTHONY, JR.

NORTHLAND PUBLISHING

*To Thomas Keam, John Candelario, and Jake Gold.
If these early traders, in their pursuit of commerce,
hadn't worked so hard to promote an endangered
art, this would be a very thin book.*

— A. H.

*To Jennie Laate, Evelyn Cheromiah, Eudora Montoya,
Mary Small, Lonnie Vigil, Phyllis Cerna, and Stella
Teller. Each brought a nearly vanished tradition back to
life. Without them, we would have no Golden Age.*

— J. B.

A portion of the proceeds will benefit the
Marin Museum of the American Indian,
Novato, California.

FRONTISPIECE: *Tradition—Black Mesa Black-on-
white bowl, ca. A.D. 1075, from north-central Arizona;
Acoma jar by Jennifer Estevan and Michael Patricio,
1992, from west-central New Mexico.*

CONTENTS: *Anasazi, Chaco Black-on-white, ca. 1050
to Zuni, Matsaki Polychrome, ca. 1550*

Text type set in Minion
Display type set in Phaistos
Edited by Susan Tasaki and Stephanie Bucholz
Design by Larry Lindahl
Maps by Keith Hayes
Production supervised by Lisa Brownfield

Manufactured in Hong Kong by South Sea International Press Ltd.

FIRST IMPRESSION, OCTOBER 1996
Second Printing, April 1997
Third Printing, November 1997
Fourth Printing, July 1999
Fifth Printing, August 2000
ISBN 0-87358-656-5

Library of Congress Cataloging-in-Publication Data

Hayes, Allan.
 Southwestern pottery : Anasazi to Zuni / by Allan Hayes
 and John Blom ; photographs by John Blom ; foreword by
 Alexander E. Anthony, Jr.
 p. cm.
 Includes bibliographical references and index.
 ISBN 0-87358-663-8 (hc). ISBN 0-87358-656-5 (pbk.)
 1. Indian pottery—Collectors and collecting—Southwest,
 New. 2. Indians of North America—Antiques—Collectibles
 and collecting—Southwest, New. I. Blom, John. II. Title.
 E78.S7H39 1996
 979—dc20 96-16957

contents

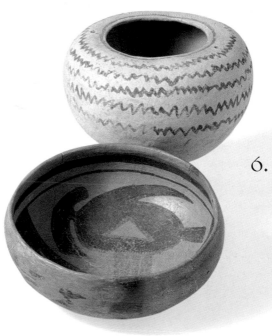

acknowledgments

▶▶ FIRST, THANKS TO CAROL AND BRENDA, who not only had to live with the insanity day after day, but pitched in and made it all happen, and to Al's son Keith, whose Macintosh skills produced all the difficult maps for virtually no compensation. Major thanks to Al Anthony of Adobe Gallery and to Claire Demaray of the Pleasant Valley Archeological Foundation, who were our tour leaders through a world that, in 1990, we didn't know even existed, and who were the experts who read our manuscript and kept us from putting our worst stupidities into print. Beyond Al and Claire, deep thanks to Bruce Bernstein and Mark Bahti, whose many comments and suggestions pushed the book to a higher level. Moreover, our thanks to more people than we can remember or name and who, by now, may not even remember us. In no particular order, they include Mark Sublette and his sister Amy, Steve de Priest, Richard Myers, Charles V. Parker, Christy Hoffman, Terry Schurmeier, Mike and Breeze Holloway, Roland Jacopetti, Ellen and Jim Woods, Russ Hartman, Spencer MacCallum, Flo and Sal Yepa, Herb Puffer, Thomas Begner, Carol Watters, Linda Stout, Steve Elmore, Jay Graham, Elvis Torres, Fred Roberts, Don Bennett, Kim Martindale, Marilyn Cosentino, Charles and Leslie Donaldson, Carl Vincent, Ron and Marjorie Brattain, Robert Nichols, Mark Hayes, Dave de Roche, Richard Sexton, Knut and Betty Danild, Patricia Hobson, Kent and Sheila Diehl, Pat and Bill Ranniger, Walter Parks, Bill Crow, Forrest Fenn, Kent McManis, Mark Arrowsmith, Mary Fernald, Greg and Steve Eich, Rick Rosenthal, Pat Messier, Joel Thall, Dick Howard, John C. Hill, Tony Barnett, Jerry Weisberg, Michael Hering, Ramona Morris, Sheilah Garcia, Val and Bonnie Valdivia, Joe Babbitt, Bill Beaver, Felicita Eustace, Bob Gallegos, Gerri Lujan, Robert Tenorio, Sandy Horn, Seferina Ortiz, Bob and Catherine Myers, Gordon Fritz, Reggie Sawyer, Wenima Washington, Len and Jeff Woods, Cynthia Bettison, Gloria Trujillo, Ron Messick, Martha Streuver, Betty Barrackman, Jon Bonnell, Lee Griffiths, Robert Vigil, Greg Hoffman, Stephanie Rhoades, Ralph Moore, James Aumell, Hank Young, Virginia Naranjo, Frank Kinsel, Joshua Baer, Erich Erdoes, Ron and Allen Milam, Wendy Possamai, Andrea Fisher, Michael J. Fox, Doc Laine, Michael and Dennis Eros, Fred Miller, John Hornbek, and all the others we neglected to mention. Also, thanks to Chris Orlie and Rob Rowley, our long-suffering business partners in our other lives, who put up with us while we did all this. And finally, thanks to David Jenney, Erin Murphy, and Northland Publishing, who were irrational enough to think we could actually complete this book.

foreword

▶▶▶ THE TASK OF WRITING this foreword is my penance for doubting Al Hayes and John Blom. When they asked me to write it, I thought I was safe in agreeing, because I knew a book like this could never happen.

I was the one who questioned Al's buying methods, and I was the one who told him not to waste money on insignificant pieces. The last thing I ever thought was that those insignificant pieces could add up to what you see in these pages.

But this book is hardly an insignificant effort. It organizes and explains the technique and development of Southwestern pottery from its prehistoric beginnings, telling who those early people were, where they migrated, what happened to them, who their descendants were, and what they made. It also presents a thorough introduction to the history of the Southwest during its settlement by the Spanish, and later, Mexicans and Americans.

That this book does what it does so well creates a dilemma for me. As a dealer in fine Southwestern pottery, I have to wince at their buying rules and at the implication that anyone can go out and buy what they bought at the prices they paid. If you try it, I'd bet you won't succeed (although I'd have bet against Al and John, too). They made it for two reasons.

The first reason is Carol Hayes. She has an antiques business in California, and is an accomplished restorer who has worked for several high-end California antiques dealers. Her skill allowed Al and John the latitude to choose nearly hopeless pieces that, in restored condition, are worth much more than what they paid for them.

The second reason is that they avoided the truly rare and valuable. The reader should be alert to the fact that pottery from the historic period was far different from the pieces in this book, both physically and philosophically. It was made primarily for the maker's use, while virtually every pot in these pages, including much of the prehistoric ware, was made for trade. Perhaps the greatest shortcoming of John and Al's collection is that it doesn't contain any of those extremely rare pieces made between 1600 and 1880.

Having made this disclaimer, I'd like to voice my support for the main points of the book. This art form is every bit as important and almost as accessible as John and Al think it is. Those of us in the business—dealers, collectors, curators—for the most part are involved because we love the art, and we see truth in their belief that Southwestern pottery is America's first important art form. We don't use the words "art form" lightly. It may have been utilitarian ware, but it evolved into art quite early, and it remained art.

This book mostly shows non-utilitarian pieces from the post-1880 era—small, non-functional, sometimes European-influenced shapes, and modernized designs. It names several hundred potters and shows their work. I wish the book could have included several hundred more, but this art form is too vast for any one book to cover. Thousands upon thousands of beautiful pieces of pottery by other potters are out there for the finding, in an infinite variety of shapes, sizes, and decorations.

What caused these changes in shape, size, decoration, and quality during the last few hundred years? Alien influences and market pressures.

Change first occurred among the tribes as a result of contact with other Indian groups. The

Plains Indians influenced the Pueblos and Navajos through trade, as did the Indians of today's Mexico. Any time two people of differing experiences meet, each imparts something to the other, and the Southwestern Indians were no exception.

The Spanish conquerors also had a major impact on their ways of life. Some Indians were enslaved, most were Christianized, and many were killed—all in the name of Church and Crown. Subjugation took its toll on their daily lives, on their food supplies, and on what we refer to today as their arts and crafts—although these were then their daily utility kitchen wares and clothing.

Spanish floral, foliage, and lacy motifs crept into the designs on Pueblo pottery. Vessel shapes slowly changed to accommodate the needs of the new arrivals from across the ocean.

The rate of change was magnified hundreds of times three centuries years later when the railroad arrived. After 1880, the Easterners came, drawn by the pristine landscape and the indigenous peoples romanticized by the railway's poster artists. No visit, of course, was complete without an authentic native souvenir.

The Smithsonian and other institutions mounted expeditions in the late 1800s to document the lives of these peoples and to collect all their material culture before these "poor Indians" vanished forever (an imminent prospect, according to standard 1900 thinking). They gathered items by the thousands—pottery, weapons, clothing, adornments, and other cultural artifacts—and shipped them back East to be stored in museums.

At the same time that government officials and educators were stripping away the daily necessities of Indian life, visitors were looking for curios to scatter about their already overdecorated Victorian homes.

In response, potters produced pots specifically for tourists. At first, they made beautifully decorated replicas of the ones made for their own use. Quickly, they learned they could speed up the process and sell more if they made them smaller. Then they learned that they could make even more if they took less time on each piece. The period of magnificent historic pottery came to an abrupt end and the period of tourist wares began.

For the next hundred-plus years, market fluctuations shaped Southwestern pottery's development. The modern section of this book tells that story, and it shows what is available on the market today—except, of course, for those fabulous pieces that exceed Al and John's budget ceiling by ten or even a hundred times.

Al and John's claim that the 1990s represent a Golden Age has a basis in fact. Today's pottery is more carefully made and designed than ever before because pottery manufacture has always followed the market, and market standards right now are at an all-time high. The market rewards potters who make pieces for discerning collectors and penalizes those who make lesser pieces for casual tourists.

What can we expect in the future? I anticipate continued improvement. As collectors like Al and John become even more discriminating, the standards will keep going up, because now people like Al and John have become the people for whom the potters are creating their work. Even this book should contribute to the improvement, simply because it will add to collectors' knowledge base.

If you decide to try collecting yourself, you can learn from Al and John's experiences, but let it be a learning experience that launches you into building the collection of *your* dreams, not of mine or theirs. If my vision of future improvement proves correct, it should turn out to be quite a collection.

ALEXANDER E. ANTHONY, JR.
Adobe Gallery, Albuquerque, New Mexico

ONE OF EACH. *The major pottery-producing pueblos, tribes, and rancherias of the Southwest have distinctive pottery styles. Here, fourteen instantly recognizable pieces from fourteen different sources.*

TOP ROW: *Maricopa, Barbara Johnson, 1980; Taos (below Maricopa), Angie Yazzie, 1993; Acoma, Adriana Vallo, 1994; Santo Domingo, Robert Tenorio, 1985*

MIDDLE ROW: *Zia, Sofia Medina, 1990; San Ildefonso, Angelita Sanchez, 1992; Zuni, Jennie Laate, 1985; Casas Grandes, Rito Talavera, 1993*

BOTTOM ROW: *Santa Clara, Victor and Naomi Eckleberry, 1993; San Juan, Rosita de Herrera, 1993; Cochiti, Felicita Eustace, 1995; Hopi, Adelle Nampeyo, 1995; Navajo, Lorenzo Spencer (below), 1993; Jemez, Carol Vigil, 1992*

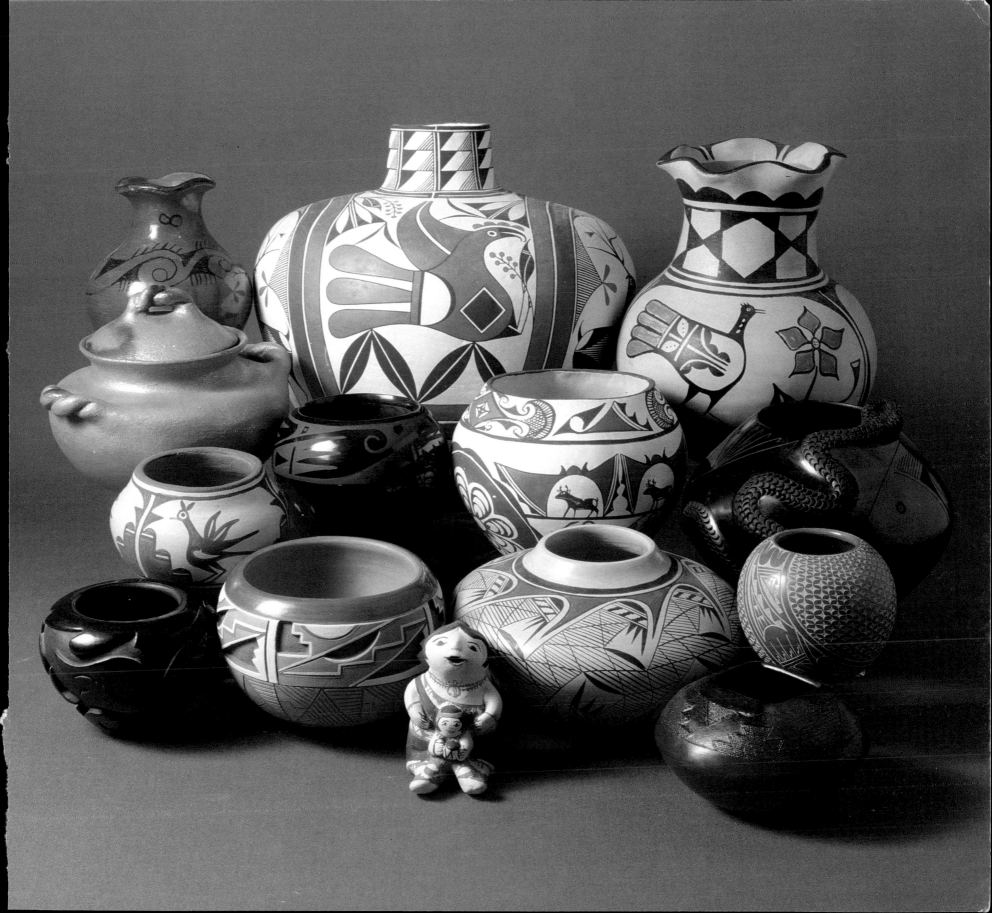

1

Getting Started

▶▶ THERE'S NOTHING ELSE in the world quite like Southwestern American Indian pottery.

The same people have made it in the same place in the same way for more than fifteen hundred years. The pot you bought last week carries the imprint of long-vanished peoples—the Anasazi, Mogollon, Hohokam, Salado, and Sinagua—whose ruins add magic to the Arizona and New Mexico landscape. Yet Southwestern pottery bears all this tradition with a youthful, even frisky, energy. This is its Golden Age, a dazzling turn-of-the-millennium burst of productivity and innovation. Now it's almost a given: next year's work will be better than this year's, and the year after, better still.

Despite all the creativity, painstaking craft, and historic value, this pottery remains implausibly accessible, more so than any other important art form. We actually bought every pot pictured in this book, almost all of them between 1992 and 1995. "We" means two beginners (or four, if you include our wives) who started out not knowing any other collectors or dealers, who wouldn't part with big dollars for anything, and who live over a thousand miles away from Santa Fe and the center of pottery activity.

None of us has the time to devote the better part of his or her life to the collection. Al Hayes is the creative director and first-name-on-the-door of an advertising agency, John Blom is a partner in a chain of pre-schools, and Carol Hayes and Brenda Blom lead equally busy lives. In fact, it was Carol's antiques business that prompted Al and Carol's first trip to the Southwest in 1989.

Al's flirtation began with an eight-dollar souvenir. The romance didn't turn serious for

him until May of 1992, and John didn't succumb until August. Within days after John plunged in, Brenda and Carol were talking about "the John & Al Museum."

Like any museum, it has its share of mistaken acquisitions and might have a mislabeled specimen or two, but this amateur accumulation represents all of the major tribal groups in Arizona and New Mexico and tells a beginning-to-the-moment history of a major art form.

If, after you look through these pages, you're intrigued enough to consider owning a pot or two, we have a few suggestions. It's no great feat to build a good collection of anything if you're willing to pour in endless hours and endless dollars, but most of us are short of both.

The management of the John & Al Museum qualifies as short on both counts. If you can relate to that, you might also relate to some of our alternative philosophies and techniques.

Before you spend a nickel. It's smart, of course, never to buy anything before you bother to learn a little about what you're buying. So look through this book and take it with you, preferably to the nearest museum that has a pottery collection. (We've listed a few good collections in the back of the book.) Even better, if they're not too far away, take a trip to Santa Fe or Phoenix or Tucson or Albuquerque or Los Angeles and look at the museums there. Not that you ever have to go there at all, but once the bug bites, you'll probably want to.

If this book nudges you into making a special trip, you'll get more out of it after you've looked at a few pots long enough to have them speak to you, and probably after you've taken a few home.

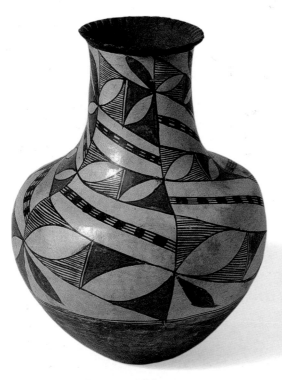

Acoma, 10 ¼″ high, ca. 1925

We learned early on that's there's no learning experience quite like living with a pot, handling it, and letting it teach you. Many Native American potters tell how deeply moved they are by the process, a combination of bonding with the land and bonding with the past. They see a pot as a living entity rather than as an object. We won't guarantee that you'll become mystical over the first pot you buy, but if you have any poet in your soul, you'll find they do start to talk. Seeing a pot at a store or a trading post isn't enough. You touch it and you look at it, but you don't understand it until it comes home.

Seeing a pot in a museum is even more remote. It's behind glass, and if it speaks, it doesn't say "Take me home," it says (sometimes untruthfully) "I'm in a museum and you can't have anything like me." The erudite little card that sits next to that pot in the museum tells you dates, typology, and points of origin, but that's not the information you really need. No card or book can substitute for time spent staring at a pot when you're holding it and can stare at it as long as you want.

Don't be afraid to buy. Just watch what you spend. The first pots you buy are more than souvenirs or ornaments, they're tuition expenses. You may get a keeper or two along the way, but don't worry if you don't, at least for the first few. As long as you follow the John & Al Museum's guidelines about spending, you won't hurt yourself.

We've held to three rules in our collecting:

If it's over $40, think hard about it.
If it's over $100, think very hard about it.
If it's over $400, don't think about it at all.

Granted, we cheated a few times, but cheating is part of the fun. On a handful of these, one or the other of us crept up to $550. Example: the larger Maria and Julian Martinez blackware jar on page 115. After all, it was a signed and authenticated Maria and Julian, which to a pottery collector is sort of like getting a baseball signed by Babe Ruth and Lou Gehrig. But—and remember this—we later found a much more valuable Maria and Julian that we bought without breaking the rules.

This cheapskate attitude flies in the face of much sound conventional wisdom. Before we go any further, you should know what right-thinking people have to say on the subject.

GENERALLY AGREED-UPON GOOD ADVICE

1.) *Never buy a cracked, broken, or flawed pot. You'll just throw your money away.*

2.) *Buy the biggest, best, and finest example you can afford. You'll never regret it.*

JOHN & AL'S ALTERNATIVE WISDOM

1.) *If you buy a beat-up or cracked pot, you'll get it far cheaper than it'll cost you to buy a good example. It's a great way to have, hold, and learn from those types you'd never have examples of otherwise.*

2.) *Buy the smallest example you can find. It's cheaper. Buy the big one way later, after you really understand the type.*

The dreadful pot:
tuition expense illustrated.
Acoma, 4¾" diameter, ca. 1955

One good learning method is to buy a pot one place, then show it around to people who really know what they're talking about. But be a little careful about what you show. Al once made the mistake of showing a disreputable, truly crummy old pot to a highly respected expert. That particular expert is the nicest man in the world, but he couldn't help himself. He looked at the pot like it was something dead he'd found on the doorstep and pummeled Al just for owning it.

The flogging went something like this: "Why do you waste money buying cracked, defective pots? You'll never get your money back if you try to get rid of them, and if you saved the money you spent on ten of these, you'd be able to buy one really good pot that meant something." He was right, of course, but the lecture wasn't enough to turn Al into a right-thinking collector. That little pot is now a mascot for the collection, prominently displayed alongside far nobler examples. And also alongside a few even worse ones.

Another respected dealer said the same thing in another way. Al had been admiring pots in the stratospheric price range, and before he'd let on that he had no intention whatever of buying, the dealer volunteered this information: "There's a natural progression with collectors. They start buying inexpensive things and then gradually upgrade. So whether their year's collecting budget is ten thousand dollars or thirty thousand dollars, they learn to buy two or three things of real value rather than buying ten things of minor worth."

Getting Started · Survival Techniques

Well, that's the dealer's viewpoint, and there's great wisdom in it, from a dealer's standpoint. But we're not dealers, or even what that dealer would consider real collectors. We march to a different drum. In fact, Al is still trying to get his head around the thought of buying ten pots of minor worth for three thousand dollars each.

Don't specialize early. Go for variety. Our museum happened because we tried to buy one of each. The quest is impossible, but it's hugely educational. When you've owned and handled, say, a couple of hundred different types, you start to know a little something about pottery. By then, you may even know enough to think about specializing. This too is contrarian advice.

One could just as easily argue that the field is so vast, so intimidating, that the beginner should narrow early. If you limit your collecting and specialize, the reasoning goes, you'll learn to recognize the fine examples more quickly and know how to negotiate for them. That way, you waste less money buying pots like the clunker that caused the expert to box Al about the ears.

But you'll have less fun. You'll search far more widely and have the gratification of buying an interesting pot far less often. Every one of the more than a thousand types of Southwestern pottery has something to say to you, and until you've seen, held, and lived with a lot of them, you won't really begin to appreciate the place each holds in the flow of history.

You can turn up examples of almost all of those types. Almost all. Some, especially those made between 1500 and 1850, are extremely rare. The most eloquent argument in favor of our tolerance of small, flawed pots is this: If you confine yourself to fine large investor's examples from the mid-eighteenth century, you'll have to shell out between five thousand and twenty-five thousand dollars. Or more. Each.

If you go the John & Al Museum's acquisition route, you'll end up with a thin representation of the pricey types. But even if you never get an Acomita Polychrome olla (we didn't) or a figured Mimbres bowl (we did, but only by buying half of one), there are way more than a thousand other types to pursue. And even some of the supposedly difficult ones have turned up in our museum, acquired within our rules.

When all else fails, trade. But not until … Yes, you can trade with other collectors and with dealers who want to freshen their inventory. If you run out of money, trading might solve the problem.

But if you're following our alternative wisdom, you won't trade a single pot until you've:

1.) *Learned everything it has to teach you.*
2.) *Found a better example.*
3.) *Decided you can live without it.*

If you're serious about all this, you'll also photograph the pot and write down everything you want to remember about it. However, be forewarned. That's what we did, and we got in so deep we had to write a book to justify our buying habit. We learned how to buy cheap, but we never learned how to keep the dollars from adding up.

Don't be too quick to trade. Once a pot is gone, it's almost certain you'll never get it back. Also, many of these guys are traders, Indians and non-Indians alike. They're not used to getting the short end of the stick. In fact, Native Americans have a long and illustrious trading history. Four hundred years ago, Aztec traders were known as people "who take more than they give."

By way of clarification, you should know that "trader" and "dealer" aren't synonymous. Dealers sell merchandise they buy mainly from traders, collectors, and other dealers. Traditional traders set up their posts on or near the reservations and learn the Indian languages. For many Indian artists, the trader is their only contact with the world of Anglo commerce.

Pick brains. And don't be afraid to ask. Four years before we wrote this book, we didn't know anybody in the field. Now, we feel as if we know everybody, just from wandering into Indian stores and from going to the many Indian shows that come up in our area (and undoubtedly in yours as well). Our success in making contacts has nothing to do with our resourcefulness or our wonderfully attractive personalities. It has everything to do with those traders and dealers.

Sure, they prefer coming out ahead in a deal, and they'd rather make a sale than talk. But they're in the business because they too are infected with whatever it is that infected us. They talk to us because we seem to care as much as they do. If you're really willing to learn, they'll teach you and help you.

We found almost immediately that some of the biggest names in the field would spend time with us, patiently correcting our mistakes. When we'd visit the priciest stores on Santa Fe's Canyon Road (the Rodeo Drive of New Mexico), we'd find owners who'd answer our dumb questions, even when we made it pretty clear we were nowhere near buying anything that day.

Without these people, there wouldn't have been a John & Al Museum. Don't be intimidated by their prestige or their prices. Find them, talk to them, and ask.

Now that you've got this book, buy a few more. We wrote this book to be the one we wished we had when we were starting, but if you care enough to acquire a few pots, one book won't do. The John & Al Museum Library has a simple policy: If we see a book on Southwestern pottery, the Bloms and/or the Hayeses buy it.

Use the bibliography in the back as a possible shopping list. Books go in and out of print, and new ones come out all the time, so it may not be much help down at your neighborhood bookstore. But check out shops in museums with pottery collections and look through the book booths at Indian or Western shows. Also, some of the better Southwestern dealers have book departments.

But even if you find most of the books we've listed, good overviews are scarce. Most books appear more thorough than they are because they're either specialized or were done as catalogs, limited by whatever was in a particular exhibit or collection. This book has the same failing, but with one difference. We tried to come as close as we could to getting at least one example of everything that's reasonably available in today's market. Fault us for completeness, but give us points for relevance.

Get on mailing lists. And watch the papers. Much of the John & Al Museum came from our two-family trips to the Southwest. But those combined vacations only accounted for 5 total weeks in 1992, 1993, 1994, and 1995. Far more pots came into our museum during the 203 other weeks of those years, mainly from sources in our own backyard.

We live in Northern California, which is probably an easier place to find this sort of thing than New Hampshire or South Carolina, but still isn't exactly a hotbed of pottery activity. In Santa Fe you can buy a pot on every corner. Where we live, we only know a handful of Southwestern pottery stores within a hundred-mile radius, and we've bought very little from any of them.

However, there are a surprisingly large number of traders and dealers who don't have stores. They sell at Indian, Western, and antique shows, and there's something going on most weekends. The problem is learning about these shows. There are two usual ways to be notified: either through the mail or through the newspapers.

In our area, the shows run little classified ads under "antiques for sale" or "collectibles for sale." They also advertise in selected national newspapers like *The Indian Trader,* and we've learned about quite a few shows from these ads. But the best way to learn is to get on mailing lists. Many shows occur regularly, and if you fill out the mailing-list cards at the shows, you'll be notified.

Some are exceptionally good, and you'll see and learn more traveling around the booths at the good shows than you ever will visiting any store. One in our area that comes up every February draws some of the most important dealers from the Southwest, and serves to remind us of what we said at the beginning: This art is incredibly accessible. Hit a few of the major shows, and you too will be on a first-name basis with the people who wrote the books.

Auctions are less well publicized. But if you go to the shows, somebody will tell you about one, or maybe you'll pick up a flyer. Some auctions are traveling events, some are always held in the same place and many accept mail and phone bids. Some deal in the rarefied top end; some sell low-end pieces. All of them, once they know you're interested, will mail you an announcement.

If you're intimidated by auctions, just go and watch until you build your confidence. Granted, an auction is a great place to get carried away and make a foolish purchase, but it's also a great place to pick up a wonderful bargain. Sometimes everybody else happens to be asleep when a treasure comes up. Some of the lower-end auctioneers have a wonderful time bending the truth, but it's all part of the game. Keep your eyes open and your mouth shut, be careful, and you'll do just fine. We have, although we've invested some tuition money along the way.

What all this adds up to is a tremendous array of opportunities to build your collection without ever driving much more than fifty miles.

Try reading this book. It's organized for quick reference. The prehistoric section is roughly chronological, but the modern section lists the pueblos in alphabetical order. That's because if you're anything like us, you bought this book to flip through the pages, look at the pictures and, every so often, check to see if you can find out a little something about the pot you just bought.

So fine. But if you *read* it, perhaps you'll understand a bit more about the scope and wonder of it all. And why the John & Al Museum happened in the first place, and why you might even consider building your own.

2

Pottery Country

▶▶ THE FUN BEGINS the minute you pick up a map. So does the mystery. For all is not as it seems with Southwestern pottery.

If you want to pin down where it comes from, the obvious answer is "Arizona and New Mexico." And if you're curious about who made and makes it, the equally glib answer is "the Indians." But, depending on what you define as Southwestern pottery and the exact historic period, the boundaries creep into northern Mexico and Nevada, Utah, Colorado, and Texas, and "the Indians" include peoples from the American plains, Mexico, and even Canada.

Today, most pottery comes from a reclining L-shaped blob that starts northeast of Flagstaff on the Hopi Reservation and runs eastward roughly along I-40 through the Navajo Reservation and the pueblos—Zuni, Acoma, Zia, and Jemez—then over to Isleta, then turns north along the Rio Grande all the way up to Taos. A smaller amount comes from around Phoenix and Tucson, and some of the best comes from Chihuahua in northern Mexico.

This doesn't mean that American pottery doesn't—or hasn't—come from other areas. Historically, it came from all over Mexico, Central America, and down to Peru. In the U.S., pottery has been excavated along the Mississippi from Ohio to Louisiana, in Tennessee, in New England, and almost everywhere else. The pottery in this book came from the American Southwest, an area once described as extending from Las Vegas, Nevada, to Las Vegas, New Mexico, and from Durango, Colorado, to Durango, Mexico. (Here at the John & Al Museum, we think it cuts off farther north, well above the city of Chihuahua.)

What makes the pottery we've focused on worth special attention isn't its quantity or even its quality so much as its continuity. The pottery from other areas appeared and died out as its makers moved on. In Arizona and New Mexico, it's been made continuously for almost two thousand years, and tracking the evolution of styles over the years is a fascinating detective game.

It's not just a simple excursion into art history. It's perhaps the most important key to the total history of the people of the Southwest. In the early 1900s, scholars drawn to the cliff dwellings and stone ruins realized that well-preserved pottery and broken potsherds were excellent clues to use in reconstructing history. The examples are plentiful, and they've received intense academic attention ever since.

A lot of otherwise-sane people have been seduced into devoting a lifetime to the investigation. At a glance, everything seems quite clear, but the more one learns, the more confusing it becomes. It's confusing enough to throw the scientific community into a state of near-paralysis whenever it tries to explain what actually happened to the peoples who made all that pottery five hundred and a thousand years ago. One archeologist lamented, "It would all make so much sense if we didn't know so many facts."

Archeologists began digging up the Southwest in the last quarter of the nineteenth century, and by 1890, poking around what is now Arizona and New Mexico was becoming a national craze. These early scientists/adventurers wrote important books about what they found, and each book influenced the thinking of those who followed. Unfortunately, the pioneers didn't use the tools of modern archeology. Stratigraphic dating—

Reserve Indented Corrugated, 5¼″ high, ca. 1125

estimating the age of items according to how deep they're buried—didn't become standard in the Southwest until after 1915, even though Thomas Jefferson used it in the eighteenth century when he excavated Indian mounds in Virginia. Dendrochronology—dating by tree rings—wasn't in place until 1929. Carbon-14 dating came after World War II.

During all those years and right up to the present, books have hypothesized about the comings, goings, and doings of the prehistoric peoples of the Southwest. Traces of human occupancy of the Southwest date back to the Ice Age, but recorded history begins quite late in Arizona and New Mexico. "Prehistoric" means anything before Coronado arrived in 1540.

Theorizing about the prehistoric period revolves around architecture, burial customs, and artifacts. Because pottery is the most plentiful, the most easily identifiable, and the best preserved of the artifacts, much of the theory, current and discredited, starts with conclusions drawn from examining it. Those who play the detective game have spent nearly a century pigeonholing all that pottery with ever-increasing accuracy.

Some experts now list up to fifteen hundred types of Southwestern pottery, and if you're an interested beginner who hopes to make an accurate type identification of a pot made much before the beginning of the twentieth century, good luck. No book we've ever found manages to discuss more than a few hundred of those types. And no book we've ever found includes all the pots we stumbled on in the first few months of buying.

But even this plethora of types may not be enough to cover everything. In a delightful intro-duction to Stewart Peckham's *From this Earth,* J. J. Brody divides the experts into "lumpers" and "splitters." The lumpers group types together, the splitters keep discovering more types, and they've been arguing ever since the early explorers started digging.

Classification. In the 1930s, the experts stopped arguing long enough to give us a classification system. It uses a "Period/Culture Center/District/ Ware/Type" hierarchy much like the biologist's "Phylum/Class/Order/Genus/Species." If you're schooled in its elements, and if you're privy to a library with all the obscure publications that describe each of those fifteen hundred types, you can do a reasonably accurate field or laboratory identification of most prehistoric fragments.

The classification system helps explain the development of Southwestern pottery, and even begins to give a context for understanding the Southwest as a whole— a context that isn't readily apparent to the casual visitor. We'll try to walk you through it without bogging down in the academic details that convert an otherwise interesting subject into instant boredom.

The system doesn't go out of its way to help the beginner. The names of the major civilizations who made the pots—the Anasazi, the Mogollon, and so forth—either barely appear or don't show up at all. To cloud the issue further, people only use the type name when they refer to a pot, ignoring the rest of the classification system, similar to the way biologists don't bother with Phylum/Class/Order. We're not *Chordata Vertebrata Mammalia Homo sapiens,* we're just plain old *Homo sapiens.*

The type names are little help. Many date from before the classification system. The names (Reserve, Snaketown, McElmo, Sikyatki, etc.) usually describe the location where the pottery was first discovered or was first found in sufficient quantity to appear to qualify as a separate type. It's logical, but much of the pottery was widely traded, so a given example of any given type may well have been made somewhere else.

Under the current but ever-revising typology, this beat-up old pitcher (there's another picture of it on page 37) is properly identified like this:

PERIOD: *Pueblo II/III*
CULTURE CENTER: *Little Colorado*
DISTRICT: *White Mountain*
WARE: *Black-on-red*
TYPE: *Wingate Black-on-red*

This accumulation of information tells you it's probably around nine hundred years old, is red with black decoration, and the best expert guess says it was made somewhere near where I-40 crosses the Arizona–New Mexico border. (Fort Wingate was a military outpost near Gallup.) If you know enough to read between the lines, you can figure out that it's red-slipped grayware and, according to current theory, was made by the

Pottery Country · Times and Places

Mogollon. But when you see the pot, you're not supposed to acknowledge all that. You're expected to nod knowingly and say, "Hmm, yes, Wingate, and not much of an example either." Sounding smart takes some homework.

It's easier to sound smart if you learn a little about the pigeonholes of the classification system. Here's what each category in the classification system tells us.

Periods. They identify the date the pot was probably made, which should be clear and simple enough. But even here, nothing is simple. The period names in the classification system have little to do with pottery. Instead, they refer to cultural changes based on migrations and developments in architecture and agricultural techniques, and scientists keep revising them. They've created at least three different chronologies for the Anasazi and separate ones for the Hohokam, the Mogollon, and the Mimbres.

Although the book you're reading might use different names for the periods, this timetable should get you past the little cards you see by the exhibits in the museums.

Basketmaker II	50 B.C.–A.D. 450
Basketmaker III	A.D. 450–700
Pueblo I	700–900
Pueblo II	900–1100
Pueblo III	1100–1300
Pueblo IV	1300–1600
Historic	1600–1880
Modern	1880–1950
Contemporary	1950–present

Earlier periods had little to do with pottery. Prior to Basketmaker II, Southwestern natives were nomadic hunters and gatherers, and pottery had no place in their lives. Even though the technology had existed in neighboring South America and Mexico for centuries, the Southwesterners didn't seem to be interested.

Ancestry, western Mexico, A.D. 100
Nayarit, Chinesco Orange-on-white, 7″ diameter

It's not that they were necessarily unaware of pottery. There's evidence of trade with neighbors to the south in prehistory, and excavations have produced Mexican metalwork, exotic bird feathers, and the like. But they didn't trade for pottery until they needed it. As long as they were wanderers, they needed more easily portable ware, and their definition of "portability" was narrow. They had no horses, burros, cattle, or other beasts of burden, and no wheeled vehicles. If a smallish dog could drag it or carry it, okay,

but otherwise, it was carry it yourself or forget it. Not surprisingly, well-made weavings and baskets preceded pottery by hundreds of years.

Pottery only became practical when the Southwestern Indians learned to irrigate and shifted their emphasis to agriculture. Now that they were tied to specific land parcels, portability dropped below permanence on the priority list for storage vessels. Once pottery began to appear, somewhere around A.D. 100, its popularity increased and its quality and variety improved steadily until around 1400, when several factors reduced the population and invading tribes began contributing the occasional massacre.

Not too many years later, European civilization arrived, catapulting the natives out of Stone Age technology and adding horses, smallpox, venereal disease, and enforced religion to the mix. Before 1600, pottery was a widely used commodity traded by people with the freedom to move about at will. After 1600, the Spanish put the Pueblo Indians to work building missions, effectively reducing mobility and trade. Pottery became less important to the native economy and was made in small quantities for people who used it until it broke.

Pottery made between 1600 and 1880—the historic period—is the rarest of all. It was discouraged as unsuitably pagan, dismissed as aboriginal trivia by Spaniard and Anglo, and by the end of the period, often replaced by manufactured tin, glass, or crockery, and kept within the pueblo by the Indians.

As Europeans laid claim to the land, the Indians lost their freedom to relocate and rebuild anywhere they wanted. Instead, they clustered

together into fewer and fewer settlements. Most of the twenty Arizona and New Mexico pueblos of today have been where they are for three centuries or more. Archeologists don't excavate them, any more than they dig up the towns in California where the authors live. Put all these influences together, and they explain why there's a dramatic scarcity of historic pottery compared to the amount of prehistoric pottery that's floating around today.

After 1880, the pattern quickly reversed. Railroads came through, bringing tourists along with a new crop of merchant/traders who told the Indians what to make for tourists. Big storage ollas wouldn't fit in a traveler's suitcase, so potters turned to making smaller pieces. Soon, pottery resurfaced as a factor in the native economy. Also, curious Anglos began gathering specimens for museums—something the Hispanics apparently never did. It's a sad fact that there isn't a single known collection of Southwestern pottery that was gathered before 1870, either here or overseas.

Today's pottery is made by a people who stubbornly adhere to tradition, but whose definition of tradition has been deeply affected by the flow of history and by outside pressure, whether it came from Spaniards, Catholic and Mormon missionaries, Santa Fe gallery owners, museum directors, or the nomadic Athapascans from Canada whom we now know as the Navajo.

Culture Centers and Districts. The "culture centers" and "districts" used in the pottery classifications often don't match our perceptions of the people who made the pots. This is because they're based on river drainages and topography rather than the cultures themselves. Pick up any book about the Southwest and by page three, you'll see reference to the Anasazi, the mysterious people who populated the Four Corners area (where the borders of Arizona, New Mexico, Utah, and Colorado touch each other). The Anasazi disappeared into the limbo of history and the archeologist's typology never resurrected them. Instead, it talks about culture centers like "San Juan" and "Little Colorado" and districts like "Chaco" and "Mesa Verde." They're all mostly Anasazi, but you'd never know it without studying some history and local geography.

Unless the books are specifically about prehistoric pottery types, they'll talk instead about the principal peoples: the Anasazi from the north; the Mogollon who spread east, west, and north along the southern Arizona–New Mexico border and northern Chihuahua; the Hohokam from around Phoenix and Tucson; the Chihuahuans and Sonorans from just across the Mexican border; the Salado from central Arizona; and the Sinagua, who left ruins up and down the Arizona map from Roosevelt Lake to Flagstaff and whose history and geography seem tangled with the Salado and later with the Hopi.

The research staff of the John & Al Museum is far more interested in people than in river drainages, so this book won't devote much space to Culture Centers and Districts.

Wares. The ware names don't help as much as they might. They often don't tell you what pots are made of, which is a good clue to where they came from. Redware simply means that the surface of the pot is red and has nothing to do with the color of the clay under the surface.

Then there are variations of materials and manufacture. As you read the books, you'll run into all kinds of confusing distinctions, none of which is readily apparent when you look at a pot with anything less than a magnifying glass and a well-tutored eye: "coiled" vs. "paddle-and-anvil" construction, "mineral" vs. "vegetal" paint, "sherd" vs. "coarse sand" temper.

Enough already.

All this goes to explain why the research staff here at the John & Al Museum has chosen to lump shamelessly and excessively. When we show a picture of a pot, we'll try to identify it as correctly as we can. But when we talk about wares and sources in a historical context, we'll portray the trends and types with a broad brush. Or more accurately, with an eighteen-inch-wide roller.

As an answer to "where it comes from," we'll start with an ultra-simplified definition of "it." Forget the classification system. As far as we're concerned, there are only five kinds of Southwestern pottery. Or, if you will, five colors:

Brown
White (including gray)
Buff
Red
Yellow

Scratch the surface of our typology a bit, and you uncover a few questions. Like what about orange—is it yellow or red? When does buff become yellow? Are we talking about the clay in the core or the slip on the surface? What about blackware? And what about temper? And paint? For the moment, this museum's staff has a simple answer to all such questions. We ignore them.

Pottery Country · Five Colors

Types. These are the identifications you're supposed to throw around as if you knew what you were talking about. All fifteen hundred of them.

From our lumper's point of view, there are far more types than we'll ever need. The fine lines between types can become almost indistinguishable to all but the most knowledgeable. Some types are scarce, some are downright unobtainable, and other, better-known types attract their share of misidentification.

As a final indignity, there are little twists and turns in the classification system to confound the unwary. Since we were speaking of "Wingate," we might mention a similar type called St. Johns Polychrome (St. Johns is a bit south and west of Gallup just across the Arizona state line). It looks exactly like Wingate Black-on-red, except that St. Johns Polychrome has white decoration on the outside of the vessel, like the bowl on page 37. Clear enough? Sure. Except that there's a St. Johns Black-on-red, with no white, and a Wingate Polychrome, with white on the outside of the vessel. The splitters are ever-active, even while we sleep.

Sigh. These maps give an answer to the initial question of this chapter—"Where does it come from?"—according to the John & Al Museum's Simplified System.

If we connect those clay colors with the names of prehistoric cultures, it works out something like this:

Brown	=	*Mogollon*
White	=	*Anasazi*
Buff	=	*Hohokam/Casas Grandes*
Red	=	*Salado*
Yellow	=	*Sinagua/Hopi*

It produces a map that looks like this:

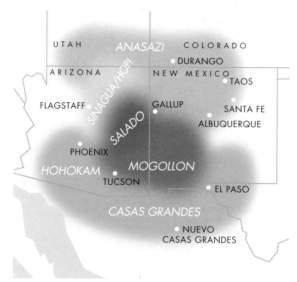

Pottery Country, ca. A.D. *1000*

The trading areas of each of these peoples extended way beyond their areas of settlement, which explains why people dig up brown pots north of Flagstaff and gray pots from California to Oklahoma.

Since then, we've had a thousand years of migration, famine, disease and real-estate crunch. Tribal populations have grown but the settlements have shrunk. They still make a little pottery in Hohokam country, but most of the made-in-U.S.A. Southwestern Indian pottery we value today comes from the area where the Mogollon and the Anasazi overlapped, from the Hopi reservation in Arizona to Albuquerque and up to Taos in New Mexico.

Meanwhile, across the border, the Chihuahuans have quietly started making beautiful traditional pottery in the remote town of Mata Ortiz, near the ancient pueblo ruins of Casas Grandes.

Those clay colors square up with modern pottery like this:

Brown	=	*Nobody much except the Navajo*
White	=	*Acoma/Zuni*
Buff	=	*Northern and middle Rio Grande, southern Arizona, and Casas Grandes*
Red	=	*Middle Rio Grande*
Yellow	=	*Hopi*

Pottery Country, now

Less area, but more pottery than ever. Nobody makes much pottery in Mogollon and Salado country these days, but nobody did much along the Rio Grande back then, and that's where much of it comes from now. Redware has moved, brownware is about gone, and the rest is where it always was.

That's pottery country, according to our lumped view.

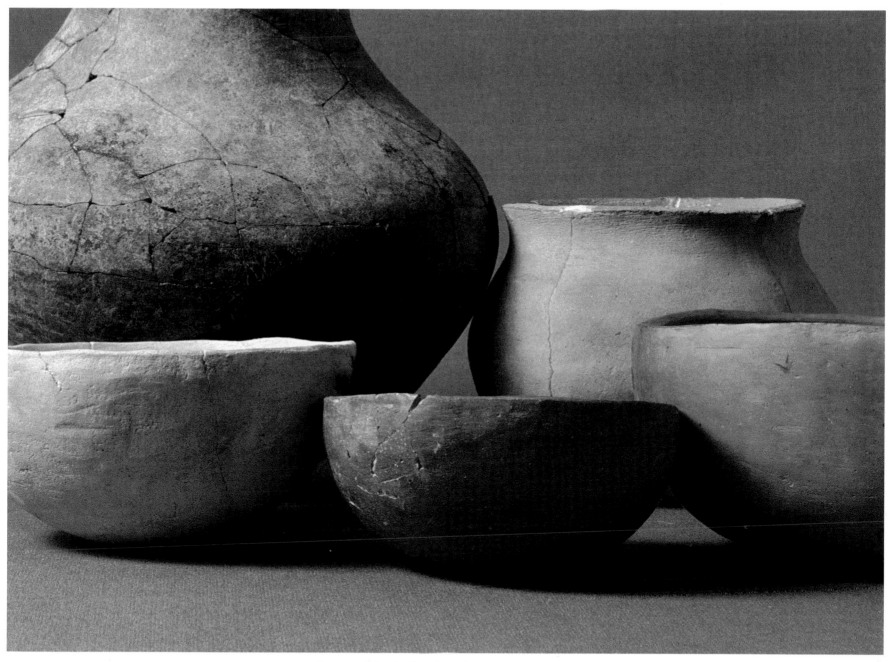

Brown, white, buff, red, and yellow, ca. A.D. *1000*

3

What to Look For in a Pot

▶▶ FIRST, YOU MIGHT want an answer to question number one: "What's a good pot?" Answers vary, based on age, scarcity, intrinsic beauty, and who's doing the answering.

Not everybody has the same priorities. Here at the John & Al Museum, Al is a sucker for good painting and for that elusive ingredient called "character." Other equally informed collectors (and better-informed ones, too) care more about the potter's craft. John increasingly looks for "degree of success," upgrading or downgrading his calls based on what he thinks the state of the art was when and where the pot was made.

Al will happily bring home another rain god—junk the day it was made, junk forever into the future—just because it's a nearly vanished bit of pottery history. John will buy yet another owl figurine from a potter he likes, even though he already has three.

We'll miss a lot of the fun if we ever become elitist, or even particularly disciplined. Sure, we're perfectly capable of turning up our noses at mass-produced refrigerator magnets and wind chimes, but we're delighted to find their now-scarce counterparts from earlier times—uncleanable Hopi ashtrays from the 1930s or Isleta cream pitchers from the 1920s. Someday we may regret not having picked up a wind chime while we could still get one.

Everybody agrees that a perfectly made, ambitious pot is nice. But given an attractive, less-than-perfect pot, would you prefer a well-painted one that's a touch lopsided or a beautifully made one with slightly crude decoration? Just because John leans one way and Al leans opposite doesn't mean either of us is right.

When you start your own museum, you can set your own priorities.

Meanwhile, here's some information that helped us set ours.

Shapes. Some books show a lot of little drawings of shapes to teach you who does what. Frankly, they confuse us. We learned all that much better by looking at pots.

However, it might help to learn a little vocabulary. If somebody offers you an *olla* (they'll say "oya"—it's Spanish for big jar), it's nice to know what one is.

Here's an alphabetical list of shapes. Some are so obvious they're not even listed. "Ladle" means a ladle, "dish" means a dish. But some of the others can be tricky.

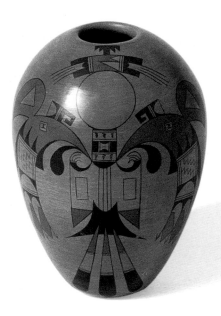

Hopi, Gloria Kahe, 6½" high, 1995

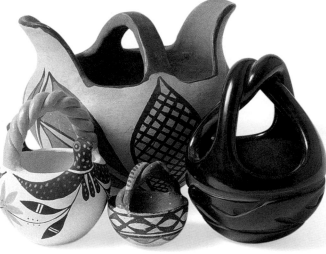

Baskets
CLOCKWISE FROM LEFT: *Acoma, Dorothy Patricio, 5" high, 1993; Santo Domingo, 7½" wide, ca. 1935; Santa Clara, Reycita Naranjo, 6" high, 1984; Isleta, 3⅛" high, ca. 1920*

• **BASKET:** Confusing only because "Indian basket" means a woven basket, not a piece of pottery. Baskets are bowls with handles across the top.

They can be souvenirs or serious pots. Not everyone defines baskets the same way. Other books might call the big one a "bowl with strap handle." Or even a "pitcher."

• **BEAN POT:** A deep bowl, somewhere between the size of a large grapefruit and a volleyball, almost always from Picuris or Taos, often with a lid. It's fired at a high temperature and is oven-safe, so you can cook in it. Purists insist that beans cooked any other way simply don't taste the way they should.

• **BOWL:** A low vessel with a big opening. The lines between "dish," "bowl," "jar," and "vase" are blurry.

• **CEREMONIAL JAR, BOWL, OR VESSEL:** Squared or stepped bowls from the nineteenth and early twentieth centuries, or pieces with figures or symbols that don't normally appear on tourist or utility pottery from a particular pueblo. "Ceremonial" can also mean something strange that the dealer thinks should have some added mystery. "If we don't know what it is, it's ceremonial," is an archeologist's cliché. Genuine ceremonial artifacts shouldn't be sold. Odds are that any ceremonial piece you buy was never used in a ceremony.

• **CHILI BOWL:** A small bowl used for individual servings. See "dough bowl." Chili bowls and dough bowls from the same period and pueblo are often identical except for size.

• **CURIO:** Or souvenir, or tourist pot. Ashtrays, cowboy hats, hornos, etc.

• **DOUGH BOWL:** A large-diameter, shallow bowl, big enough to allow you to knead dough with both hands. Applies to historic and modern Pueblo pottery.

• **EFFIGY:** Any vessel in the shape of a human, animal, or even a plant, either literal or implied. Some prehistoric effigy pots—like the black owl bowl in the bottom row on page 41—require a long leap of the imagination. "Effigy" can also apply to decoration. See "Figurine."

Fetish bowl—bogus?
Zuni (?), 4″ diameter, 1992

• **FETISH BOWL OR FETISH JAR:** Generally, any pot with appliquéd animal or human figures. Specifically, a Zuni pot made to hold carved fetishes, usually covered with crushed turquoise. It has a hole in the sidewall for feeding the fetish, and it contains a bit more magic than the average Zuni feels comfortable selling to outsiders. The one you bought at the gift shop was probably made by a Navajo.

• **FIGURINE:** Another point on the pots-shaped-like-living-things continuum. We shake it out this way: a figurine is a little solid clay statue. An effigy is a jar or a vase in the shape of a creature, human or otherwise. And a fetish pot is a bowl, jar, or vase with the creatures attached.

• **HORNO:** The traditional Pueblo earthen bread oven, miniaturized into an ashtray or an incense burner. Pueblos have

Horno
Taos, Paula Romero, 4½″ long, ca. 1980

cranked them out for tourists since the incense-happy sixties.

• **JAR:** A bowl with a constricted neck or opening, tall or squatty.

• **KIVA JAR OR BOWL:** A pot with a stepped shape to the opening. The word "kiva" refers to the underground ceremonial chambers that have been used at pueblos from prehistoric times. These are "kiva pots" because the steps on the pot's rim suggest the steps down into the kiva.

• **MATCH HOLDER:** A little ashtray companion designed to hold wooden matches. There's one attached to the horno below.

• **MINIATURE:** A piece too small to be used for anything. Bowls, jars, figurines, and curios under three inches in their largest dimension.

• **MELON JAR:** A jar with an impressed design of vertical fluting that reminds you of a casaba melon or an acorn squash. The modern melon bowl started at Santa Clara, probably as an imitation of Mexican or Peruvian pieces brought in by traders, and is now also made at Jemez.

• **MONO:** A nineteenth-century term, Spanish for "monkey," originally intended as a put-down for Cochiti and Tesuque figurines.

• **MUTTON BOWL:** A serving bowl peculiar to nineteenth-century Hopi pottery. See the pot at middle right on page 73.

• **OLLA:** A great big jar, basketball-sized or bigger.

• **PLAQUE:** A round or rectangular flat trivet for hot dishes or teapots, encouraged around 1900 at Hopi by trader Thomas Keam.

- **RAIN GOD:** An endearingly ugly figurine from Tesuque, first collected in the 1870s, mass-produced from the 1890s into the 1930s. In its early days, a candy company popularized it as a giveaway.

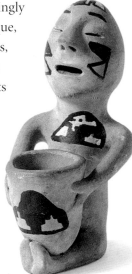

Rain god, ca. 1930
Tesuque, 6½″ high

- **SEED JAR:** A jar with a very small opening, or mouth, made for shaking out seeds. The shape occurs in prehistoric pottery and reappears in modern pottery for less-functional reasons. Some recent jars have holes so tiny you'd have to put the seeds in one by one.

- **SERVICE VESSEL:** In prehistoric pottery, a blanket designation describing anything that isn't a "utility vessel." If it's painted, decorated, or in any way fancy, so goes the logic, it must have been meant to serve something to somebody. See "Ceremonial" and "Utility vessel."

- **SINGING MOTHER:** See "Storyteller Doll." Helen Cordero intended her original storytellers to represent her grandfather, so all storytellers are supposed to be male. A female storyteller is a singing mother, even though you'll almost never hear a collector or dealer use the term. Singing mother *monos* go back to the late 1800s at Cochiti.

- **STEW BOWL:** Halfway between a dough bowl and a chili bowl.

- **STORAGE JAR:** A big, old olla, up to twenty-four inches high and on rare occasions even bigger, that usually held grains; made for use rather than show, now rare. The bigger the piece, the harder it is to make.

- **STORYTELLER:** A surprisingly long-running fad. In 1964, Helen Cordero of Cochiti Pueblo started making figurines of a seated figure with lots of tiny people sitting all over it, ostensibly listening to a story. These caught on so spectacularly that thirty years later, most of the pottery output of Cochiti and a good portion of that from Jemez is still devoted to making storytellers, singing mothers, and anthropomorphic versions with turtles, bears, and the like.

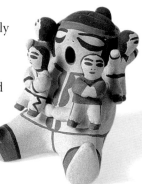

Storyteller, Cochiti
J. Suina, 3¾″ high, ca. 1990

- **TILE:** See "Plaque."

- **TULIP VASE:** A shape peculiar to Hopi pottery from the 1920s and 1930s, borrowed from mainstream European/American art pottery. It occasionally pops up elsewhere.

- **UTILITY VESSEL:** Undecorated prehistoric bowls, jars, and ollas whose owners may have used them to put something in, cook something in, or eat something out of. See "Service Vessel."

- **VASE:** A bowl or jar that's taller than it is wide, or a long-necked jar, like a bud vase.

Tulip vase, Hopi
8¼″ high, ca. 1937

- **WEDDING VASE:** A two-necked shape, supposedly designed to allow the bride and groom to share a ceremonial drink. The Santa Clarans claim it, most pueblos make it, and tourists buy it. It does show up in some weddings.

The Potter's Craft.

Southwestern Indian pottery resists change. More than a few potters dig their own clay, grind and mix it by hand, shape their pieces without a wheel, polish them with a stone or gourd, dry them outdoors, color them with pigments boiled down from plants or dug from the earth, paint them with brushes made from the chewed ends of yucca fibers, and fire them in pits they built themselves—just as their distant ancestors did more than a thousand years ago.

Wedding vase, Santa Clara
Jane Starr, 3″ diameter, ca. 1990

This doesn't mean that progress never intrudes. Today, some potters fire in an electric kiln. Many use store-bought paintbrushes. A few use store-bought paints and some, store-bought clay. At the souvenir level, potters decorate pre-cast pots called greenware.

But today's Golden Age has nothing to do with modern production methods. The really good potters concentrate on doing it the old way, only better. Each year, pots get thinner, carving gets more precise, painting gets more accurate.

One of the best-known contemporary potters, Nathan Youngblood of Santa Clara, said this in *Fourteen Families in Pueblo Pottery*:

I get a lot of feedback from people who say, "Why do you fire that way? Why don't you fire in a kiln? Why do you prepare your clay? Why don't you go to the store and buy it?" I guess the reason I don't want to go down that road is because when I lived with my grandparents, the one thing they constantly tried to instill in me was that the way we do our pottery, the traditional way, was the way that was handed to us by the spirits that come before us. In order to show the proper respect for the clay and to the clay, we need to keep doing it in the old way.

The old way is a laborious process, and Pueblo women have defended it well. At different times in different locations, the craft has been entirely the property of women, traditionally passed down from mother to daughter. In some Southwestern indigenous cultures, families are matrilineal (when you're born, you automatically belong to your mother's clan, not your father's), which may have something to do with the custom, or may not.

But times are changing. Early observers wrote of male potters who disguised their gender, dressed as women, and performed women's duties. The "man-woman" potter suffered no social stigma and was regarded as an important figure in Pueblo society.

In the early twentieth century, celebrated potters (including Nampeyo of Hopi and Maria Martinez of San Ildefonso, two of the most celebrated) began leaving the painting to their husbands. The ratio of men to women in the craft is increasing. Pueblo Indians are as prone to Equal Opportunity–male/female modes of thinking as anyone else.

Here's what you go through to make a Southwestern pot:

• THE CLAY: First, you mine your clay yourself and you lug it home, just as it's been done for the last thousand years. Sure, you can buy some from the Clay Man on one of his swings through the pueblo, but it's not the same.

Mining clay is no small task. Today, you might throw a sack in the back of the pickup, but until recently, you'd walk home with it, most likely for several miles, carrying enough to make the trip worthwhile. And you'd be hauling a sack of dense, wet dirt.

With very few exceptions, potters don't shop around looking for the clay they like best. They learn to make pots out of the clay that's nearby, and they treasure it. They've been known to keep the location of the family clay mine a secret for generations.

That's why clay is Southwestern pottery's first clue to identification. Acoma potters use white clay, San Juan potters use red clay, and Taos potters use a golden-buff clay with shiny little mica flecks. Zia potters use a clay with an unfortunate time-bomb characteristic caused by tiny chunks of limestone that can pop out months after the pot is fired, creating little dings that blemish both the pot and the potter's reputation.

On our first trip to Santa Fe, we watched an educational video at the Wheelwright Museum, and we came away convinced that potters were fanatic, even irrational, about clay. One broke down and cried as she recounted how a soulless neighbor had actually THROWN SOME OUT. Now we understand the fanaticism. Good clay is rare, hard won, and to be greatly valued.

• TEMPER: Most clays won't fire up to produce a sturdy pot unless you mix in a tempering substance. Instead, they'll shrink and crack. It's something like the difference between cement and concrete. Like clay, cement doesn't have much strength by itself, but temper it with sand and rocks and you have concrete.

Southwestern potters figured this out more than fifteen hundred years ago. Almost immediately, they learned the first principle of brickmaking and mixed straw with the mud. Other tempers came along quickly afterwards, and today they vary from pueblo to pueblo. At San Juan and Santa Clara, they use a coarse sand of ground-up tufa, the volcanic stone the Navajos use in making casts for their silver work. At Acoma, they grind up old potsherds, even prehistoric ones salvaged from the dumps below the mesa. Hopi potters are luckier with their clay, and many get by without adding any temper whatever. Because of their exploding clay, Zia potters use a lot of ground-up basalt, sometimes almost as much temper as clay.

The combination of clay and temper tells scientists and archeologists most of what they need to know about the source of any given pot. If a pot is chip-free, well-slipped, and polished, you can't tell much about temper. If you care more about science than you do about art, you won't much like nice, well-polished pots. A freshly broken fragment is a treasure trove of information. An intact pot is a crime against science.

• PREPARATION: The preparation is also like mixing concrete, only far more delicate. The potter grinds the lumps out of the clay and

grinds the temper down to the smallest-possible particles. Some older pottery shows big, obvious chunks of temper, but nobody gets away with that now—to compete with commercial ware, modern potters have to deliver a perfect surface.

After the grinding, you have to arrive at the right mix of clay, water, and temper, and knead it into a smooth, workable mass. It takes hours and hours, and if you mess up the proportions, you've blown it. Too little temper and your pot breaks in the firing or cracks in the drying. Too much, your pot breaks in the handling. Too much water, and you can't work the clay. Too little, and you can't get an even mix.

• COILED POTTERY: Most of us remember making a snake out of clay as one of our first artistic expressions. For two thousand years, Pueblo potters have done just that. They roll out snakes and coil them

Coiled pottery, undisguised
Tularosa Banded Corrugated, 7¾" diameter, ca. A.D. 1250

slowly and laboriously from the base up until they form the shape of the finished pot. Potters usually start their bases in a mold, called a "puki," which might be no more than the bottom of a broken jar. But some prehistoric potters went all the way, and a few potters still experiment with the technique today. Once you've seen an ancient corrugated pot, you appreciate coiled construction.

The only mystery is how potters manage perfect symmetry without a wheel. It would be foolish to maintain that no Southwestern Indian pottery has ever been made on a wheel, but you'll

be hard-pressed to find an example. Pueblo potters have become incredibly adept at building those long clay snakes into round vessels. Doubters have measured their work and found jars as big as a basketball to be within hundredths of an inch of true round.

These days, potters usually coil snakes into hoops that are somewhat greater in diameter than the final thickness of the pot and pile them up on the puki base, shaping and smoothing them with the tool of their preference, such as an old potsherd, a shell, a carved fragment of gourd, a rock, or a piece of wood.

There's no magic to the perfect roundness of a good pot. It's just the product of hands and eyes conditioned by countless hours of practice, plus enough patience to meet exceptional standards.

These days, the standards *are* exceptional, raised higher and higher by a natural competitiveness among the potters and the ever-increasing stakes in the market. The better the pot, the better the potter's reputation, and the better the reputation, the higher the price and the quicker the sale. Quality pays.

• PINCH POTS: As a general rule, if the base of the pot is smaller than the palm of your hand, the potter started with a ball of clay and hand-sculpted the pot. If the pot is larger, it was made by coil-and-build. Yet, potters have been known to make pinch pots ten inches or more high.

Purists might dismiss jars and bowls that depart from the traditional multiple-coil technique as lesser creatures. But before you turn up

your nose, look at one of the better Mata Ortiz pinch pots. They roll out the base, then make one big doughnut for the side walls and shape it by hand. Acoma's finest potters never made pottery any thinner or more beautifully finished.

• PADDLE-AND-ANVIL: Prehistoric Hohokam and Mogollon potters used a different method, and it persists in Tohono O'Odham and Maricopa pottery. Instead of a coil, the potter rolls out a flat pie crust of clay and shapes it upward, pinching and smoothing it together.

The potter holds an "anvil"—a suitably curved piece of wood, rock, or gourd—inside the jar or bowl and worries the outside with the "paddle"—a flat rock or piece of wood—until the pot assumes its proper shape. If the potter hasn't spent much time smoothing the inside of

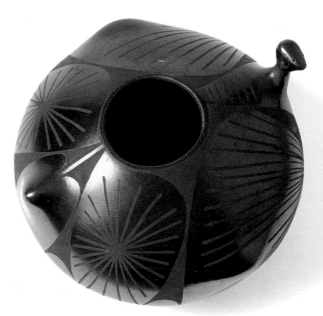

Mata Ortiz: state-of-the-art pinch pot
Casas Grandes, Jaime Quezada, 8" diameter, 1992

a jar, you can recognize the method by the anvil dents you find on the interior.

• SMOOTHING, SLIPPING, AND POLISHING: Once pots are shaped and dried, potters smooth them with a carved gourd rind or whatever other tool they prefer. This is no quick process. The more hours spent polishing, the deeper and richer the sheen. The quality of the polish influences the value of the pot, and with some pots, it provides most of the value.

Polishing completed, the potter gives the pot its final background color by putting on the slip, a highly diluted wash of clay. The clays used in slips are usually rarer and choicer than the clay that the pot was made from, and they're gathered from all over, selected for their fineness and color. A good pot can't simply be painted an attractive color because paint can't be polished quite like clay. Slip, on the other hand, *is* clay. It's just used as paint.

The slip goes on in thin coats, applied with a brush, a cloth, or a piece of leather. The black glossy surface of Santa Clara pottery is achieved by polishing with a river stone. The stone has to be a good one, with an unblemished surface and correct shape. A really good one gets passed down from generation to generation.

• IMPRESSING, INCISING, CARVING, AND SGRAFFITO: Long before any Mogollon or Anasazi thought to paint the surface of a pot, they poked sticks and reeds into them, creating impressed patterns that occasionally approach fine art and which some of today's potters still emulate.

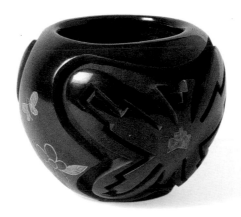

Sgraffito and carving on the same pot
Santa Clara, Madeline Naranjo, 3¾″ diameter, 1993

Impression is basic no-tool or minimum-tool sculpture. Classic latter-day example: the Santa Clara Pueblo hallmark, a bear-paw imprint that's little more than a three-eyed happy face.

Incising takes impression one step further. Before the pot is fired, the potter cuts through the surface to create a change of color or texture. San Juan, San Ildefonso, Santa Clara, Acoma, Jemez, and lately the Navajo all do good incised work. In recent years, the Utes have cranked out multi-colored tourist pottery with fine incision in parallel rows, and Navajo and Acoma potters have joined in with a flood of imitations. (There's a factory-made Navajo version at middle row, left, on page 105.)

Carving comes closer to true sculpture. The highest form of the art these days takes place at San Ildefonso, Jemez, Nambé, and especially at Santa Clara, where the potters seem to be competing on two levels—trying to see how deep they can carve the bas-relief while at the same time trying for the

Impression: the bear paw
Santa Clara, Sharon Garcia, 1992

thinnest possible pot. The better you are at the game, the higher the price of your pots.

Sgraffito, unlike carving and incising, takes place after firing. It's fine ornamentation etched through the slip to reveal the color of the clay beneath. The Santa Clara pot at left shows the difference between carving before firing and carving afterwards. The carved part fires up black like the surface. The sgraffito part reveals the light color of the clay. (It's also a handy way for the potter to hide any blisters that pop out in the firing.)

• SCULPTURE AND APPLIQUÉ: Sculpted pottery has been around from the beginning. Most of it, like the pre-Columbian sculpture from Mexico and South America you see in books, is hand-molded, helped along here and there with a little tool. This little bear is just a blob of clay

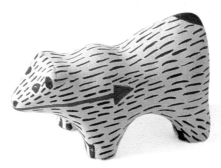

A pinch here, a pinch there
Zuni, Jack Kalestewa, 2½″ long, 1993

quickly and deftly pinched into a simple shape—the pottery counterpart of a dashed-off sketch by a skilled painter, a pinch pot at its simplest level.

True sculpture most commonly occurs in figurines like storytellers from Cochiti and Jemez and in the increasingly popular appliquéd pieces, mostly from Hopi, Zuni, and Acoma.

What to Look For in a Pot · Decoration and Firing

• **PAINTING:** If you've ever tried to do any decorative painting yourself, you'll be impressed watching a good Pueblo potter paint a design. Traditionally, potters used a brush made from yucca leaves chewed until they separate into the right number of strands, usually between one and twelve. (These days, most use commercially made paintbrushes. One potter told us he tried to chew yucca, but one taste and the experiment was over.)

Potters might draw the design in pencil—it's supposed to burn off during firing and disappear—but if they're really good, they probably won't. They'll just start painting somewhere, and keep going around the pot until, miraculously, it all comes out right.

If you want to appreciate the extent of the miracle, look at the lightning pattern on this Acoma jar, turn your head away, and try to draw the design from memory. Then think about making that design come out even and level, row after row, all around the pot.

The paints come from many organic and mineral sources. The usual black comes from boiled-down Rocky Mountain bee plant ("wild spinach"), but some potters say that almost any plant, reduced enough, will work. Reds and yellows are usually mineral, from

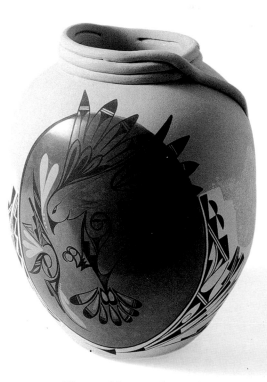

Poster paint as low-end curio, acrylic as art
LEFT: *Jemez, 6½" high, ca. 1970*
RIGHT: *Zia, Ralph Aragon, 6" high, 1992*

ground-up ocher or clay. But colors may also come from the art supply store.

In the 1930s, Tesuque and, later, Jemez potters discovered poster paints and created a whole school of garish tourist pottery that hasn't yet entirely disappeared. In the 1960s, Zia and Jemez potters began using acrylics. Like poster paint, they're applied after firing, but are more durable. At Zia, acrylics have attained a level of artistry worthy of respect in its own right.

Each pueblo has its traditional decorations, and you can pretty well tell where a pot came from by its painting. But not always. The Jemez potter who made the remarkable piece at right called it a "teaching pot." It shows coil construction, appliqué, matte and polished slip, and marvelous painting, all in Jemez style, but with character and elements that could be used at Hopi, Santa Clara, Zia, San Ildefonso, Acoma, or Zuni.

• **FIRING:** The technique varies from pueblo to pueblo. Traditionally, the potter digs a shallow pit and covers the bottom with fuel. Potters from the Anasazi to the present have used everything from coal to corncobs. Today it's usually wood or sheep dung, but there are proponents of the cow and horse variety as well.

When the fuel is smouldering, the potter sets a well-dried vessel on a rack above the coals, surrounds it with pot-

sherds or scraps of sheet metal, and covers it with still more fuel. If the potter isn't careful, the coals scorch the slip, creating dark fire clouds on the surface. If the potter hasn't mixed the clay and temper right, or if the heat is uneven, the pot can crack or the paint can burn. And if it rains or the wind comes up wrong, the potter either packs it in or risks ruining the pots.

All this explains the appeal of the electric kiln. Very few Acoma, Laguna, or Zuni potters have fired their pots in the traditional way since the 1960s, and even the holdouts understand the lure of the controlled, weatherproof kiln. But the old ways refuse to die out, and there's evidence the trend is reversing—we just bought a new Laguna pot with a fire cloud.

Kids, don't try this at home
Acoma, J. Estevan and M. Patricio, 1992

The teaching pot: lots to learn
Jemez, J. Fitzgerald Toya, 10¾" high, 1994

The last to convert to kiln firing will be the pueblos who produce blackware. It requires a "reducing" fire, one with a smothering enclosure over the pit. Redware from Santa Clara and San Ildefonso starts with the same clay and slip as the blackware, but it's fired in an open, oxidizing fire. The firing techniques of Pueblo blackware potters are worth long chapters in specialized books. If you'd like to know more, Stephen Trimble's *Talking With the Clay* reports long conversations with the great potters, and it's excellent reading.

Same clay, different firing

LEFT: *Santa Clara, Carol Velarde, 2¾″ diameter, 1993*
RIGHT: *Santa Clara, Marie Suino, 3″ diameter, 1992*

Quality. As with any art form, you can find Southwestern pottery at various levels of quality. At the bottom, it's cheap and mass-produced, painted in strange colors by people who may be authentic Native Americans but clearly aren't authentic potters. Spend an hour looking at the real thing in a good gallery, and you can spot the lowest level instantly.

"Greenware" is up a notch, and harder to spot. Greenware is unfired pottery, almost always cast in a mold, sold to be decorated and fired by someone other than the maker. It's commercially cast, but the best is decorated by a serious potter and fired at the pueblo.

At the top end, you have exquisitely crafted hand-formed pottery fired outdoors in an open pit, made exactly the same way the potter's ancestors worked a thousand years ago.

But "traditional" is a continuum, not an either/or matter. Some fine potters will fire outdoors during the summer and in kilns during the winter. Others are simply better painters than they are potters and augment their traditional output with an occasional piece of beautifully decorated greenware. Not that there isn't quite a bit of tradition even in this. Archeologists have turned up molds for sculptural pottery elements in Aztec ruins. Cast pottery goes back to B.C. days, and some of today's best-known traditional potters started out with greenware. Some things to look for when judging a pot:

• MOLD MARKS. Cast pottery is made in two-part molds, so unless the potter has taken extra time sanding them away, you can find seams. If you feel suspicious bumps or divots on opposite sides of a jar, the jar is presumed guilty. Seed jars are a favorite greenware type because they don't give themselves away as readily. If you can't get your finger in the hole, you can't find a seam.

• PROTRUDING FLECKS OF TEMPER. Greenware never shows a lump of foreign substance protruding through the slip. If you see a little chunk of sand or rock sticking out somewhere, you can be pretty sure the pot is traditional. Look for little flaws and, if they don't disfigure the pot, be glad you found them.

• LOPSIDEDNESS. A round pot should be round, the hole in a seed jar shouldn't be slightly off to one side, and so forth. The people who make cast pottery don't make off-balance pots. If your pot is off center, it's probably traditional. However, its potter loses points for skill—a no-win situation.

• GOOD FIRING. A traditional firing often means imperfect firing. Underfiring is subtle, and you can hear it more easily than you can see it. Santa Clara and San Ildefonso blackware and redware are fired at low temperatures, and they don't ping. But if a thin-walled Acoma or Zuni pot doesn't ring like a bell when you tap it, it hasn't been fired hot enough or it has a crack. Overfiring is rare on modern pottery, but it shows up on prehistoric pieces as burned-off or discolored paint. Fire clouds

Green, left; traditional; right. Not easy, is it?

Acoma, Marcella Augustine, LEFT: 6½″ diameter, 1992
RIGHT: 4½″ diameter, 1990

can disfigure pristine white Acoma and Zuni pottery. On the other hand, fire clouds can give yellow-to-orange Hopi pottery a pleasing burnished-amber variation. If it has a fire cloud, it's traditionally fired. You decide whether the cloud ruins the pot or enhances it. Or whether you can just turn the dark spot to the wall.

• GREENWARE CLUES. When you see colors not found in nature—pinks, turquoises, lavenders, and such—the greenware buzzer should go off in your head. Likewise, if you see slick painting on a large, new-looking white or red olla and if the price is too good to be true, think greenware. Tap a pot with your knuckle and listen to its ring. Commercially cast pottery is fired at a high temperature and usually has a higher-pitched ring than traditional pottery. Also, greenware tends to have a bottom that looks flat but is actually slightly concave. *Slightly* is the key word. Traditional ollas usually had—and have—really concave bottoms that sit snugly when you're balancing it on your head.

• GRACE AND BALANCE. An aesthetic call. Some shapes seem awkward, some seem graceful. The more practiced your eye, the more you'll see that some pots are more equal than others.

• AN UNFLAWED FINISH. If you see pits, blisters or scratches, the pot is damaged. If you see sgraffito in the wrong place, the potter probably tried to hide a glitch. Some people feel the slightest flaw is disqualifying. We're not that hard-nosed.

• EVEN THICKNESS OF THE WALLS. We recently saw a glorious Mata Ortiz blackware pot, flawlessly sculpted on the outside. When we put our hands into the opening, the inside felt like craters of the moon. The pot instantly downgraded from

"impressive" to "forget it." Generally, the thinner and more uniform the walls, the more admirable the pot.

• GOOD PAINTING AND CARVING. These qualities are high on the list with both of this museum's curators. A shaky line in a design that calls for accuracy, a graceless curve instead of a smooth one, a badly drawn animal instead of a stylish one, tasteless colors or ham-handed design—these bother us.

• ORIGINALITY WITHIN THE RULES. If we see a traditionally made pot that clearly falls within the tradition of a specific pueblo and we can still say, "Hey, we've never seen anything like that," we dig deep to buy it.

• AGE AND WEAR. This is a personal call. A new pot should look new. With an older one, you can forgive increasing amounts of wear. The exact definitions of "honest patina" and "dilapidated" are up to you.

We bought the early twentieth-century Santo Domingo bowl at right from a trader who got permission at the pueblo to salvage it from a dump. Its painting is worn and it has a huge chunk missing from one side. We showed it to an expert who's normally a stickler for good condition, and he was quite taken with it. We asked him whether we should restore it, and he surprised us by saying, "No, that's the

history of the pot." Well, at one point, that "history of the pot" prompted a previous, probably far less affluent owner to throw it away.

The first wear that shows on a pot that hasn't been mistreated is a natural softening of the colors from age and handling. Some discolorations are informative. You see age when you see a color difference between the body of the pot and the base, which sits protected from air pollution through the years.

The paint on much of the recent decorated pottery is fragile. Santa Clara and Hopi painted pieces seem especially susceptible to wear. If you have a nice traditional Hopi pot from one of the great pottery families, be aware that if it rubs up against hard surfaces, it might start looking like the one at right. Never handle a pot, especially a matte-finished one, while you're eating a bag of french fries. Oil and grease can discolor the surface.

Too much history?
Santo Domingo, 8½" diameter, ca. 1925

Sticky tape: bad idea

The taped-on price tag is one of Southwestern pottery's most fearsome enemies. (Antiques dealer Carol Hayes says never put a sticky label on anything other than glass or commercially fired glazed crockery.) The pot may seem perfect, but when the dealer yanks off the tag, wham—a little tape-shaped patch of picked-off slip and paint. If your pot has something taped on it, or stuck to it, remove it with a solvent (nail polish remover works). Even the most careful fingernail exploration can bite you before you know it. However, if you see an original trader's label on an older pot, leave it on. It adds to the value and confirms the pot's history.

All of the things that age a pot—exposure, handling, abrasion, water damage—accumulate over the years, and in each case, you have to make the decision: Is it "history of the pot," or is it garbage? Is a chip honest wear or a fatal flaw? How old does a pot have to be before a crack is okay? How rare does that old pot have to be before you tolerate a reassembled one? You make the call one pot at a time, and your call won't always agree with ours.

Water and Southwestern Pottery.
When pottery isn't glazed, "vase" merely describes a shape, not a use. That vase isn't waterproof. Depending on the temperature at which it was fired, water can either discolor it or eat it alive.

You can cook in a Taos pot without much happening to it. A well-fired Acoma pot will hold water for generations and show a little discoloration, while the slip on a similar Zuni olla might crack and start to peel away. A Hopi vase won't leak but will discolor badly. And all those poor Eastern tourists who bought Maria Martinez masterpieces from San Ildefonso and put flower arrangements in them learned the worst. Modern blackware doesn't just discolor, it can disintegrate. This has nothing to do with the quality of the pottery. The prized black color and polish require a low firing temperature, and the pot remains porous.

Reconstruction and Restoration.
In prehistoric pottery, a reconstructed pot—one that's been broken and pasted back together—is considered almost as elite as an intact pot, providing it's complete.

"Intact" is not quite "flawless." Many intact pots have stress cracks, not surprising in a breakable object that may have been buried for centuries. Intact pots might be "stabilized." That means some good soul has put glue in the cracks to keep it from falling apart.

A "killed" pot that's otherwise complete is

Water plus blackware: bad idea
San Juan, ca. 1960

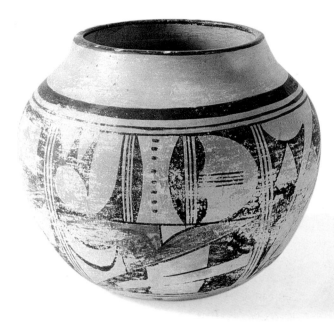

Scratchy handling: bad idea
Hopi, 8½″ diameter, ca. 1940

considered intact. The prehistoric Mogollons buried pots with their owners and ceremonially broke out small pieces from the center or the rim—a custom that has fascinated archeologists, curators, traders, and dealers for a century or more. If a Mogollon pot has a nicked edge and a shaky provenance, it's almost inevitable that someone will identify that nick as a "kill." It's more romantic than calling it a "rim chip."

Restored pottery is lower on the prestige list. A restored pot has missing pieces filled in and replaced. Many experts, and many museums, prefer patching to be obvious, so you can tell new from old at a glance.

One archeologist we know mildly disagrees. She thinks of restoration as a simple act of respect for a worthy object. We take no official position, but we do think complete pots look nicer than the ones that look like Swiss cheese.

What to Look For in a Pot · Restoration and Who Signed It

"Kills," or so we're told

LEFT: *Reserve Black-on-white, ca. A.D. 1050* RIGHT: *Puerco Black-on-red, ca. A.D. 1050*

Restoration is a big issue once money and misrepresentation enter the picture. Flawless pots are worth more than beat-up pots, and it's dirty pool to fix up an old pot and pretend it's in mint condition. At the low end, concealed restoration makes little difference. As the stakes go up, it can be classified as fraud.

At our level of acquisition, it's simple. Is the pot worth its asking price regardless of its history? If we like it at the price, fine. If it was restored, so what. If it wasn't, so much the better. And if we never find out, we didn't expect to anyway.

Most repairs show up under black light, but it's an inexact lie detector. There's a sure-fire test, but you won't like it. Experts drill sample holes and do a laboratory analysis. Then you know— but your unrestored pot now has holes in it that need restoration.

The Signature. The potter's signature is almost universal today, but it's a recent phenomenon. Before 1940, many potters didn't speak English and even fewer wrote it. A potter's name on the bottom of an old pot was probably written by the buyer or by the trader who sold it. By the way, signatures can wear off the base of a pot just from being moved around. (You should rest all your pots on soft fabric, and one of these days we'll actually get around to doing it.)

This 1940s-vintage bowl has the name "Nampeyo" written on the bottom in pencil, almost certainly by a hopeful seller trying to inflate its value. It may have been made by a member of her large and productive family, but the odds are astronomical against its having been made by the original Nampeyo, a potter whose work—done nearly a hundred years ago—is the single strongest influence on contemporary Hopi pottery.

On pots made from the 1930s to the 1950s, a crude signature is often what dealers call "graffito," added the same way you'd write your name on the flyleaf of a book. When you bring a bowl of chili to the potluck, you want to get the bowl back.

Signing work is an Anglo market-driven concept. Navajo and Zuni silversmiths often don't sign their work, and Zuni carvers seldom sign fetishes. Acoma potters once thought signing their work was an inappropriate expression of ego. Maria Martinez of San Ildefonso, already a celebrity and much closer to the Santa Fe world of art-as-commerce, began signing pottery in the mid-1920s, and Santa Clara potters followed soon after. Also in the 1920s, "Acoma, N. M." and "Laguna, N. M." started appearing on tourist pots. Fortunately, they resisted adding "Souvenir of" and writing it on the top. By the 1960s, most potters signed their work.

These days, the market is heavily influenced by what a trader-friend of ours refers to as "bottom collectors"—people who buy a pot for the

Not Nampeyo, despite the signature

Hopi, 5¼″ diameter, ca. 1945

signature rather than for the pot itself. Bottom collectors have pushed the price of work by some potters up by tenfold over what potters of nearly the same ability can get. This holds for the work of a historic figure like Maria Martinez of San Ildefonso or of a contemporary master like Santa Clara's Nathan Youngblood.

We try to avoid acting like bottom collectors, but we have to admit that a good signature does elevate a pot's attraction. If you find a fine pot from a fine potter, you've struck gold.

However, if you've paid attention to everything we've said, you'll never find a pot worthy of purchase. This combination of beauty, originality, flawless execution, immaculate condition, and artist's prestige almost never falls within a mere mortal's price range.

Golden Bottoms

Maria and Julian Martinez

Fannie Nampeyo

Lucy Lewis

Lela Gutierrez

Rose Gonzales

Marie Chino

4
Prehistoric Pottery

▶▶▶ IN OUR SOUTHWEST, pottery's prehistory began about A.D. 100, probably with mud-lined baskets, and lasted until recorded history began in the sixteenth century. During those years, a dozen or more native and invading peoples passed through, and pottery tells much of their story. Scientists can date a pot from the tree rings in the timbers of the room where they find it, and figure out trade patterns based on where it traveled.

Happily, prehistoric Southwestern pottery is plentiful and reasonably priced. Unhappily, you'll hear a great many political, ethical, and even moral reasons why you shouldn't even think about owning a single piece—reasons like these:

Why nobody should ever buy a prehistoric pot. In the old days, scientists, hobbyists, and in-it-for-the-money pothunters dug up thousands of pots, filling mantels, trading posts, and museums. There are as many as two archeological sites per square mile over vast areas of Arizona and New Mexico—over a hundred thousand locations, many excavated, many more still uncovered, each with its share of pots, a handful from one, a hundred from another.

In the 1890s, pothunting picnics made fashionable outings. Traders sold "pottery from the Ancient Ruins" by mail order. At Walnut Canyon near Flagstaff, enterprising excavators sped up the process with a little dynamite.

Quite early, observers recognized that pothunters were damaging sites. Congress passed laws in 1906 to curtail excavation on federal land, but enforcement didn't begin until the 1970s. Scientists complained about treasure hunters bulldozing sites, and Native Americans spoke up about grave desecration and loss of sacred objects.

Mark Bahti likens what was happening to "tearing the pictures out of daVinci's notebooks and throwing away the text." Congress responded with the Archeological Resources Protection Act of 1979. It added specific prohibitions against disturbing burial sites and set scary penalties—up to five years in jail and $250,000 in fines—for digging on federal or Indian lands.

The Native American Graves Protection and Repatriation Act of 1990 added still more teeth, and government agencies took to heavy-handed enforcement, even conducting sting operations. In Santa Fe in 1993, an enthusiastic federal agent wheedled a dealer into buying an undistinguished prehistoric pot for $150, then confiscated the trader's motor home and everything in it. The dealer chose to avoid a protracted court battle and pleaded no contest to a light charge. The judge returned the motor home, fined the dealer twenty-five dollars and bawled out the government for creating crime instead of preventing it.

Today, collecting prehistorics has become so politically incorrect that any defense sounds self-serving and greedy. Small wonder, in this highly polarized and dangerous world, that most dealers don't sell prehistorics, and their attitudes about them range from a bland "I don't know anything about them so I don't deal in them" to a horrified "I wouldn't touch them with a stick."

So if you're tempted to buy one, bear in mind that it could have been a sacred object looted from a sacred site, that the seller might be a criminal, and that you might go directly to jail.

Why we bought them anyway. We've talked this through with Native Americans, archeologists, government employees, traders, and interested

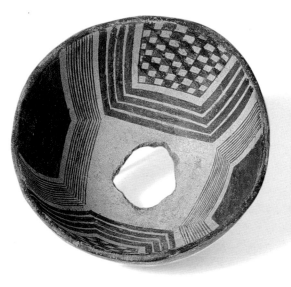

Mimbres Transitional Black-on-white, 7" diameter, ca. 975

lawyers, including one who prosecuted related cases. Here's how we sort it out:

• ITEM: There are thousands of prehistoric pots now legally owned by dealers, museums, and private collectors, all bought in good faith under then-existing laws. They can never be returned to the ground undisturbed. With the exception of a minute percentage of sacred vessels, the tribes and pueblos aren't asking for them back.

• ITEM: The alternatives to open buying and trading of legally acquired prehistoric pottery seem worse. Take away the legitimate market, and prehistorics will become even more politically incorrect. In response to increasingly negative attitudes, we believe that museums will become more reluctant to display their collections, and the black market will become an even greater factor. Prohibition attracts profit.

• ITEM: Excavation on private land away from burial sites is still legal under certain conditions in Arizona and New Mexico. Unless you believe that all archeology is "looting," and many sincere people do, it makes no sense to condemn those who excavate prehistoric pottery with respect for the current laws and for its historic content.

• ITEM: Conventional wisdom says most prehistoric pottery comes from burial sites. In fact, it was a commodity, widely traded and often left behind when a group moved on. Yes, there are still a few grave-robbers out there, but the 1990 legislation is reining in their activities. Now almost all of it comes from excavated living quarters at abandoned sites. Similar wisdom says all prehistoric pottery was originally dug by looters. Actually, much surfaced accidentally. Traders have designated more than one piece we've seen as "I-40 pottery," referring to pots turned up by

construction crews from Flagstaff to Albuquerque. Convenient explanation or not, it's true that Arizona's Salt River Project has a museum full of pottery salvage excavated because of its earth-moving projects.

So why do we collect archeological pots? We consider them beautiful, important pieces of history, meant to be admired, respected, and given care. We know buying properly documented specimens is perfectly legal, and we feel it's perfectly moral as well.

Forgeries. Could any of the pots in this book be forgeries? Probably not. Serious art forgery involves organized crime, six- and seven-figure sums, and the occasional murder, but none of that applies here. The John & Al Museum's cheapskate buying rules make fraud a long shot. After all, nobody counterfeits dollar bills.

If you're worried about forgeries, buy from a trustworthy dealer and keep your fingers crossed. Really good forgeries can fool the experts, as curators the world over can attest.

A word about dates. Take the dates in this book with a grain of salt. Most of our prehistoric pots were dug up (not excavated) years ago, their provenances lost. Under these conditions, proper scientists never commit themselves. In one reference work, we saw an obscure type dated with this helpful notation: "ca. 1150 to modern (?)".

Since we're not proper scientists, we put dates on everything. We check out the type, go to the books, take the middle of the range of dates, and add a "ca." for circa. If we say "ca. 1050," the type may have been made from 900 to 1200, or from 1025 to 1075. If we miss a date or two by a

couple of hundred years, we have an excuse. We've never seen a definition of "circa" firm enough to make us feel guilty.

How to buy a prehistoric pot without breaking the law. Buy on the open market, not off the back of a truck from a guy you met in a bar. Pay with a check or a credit card and get a receipt. Then insist on documentation. We have a form like this one for every prehistoric pot we own.

Unfortunately, we've met few dealers who have this kind of paperwork on hand. So we bring our own and fill it out when we buy. It's a nuisance, but these papers are why, even in today's world, we're not afraid to print pictures of our pottery.

Now, do these forms protect us completely? Of course not. A true crook will sign one whether the pot has been stolen, forged, or dug illegally. We only have the same protection we have when we buy any antique: open purchase in good faith plus good paperwork. That matches both the letter and the spirit of the law.

Mogollon · The Brown Pottery

▶▶ **It begins.** The Mogollon (say MUG-ee-on, not muh-GOLL-on as we did until someone corrected us) were probably the earliest Southwestern potters, probably the earliest to grow corn and squash, and probably the earliest to irrigate. Archeologists pick up their trail around 300 B.C.

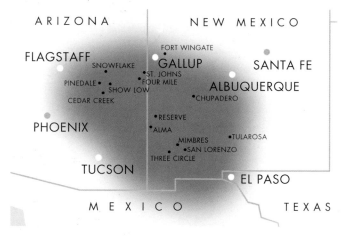

in eastern Arizona, where they lived more-or-less successfully for over a thousand years.

By A.D. 1150, the Mogollon had spread through the Mimbres Valley to West Texas and into Mexico, and by 1300, had gradually withdrawn back into the Mogollon Rim area of Arizona where they first appeared. By 1450, they were gone, perhaps north to Hopi, Zuni, or the Rio Grande. Or perhaps to Tarahumara, three hundred miles south of the Mexican border and beyond our narrow definition of the Southwest.

The Mogollon began lining (or patching) baskets with clay somewhere around A.D. 100, and by 200 or so, were making a lumpy pit-fired brownware that could be called true pottery. Century by century, its sophistication increased, and the Mogollon made beautiful coil-and-build brownware for the remainder of their history, managing in the years around 1000 to produce

some of the finest plainware ever made, ancient or modern.

From the beginning, they put texture on their pottery. Some of the earliest examples have an undulating surface created when potters drew their fingers through the wet clay. Soon after, they added simple textures by poking their vessels with sticks and reeds.

By 1000, these textures had developed into full corrugation, perhaps borrowed from the Anasazi next door. Whether or not the Mogollon invented corrugation, they had fun with it, experimenting with every variation on the theme. Mogollon and neighboring Hohokam potters also picked up the trick of turning their bowls upside down during firing, which made the insides turn black. On the oldest pottery, these "smudged" interiors were light gray and probably unintended, but on later Mogollon and Salado pottery, they often have a deep enough color and high enough polish to rival modern blackware.

The best Mogollon brownware, plain or decorated, came from the Mimbres Valley in southwestern New Mexico. The Mimbres branch of the Mogollon culture seem to have been in close touch, at least in the beginning years of the Mimbres culture. There's considerable design crossover between early Mimbres painted ware and Hohokam ware from the same period, but by 950, the Mimbres had left brownware and Hohokam designs behind.

Trendsetters to the end, the Mimbres were among the first of the Southwestern people to vanish, which happened by 1200. Vanishing became an unfortunate habit. Science has lost all

six of the prehistoric peoples who produced important pottery in the Southwest. The Mogollon, the Anasazi, the Hohokam, the Salado, the Sinagua, and the Casas Grandes cultures all disappeared within a few years of 1400.

To anyone who hasn't studied the subject, it seems logical that those ancient cultures are the direct ancestors of today's Pueblo Indians. It's equally obvious to the Indians. Every tribe has a spoken history that identifies its ancestors, and each seems to include references to one of these early cultures.

Unfortunately, it's not so simple for the archeologist. Most of those spoken histories don't show up in the textbooks because the scientific community isn't satisfied that the histories match up with the physical evidence. Even though scientists can date pueblo construction and abandonment down to the exact year and can identify the exact branch of a culture by its burial customs, it's still difficult to state flatly that any current peoples have Mogollon ancestry. Yet, unless they were carried off by the same space alien who carried off the Mimbres, they went somewhere. More on this later.

TOP ROW: *Mimbres Plain jar, 10½″ diameter, ca. A.D. 950; Tularosa Fillet Rim bowl, 12″ diameter, ca. 1250*
MIDDLE ROW: *Three Circle Neck Corrugated jar, 6″ diameter, ca. A.D. 750; Tularosa Banded Corrugated bowl, 7¾″ diameter, ca. 1250; Mimbres Boldface bowl, 7¼″ diameter, ca. 850*
BOTTOM ROW: *Alma Plain bowl, 2¾″ diameter, ca. A.D. 400; San Lorenzo Red-on-brown bowl, 4¼″ diameter, ca. A.D. 650; McDonald Corrugated bowl, 5¼″ diameter, ca. 1275*

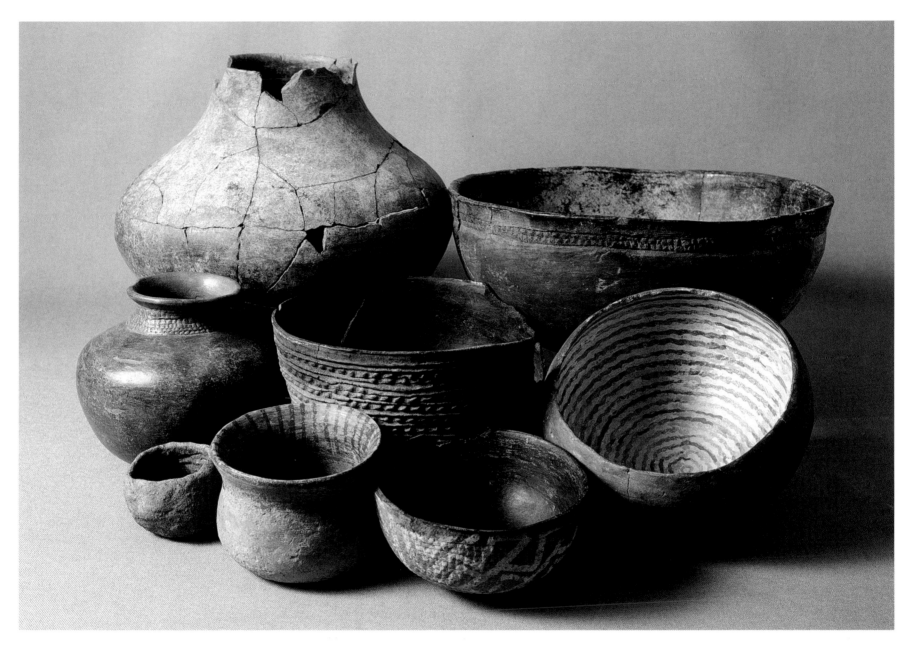

According to artist and pottery student Charles Parker, the pot at lower left is the essence of Southwestern pottery. The Mogollon made Alma Plain for a thousand years, so this may not be as old as we think, but whenever it was made, it's right at the beginning philosophically. Before this, almost nothing. After this, everything else in the book.

By A.D. 600 or so, the Mogollon were playing with the surface, tooling it, and, less often, painting it. Early Mogollon painted pottery gave little hint of the visual delights to come, but the polish was centuries ahead of its time.

Over the next three hundred years, Mogollon potters got better and better. The large Mimbres Plain jar in the top row is probably the single finest prehistoric vessel in this museum—uniformly round, a perfect one-eighth of an inch thick overall, feathering to one-sixteenth of an inch at the rim. Even in today's Golden Age, nobody does much better.

The decorations became increasingly more ornate; the fancy corrugation on the bowl in the center is actually a rather tame example.

Around A.D. 900, the Mogollon began to get more serious about painted decoration. The Mimbres Boldface bowl (middle row, right) is brownware, but the white slip and linear design hint at the fabulous black-on-white Mimbres Classic soon to follow.

Corrugations and smudged interiors persisted to the end, as on the bowl at the bottom right, done just a few short years before the Mogollon's mysterious exit.

Anasazi · The Gray Pottery

▸ **Diverging development up north.** Books assign the Anasazi to the high plateaus surrounding the Four Corners area. At the peak of its development, the Anasazi civilization covered a twenty-thousand-square-mile area stretching from Flagstaff, Arizona, to the Rio Grande area of New Mexico.

Early archeologists thought it meant simply "old ones," but in the Navajo language, the word "Anasazi" means "enemy ancestors." They first

lived in caves and pithouses like the Mogollon, but by A.D. 800, they'd developed the high-rise architecture that later caught the attention of nineteenth-century anthropologists. Ever after, the Anasazi got the publicity while the Mogollon got no respect—when one image is selected to represent the prehistoric Southwest, it always seems to be an Anasazi Black-on-white pot.

Like the Mogollon, the Anasazi were agrarian planters and irrigators, but more cosmopolitan and trade-oriented. Chaco Canyon in western New Mexico was a thriving trade center by 900, with a population of perhaps ten thousand. Its ruins reveal trade with Mexico: macaw feathers, turquoise ornaments, and even copper bells.

(None of the peoples in this book's Southwest used metal until the Spanish came). By 1200, the Anasazi built another great complex at Mesa Verde, with remarkable towers, cliffside apartments and a half-million-gallon reservoir. But no Anasazi settlement held its population for much more than a century. Most likely, they just ran out of firewood, farmed out the soil, and moved on.

The Anasazi began making plain gray pottery around A.D. 500 and quickly found the clays and pigments to make a thin, highly fired ware decorated in black. Black decoration appeared as early as 600, and by 850, the designs on their pottery had become as sophisticated as their society. Also by 850, they were making corrugated pottery for their cookware. Although the Mogollon took the idea further, the Anasazi can claim simultaneous (if not prior) development.

If the Mogollon were the first potters, the Anasazi were probably the first to develop pottery for trade. Many books talk about the significance and symbolism of the designs on prehistoric pottery—sometimes, we suspect, to the point of overemphasis. The rapid transformation of Anasazi pottery from a plain utilitarian craft into a fanciful art form may have had more to do with commercial pressure than with ceremonial needs.

By the time the Anasazi were settled in at Chaco, they'd found clays to make the pure white slips that covered the gray, and they'd learned to make ever-blacker vegetal and mineral paints. Black-on-white remained the predominant Anasazi ware through the 1200s, until the

fashion pendulum swung toward redware, and the Anasazi began their own disappearing act.

As they spread from the Four Corners to the south, east, and west, they encountered other cultures—Mogollon and Sinagua, and, less pleasantly, two sets of fifteenth-century immigrants: the nomadic Navajo from the north and the Apache from the plains.

By the 1300s, the Anasazi were gone from Mesa Verde and, according to tourist literature, became lost in the fog of historical transition. But they weren't lost in Pueblo oral tradition. At San Ildefonso, they'll tell you their ancestors came from the Anasazi ruins across the river at Bandelier. At Santa Clara, they'll point to Puyé ruins just up the hill from the pueblo. They do the same at Zuni, pointing up to Hawikuh. And at Hopi, they point to prehistoric Anasazi artifacts and identify them with specific Hopi clans.

The pottery we've collected tells its own story. If we could only understand it, we'd have a lot more answers.

TOP ROW: *Kana-a Black-on-white jar, 8½″ diameter, ca.* A.D. *900; Lino Gray pitcher, 5½″ high, ca.* A.D. *700; Mancos Corrugated jar, 7⅛″ high, ca. 1100*
MIDDLE ROW: *Chaco Corrugated cup, 4⅞″ diameter, ca.* A.D. *950; Sagi Black-on-white pitcher, 8″ diameter, ca. 1250; Black Mesa Black-on-white bowl, 6¼″ diameter, ca. 1150; Tusayan Black-on-white jar, 5″ diameter, ca. 1225*
BOTTOM ROW: *Mancos Black-on-white bowl, 4¾″ diameter, ca. 1025; McElmo Black-on-white ladle, 11″ long, ca.* A.D. *800; Kiatuthlanna Black-on-white bowl, 5½″ diameter, ca.* A.D. *650*

Map labels:
UTAH
COLORADO
MANCOS
DURANGO
McELMO
MESA VERDE
KAYENTA
TAOS
BLACK MESA
PUYÉ
TUSAYAN
CHACO
BANDELIER
GOBERNADOR CANYON
GALLUP
SANTA FE
FLAGSTAFF
HAWIKUH
ALBUQUERQUE
ARIZONA
NEW MEXICO

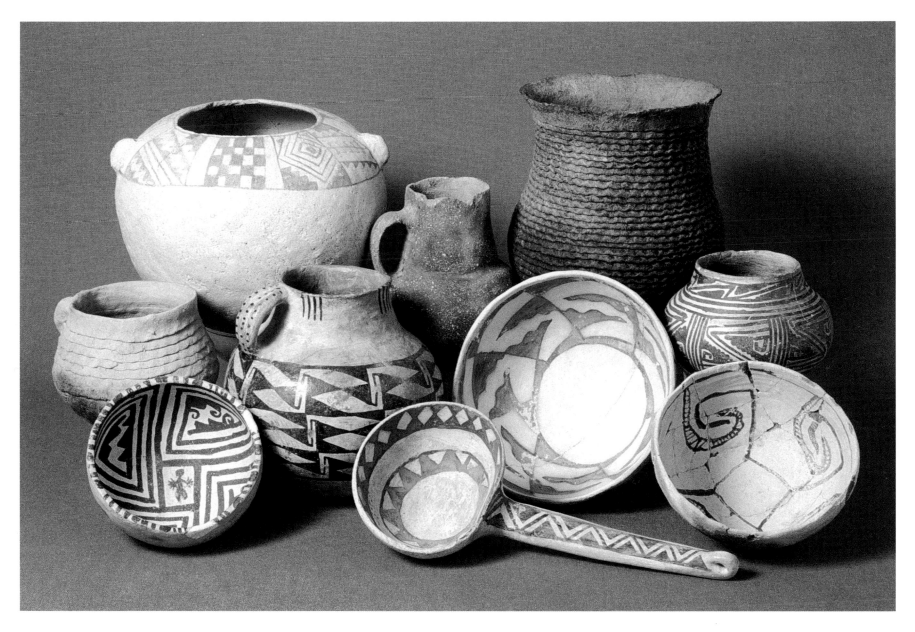

The first Anasazi grayware, like the Lino Gray pitcher at top center, was as unassuming as the first Mogollon brownware. In fact, it was brown. But gray-and-white was the Anasazi signature for seven hundred years. Almost immediately after they turned to grayware, they began decorating with black paint—sometimes made from boiled-down plants, as on most of these examples, and sometimes with a blacker paint made from minerals, as on the bowl at the lower left.

Corrugated cookware first appeared around A.D. 850. The Anasazi quickly became masters of the genre, as the surprisingly thin Mancos example at top right indicates. The Chaco cup at the left demonstrates an Anasazi specialty, the "clapboard" style.

By A.D. 900, black-on-white was hitting stride. Designs became more interesting, and pottery walls became thinner and finer. The Black Mesa bowl to the right of the ladle is so fine it's almost translucent, and the Kana-a at top left is paper thin.

Designs remained mainly geometric, and the Tusayan jar at the right end of the middle row, with its "sheet music" motif represents the defining model for Anasazi pottery in general. Figurative portrayals were scarce. If you see one on a piece made before 1200, it's most likely Mimbres. But every so often, you see something like the little fellow with the six-fingered hands in the Mancos bowl at lower left.

The Anasazi made imaginative shapes quite early, and, until the Casas Grandes peoples started making effigies around 1400, their pitchers, dippers, and coffee mugs showed a variety that few of the other prehistoric Southwestern peoples ever matched.

Cibola · Mogollon Goes Black-on-white

▶▶▶ **Cultural exchange.** By A.D. 1000, the Mogollon and the Anasazi were meeting all along the Mogollon Rim, the shelf that divides Arizona's high-altitude, pine-covered north from its desert south. And if the Anasazi of five hundred years earlier had entered the pottery race by copying Mogollon brownware, the Mogollon returned the compliment many times over. From present-day Pinedale in central Arizona to Socorro in central New Mexico, the Mogollon began producing thin, elegant, and finely painted black-on-white.

Into the early 1980s, anthropologists called black-on-white ware from the territorial overlap areas "Anasazi." However, as it became evident that many of the later wares were Mogollon-created, they adopted a designation that spared them having to pin down who made what: Cibola ware, a convenient blanket term that covers all Anasazi and Mogollon pottery made between I-40 and the Rim.

Mogollon Black-on-white quickly matched Anasazi ware for sophistication. By 1150, it had redefined the standards. The finest of all came from the Mimbres Valley, near present-day Silver City, New Mexico. Mimbres pottery has been both the most prized and most shunned of all the prehistoric wares. Where a large percentage of other prehistoric pottery was traded widely and shows little evidence of involvement in ceremony or burial, Mimbres Classic Black-on-white was closely held and mysterious.

Pictorial representations are uncommon on prehistoric pottery—most designs are so abstract that only an anthropologist can explain what they represent. But the Mimbres went over the top with their designs. The fragment in the picture shows a coatimondi (a desert relative of the raccoon) standing on its tail, and it's like most of the Mimbres Classic pieces you see in the picture books. Take a quick trip to the library or pick up some Mimbres-design dinnerware, and you'll think they only did stylized pictures of bunnies, bugs, birdies, and mom doing household tasks. On the other end of the spectrum, less-publicized Mimbres depictions explore a full and lurid tapestry of sex and violence—rapes, decapitations, bestiality, you name it.

The Mogollon buried their dead, as did the Anasazi—a trait that differentiates them from their Hohokam neighbors, who cremated. But the Mimbres went a step further. They inverted a bowl over the face of the dead and punched a ceremonial "kill hole" through the bottom. Much Mimbres Classic pottery comes from burials. Almost none of it comes from other areas.

There are a couple of theories to explain why, unlike other competent prehistoric potters, the Mimbres didn't trade their pottery. Most books say that pottery was so sacred to the Mimbres that they refused to let others have it. Another explanation might make even more sense: that the Mimbres were a pariah cult. The bizarre nature of many of their images leads us to vote for the cult theory. In a society where almost all decoration was conventional, polite, and trade-oriented, Mimbres pottery must have been disturbingly weird.

The publicity surrounding killed Mimbres pottery has provided fuel for the myth that all prehistoric pottery is burial-related. But Mimbres burial pottery comprises only a small percentage of the prehistoric Southwestern pottery that's floating around today, and perhaps not quite as much Mimbres pottery came from burials as we think. There are more than a few Mimbres bowls with holes punched from what seems to be the wrong side.

It stands to reason that if you caringly place an important bowl over the face of a loved one and make a hole for the departed's spirit to escape through to the next world, you'll punch the hole from the back. This produces a clean break on the outside and a jagged break on the inside, like the bowl in the picture at right. On the other hand, if you're a pothunter who wants to add a little romance to a Mimbres bowl, you'll set it on the table, bottom down, and punch the hole from the front, being careful to avoid damaging the best part of the design—leaving, of course, a clean break on the inside.

This doesn't mean that a wrong-side punch is any proof of funny business by a trader or a pothunter. It's just one more thing to wonder about, one more piece of lore added to the Southwest's most lore-burdened pottery.

TOP ROW: *Snowflake Black-on-white bowl, 7¼" to 9" diameter, ca. 1200; Mimbres Classic Black-on-white bowl, 10" diameter, ca. 1100; Reserve Black-on-white bowl, 7½" diameter, ca. 1025*
BOTTOM ROW: *Pinedale Black-on-white bowl, 6½" diameter, ca. 1325; Puerco Black-on-white mug, 5½" high, ca. 1050; Chupadero Black-on-white bowl, 7¼" diameter, ca. 1150; Mimbres Classic Black-on-white bowl (fragment), 8¼" diameter, ca. 1100; Tularosa Black-on-white jar, 5½" high, ca. 1050*

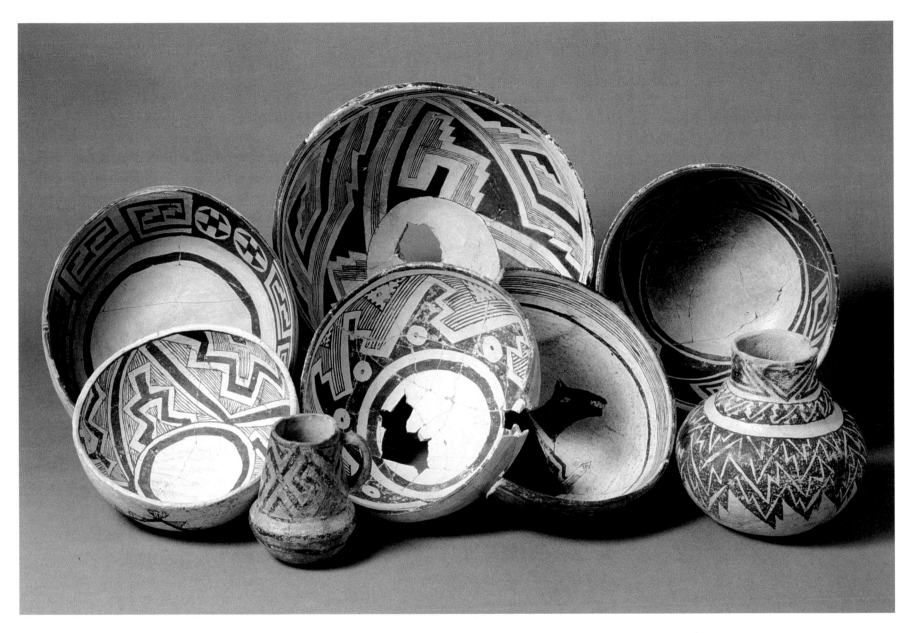

The Mogollon learned fast—witness the Puerco mug in the bottom row. Mugs and pitchers were an Anasazi specialty (they invented the modern coffee mug at Mesa Verde). Even early Mogollon Black-on-white had a finish and style that should have made the Anasazi sit up and take notice, like the Reserve bowl at top right. Cibola decoration has influenced potters ever since. The swirls and lightning bolts of Tularosa designs have been worked and reworked for the last hundred years by Acoma and Laguna potters. For literal interpretations of Tularosa swirls, see page 45, left, and page 89, top, second from right. And for some exact replications of the lightning pattern on the jar at right, see page 49.

Down south at Mimbres, the Mogollon were developing Mimbres Classic, and the big bowl in the top row is a classic. It shows the precision and design sensitivity that made Mimbres Classic the most prized of all prehistoric pottery. Figurative pieces are the most highly prized of these. On the fragment at bottom and right of center, the coatimondi stands on his tail and glowers at the world. Both the beauty of the figure's design and its unfriendly attitude are quintessentially Mimbres. There's great beauty but little warmth in Mimbres representational imagery.

The Chupadero Black-on-white bowl at bottom center, almost to Mimbres standards, came from near present-day Acoma. The Snowflake bowl, top left, was so squashed in the firing that it's oval. "Snowflake" is an unintentionally apt name—slips tend towards a dazzling white. And the Pinedale, bottom left, unusual because it has a design on the outside of the bowl, comes from the last days of Mogollon Black-on-white.

Hohokam · The Buff Pottery

➤➤ The canal builders. Pick up one book, and it will say that the Mogollon were the first irrigators and the first potters in the Southwest. Another will credit the Hohokam, the quiet people who lived in Arizona, Sonora, and Chihuahua.

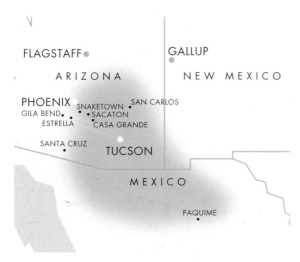

Current thinking has the Hohokam as short-distance immigrants from northern Mexico who came to southern Arizona around 300 B.C. and hung around until about 1450.

Certainly, the Hohokam were the first to build large settlements. They didn't, however, build densely populated pueblos. Instead, they lived in widely spaced, one-family rancherias, a custom that persists to the present in Hohokam country.

Snaketown, south of Phoenix on I-10, was occupied for almost the whole history of the Hohokam. It covered four hundred acres and had a population of five hundred to a thousand at its peak—hardly high-density. It was more like a modern suburb with two-acre-minimum lots.

Snaketown had one of the most intricate complexes of irrigation canals of any prehistoric Southwestern community. The Hohokam used

the seasonal downpours and burning heat of the Sonoran Desert to maximum agricultural advantage, growing enough corn and beans to live peaceably and comfortably in the same location for more than a thousand years. Between A.D. 500 and 1350, they expanded east and southeast of present-day Phoenix and north into the upper Verde valley. Hohokam sites from those years exist right alongside (and sometimes right under or on top of) Salado and Mogollon sites.

This proximity leads to great archeological confusion and spawns a multitude of theories. One view suggests that the Salado never existed at all, but were merely the Hohokam in a different guise. Scholars have held this belief for years despite the fact that, like the Mogollon, the Salado buried their dead while the Hohokam cremated. Pottery offers little clarification. There's great stylistic crossover between Hohokam, Salado, and Sinagua plainware.

Hohokam architecture didn't reach the impressive levels of Anasazi construction. They built pithouses long after other cultures had abandoned them, possibly because the snow-free southern Arizona climate made their housing needs less demanding. Archeologists think the Hohokam used their buildings primarily for shelter in bad weather, preferring to live outdoors most of the time.

After 1100, when trade and travel had exposed them to the high-rises built by their northern neighbors, the Hohokam built some big structures—the Casa Grande ruin near Phoenix is four stories high, tall enough to have served as a landmark for pioneers. But the multiunit apartments of the Anasazi, Sinagua, Salado, and Hopi didn't exist for the Hohokam. Even during their

greatest expansion and influence, they seem to have lived a simpler, less-urban life.

They were a strangely ephemeral people. Even their name reflects their mystery: It's taken from a Pima word meaning "those who have vanished." Despite this contempt for their possible forebears—Pima oral history has their ancestors arriving from the east and vanquishing the weak, arrogant Hohokam—current thinking names the Pima as their most-likely descendants.

Mainstream Pima pottery doesn't look anything like Hohokam pottery, however. It looks more like Salado redware. The Salado occupied the mountains directly northeast of Snaketown and Sacaton, and if there's truth in the ancient legends, they sound a lot like those people who swooped down from the east.

Perhaps the Hohokam fled to Paquime, the center of the northern Chihuahua culture, people with whom they had long-term trade connections. Or maybe they went to California. Archeologists have found traces of a Hohokam-like culture that existed near Palm Springs, during and after the Hohokam era.

They may have vanished, but not without leaving enough evidence behind to fuel years of scientific debate.

TOP ROW: *Gila Plain jar, 6 ¾″ diameter, ca. A.D. 700; Savik Red bowl, 10 ¼″ diameter, ca. A.D. 400*
MIDDLE ROW: *Gila Butte Red-on-buff bowl, 4″ diameter, ca. A.D. 800; San Carlos Red-on-buff jar, 5 ¾″ diameter, ca. 1275; Santa Cruz Red-on-buff jar, 4 ¼″ diameter, ca. A.D. 950*
BOTTOM ROW: *Estrella Red-on-gray bowl, 3″ diameter, ca. A.D. 500; Snaketown Red-on-buff bowl, 4 ¼″ diameter, ca. A.D. 650; Sacaton Red-on-buff dish, 4″ diameter, ca. 1050; Sacaton Red-on-buff jar, 5 ½″ diameter, ca. 1050.*

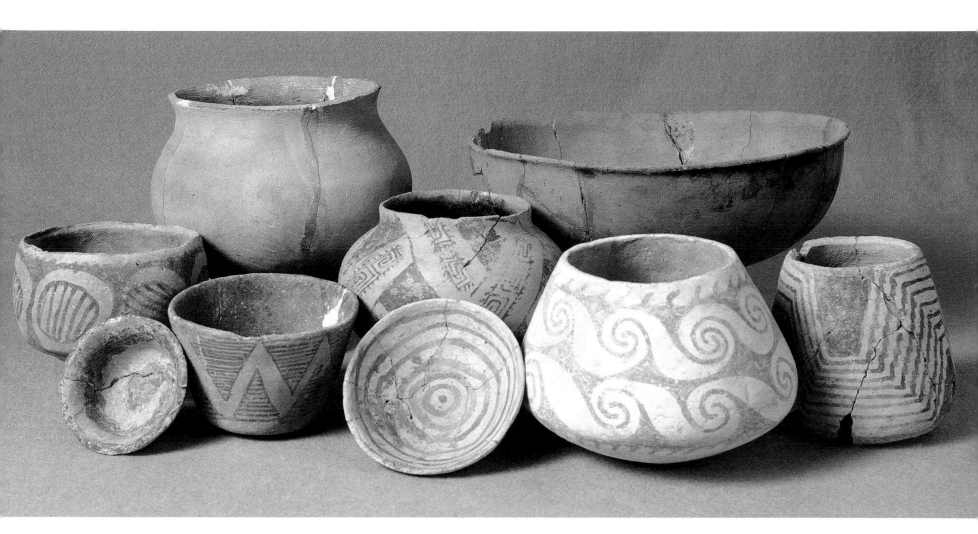

The bowl at top right is one of the oldest pots in this collection, and the earliest form showing added color. Some early Mogollon and Anasazi potters colored pots with red pigment made from hematite. At the beginning, as here, the Hohokam tried mixing hematite right into the clay.

Most early Hohokam plainware was natural buff, like the jar at top left. It was broken and repaired by its ancient owners, then salvaged and re-repaired by moderns. You can't see it in the picture, but holes near the neck demonstrate a repair technique used by Southwestern Indians from A.D. 500 into the twentieth century. They drilled holes on either side of the crack, filled the crack with resin, then bound the bowl, probably with wet rawhide. As the rawhide dried, it shrank and served as a clamp. The pothunter who put this back together used glue and plaster, and put a loop of straw there just for looks.

The little Estrella bowl with the snake coiled around inside it (bottom left) is the oldest decorated piece in the John & Al Museum. Estrella was probably the earliest Southwestern painted pottery, preceding Mogollon Red-on-brown by perhaps a hundred years.

The Hohokam hit their design stride early. The Snaketown bowl to the right of the Estrella dates from A.D. 600, and Hohokam decorated ware kept this distinctive look for the next eight hundred years. The inside is lightly smudged—a far cry from the polished blacks the Mogollon and Salado achieved.

Between A.D. 500 and 900, the Hohokam moved away from the Phoenix basin into outlying provinces. Textbooks call it the "Colonial" period. Gila Butte lay to the west, and Santa Cruz is near the Mexican border, south of Gila Butte.

Sacaton itself is just a bit south of Phoenix, but the Sacaton period was the time of the greatest Hohokam expansion. The settlements and trade areas spread north and east, reaching as far as the Mimbres Valley in New Mexico. The dish with the concentric circles fits right in with the Hohokam-Mimbres connection. The Mimbres Boldface bowl on page 27 has the same bullseye pattern.

Colonial Hohokam pottery was coarse, well fired, and durable. As the years went on, it became increasingly finer and more fragile. After the Colonial and the "Sedentary" periods (a time when they went nowhere and did little), buildings got bigger, but artifacts got worse. The San Carlos jar in the center came from the Classic period, which began around 1100. Pretty as it is, it wasn't built to last. Al once broke a large triangular chunk out of the rim just by picking it up. Remember the first rule of pottery handling: pick it up from the bottom.

Salado · The Red Pottery

The people up the hill. Just who were these people who lived up present-day Highway 80 from the Hohokam?

Pima oral history suggests they descended on the Hohokam and sent them running. The textbooks usually tell another story.

Some things, we know for sure. We know their pottery, and we know their countryside. Drive east from Phoenix to Globe, Arizona, visit Roosevelt Lake, then head north on endless dirt roads, and you're in Salado country—some saguaro and sage, but many more pine trees and mountain meadows.

We know their architecture, and we know their burial customs, but there's a lot we don't know. In 1925, a doctoral student named Erich Schmidt excavated Togetzoge, down the hill from Globe near Superior, and the Armer ruin. Roosevelt Lake's level dropped during a drought, revealing Armer's walls, and a *New York Times* reporter wrote a fanciful article about a five-thousand-year-old ruin with apartment houses larger than Park Avenue's. It wasn't all that big, and five hundred years old was more like it, but amid all the publicity, Schmidt identified the Salado as a separate culture.

In 1930, Harold Gladwin named them "Salado," after the Rio Salado, or Salt River. The river runs through the Little Grand Canyon on the San Carlos Apache Reservation, down into Roosevelt Lake and through the middle of Phoenix. In 1945, Emil Haury identified the Salado as a blending of Mogollon and Anasazi who, as the Pima claim, invaded and displaced the Hohokam.

Others disagreed. Albert Schroeder said they were a blend of Hohokam and Sinagua. Charles diPeso said they were outpost traders from Paquime in Chihuahua. One current faction says they were pure Hohokam. And another says they didn't exist at all. The sites are little help. In the small and remote Pleasant Valley area of Arizona, there are thousands of sites, variously occupied by Hohokam, Mogollon, Anasazi, and Salado.

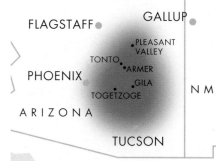

In Schmidt's day, archeologists subscribed to the theory that "pottery equals people." Since then, we've found too much information to embrace such a simple concept, but one fact won't go away: Salado pottery is widespread and instantly recognizable. It shows up from Arizona to New Mexico and from above the Mogollon Rim to below the Mexican border.

The picture at right summarizes that pottery style. Others made plain and corrugated redware —the Hohokam made a lot of it, and the northern Sinagua made similar-looking pieces up around what is now Flagstaff. Eventually, everybody put black-and-white decoration on redware—it was the prevalent fashion from the thirteenth century on. But if you find a piece that looks like these, the odds are it's Salado.

Sometime in the 1200s, the Salado noticed what the Mogollon were doing up around today's St. Johns and Pinedale, and started making black, white, and red pottery for trade, using designs derived from (or swiped from) their northern White Mountains neighbors. If we think of

prehistoric pottery as market-driven, the next two hundred years or so of Salado pottery is some of the most market-driven of all.

Pinto Polychrome dates from 1200, hits stride about 1250, and persists to 1350. It flows smoothly into Gila Polychrome, one of the most widely traded of all prehistoric styles. Gila shows up around 1300 and lasts through most of the fifteenth century. Bowls comprise the great preponderance of Pinto and Gila ware.

Tonto Polychrome, the most consistently flamboyant of all the made-in-U.S.A. prehistoric Southwestern styles, first appears around 1350. It bothers some purists. Florence Hawley's *Field Guide to Prehistoric Pottery Styles* uses words like "gaudy use of red, black and white," "bizarre effect," and "decadent in design."

Decadent, as in the "Last Days of the Salado Empire." By 1450, the Salado were history.

TOP ROW: *Tonto Polychrome jar, 6¼″ high, ca. 1400; Gila Polychrome bowl, 8″ diameter, ca. 1350; Pinto Polychrome bowl, 7½″ diameter, ca. 1275*
MIDDLE ROW: *Pinto Polychrome bowl, 5½″ diameter, ca. 1350; Salado Corrugated jar, 4¾″ high, ca. 1075*
BOTTOM ROW: *Salado Corrugated bowl, 4¾″ diameter, ca. 1075; Rugosa Corrugated bowl, 7″ diameter, ca. 1375; Salado Red bowl, 6¼″ diameter, ca. 1275; Salado Red effigy bowl, 5½″ diameter, ca. 1275; Tonto Polychrome bowl, 7½″ diameter, ca. 1400*

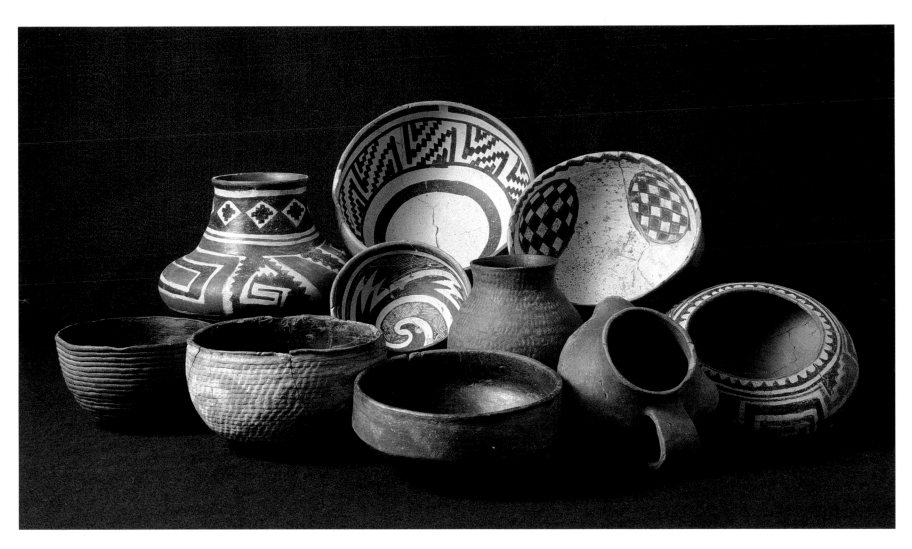

Typical Salado redware is "obliterated corrugated," with the corrugations visible but mostly smoothed out, like the jar at center right. Its quality isn't typical, however. This is as good as they come—thin, perfectly round, and precisely and evenly smoothed. The corrugated bowl at far left is unusual in that the corrugations are large and not obliterated, usual in that the inside is smudged and polished. By this time, the highly polished interiors weren't just smudged. They helped the blackening along with black paint.

Uncorrugated Salado redware sometimes came in effigy form. The cup in the bottom row with the three bumps is, so Claire Demaray tells us, a bird.

The bowl at front center has a distinctive central-Arizona feature—the angular "Gila Shoulder." You'll also see it in a different form on the Sinagua jar on page 39.

On page 27, we show a McDonald Corrugated and identify it as Mogollon. Here, at bottom middle left, Rugosa Corrugated, identified as Salado. The interesting thing is, we could switch the two and almost no one would be the wiser. This style illustrates the lack of hard knowledge (and consensus) you'll find among the experts about exactly who made what, when and where.

The Salado switched to black-and-white-on-red around 1200. Pinto, the earliest Salado Polychrome, tends to have thin slips and, occasionally, watery black vegetal paint. The bowl at top right looks early, the little one in the middle seems later. It supports the theory that Pinto took its design inspiration from Pinedale, St. Johns, and Jeddito (examples on pages 31, 37, and 39, respectively). The experts, who understand these things, call the smaller bowl's design a "parrot."

The big bowl at top is Gila Polychrome. One almost universal distinguishing feature of a Gila bowl is the "lifeline," the heavy black band just below the rim. It shows up in Jeddito and Four Mile as well. The lifeline is usually incomplete, and if you read a dozen books, you'll read a dozen different explanations of the custom. The little gap is called a spirit or ceremonial break (or simply a line break), and some Pueblos still use it.

The jar at top left is Tonto Polychrome at its most garish, in superb condition. This piece is as well-preserved as it is because it's spent the last six hundred or so years largely protected from abrasion, light, and the elements—perhaps aboveground in a nice, dry cave. The equally wonderful Tonto piece at far right wasn't so lucky. It needed restoration to look this good.

White Mountain and Beyond

➤➤ *Redware takes over.* Earlier in the book, we made simplistic, sweeping assignments of specific pottery colors to specific people. "Red" went to the Salado. Actually, the Hohokam made undecorated red pots for years, the Anasazi made more than a few along the way as well, and ultimately, it was the Mogollon rather than the Salado who made redware into the predominant form.

Up until 1100 or so, black-on-white was king, and if you wanted to trade your bowls and jars for food or other treasures, you worked to make your black-on-white better than the black-on-white from the next settlement. But near the Arizona–New Mexico border, in the White Mountains south of where I-40 runs today, change was afoot.

Instead of painting black-on-white, the northern Mogollon hill people started painting black-on-red. The first White Mountain Black-on-red looked very much like the black-on-white of the same period. In fact, the designs on the Wingate, Puerco, and St. Johns pieces at right would have looked unremarkable on Gallup, Puerco, or Tularosa Black-on-white pieces.

But because they were black-on-red, these pieces *were* remarkable. They foreshadowed a fashion trend that persisted to the end of the prehistoric Southwest. The changeover was so complete that it testifies to the pervasiveness of trade among the native agrarians from Flagstaff to El Paso.

The second stage of this new trend hit in full force somewhere between 1250 and 1300. A hundred years earlier, White Mountain potters had added a little white to the outside of some Wingate bowls and created St. Johns Polychrome. This simple cosmetic change turned out to

be profoundly influential. Before St. Johns, polychrome pottery barely existed, but this new two-colors-of-paint style took hold so completely that for more than two hundred years afterward, black, white, and red polychromes made up almost the entire output of trade-for-food potters all over Arizona and New Mexico. Anasazi, Mogollon, Salado, Hohokam, Hopi, and Chihuahua potters picked up on the idea.

Four Mile and its allied polychrome types—Pinedale, Cedar Creek, Show Low, and Kinishba—define the latter-day polychrome style. They evolved from St. Johns and spread all over the pottery-trading area. The Homolovi polychrome bowl on page 39 shows how quickly the Hopis picked up the idea, and the Pinto, Gila, and Tonto bowls on the previous page show what the Salado did with St. Johns.

Collectively, these Four Mile types (almost entirely bowls) represent the last major Anasazi/Mogollon pottery style. They segued almost imperceptibly into the rare later types such as Sikyatki from Hopi and Heshlotauthla from Zuni, and persisted up to the sixteenth century, a time when pottery trade between the pueblos all but disappeared.

Some of the type names of prehistoric pottery carry romantic overtones that pique our curiosity. We wondered about "Show Low" until we actually visited the town and found that the main artery was named Deuce of Clubs Street. The name "Four Mile" turned out to be less colorful. We at the John & Al Museum wondered, "Four miles from what?" Answer: The type got its name from a site on Four Mile Wash, just outside the town of Taylor, a bit south of St. Johns and not far from Show Low. It's in the mountains of eastern

Arizona where the Anasazi, Salado, Mogollon, and Sinagua cultures overlapped.

Archeologists never cease to argue about who overlapped whom. Books written before the mid-1980s call Four Mile and White Mountain Redware "Anasazi." Currently, they're more apt to be called "Mogollon." In a display of aggressiveness never exhibited during their existence, the Mogollon have grabbed an alarming amount of territory since the mid-1980s. Without shooting a single arrow, they've snatched away Snowflake, Reserve, Wingate, St. Johns, Tularosa, Puerco, Show Low, and a dozen other pottery types from the Anasazi.

Watch out, Salado. You may be next.

TOP ROW: *Wingate Black-on-red pitcher, 7½″ high, ca. 1175; Puerco Black-on-red bowl, 8½″ diameter, ca. 1150; Fourmile Polychrome bowl, 8″ diameter, ca. 1350*
MIDDLE ROW: *St. Johns Polychrome bowl, 8¾″ diameter, ca. 1200; Fourmile Polychrome bowl, 5¼″ diameter, ca. 1350; Cedar Creek Polychrome bowl, 6¾″ diameter, ca. 1325; Fourmile Polychrome bowl, 6¼″ diameter, ca. 1350*
BOTTOM ROW: *Show Low Black-on-red seed jar, 4″ diameter, ca. 1350; Fourmile Polychrome bowl, 7″ diameter, ca. 1350*

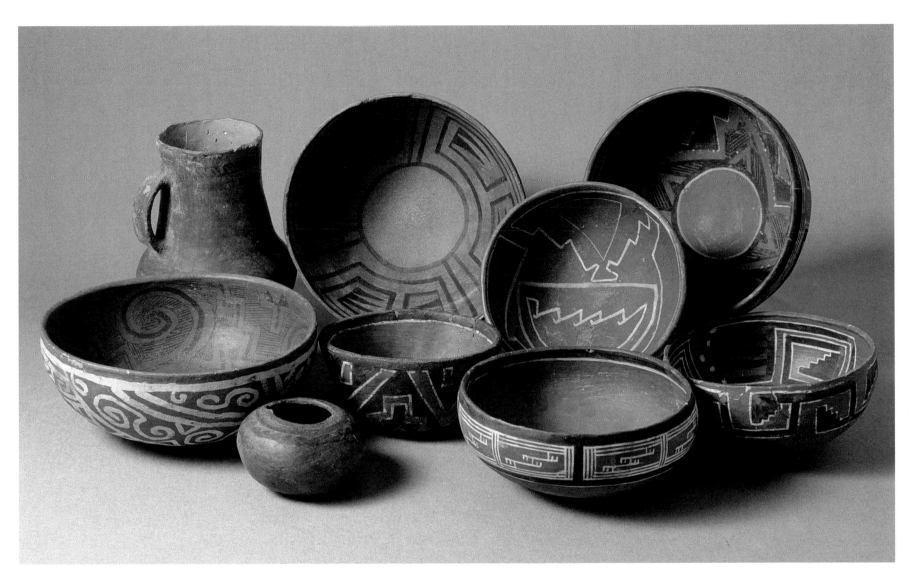

The pitcher at top left is early black-on-red, cruder than most. The design looks Anasazi, but the piece, like all the others on this page, is Mogollon. The bowl to the right of it comes from the Rio Puerco—Pig River, named for the javelinas that populate the White Mountains area. Puerco pottery uses bold, black pennant shapes with linear mazes that are often more intricate than they first appear.

Early in the black-on-red period, potters put white decorations on the outsides of black-on-red bowls and created St. Johns Polychrome. This three-color look caught on so well it became the dominant pottery decoration style in the last years of the prehistoric Southwest.

The Four Mile bowls in the picture all have a high-probability Four Mile characteristic, a heavy black band on the interior rim with a ceremonial break such as the Salado used on Gila Polychrome. It should be an easy identifier for Four Miles, but just to keep us on our toes, the bowl at the far right has a thin line instead of a fat one.

The small one at left center was Al's first prehistoric, and it's still one of his most beloved. Its most endearing feature: a jack-o-lantern face. Turn it around and flip it upside-down and there's another jack-o-lantern face.

The bowl at bottom right looks exactly like a Four Mile is supposed to look. If it were a superb example, however, it wouldn't have a mostly undecorated interior. It would have something wonderful happening inside, like the Cedar Creek above it. The decoration in the bowl is a kachina, but John turned it upside-down in the picture and made it into an attack dog, with squinty eyes and bared fangs, ready to bite the instant you finish your morning cereal.

The little seed jar at the bottom came late in the black-on-red period, by the time black-on-red had said all it had to say.

Jack-o-lantern, upside down

Hopi and Sinagua · The Yellow Pottery

➤➤ **The ones who didn't vanish.** The latter-day universal popularity of red pottery may have forced us to equivocate about giving that color all to the Salado, but there's no ambiguity whatever about yellow and the Hopi.

Until 1150, yellow-to-orange pottery meant the Anasazi and Sinagua who settled in northern Arizona and southern Utah, and whom archeologists, ethnologists, and the Hopi themselves agree were the Hopi's direct ancestors. The Hopi don't like the name "Anasazi." These weren't "enemy ancestors" in their minds. They much prefer the name *Hisatsinom*, a Hopi word for "Long Ago People."

After 1150, yellow-to-orange pottery meant the Hopi, who have lived continuously in settlements in and near three mesas northeast of Flagstaff. The Anasazi were first with yellow-to-orange pottery, starting about A.D. 700 in present-day southern Utah. Later, the Sinagua made yellowish plainware. Sinagua architecture was fancier than their pottery, and their irrigation was even more elaborate. The name Sinagua—*sin agua*—means "without water." (Spanish explorers once called the San Francisco Peaks near Flagstaff the *Sierra Sin Agua*.)

The Sinagua had two homelands: one around Flagstaff and one in the Verde Valley, below Sedona. Archeologists date the earliest northern branch settlement around A.D. 500. Southern branch settlements appear about 700. Back then, they lived in pithouses like the Hohokam, with whom they traded freely. They

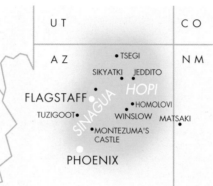

happily traded with Anasazi, Mogollon, and Salado as well.

The northern branch had its ups and downs. Sunset Crater, by Wupatki just north of Flagstaff, was created when a volcano blew up in 1064 and erupted for years thereafter. The resulting layer of ash, combined with years of heavy rainfall, created an agricultural area attractive enough to encourage immigration. Pithouses turned into citified structures and, a bit later, improbable cliff dwellings. By 1350, however, things took a turn for the worse and the northern Sinagua were gone, perhaps to join their southern neighbors.

The southern branch developed equally impressive architecture. Montezuma's Castle and Montezuma's Well appear on almost as many postcards as Chaco Canyon's Pueblo Bonito. Both ruins were at the south end of the Palatkwapi Trail, a trade route from the Verde Valley to the Hopi mesas. But by 1425, the southern Sinagua were gone too—probably up the trail to meet the Anasazi who had settled the other end almost four hundred years earlier.

Sinagua pottery seems borrowed from the Hohokam and Salado, with Gila shoulders and paddle-and-anvil rather than coiled construction. Older books and museum displays often state flatly that the Sinagua made no decorated pottery whatever. That's not quite true, but you'll search long and hard to find a decorated piece.

About 1150, Kayenta Anasazi redware crossed over into orange. Jeddito Black-on-orange

appeared by 1250, and Jeddito Black-on-yellow followed after 1300. In those years, the Anasazi built pueblos on the Hopi mesas, right where they live today, and suddenly they weren't Anasazi anymore; they were Hopi.

Jeddito ware lasted almost until 1600, segueing neatly through Homolovi, Bidahochi, and other polychromes, and ultimately evolving into the Sikyatki, San Bernardo and Payupki Polychromes that helped to define modern Hopi pottery.

This makes Hopi pottery unique among the Southwestern wares. Most modern pottery appeared rather suddenly, taking shapes and using clays and slips that differentiate it from prehistoric wares made nearby. You can't take a fifteenth-century pot from the Puyé ruin and compare it to a modern piece made across the road at Santa Clara Pueblo and see a connection. But Hopi pottery has a clear, unbroken link to those supposedly vanished ancestors. When you look at Hopi pottery, it's hard to believe in disappearances.

TOP ROW: *Jeddito Black-on-yellow bowl, 9¼″ diameter, ca. 1350; Homolovi Polychrome bowl, 9½″ diameter, ca. 1375; Matsaki Polychrome bowl, 8″ diameter, ca. 1550* BOTTOM ROW: *Jeddito Black-on-orange bowl, 4½″ diameter, ca. 1250; Tuzigoot Red jar, 5¾″ diameter, ca. 1200 (Sinagua); Jeddito Black-on-yellow bowl, 8″ diameter, ca. 1400; Deadman's Black-on-red seed jar, 2⅝″ diameter, ca. 950 (Kayenta Anasazi)*

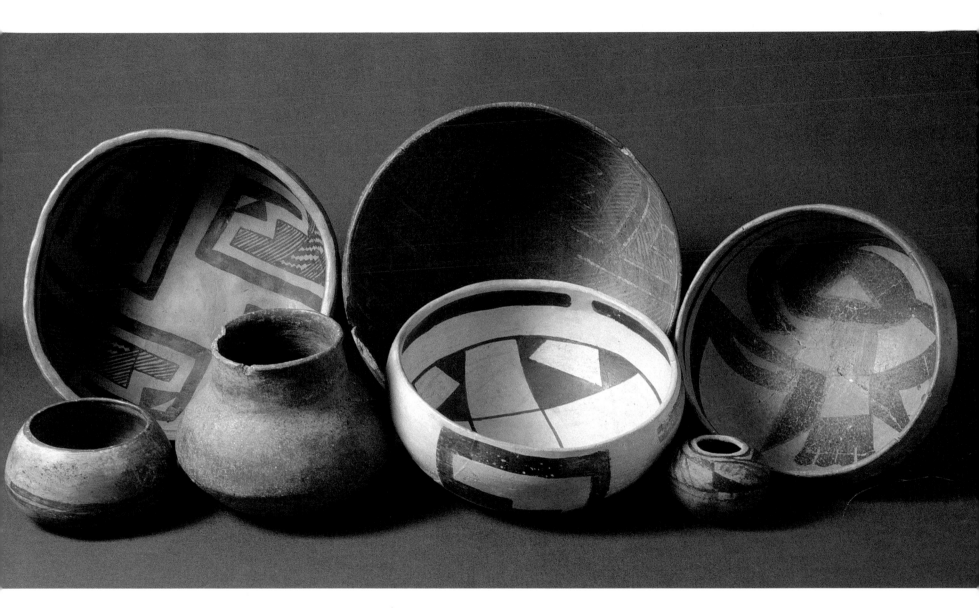

Experts call the little Kayenta Anasazi piece in the bottom row "red" rather than orange, but it foreshadowed the future, as did the undecorated Sinagua piece, which came from the southern Verde Valley north of Phoenix, probably traded in from a settlement near Sedona. The Gila shoulder looks Hohokam/Salado; the mica flecks in the clay seem Hohokam. But the yellow-orange color of the clay makes us think of Hopi, where the Hopi say the Sinagua went. Hopi elders have identified many Sinagua artifacts as belonging to modern-day Hopi clans.

Most Jeddito was complex and mannered in design, and the simplicity of the orange jar at the left is refreshing in comparison. And no, we're not color blind. This really is black-on-orange, despite the fact that the high-temperature coal firing turned the decoration into a beautiful clear red. We had a hard time making the type call on this until we saw an example on which the decoration was pure black on the side away from the heat, and this clean red on the side toward the heat.

The Jeddito bowl at top left is down-the-middle in design, right in style for the times. The design would look at home on a dozen different Anasazi, Mogollon, and Salado types. The black-on-yellow bowl in the bottom row, on the other hand, is way off-center. It gives some idea of the range of design inventiveness that later prehistoric pottery demonstrates. Here, you see a more moderate example of firing unevenness—it almost makes you think this is a polychrome.

Ultimately, the Hopi succumbed to fashion. By 1375, the pendulum had swung dramatically toward multicolored pottery. Red-slipped Homolovi Polychrome (Winslow Polychrome in some books), the Hopi effort to compete with the pottery factories over at Four Mile, hides the yellow clay completely.

From there, the Hopi moved on to Sikyatki Polychrome and the historic era. The bowl at bottom right is a Sikyatki impostor, made by the Zuni, with yet another feature to confound the experts. It's been repaired, but it once had a Mimbres-style kill hole in the center.

Casas Grandes · Last Ones Out

➤➤ **Down Mexico way, a whole other civilization.** In A.D. 700, the Casas Grandes tribal area of Chihuahua, Mexico, known as Gran Chichimecha was a fairly primitive agricultural population living in pithouses, according to Charles diPeso, whose excavations and research provide the basis for most theory on this culture.

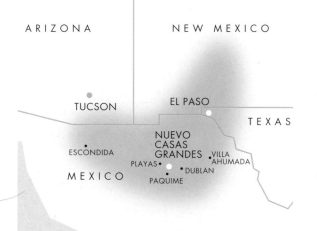

However, diPeso thought the village of Paquime was built as a distribution center by traders representing the business interests of more advanced southern Mexican cultures. Paquime reached the peak of its population and influence somewhere between 1250 and 1450. Recent research leans toward the later date.

As many as a thousand villages across Chihuahua and Sonora looked to Paquime as the cultural center. Many goods that went to the Anasazi, Hohokam, Sinagua, and Hopi could only have come through Paquime: copper bells, macaw feathers, and the macaws themselves.

A vast irrigation system supported this commerce. Thousands of check dams, terraces, and trenches brought water to the Gran Chichimecha, and these *trincheras* still exist today.

Apparently the great culture of Paquime missed the Spanish *conquistadores* by about fifteen minutes. There's a pot on the opposite page that experts tell us dates from 1500. Cortez landed in Mexico in 1519. In 1565, Baltasar de Obregon visited Paquime, found it deserted, and wrote that it looked like a great city built by the ancient Romans. If our dates are correct, it was no ancient ruin, it was a ghost town of fairly recent vintage.

What happened? There's evidence of a large-scale massacre and burning late in Paquime's history. Who did it? Circumstantial evidence might suggest the Apache, hunter/gatherers, who at the time were recent arrivals to the area. Behavioral evidence, however, points to the Aztecs, who, according to Spanish records, sacrificed neighboring unfortunates by the tens of thousands.

Either way, the survivors of Paquime had little recourse other than to run. Where to? Look at the pots in the picture. Escondida Polychrome looks like Pinto and Gila Polychrome from the Salado, which looks like Kwakina Polychrome from Zuni, except that the black paint on the Zuni version is a shiny glaze—like the black on Carretas Polychrome. We've seen a Carretas Polychrome bowl with a kill hole in the bottom, just like Mimbres, which starts us thinking about yet another disappearance. And, in the sixteenth century, those kill holes show up at Zuni.

But, as we keep reminding ourselves, we're too sophisticated to believe that pottery equals people. So, for the official record, the people of Casas Grandes vaporized, just like everyone else.

And unofficially? Try this: Anasazi to Hopi and the Rio Grande pueblos. Mogollon splitting, with Mimbres to Paquime, the northern group merging with the Anasazi, populating Zuni to Acoma, the southern group to Casas Grandes or Tarahumara. Sinagua north to Hopi. Salado either down to Phoenix or to Tarahumara. Hohokam splitting, some to California, some to Paquime. And what was left of Paquime, scattering north. Some of this may have been prompted by Navajo and Apache raids, although their time periods barely overlapped, and some perhaps by an occasional outbreak of hantavirus, the "Navajo flu" that frightened the country in 1993.

Okay, none of the above may be true. But at least it's tidy.

TOP ROW: *El Paso Black-on-red jar, 5¼″ high, ca. 1300; Dublan Polychrome jar, 7½″ diameter, ca. 1350; Villa Ahumada Polychrome effigy, 7″ high, ca. 1400* MIDDLE ROW: *Babicora Polychrome jar, 5½″ diameter, ca. 1400; Carretas Polychrome bowl, 6¾″ diameter, ca. 1500; Corralitos Polychrome jar, 6½″ diameter, ca. 1350; Playas Red incised jar, 5¾″ diameter, ca. 1300* BOTTOM ROW: *Escondida Polychrome bowl, 5½″ diameter, ca. 1350; Ramos Black bowl, 3⅝″ diameter, ca. 1325; Ramos Polychrome effigy, 8½″ long, ca. 1450*

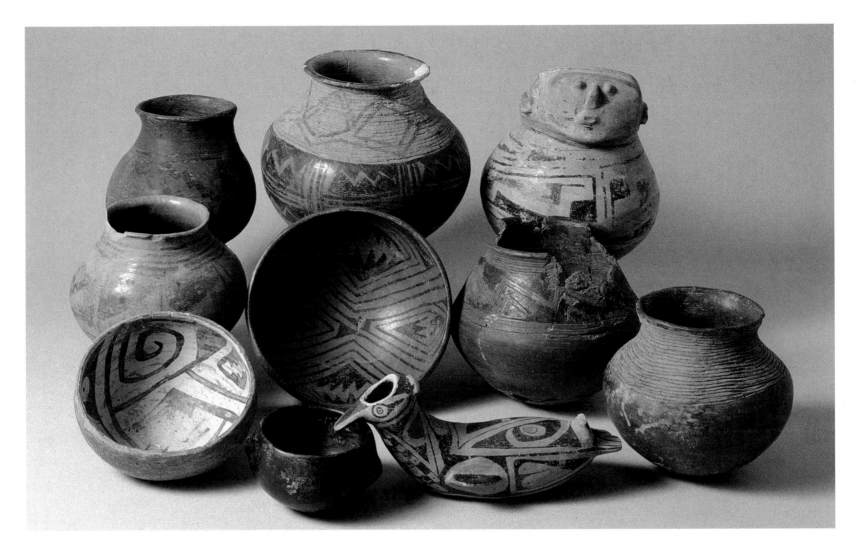

In 1300, Casas Grandes pottery didn't give much hint of where it was headed. The polished redware piece at the right reminds us of Mogollon pieces made six hundred years earlier, and the El Paso piece (top left) looks like what was happening about four hundred miles to the northwest in the White Mountains and the Tonto Forest.

Gran Chichimecha pottery soon found a direction and added color, if not necessarily technical expertise. The pot right of center was fired at such low heat that it's little more than a sculpted and decorated dirt clod. (It defied Al's efforts to restore it, but Claire Demaray saved its life.)

The larger jar at top center is a better-made incised polychrome, a short evolutionary step from the self-destructing Corralitos. The painting on later Casas Grandes polychromes became more and more elaborate, but the exuberant incising of the earlier styles disappeared.

For painted Casas ware, the Babicora Polychrome (middle row, left) is pretty subdued. Casas Grandes effigies were much fancier than those of their northern cousins, and the gentleman in the top row is bush league for a Casas piece. The duck in the bottom row is more like it. He's lost his strap handle and the topknot that made his spout, but he still has the design extravagance that makes the best examples of Casas Grandes pottery the showiest of all Southwestern prehistorics.

Since the late-nineteenth century, the Rio Grande pueblos have made an institution of polished blackware. But pure black is rare in prehistory. The little Ramos Black bowl at bottom center represents just about the only all-black prehistoric type you'll ever see. Unlike modern blackware, Ramos Black is thin, light, and highly fired, almost like porcelain.

Yes, the bowl at lower left looks like Salado Polychrome. Some take this as evidence of Hohokam contact with Casas Grandes, especially those who think the Salado were Hohokam. Others draw no connection at all, but the resemblance is hard to accept as pure coincidence.

Finally, the bowl in the middle is one of the most fascinating of all prehistoric types. It has glaze paint, which shows up on Zuni and Rio Grande Pueblo pottery from the fourteenth century into the eighteenth, the dark ages of Southwestern pottery. And we've seen an example with a Mimbres-style kill hole in the bottom. Carretas Polychrome tantalizes us with all kinds of who-went-where clues—clues that, unfortunately, aren't all accepted as evidence in the Great Archeological Courtroom.

5

Modern Pottery

➤ *Recorded history begins.* It started with Hernan Cortez, who came in 1519, and by 1521 had conquered Mexico City and the Aztecs. He managed the feat with only five hundred men, but his sixteen muskets undoubtedly helped.

His success brought thousands of Europeans looking for gold, including the improbably named Alvar Nuñez Cabeza de Vaca. *Cabeza de vaca* means "cow head," and his cow-headed fabrications did immense damage to the natives of the Southwest. After a disastrous 1528 expedition that began in Florida and included a shipwreck on the Texas coast, he spent six years mostly as a captive of whatever Indians he encountered.

When he and a Moorish slave named Estebán, or Estevancio, made their way across the Rio Grande and down to Mexico City, the center of New Spain, in 1534, he told fantastic tales of the Seven Cities of Cibola, where the houses were of gold and the doors were inlaid with turquoise—all in the upper Rio Grande. It's been suggested that the Aztecs in Mexico City had seen traded-in Jeddito and Sikyatki yellow-ware from Hopi and were quite willing to reinforce Cabeza de Vaca's stories by telling the new Spanish government of Indians to the north who drank from vessels of gold.

His stories prompted a 1539 expedition led by Fray Marcos de Niza and Estebán, who found their way to the Zuni pueblo of Hawikuh. Estebán went on ahead and the Zunis, perhaps terrified by the unexpected appearance of this large, black man, promptly did him in. In a display of cow-headedness worthy of his original informant, the good friar concluded that the Zunis must have dispatched Estebán because they did in fact have a golden city to defend. Besides, those

rocks looked pretty yellow in the late afternoon light. He went no farther. Instead, he turned the expedition around, returned to New Spain, and gave the Viceroy his message: "We've found the treasure, send an army."

The army was Francisco Vasquez de Coronado's, and the year was 1540—year one of the modern, European-governed Southwest. Coronado went to Zuni, found no gold, but shot some angry Indians and chased the rest away. He harassed the Hopi without finding any gold there either, found the Grand Canyon, decided Acoma was too inconvenient to plunder, and moved to the Rio Grande and the Tiguex pueblos near modern-day Albuquerque.

The Tiguex residents objected to the raping and pillaging, and Coronado responded by burning the villages. Ironically, you can now visit a restored kiva just north of Albuquerque at a national monument named in honor of Coronado.

By the time he returned to New Spain in 1542, Coronado had ventured as far as Kansas, but never found an ounce of gold.

Government, Spanish-Style. The best fallout from the Coronado expedition, as far as the Anasazi and Mogollon were concerned, was that the Spanish didn't bother them again for another forty years. But the trickle of immigrants and adventurers began again in 1581, and by 1598, Nuevo Mexico had a government headed by the impressively titled Governor Captain General Juan de Oñate and a capital at San Juan Pueblo. Oñate simply moved in. The fact that the Spanish had guns and horses, and the Indians didn't, hastened the relocation.

Zuni, 6½" diameter, ca. 1915

Oñate was a loyal Catholic and a highly successful proselytizer for the faith, at least by decree. He ordered that all Indians be immediately converted, outlawed all traditional Indian religions, and banned the use of the kiva. The last point was particularly significant, as the kiva served as both the ceremonial chamber and political center of the pueblo.

By the time the Pilgrims hit Plymouth Rock, the building boom was on in New Mexico. Most pueblos had resident padres who showed far more concern for the spiritual welfare of the Indians than they did for their physical well-being. The first order of business was usually the construction of an imposing mission, built with backbreaking effort by forced labor.

The Spanish also invented a taxation system called *La Encomienda,* so onerous that in dry years, it brought the Indians to the brink of starvation. The padres bullied and flogged their way through most of the seventeenth century, until the Puebloans could stand no more. In 1675, the authorities arrested forty-seven tribal leaders on witchcraft charges and hanged or publicly whipped them. Had they foreseen the future, they would have hung at least one more.

The Pueblo Revolt. A San Juan leader named Popé escaped the noose, but didn't forget the injustice. He spent five years figuring out how to get rid of the Spanish, and on August 10, 1680, heavily armed warriors from nearly every pueblo attacked the Spanish in outlying villages and the countryside. They killed more than four hundred men, women, and children, including twenty priests, and burned most of the great missions to the ground.

A week later, they attacked Santa Fe, by then the capital of Nuevo Mexico, and the governor and fifteen hundred refugee Spanish fled to El Paso. Once again, the pueblos were free of foreign control. The paradise didn't last. After an abortive effort in 1681, the Spanish hit hard in 1688, sacking and burning Zia and killing six hundred residents.

In 1692, it was all over. Don Diego de Vargas rode north from El Paso with two hundred soldiers and entered Santa Fe without firing a shot. The war-weary Indians capitulated and accepted Catholicism and the Spanish. To this day, Santa Fe celebrates the heroism of de Vargas and the bloodless restoration in the annual Fiesta de Santa Fe.

Of course, it wasn't quite bloodless. De Vargas had to recapture Santa Fe by force a year later, and in the process, slaughtered quite a few Indians before he regained a semblance of control.

Two More Governments. During the eighteenth century, the misery evolved. There were fewer atrocities, but there were hunger, hardship, Navajo and Apache raids, a smallpox epidemic, and unceasing efforts to suppress the native religion. All this made life grim for the Pueblo people. Once-great pueblos dwindled and vanished.

In 1821, Spain ceded the Southwest to Mexico, which brought new bureaucrats and new regulations, but the culture shock was mild compared to what was to come.

In 1846, America took over. The good news: The Indians were now free of enforced Catholicism. The bad news: They suffered new regulations, new officials who spoke an unfamiliar language, and missionaries every bit as enthusiastic as the padres who had hectored them for centuries.

Now Methodists and Mormons were in charge, but the message was the same: Join our church or else.

It's not difficult to understand why today's Pueblo Indians remain so secretive about the details of their native religion. If you'd spent four hundred years being told by people with guns that your religion was evil and barbarous, you'd be a bit hesitant to talk about it, too.

When the Americans poured in during the second half of the nineteenth century, some good things happened as well. A new class of citizen emerged: the Indian traders. Their motives may have been commercial, but they were smart enough to realize that their own welfare was directly connected to the welfare of the Indians.

Government efforts for the first hundred years of American administration were focused on making the Indians good tax-paying, English-speaking citizens. Church efforts focused on making the Indians good Christians. Neither group was particularly interested in how the Indians felt or what the Indians wanted.

The traders, however, had to have the help and cooperation of the Indian artists and craftworkers. It was to their advantage to learn the Indians' languages and look after the Indians' needs. And they, as much as anyone, are responsible for what's on the remaining pages of this book.

Acoma

⯈ The People of the White Rock. Acoma (say OCK-o-ma, accent on the first syllable) is in New Mexico, south of I-40 between Grants and Albuquerque. It's a sprawl of villages—Acomita, McCartys, Anzac, San Fidel, and Seama—with three thousand people spread over four hundred square miles of farmland. But it's hard to think of it that way.

Every visitor to Acoma is drawn to the Sky City, the old pueblo of Acoma, America's most implausible seven acres of real estate. It claims to be the oldest continuously occupied settlement in the United States. Although the Hopi village of Old Oraibi probably has a stronger case for this distinction, Acoma is undeniably ancient.

It's also absolutely spectacular: a sheer-sided, 350-foot-high mesa covered with connected adobe homes, great pools in the natural rock and a seventeenth-century church that defies belief. Today, there's a bulldozed road and you can ride the tour bus up to the mesa top, but in 1629, when Fray Juan Ramirez came to Acoma, every sack of sand for the adobe had to be carried up the narrow accesses, one step at a time, and every timber for the roof had to be carried from Mount Taylor, thirty miles away.

And yet, there's the church: 60-foot-high walls, 10 feet thick at the base, a 150-foot-long hall under a roof supported by 40-foot-long, 14-inch-square timbers resting on massive sculptured corbels, all carved with stone tools. It stands as mute testimony to the amount of labor the priests were able to extract from the Indians.

To appreciate Sky City's inaccessibility, you only have to understand that even the greedy Coronado wouldn't attempt it. One of his lieutenants said it flatly: "No army could possibly be strong enough to capture the village."

He was wrong, of course. In 1599, Governor Oñate sent Vincente de Zaldivar to punish the Acoma, and the troops gained the mesa top. They pacified the Indians by killing six hundred and taking six hundred prisoners. To ensure the peace, they cut one foot off the adult males and sentenced the women to slavery. Even so, it took another hundred years before a defeated Acoma formally submitted to Spanish rule.

According to Acoma legend, the sacred twins led their ancestors to Ako, the magical white rock that would be their home forever. The twins also led them to the whitest, finest clay in all the Southwest. Since the eighteenth century, Acoma potters have made thin-walled, large ollas, slipped in pure white and decorated in red and black, a description that hardly begins to suggest the intricate and dramatic designs that characterize Acoma pottery.

In 1880, the railroad came through, stopping at neighboring Laguna. With the trains came traders and a brand new tourist market. Acoma pottery adapted almost immediately. Since fourteen- and sixteen-inch storage jars were far too big for tourists to fit in their suitcases, potters and traders devised a whole new class of eccentric little pieces.

But from 1750 to the present, Acoma's standard for fine pottery has been set by the large, thin-walled white olla. Tempered with the ground-up sherds of broken pottery, the surface of a smothed and unpolished Acoma jar has a matte velvet feel that ware from other pueblos seldom approaches.

TOP ROW: *Olla, 9¼″ diameter, ca. 1920; olla, 9″ diameter, ca. 1915; olla, 8″ diameter, ca. 1935*
MIDDLE ROW: *Olla, 8″ diameter, ca. 1930; olla, 8½″ diameter, ca. 1950; olla, 10″ diameter, ca. 1955; olla, 8⅝″ diameter, ca. 1930*
BOTTOM ROW: *Canteen, 6½″ diameter, ca. 1920; vase, 3¾″ high, ca. 1910; vase, 4″ high, ca. 1920; bowl, 6″ diameter, ca. 1925*

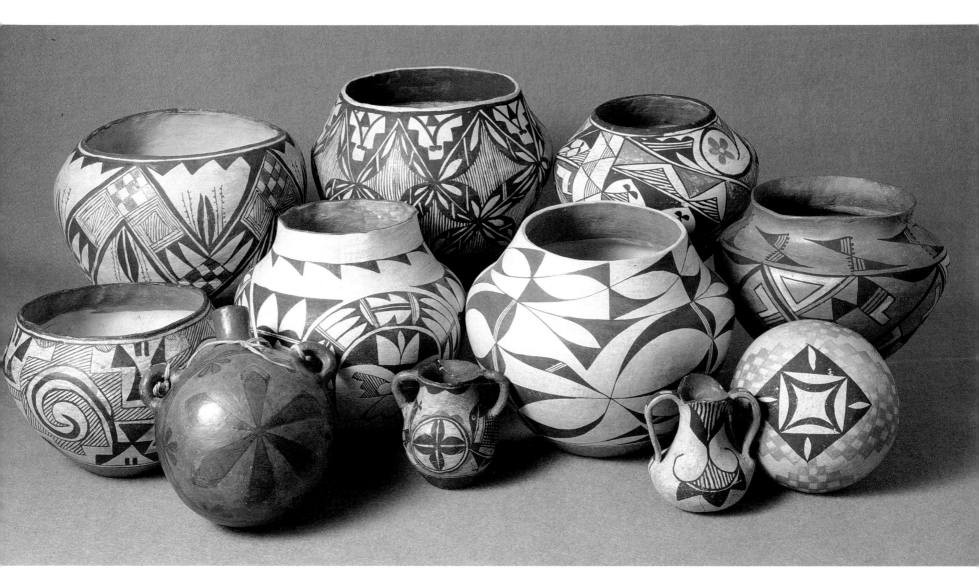

Here, a look at older Acoma, with an emphasis on the ollas that serve as the pueblo's signature. All seven of these examples have the traditional indented bottom, the better to provide stability when carried on one's head.

The olla at top center is old enough to have seen service, and probably has held more than a little water in its life. The deep red color of its underbody and inner band tended to become more clearly orange in later examples.

Acoma design often displays strikingly dramatic graphics. You can see this in the 1920-vintage olla at top

left, in the 1935 olla at top right, and in the later olla just below it. By the time that beautifully painted jar was made, Acoma people used store-bought vessels for water storage. In 1955, an olla like this was made strictly for the collector's market.

Acoma jars could be painstakingly traditional, as the carefully recreated prehistoric Tularosa patterns on the jar at the lower left demonstrate. Or they could surprise. The olla at far right has a Hopi yellow rather than a white slip, almost never seen on an Acoma piece.

The bottom row has some purely for-the-tourist shapes. The banged-up little vase in the middle dates from 1910, and the canteen and the other little vase perhaps ten years later.

The inverted bowl with the decorated bottom is another story. Dealers always call these bottom-decorated pieces "ceremonial," and it may have been just that. But it could also have been made as the lid for a giant olla.

Acoma · For the Tourist

Anything goes, as long as it's cute and "Indian." The olla may represent the highest achievement of the Acoma potter's art, but through the 1960s, even the most respected would turn their backs on the art collector and turn out unashamed tourist pieces. When they were working in the tourist mode, nobody seemed to care whether the designs came from Acoma tradition, a magazine, or a trader who knew what the tourists bought.

The dozen pieces on these two pages give an idea of the unlimited assortment of shapes turned out for tourists, and of the range of pottery skills involved. The turtle is by Mary Histia (1881–1973), perhaps the best-known Acoma potter before Lucy Lewis and Marie Chino came into prominence.

Most of these pieces are unsigned, or signed "Acoma, N.M." They were made between 1930 and 1965, a time when Acoma potters felt that it was

Spalling, ca. 1960

an inappropriate display of ego to put one's name on a pot.

The latter days of that period were also a time of embarrassment for Acoma's potters. Inexplicably, Acoma's beautiful clay developed impurities, and these impurities led to spalling: little pits that pop out during the firing and occasionally after. The phenomenon became so prevalent that Acoma's potters just about gave up. In other times, as now, the rare pot that spalled was ground up for temper. But back then, such a high percentage spalled that even the best potters sold them anyway. You can look at a spalled Acoma pot, say "1960," and be pretty close.

No one was exempt. The next four pages include spalled pots by two of Acoma's most celebrated potters, Lucy Lewis and Marie Chino—pieces that under other conditions, neither would have admitted to, much less have signed proudly.

TOP ROW: *Canteen, Jessie Louis, 6¾″ high, ca. 1965; cow wedding vase (!), 7″ high, ca. 1965; vase, 8″ high, ca. 1950*
MIDDLE ROW: *Basket, 7″ high, ca. 1950; canteen, 7″ high, ca. 1960; vase, 5½″ high, ca. 1955; turkey figurine, 6″ high, ca. 1950; owl figurine, 6″ high, ca. 1940*
BOTTOM ROW: *Turtle figurine, Mary Histia, 5½″ long, ca. 1940; baby rattle, 6½″ long, ca. 1950; ashtray, 5″ diameter, ca. 1930; pitcher, 6½″ high, ca. 1950*

The ashtray in the bottom row says a lot. The very fact that it's an ashtray tells how little Southwestern potters cared (and care) about utility when it came to making curios for the tourist. Unglazed Southwestern pottery makes terrible ashtrays, all fated to be stained forever after their first encounter with a cigarette. The design is the "Thunderbird," an omnipresent motif on ashtrays and other tourist pieces after 1910.

Cute figurines sold well, and there was a slightly longer tradition behind them. As early as the late nineteenth century, interest in pre-Columbian figurines from Mexico prompted Santa Fe traders to offer grotesques from the potters of Cochiti, Tesuque, Acoma, and Laguna as ancient pottery. Mary Histia's turtle, the owl at the right, and the turkey are all much less grotesque than their predecessors.

From 1950 on, inspiration came from everywhere. Pitchers, vases, baskets, and canteens were commonplace. Baby rattles were somewhat more scarce. But then as now, wedding vases with cowheads were rare.

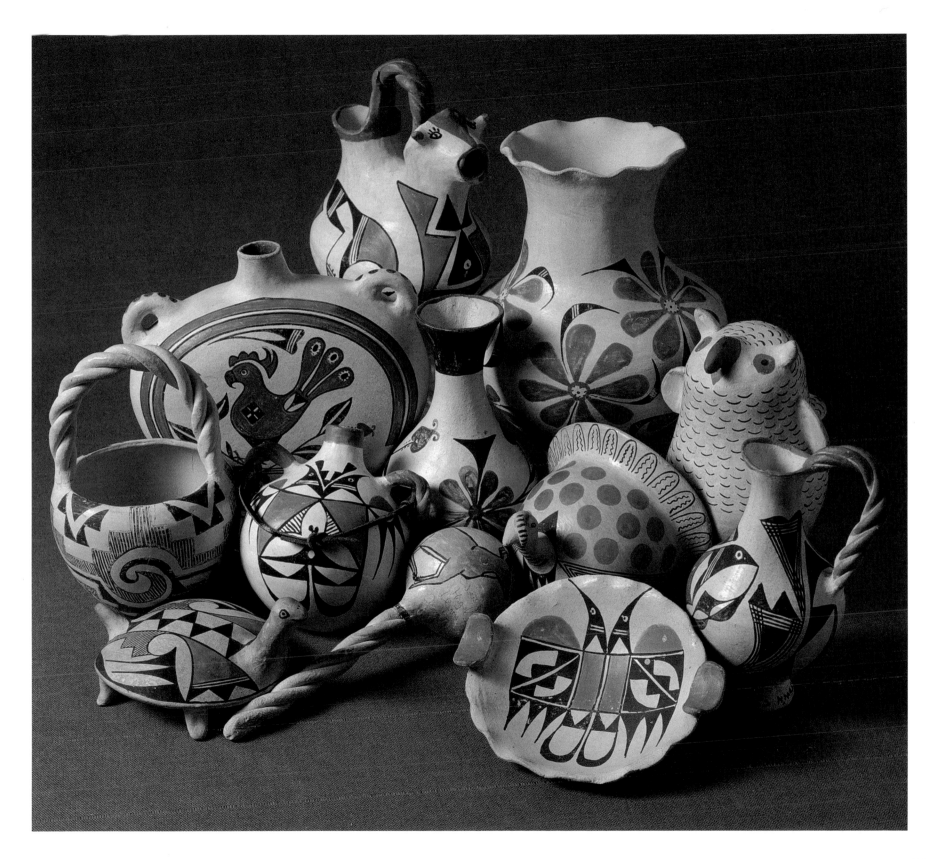

The Seven Families #1: Lewis. In 1974, the Maxwell Museum at the University of New Mexico had a showing by members of seven families of Pueblo potters, each descended from a celebrated matriarch—Lucy Lewis and Marie Chino from Acoma, Maria Martinez and Rose Gonzales from San Ildefonso, Sara Fina Tafoya and Lela Gutierrez from Santa Clara, and Nampeyo of Hano ("The" Nampeyo) from Hopi.

The exhibit had a profound effect on the development of modern pottery, and the thin little catalog remained in print into the 1990s. The show gave the anointed families a great leap ahead in the marketplace, much to the frustration, we suppose, of deserving families who weren't included. Their lead may be shrinking (Rick Dillingham's *Fourteen Families in Pueblo Pottery* came out in 1994), but the original seven's jumpstart was probably strong enough to attach premium prices to their work well into the twenty-first century.

Lucy Martin Lewis (1900?–1992) became the most famous Acoma potter, and next to Maria Martinez of San Ildefonso, perhaps the best-known of all Southwestern potters. She began her career in the 1920s and had a following by the 1940s. She and Marie Chino started signing their pots around 1950, and by the late 1950s, the two of them had brought sufficient attention to their use of prehistoric design motifs to create a new fashion in Acoma pottery.

Many writers credit this design influence to 1958 meetings between Lucy Lewis and Kenneth Chapman of the Museum of New Mexico. As Jesse Fewkes had introduced Nampeyo to Sikyatki pottery at Hopi sixty years earlier, Chapman encouraged Lucy to study the museum's extensive collection of Anasazi and Mimbres pottery. However, all this hardly could have been a dazzling revelation to Lucy. She'd been exposed to Anasazi and Mogollon Black-on-white sherds all through her life and, like other Acoma potters, was already doing Tularosa-inspired hatched designs when she met Chapman. Back then, Acoma potters didn't particularly care *which* ground-up sherds they used as temper, and prehistoric ones are so plentiful in the trash dumps around the mesa that we've seen potters sell nice big ones to tour-bus crowds for fifty cents each.

Lucy lived to see six children become highly regarded Acoma potters, and to see her son Ivan become equally well known for his work at Cochiti. The family tradition seems to be eroding under the pressure of modern life, however. None of her adult grandchildren are currently well-known potters.

On the right, forty years of Acoma work by Lucy and her children. The Mimbres hatchure on the black-and-white jar by Lucy and the lightning bolts on the Carmel Lewis and small Dolores Garcia jars all evidence the continuing presence of prehistoric elements in Lewis family pottery.

TOP ROW: *Seed jar, Emma Lewis Mitchell, 5¾″ diameter, 1993; jar, Emma Lewis Mitchell, 7¾″ diameter, 1992; bowl, Carmel Lewis, 7¼″ diameter, 1993*
MIDDLE ROW: *Wedding vase, Dolores Lewis Garcia, 7″ high, 1985; jar, Anne Lewis Hansen, 5¾″ diameter, 1986; bowl, Drew Lewis, 7¼″ diameter, ca. 1980*
BOTTOM ROW: *Bird effigy canteen, Drew Lewis, 3½″ long, ca. 1975; seed jar (below canteen), Dolores Lewis Garcia, 3¾″ diameter, ca. 1985; pitcher, Mary Lewis Garcia, 3¼″ high, 1989; bowl, Lucy Lewis, 3¼″ diameter, ca. 1950; snake figurine, Lucy Lewis, 2⅞″ long, 1961; jar, Lucy Lewis, 5″ diameter, ca. 1960*

The Lucy Lewis examples show her in three different modes: the traditionalist, as at bottom center; the experimenter with black-on-white prehistoric motifs, as on the lightly spalled jar at bottom right; and the playful master potter, as in the little snake, an entrant in the 1961 Gallup Ceremonial.

The work by her children follows closely behind. There are few surprises here. Ann Hansen and Emma Mitchell's parrot-and-rainbow jars have a design used by Acoma potters for the last hundred years or more, Dolores Garcia put a stylized bird on a wedding vase meant purely for the tourist, and Mary threw one onto a little tourist pitcher. Drew Lewis's large bowl (middle row, right) is equally traditional, and his little effigy canteen puts birds and flowers on a thousand-year-old shape. (You can see an old one—top left, handle to the left—among the miniatures on page 176.)

The most dramatic prehistoric replays in the book appear on the Carmel Lewis bowl (top right) and the Dolores Lewis Garcia seed jar (bottom row). Turn back to page 31 to see the exact source for the design.

Only the Emma Mitchell seed jar at top left looks to the future. Eventually, even institutions like the Lewises will move on.

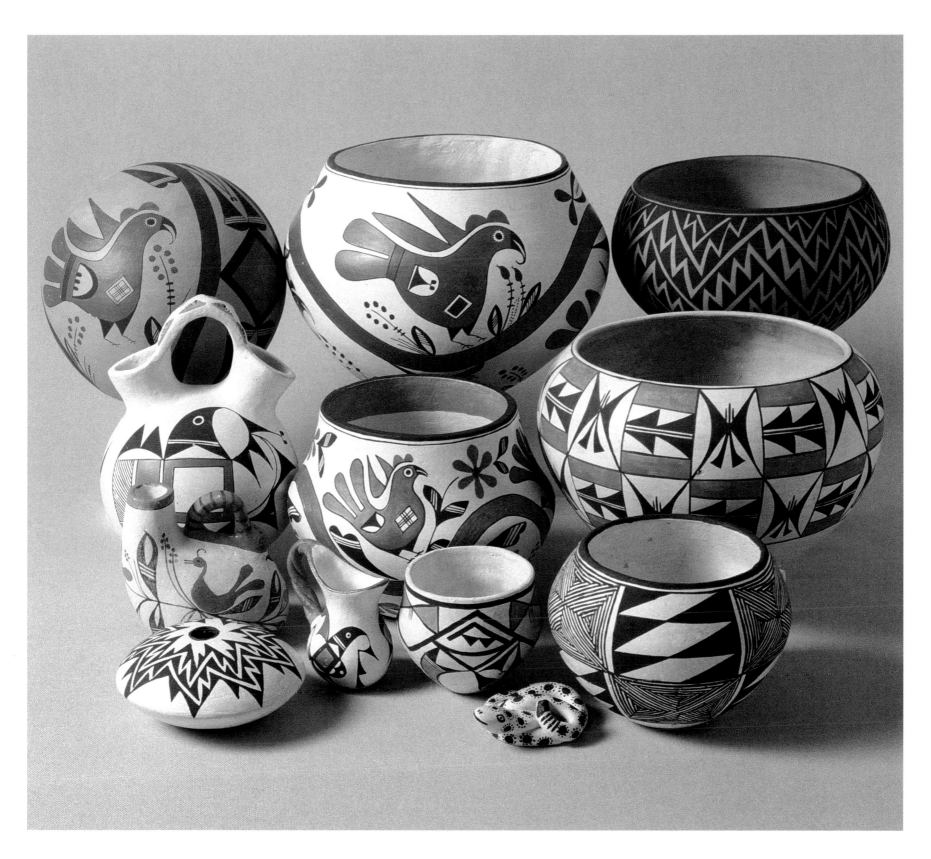

Acoma · Marie Chino

The Seven Families #2: Chino. Although Marie Chino and Lucy Lewis got equal billing in the "Seven Families" exhibit, Marie never quite achieved Lucy's level of stardom. In 1984, Lucy became the subject of a coffee-table biography, a distinction she currently shares only with Maria Martinez and Margaret Tafoya. Marie, on the other hand, has been largely ignored by writers, editors, and publishers.

This may not have been totally fair. Both potters had equally lengthy careers, both had famous potter children, and both influenced the pottery of their pueblo for years.

Marie Zieu Chino (1907–1982) was a celebrated potter from the beginning. She was a prizewinner at the first Southwest Indian Fair in 1922, the event that ultimately evolved into Indian Market, the World Series of Southwestern Indian art. She and Lucy Lewis were friends as well as competitors and occasionally did each other's designs. Actually, according to Betty Toulouse in her 1977 book, *Pueblo Pottery of the New Mexico Indians,* Marie did black-on-white pots with fineline hatching based on intricate prehistoric designs several years before Lucy started doing them. Perhaps Lucy owed more to Marie Chino than the books concede.

Marie took her inspiration from the prehistoric sherds she found around the pueblo, and adapted the designs to modern shapes. She may also have had other sources. Erich Erdoes,

a Santa Fe dealer, told us a story that comes to mind every time we look at a Lewis/Chino prehistoric-inspired piece, and especially every time we see a piece like the one on page 45 with the Tularosa swirls. Erich's family had a close friendship with an Acoma potter active in the 1930s, and she told of a cave filled with prehistoric pottery whose location her family had kept secret for generations. They visited it only to learn designs for their own work.

Marie had five potter daughters, and three achieved reputations almost comparable to their mother's—a body of work whose importance rivals the total output of all seven of Lucy Lewis's potter children. Grace, Carrie, and Rose did their mothers' designs, and each carved out a niche. Carrie Chino Charlie became the master of black-on-white, fineline hatchure. Grace Chino became known for her severely precise geometric polychromes, and Rose Chino Garcia produced the most imaginative designs. In another parallel to Lucy's life, none of Marie's grandchildren managed to achieve any celebrity as potters.

Today, there's still considerable vitality in a few of the anointed seven families. The Tafoya family dominates Santa Clara pottery and the Nampeyo family gets most of the attention at Hopi. At Acoma, however, the Lewis/Chino influence is waning. The stars of the 1990s come from different bloodlines.

TOP ROW: *Seed jar, Grace Chino, 4⅜″ diameter, 1988; jar, Marie Chino, 5″ diameter, ca. 1960; jar, Rose Chino Garcia, 4⅜″ diameter, 1989*
BOTTOM ROW: *Wedding vase, Rose Chino Garcia, 3¼″ high, ca. 1965; seed jar, Marie Chino, 3½″ diameter, ca. 1965; vase, Marie Chino, 4⅛″ high, ca. 1955; seed jar, Carrie Chino Charlie, 3¾″ diameter, ca. 1965*

Like Lucy Lewis, Marie Chino also worked in the traditional Acoma mode, and her work also suffered spalling, as the jar at top center demonstrates. But the rest of the pieces display the style that attracted attention to Marie and her family.

The tall vase and the seed jar to the left of it qualify as unmistakable Chino (or Chino/Lewis) designs, and many Acoma potters still produce variations of them today. The similar seed jar at lower right is by a young Carrie, and barely hints at the incredible accuracy she displayed when she made large jars with fine hatchure like her mother's work on the vase in the front row. Likewise, the wedding vase was done by a young Rose. The decoration has a prehistoric source, but the work doesn't suggest her mature style.

The two jars at top left and right describe Grace and Rose far better. Although her mother originally developed the design, Grace made the jar on the left many times over, and it became something of a signature piece, one that shows up in most recent books on Southwestern pottery. Rose's jar is more free-spirited, and the difference in approach between the two pieces gives a neat little summary of the difference in work between the two sisters.

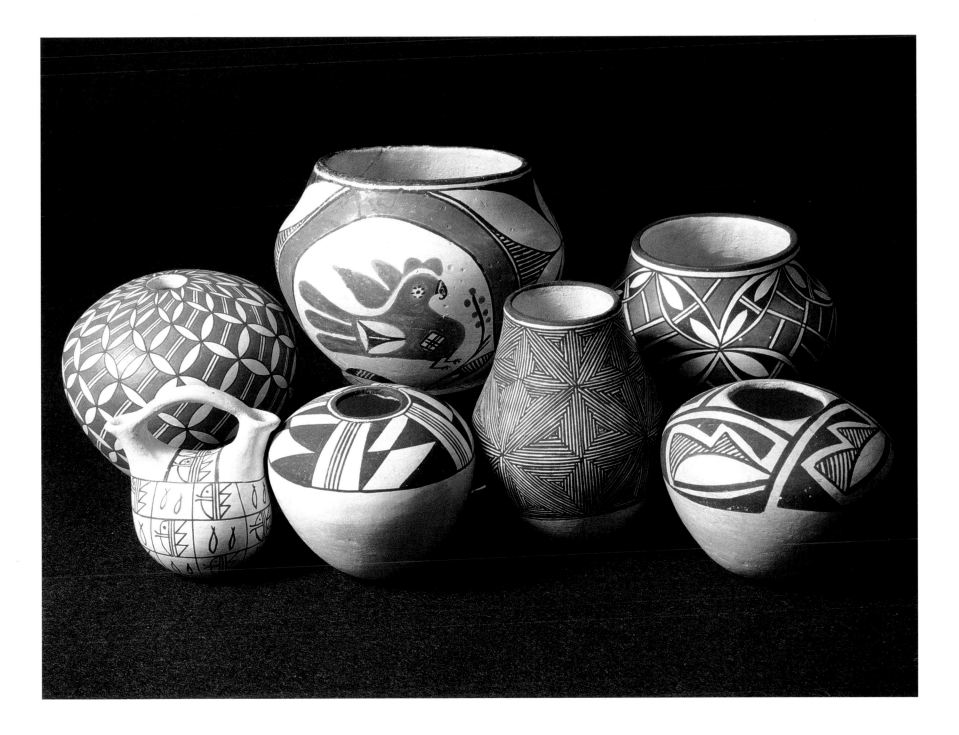

Acoma · Stars and Superstars

Rising above it all. During the 1970s and 1980s, new phenomena threatened to bury the old pottery traditions at Acoma. Kiln-firing became prevalent, and the economics of greenware drew more and more potters.

The kiln's attraction is hard to dispute. If the appeal of your work depends on its pristine whiteness, and a fire cloud destroys it, it's relatively easy to embrace the kiln and leave fire clouds behind forever. The only argument against it is "That's not the traditional way," but if your financial well-being is directly related to the number of successful pots you can produce, tradition can suddenly plummet on your priority list.

Greenware—unfired, undecorated pottery—has an even greater attraction. It takes hours to make a pot, and, unless you're a superb potter, it's apt to be less than perfect once you've finished it. On the other hand, if you buy a slip-cast blank, you have a well-made pot with no effort at all. With a little care in finishing and some nice painting, this pot will bring almost as much money as a traditionally made and fired piece. Under these pressures, the amount of traditionally made pottery dwindled steadily through the 1980s at Acoma, while the amount of kiln-fired greenware increased.

Despite all this, a few excellent potters bucked the trend. For the most part, they resisted greenware entirely, and those who didn't still produced a considerable body of handmade work. Although most succumbed to the lure of the kiln, they stayed with traditional coiling, smoothing, and finishing.

That they could do this was also a matter of economics. If you're a low-end potter, you can sell your greenware for almost as much as you can sell a handmade pot. But once you've achieved a reputation, your handmade work boosts you into an elite price category, and it's no longer worthwhile to waste your time with slip-cast wares.

The pots in the picture at right were made by members of the elite corps, sometimes in collaboration with a spouse or partner. A few, like Nelda Lucero, made a little greenware as well. Others, like Stella Shutiva, Dorothy Torivio, and Charmae Natseway, achieved such rarefied status that greenware would be out of the question. All, however, contributed mightily to raising the standards of Acoma pottery.

TOP ROW: *Jar, Nelda Lucero, 6½″ diameter, 1987; sculptured jar, Wilfred Garcia and Sandra Shutiva, 8½″ diameter, 1990; vase, Edwin and Minerva Sarracino, 8″ high, 1992*

MIDDLE ROW: *Cylinder bottle, Charmae Shields Natseway, 4″ high, 1994; owl figurine, Stella Shutiva, 5¼″ high, 1980; jar, John Aragon, 5″ diameter, 1993; jar, Wilfred Garcia, 5½″ diameter, 1992; canteen, C. Maurus Chino, 4⅛″ diameter, 1987; pyramid bottle, Charmae Shields Natseway, 4″ high, 1994*

BOTTOM ROW: *Seed jar, Rachel Concho, 5″ diameter, 1993; seed jar, Rebecca Lucario, 3½″ diameter, 1993; storyteller figurine, Marilyn Henderson, 7″ long, 1993; seed jar, Dorothy Torivio, 5″ diameter, 1994; seed jar, Adrienne Roy Keene, 2¼″ diameter, 1994; seed jar, Charmae Shields Natseway, 4¾″ diameter, 1989; seed jar, Rebecca Lucario, 2¾″ diameter, 1993*

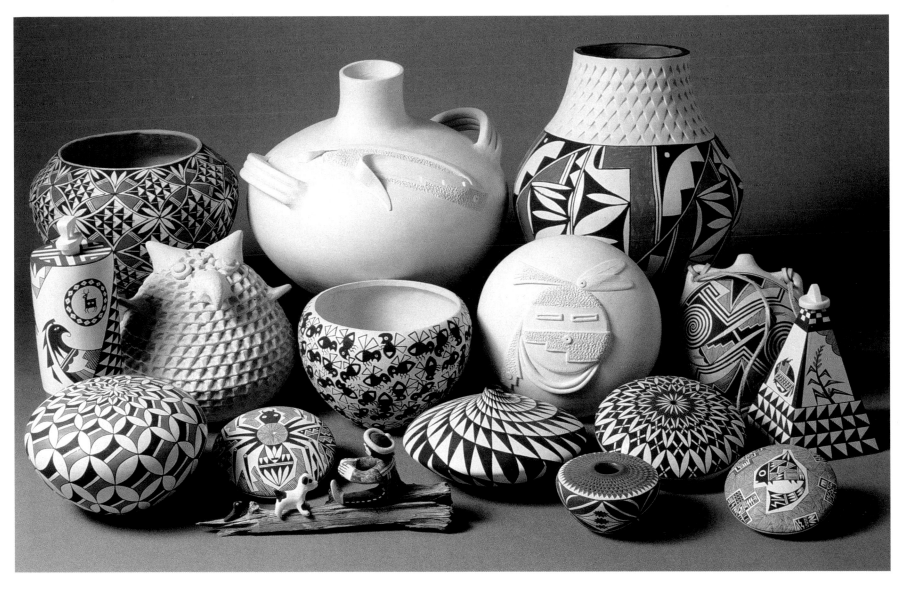

The big white jars by Wilfred Garcia and Sandra Shutiva and the corrugated owl by Sandra's more-celebrated mother, Stella, represent the pure elegance of Acoma pottery at its finest, and both mother and son-in-law rank at the top of the Acoma prestige ladder.

But Acoma built its reputation on more than well-made pots. While the tall vase at top and the small seed jar in the bottom row have little impressed rows of teeth ("punctate" decoration), Acoma pottery owes most of its attraction to the intricacy, imaginativeness, and accuracy of its painted decoration.

Maurus Chino made a canteen with a Tularosa design Lucy Lewis and Marie Chino would applaud. Nelda Lucero's jar (top left) appealed to us so much that we've put it somewhere on every cover design we've contemplated. Rebecca Lucario and Marilyn Henderson are members of the Lewis family of the 1990s—the "other" Lewises, not descended from Lucy. Together with Diane, Judy, and Sharon Lewis and Carolyn Concho (all represented on the following pages) this family has produced a body of work that promises to have as much influence over the next decades as the work Lucy and her children created in the 1950s and 1960s. Rachel Concho is Carolyn's mother-in-law.

The picture includes three ranking superstars. The late Stella Shutiva (owl) brought corrugated pottery back into prominence for the first time in a thousand years, and her daughter Jackie (page 55) is carrying on her work. Dorothy Torivio does startling, much-imitated black-on-white geometric designs that appear in almost every book on pottery that has come out since 1985.

On the other hand, no one imitates Charmae Shields Natseway's intensely personal pyramidal and cylindrical lidded jars. They deliver everything this museum looks for in a pot: tradition, skill, precision, striking design, and enough imaginativeness to make us realize we've never seen anything like it before.

Acoma · Up and Coming

New incentives, old pressures. If you're a young potter at Acoma today, you're no longer bound by tradition, forced to do one thing in one way. Instead, you make a choice: take the easy path and run the risk of never amounting to much, or do it the hard way and run the risk of never quite learning how to do it perfectly.

The incentives that pushed potters down the kiln-and-greenware path in the 1970s and 1980s are slowly disappearing. These days, greenware is increasingly confined to junky tourist stores. Major pottery retailers in the Southwest who sold large quantities of greenware in 1985 carried very little of it in 1995. They're phasing it out because their customers are able to recognize it and therefore to avoid it. And because more customers avoid it, more potters are turning away from it in favor of more easily saleable traditional pieces.

This trend feeds on itself. As the market rejects greenware, the price gap between slip-cast and hand-coiled pottery increases, making the effort involved in doing it the old way seem more attractive.

If the direction continues, Acoma pottery is starting the twenty-first century on a roll. The best potters in the new generation approach their craft with a competitiveness that pushes the standards ever higher. If it's thin, make it thinner. If the lines should be fine, make them finer. If they should be straight, make them straighter. This is today's route to fame and what passes for fortune in the Southwest.

If you could step in a time machine with, say, Frederica Antonio's black-on-white fineline jar, Diane Lewis's little pitcher, or almost any of the other pots on the next page and take them back to 1960, Lucy Lewis and Marie Chino would have trouble believing what you brought. The fame of these great pioneers may last through the ages, and we hope it does, but none of them could have made most of these pots.

This really is the Golden Age, and the pieces in the picture offer silent but inarguable proof.

TOP ROW: *Jar, Evelyn Chino, 7¾″ diameter, 1992; olla, Florence Aragon, 10½″ diameter, 1994; jar, Sandra Victorino, 8″ diameter, 1994*
MIDDLE ROW: *Wedding vase, Judy Lewis, 8½″ high, 1992; jar, Frederica Antonio, 7″ diameter, 1993; vase, Tina Engle, 7″ high, 1992; basket, Charlene Estevan, 6¾″ high, 1993*
BOTTOM ROW: *Seed jar, Diane Lewis, 3½″ diameter, 1994; canteen, Sharon Lewis, 4″ diameter, 1993; jar, Rebecca Lucario, 3½″ diameter, 1993; seed jar, Bernice Cerno, 5″ diameter, 1990; jar, Carolyn Concho, 2¼″ diameter, 1993; pitcher, Diane Lewis, 3¼″ diameter, 1994; corrugated jar, Jackie Shutiva Histia, 5½″ diameter, 1994; canteen, Judy Lewis, 3⅜″ wide, 1992; jar, Carolyn Concho, 4⅝″ diameter, 1993*

If you need evidence that the old ways are alive and well, you need only to look at Florence Aragon's fabulous traditional olla at top center, as beautiful and dazzling as anything made in the past hundred years, or (below it) at Tina Engle's vase, restrained and masterful and purely traditional, yet somehow alive and fresh.

If you need evidence that precision is increasing, look at Frederica Antonio's crossword-puzzle grid (right of wedding vase) or Sandra Victorino's pinwheels and snowflakes (top right).

For proof that today's potters can find something new to do with the Lucy Lewis/Marie Chino legacy, try the large jar at top left by Evelyn Chino (no relation) or the seed jar with those Tularosa lightning bolts by Bernice Cerno, member of another famous Acoma pottery family.

The corrugated jar by Jackie Histia puts a new spin on her mother's work (see the owl in the previous picture). And if that picture didn't convince you that the new Lewis family has a major style building, look at the pieces on this page by Judy, Diane, Carolyn Concho, and sister-in-law Sharon.

These days, pottery at Acoma is exciting. We can hardly wait to see what happens next.

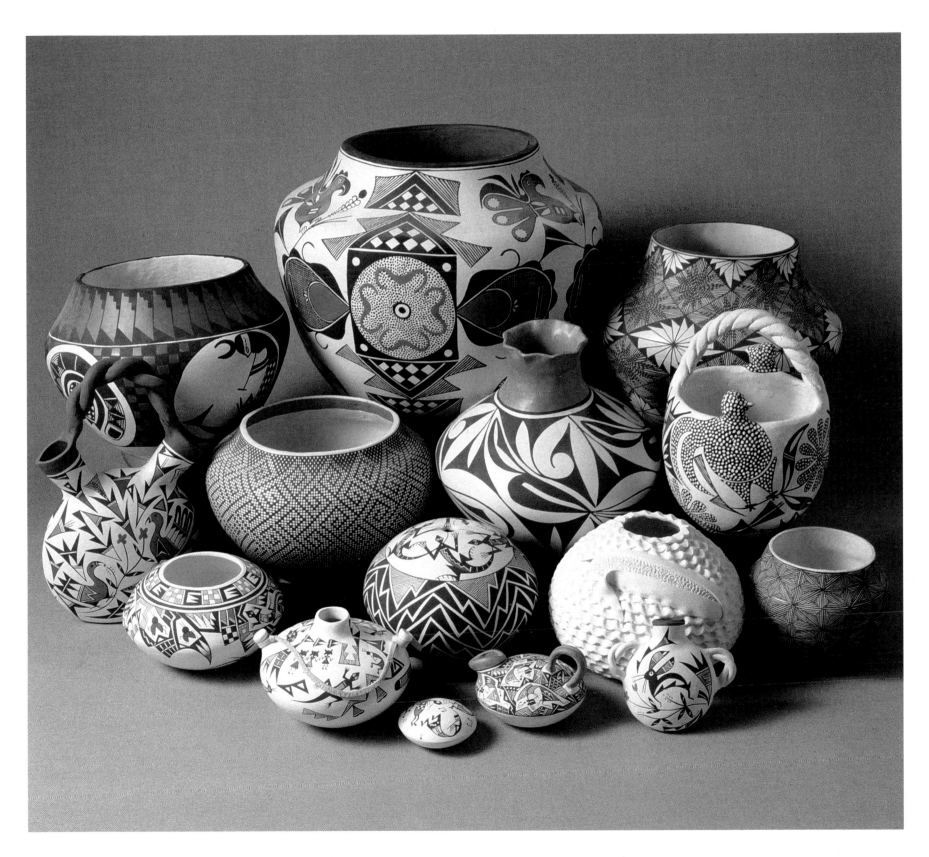

Casas Grandes / Mata Ortiz

➤➤➤ *From out of nowhere.* When the inhabitants of Paquime vanished, the Apaches took over northern Chihuahua, and the area remained unsafe for settlers until the late nineteenth century. Eventually, American troops rounded up the Apaches on both sides of the border and herded them into reservations. The land evolved into cattle country, and foreigners developed lumber and agriculture until the Pancho Villa uprising of 1912–1914 kicked them out.

Bandelier explored the ruins of Paquime in the 1890s and diPeso explored them in the 1950s. But the post-Villa natives—Hispanics and Indians alike—lived in small, poor villages and had little interest in ancient history.

The pueblo of Mata Ortiz was one of these villages, fifteen miles from Nuevo Casas Grandes, an agricultural town that grew alongside the ruins of Paquime, itself about seventy miles south of the east corner of New Mexico's bootheel. One of the new natives was a young *mestizo* named Juan Quezada, who, like the other young men in the pueblo, learned to box, picked fruit, and worked for the railroad.

Unlike the others, he loved to draw, and as a teenager, taught himself to make paints from the plants and minerals he found in the area, grinding them on grinding stones left over from the old days of the Gran Chichimecha. In his wanderings, he discovered Casas Grandes pottery sherds, and it seemed perfectly plausible that, if

the ancients could make beautiful things, he should be able to as well.

He learned about clay through trial and error. He learned how to form the bottoms of his vessels out of frustration. When nothing else worked, he forced some clay into the bottom of one of his mother's dishes, thereby discovering the value of a puki, the mold used by prehistoric and modern potters alike. His pots always cracked, so he looked closely at the edges of the old sherds and rediscovered temper. The natives of Mata Ortiz understood that clay hardened in firing, but how? And using what fuel? He ultimately learned to use dried cow chips, a Rio Grande Pueblo standby. In short, he reinvented the entire technique of Southwestern pottery manufacture just by looking at sherds.

By 1970 or so, he made good pots, which the local traders promptly sold as prehistoric. When a friend told Juan about famous potters in the U.S. who signed their work, he painted signatures on his. But the traders ground off the signatures in sand and continued to sell his work as prehistoric. So he etched his signature instead of painting it, and the etched signature has remained a Casas characteristic ever since.

In fairy tale fashion, an American named Spencer MacCallum found a couple of Juan's pots in a junk shop in Deming, New Mexico, in 1976. Something made MacCallum want to search out this potter, and he found Juan in Mata Ortiz.

For the next seven years, MacCallum showed and promoted Juan's work with evangelical zeal.

In the meantime, Juan taught his relatives and neighbors how to make pots, and ultimately, taught most of the population of Mata Ortiz.

Between 1982 and 1990, Juan, now a recognized celebrity, taught summer seminars at the Idyllwild School of Music and Arts near Palm Springs, an honor accorded at various times to Maria Martinez, Lucy Lewis, and other notable Southwestern potters. In 1990, a Japanese investment company contracted to buy all of Juan's output for world distribution. The deal fell through in 1991, but the implications were clear. Juan Quezada and the now perhaps three hundred potters of Mata Ortiz belonged to the world.

They also belonged to the world of Southwestern pottery, a fact not totally appreciated by the pueblo potters of the north. They view the bulk of today's casas Grandes ware as inauthentic and mass-produced, undercutting the market for pottery with true tradition. The debate can last half the night, but it can't change the fact that Mata Ortiz potters include a few near geniuses, some serious artists and a number of lesser talents working hard to support their families with their pottery. Virtually all use native clay, traditional paints and traditional firing. No pueblo of the north can claim more, and quite a few, not as much.

TOP ROW: *Bowl, 7½″ diameter, ca. 1955; jar, Benjamin Soto, 8″ diameter, 1990; human effigy, probably Juan Quezada, 6¾″ high, ca. 1975*
MIDDLE ROW: *Jar, unsigned, 4⅜″ diameter, 1994; jar, San Be, 6″ diameter, 1990; owl effigy, Nena Quezada, 6″ high, 1990; jar, Beta Teno, 8½″ diameter, 1990*
BOTTOM ROW: *Jar, Enrique Pendragon Ortiz, 3¾″ diameter, 1994; jar, Amy Amigo, 4¼″ diameter, 1994; jar, Olga Quezada, 4″ diameter, 1992; jar, Angel Amayo, 4½″ diameter, 1992*

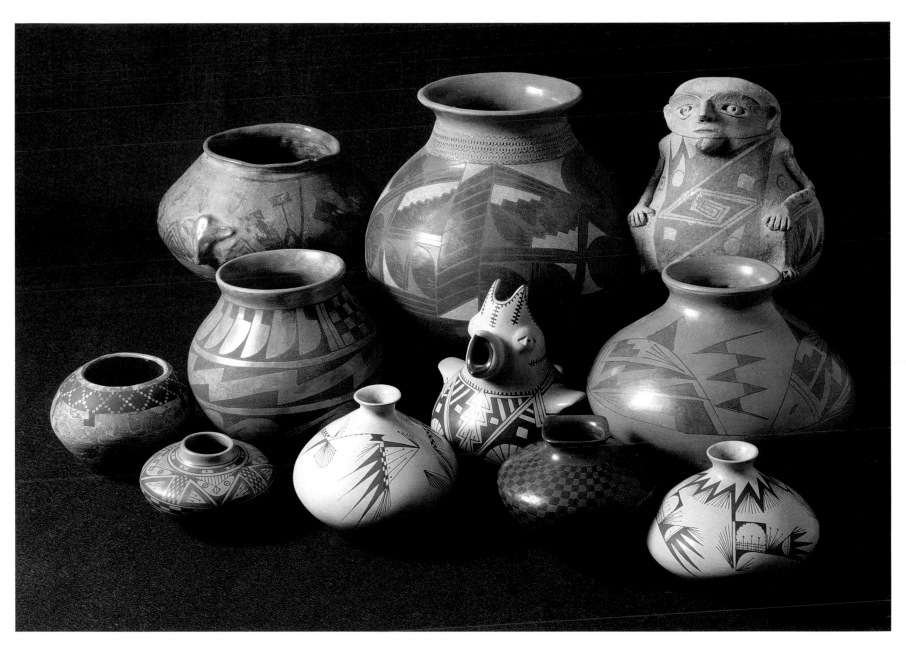

The bowl at top left, with antlers painted on steer heads, is a pre-Quezada attempt by someone—Indian, Mexican, or Anglo—to forge prehistoric Casas pottery, and probably dates from the mid-century, about the time diPeso's excavations created interest in Paquimé and its art. Its lack of authenticity is obvious. The effigy in the top row, however, looks like the real thing, and according to Spencer MacCallum, is probably by Juan himself.

The other nine pieces in the picture represent the polychromes of the Mata Ortiz of the 1990s, now the source of great quantities of some of the finest pottery ever made in the Southwest.

The owl effigy in the center is by Juan's oldest daughter Nena, while the beautiful black-on-red jar in front of it is a trademark pot by Olga Quezada, one of the finest Mata Ortiz potters, and unrelated to Juan.

The large jar at top center by Benjamin Soto and the smaller one by San Be below it and to the left are examples of the Ortiz style of Casas polychromes. Felix Ortiz was one of Juan's first students, but soon developed a distinctive style of bold decoration with heavy paint coverage. His neighbors in the Porvenir district south of Mata Ortiz picked up on the style.

The pieces by Angel Amaya, Amy Amigo, Enrique Ortiz, and Beto Teno follow the Quezada style, and together provide a cross-section of the current state of the art.

The marbled surface and stylized turtle on the unsigned pot at the far left don't quite fit either style and might foreshadow future experimentation.

Casas Grandes / Mata Ortiz · Basic Black

Remembering Ramos Black and San Ildefonso.
Turn to page 47 and you'll see a little bowl at bottom center like the ones Juan Quezada found in his early wanderings. Ramos Black from Paquime was a pure black prehistoric type, and Juan knew it well.

In 1978, Spencer MacCallum reported that Mata Ortiz potters had already figured out how to fire pottery so that it came out black, like Ramos Black, or like turn-of-the-century ware from Santa Clara.

As MacCallum introduced Juan to the world, the Quezadas were able to travel. In 1980, Juan actually spent an hour with the ninety-two-year-old Maria Martinez at San Ildefonso. That same year, Juan's sister Lydia tried to touch up the surface of a polished, fired blackware jar, and saw an effect that connected with the black-on-black ware she'd seen at San Ildefonso. Experimentation followed, and black-on-black became a staple at Mata Ortiz.

Casas Grandes Black-on-black differs greatly from its northern counterpart. San Ildefonso and Santa Clara ware is thick, while Casas ware, both prehistoric and modern, is thin and fired at a higher temperature. Casas ware is in fact just about the thinnest of all Southwestern wares, and its rounded bottom makes it immediately recognizable.

Lucy Lewis and Juan met at Idyllwild, and, so the story goes, she watched him work with the clay and said to her daughters in Keresan, the Acoma language, that Juan must actually be an Acoma. One of the legends surrounding the church at Sky City says that when the Indians completed the bell towers, the padres were out of money. With a resourcefulness typical of the times, they took a group of Acoma children to Mexico and traded them for a nice new bell. Lucy felt the most plausible explanation for Juan's talent was that he was descended from those lost children who bought the bell.

TOP ROW: *Sculptured jar, Ivona Quezada, 7½″ diameter, 1993; sculptured storage jar, Jesus Quezada, 11″ diameter, 1992; sculptured jar, Jaime Quezada, 8″ diameter, 1992*
MIDDLE ROW: *Sculptured jar, Rito Talavera, 8½″ diameter, 1993; sculptured jar, Hector Ortega, 6″ high, 1995; sculptured jar, Martha Quezada, 9″ diameter, 1993; jar, unsigned, 4¼″ diameter, 1992*
BOTTOM ROW: *Sculptured jar, Irma Juarez, 5¼″ diameter, 1993; double jar, Olivia Dominguez Renteria, 11⅛″ wide, 1992; swirl-pattern seed jar, Baudel Lopez, 3⅜″ diameter, 1995; jar, Efrain Lucero, 4¾″ diameter, 1991*

The big jar at the top, by Juan's younger brother Jesus, and the turkey effigy, by Juan's nephew Jaime, demonstrate the Quezada style translated into blackware, while the unsigned piece at the right end of the middle row shows the Ortiz style from Porvenir.

Rito Talavera, Lydia's husband, developed a style of his own, which younger-generation potters like Ivan and Martha Quezada have embraced.

Efrain Lucero has been making beautiful plain blackware for years. The jar at the right of the bottom row has a gunmetal sheen, a color once thought to be the exclusive property of Maria Martinez. The swirl seed jar in the bottom row tries for that elusive gray color. In 1994 and 1995, Casas potters achieved true gunmetal in swirl jars as large as a volleyball.

Olivia Renteria's family were neighbors of the Quezadas, and her mother was an early student. The double jar looks strange, but the form existed in prehistoric times.

Hector Ortega, who made the remarkable jar with the double rams' heads, and Toma Juarez, who did the lizard pot at lower left, are newer talents, not listed among the 180 potters named in the 1993 definitive book on modern Casas Grandes, Walter P. Parks's The Miracle of Mata Ortiz.

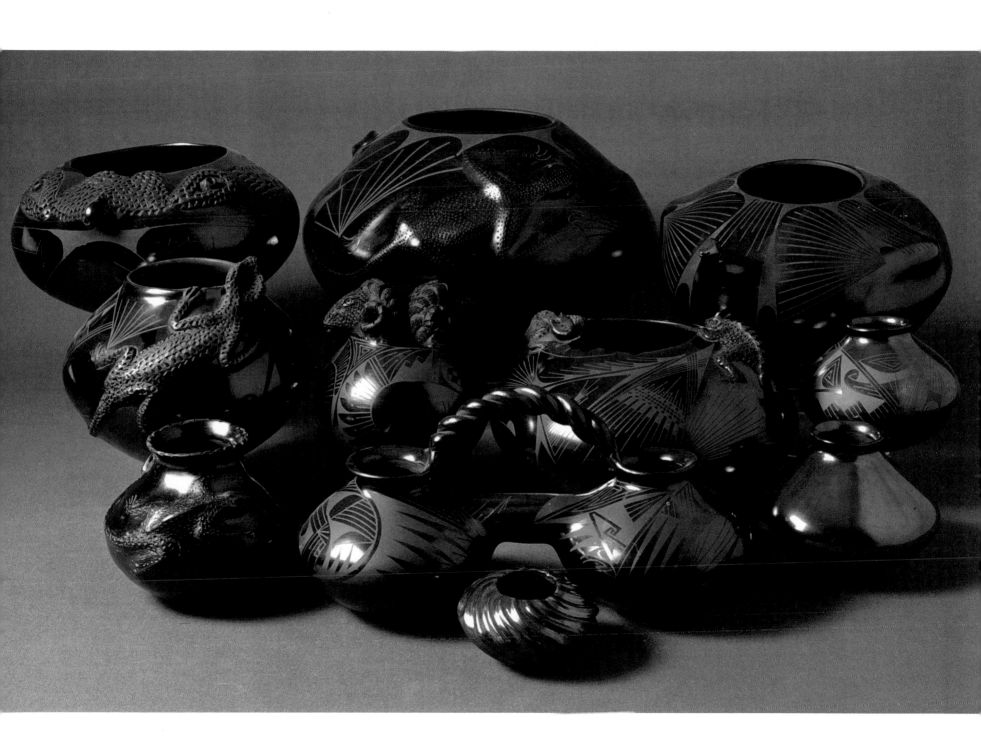

Cochiti

▶▶ In the shadow of the dam. Like most of the pueblos of the Southwest, Cochiti (it's pronounced CO-chi-tee) predates the Spanish.

Archeologists suggest that the Cochiti once occupied the Anasazi village of Tyuonyi in the Jemez mountains to the west, moving down to their present location by the Rio Grande long before the Spanish came.

Coronado missed Cochiti, but the first padre arrived in 1581. Fray Rodriguez had a brief ministry. Warriors from a neighboring pueblo dispatched him within weeks, but the respite ended soon. The Spanish kept returning, and by 1600, European civilization had settled in permanently. The mission of San Buenaventura went up around 1630, and it lasted until the rebels burned it in the Pueblo Revolt of 1680.

After the revolt, Cochiti and Santo Domingo Indians established a stronghold at Cienguilla in the mountains, which came in handy again after de Vargas reappeared in 1692. A year later, as part of his bloodless return, de Vargas stormed Cienguilla, killed twenty warriors and captured three hundred women and children. He rounded up most of the rest, returned them to Cochiti, and set them to work building a grand new mission. It still stands in the main plaza. The ones who got away fled west, eventually establishing the pueblo at Laguna in 1699.

Today, Cochiti is a 175-square-mile reserve below the gigantic Cochiti Dam, a looming earth-fill presence that created another world

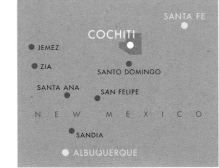

above: Cochiti Lake, with its waterskiing, golf, charterboat fishing, and vacation timeshares. Down below, Cochiti itself might be considered up-to-date as pueblos go. Many of its eight hundred tribal members commute to jobs in Santa Fe and Albuquerque. Nonetheless, it still gives the impression of being frozen in earlier times.

Cochiti pottery from the late eighteenth century on has been a gray-to-cream-to-white-slipped polychrome with black-and-red decoration. Cochiti potters entered the tourist market early. Jonathan Batkin's *Pottery of the Pueblos of New Mexico, 1700–1940*, has a wonderful photograph of pottery from the shop of L. Fisher of Rio Chiquito Street in Santa Fe, taken about 1880. It shows fourteen Cochiti mono figurines, including caricatures of Anglo missionaries and Catholic priests over a sign that reads RARE SPECIMENS—ANCIENT MONTEZUMA POTTERY TAKEN FROM RECENT EXCAVATIONS IN NEW MEXICO —ALSO OTHER INDIAN RELICS AND FIGURINES! Juan Quezada's early dealers followed a simple principle: If it looks old, say it's old. L. Fisher went them one better: If it looks strange, say it's old.

Production of whimsical figurines declined between 1900 and 1960 in favor of more conventional shapes. In the 1960s, when the tribal government deeded part of its land for the dam and the lake, Cochiti lost its supply of gray clay forever. But through it all, Cochiti potters retained their sense of playfulness. Now, as then, Cochiti pottery remains the funniest, the most human, and the most enjoyable of them all.

TOP ROW: *Bowl, 7½″ diameter, ca. 1930; bowl, Marianita Venardo, 5½″ diameter, ca. 1945; bowl (in front) 4″ diameter, ca. 1935; bowl, 8¼″ diameter, ca. 1915; bowl with turtle, Elizabeth Trujillo, 5¼″ diameter, ca. 1950; pitcher (in front) 4⅞″ high, ca. 1920*
MIDDLE ROW: *Horned figurine, 7″ long, ca. 1900; bowl, 4½″ diameter, ca. 1920; lizard figurine, Damacia Cordero, 11½″ long, ca. 1980*
BOTTOM ROW: *Bird effigy bowl, 3⅝″ long, ca. 1970; basket, 3⅜″ diameter, ca. 1925; bowl, 3¼″ diameter, ca. 1920; bird effigy bank, 6½″ long, ca. 1910; cat figurine, 3½″ high, ca. 1890*

This picture gives a taste of Cochiti monos. The little cat at bottom right and the strange beast at the left of the middle row are small but pure examples. The bird to the left of the cat is really a dime bank—the slot won't even accommodate a penny. It could have been made anywhere between 1880 and 1940; the 1910 date merely represents the middle of the time span. The little bird bowl at the bottom left shows how hard it is to date these pieces. It looks old, too, but the red clay that shows through some little nicks gives it away as post-dam.

If the little bird at left lies about its age a bit, the big lizard in the middle row commits perjury. We would have labeled it as one hundred years old without a moment's hesitation if we hadn't known it was by Damacia Cordero, and that she made it around 1980. Cordero was born in 1905, started potting in the 1920s, and worked into the 1980s. We're told all her work looked older than it was.

The larger bowls and the pitcher show the style of utilitarian Cochiti wares during the first part of the century. The largest bowl on top is early Cochiti ware at its best, and the 1945 bowl by Marianita Venardo to the left of it describes the other end of the scale.

The smaller tourist pieces have a similar quality range. The one at middle front was easy to identify as Cochiti: Why else would it have a big C on the side?

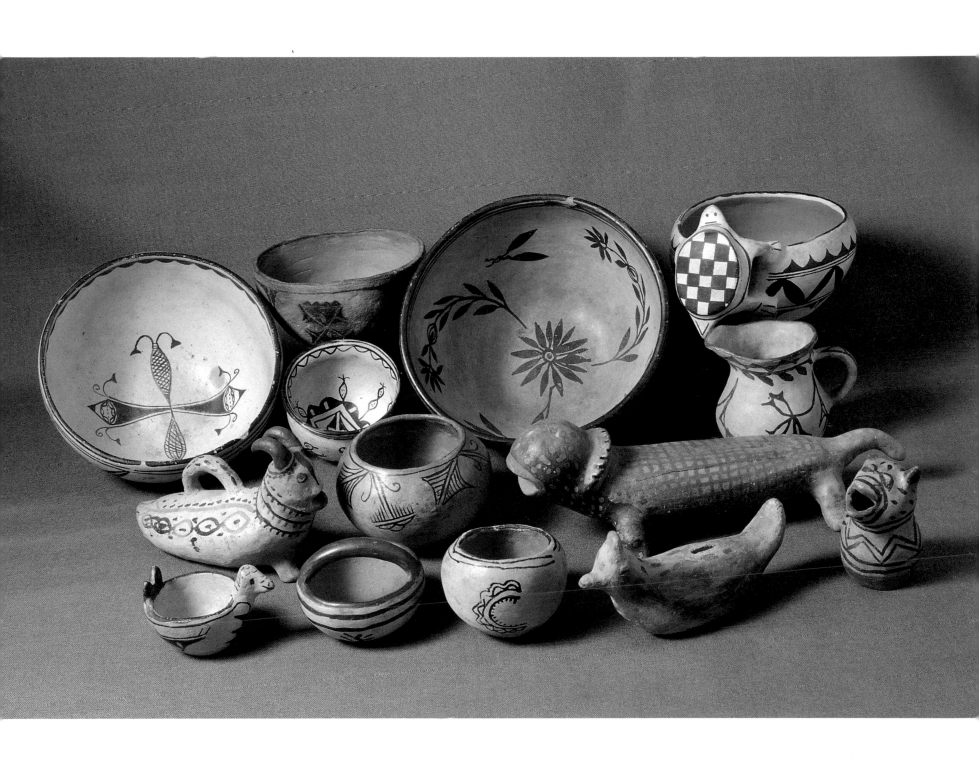

Cochiti · Storytellers

Singing Mothers and Helen Cordero's grandfather. Cochiti pottery production went into a gradual decline as the twentieth century progressed, until 1964, when a minor, unsuccessful potter paid attention to some advice. After that, everything changed.

Helen Cordero asked her husband's cousin, Juanita Arquero, to teach her how to make pottery, but none of her pieces ever came out right. Finally Juanita gave up on Helen's ability ever to make a proper bowl or jar and suggested she try making figurines.

As they say, the rest is history. She began with nativity scenes and singing mothers, open-mouthed Madonna-and-child figurines that had been a staple design at Cochiti for eighty years. A folk-art collector bought one of her singing mothers and asked her to make a larger one with multiple children.

As she told it, she kept seeing visions of her grandfather, a master storyteller who was always surrounded by children. Her first storyteller had five children hanging off her grandfather's figure, and the idea caught on immediately.

Helen added more and more children, and other potters topped her number, piling increasing numbers of tiny children on a giant figure, like crawling ants. By now, hundreds of potters have made storytellers. (In a 1986 book, *The Pueblo Storyteller*, Barbara Babcock and Guy and Doris Monthan listed 237 by name, and probably as many more have entered the game in the intervening years.)

In any event, Helen Cordero's success plunged Cochiti back into the figurine business. By 1975, most Cochiti potters had stopped doing whatever they were doing and started turning out their versions of the storyteller. A few, like Marie Suina, Felicita Eustace, and Dorothy Herrera, developed instantly recognizable styles. Others, like Martha Arquero and Snowflake Flower, stretched the bubble. And still others made pedestrian figures with blank expressions.

But for better or worse, they made them and they made them and they made them, and they're still making them.

Helen Cordero's storytellers had motion and expression, much like Carol Suina's 1989 effort. But others developed recognizable styles as well.

Somehow, Marie Suina's storytellers all look like linebackers, while Louis and Virginia Naranjo's tableta-wearing family groups look faintly Russian. Other members of the Suina family have their own styles, and Denia's twenty-eight-passenger model is this museum's highest-population storyteller. (The number isn't all that impressive. We've seen Jemez storytellers with over two hundred.)

It didn't take long for potters to start exploring the genre, and Cochiti potters have made storytellers out of almost every animal imaginable. Snowflake Flower makes coyotes, Inez Ortiz does owls, Martha Arquero makes frogs, Rose Brown makes turtles, and E. Herrera makes bears.

Bears show up a lot. Dorothy Herrera makes teddy bears; Martha Arquero makes wonderfully sappy, blank-eyed bears; and the Naranjos make loveable, partially clothed bears. There's a delightful family group on page 178.

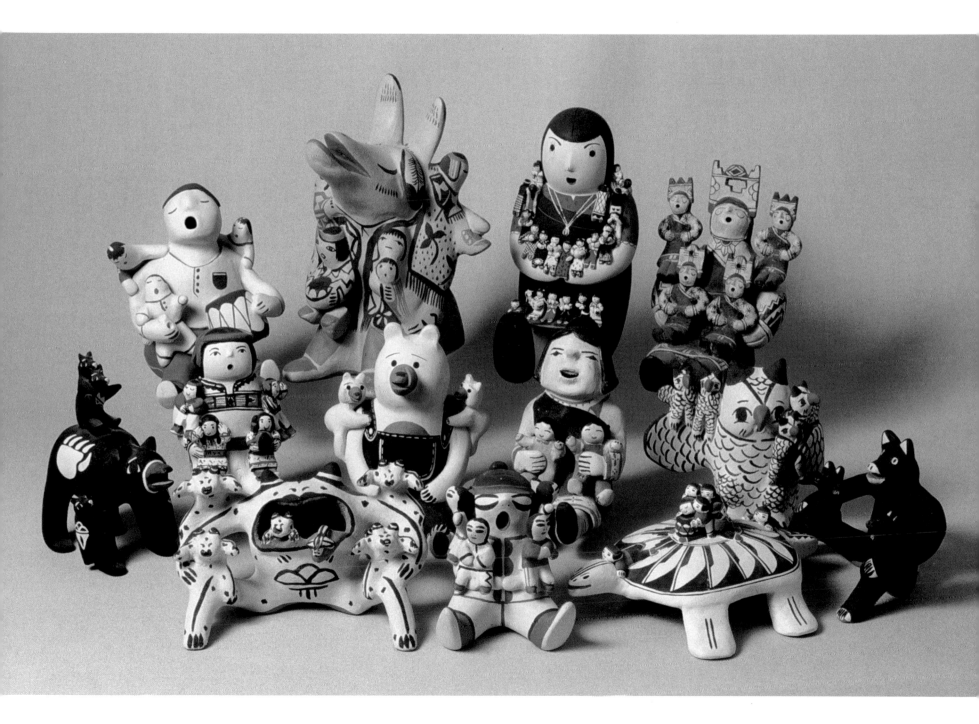

Cochiti · It's Not All Storytellers

Forward into the past. Nothing lasts forever. Although more than a hundred potters may still make them, there are signs that the thirty-year dominance of the storyteller may be winding down.

In the mid-1990s, Virgil Ortiz is probably the hottest potter in Cochiti. Gallery 10, the Tiffany's of pottery stores, features his work, and the 1995 *Santa Fe Collector's Guide* showed three of his pieces on the cover.

Virgil, born in 1969 to Seferina Ortiz, takes his inspiration not from Helen Cordero, but from the potters who made the "Montezuma Pottery" that L. Fisher displayed in 1880. At the other end of the generational scale, so does Ivan Lewis, son of Acoma's Lucy Lewis and fifty years Virgil's senior.

To some of us, this reversion to past amusements seems long overdue. The museum-and-art establishment has saddled figurative Southwestern pottery with a century-long discouragement. Back in the days of L. Fisher's fleece-the-gullible marketing, curators and ethnologists gathered hundreds of Cochiti mono figurines and brought them to museums back East, where experts decided they were debased, savage art, contaminated by unacceptable commercial influences. Today, these monos are rare and highly sought-after.

From 1890 until not very long ago, serious critics wrote scholarly pieces about the purity of ancient utilitarian pottery forms and decorative symbols. Dealers, curators, and exhibition judges turned their backs on any Southwestern pottery that, perish the thought, was made neither for art nor for tradition's sake, but only because someone might actually want to buy it.

Cochiti artists never really seemed to understand the establishment's rigid determinations. They kept making singing mothers, and their storytellers were only a very short philosophical step from the old "debased, savage art."

Well, guys, the monos are back, and bringing a fancy price at that. And the art of the Cochiti potter remains happily untamed and uncivilized.

TOP ROW: *Wall sconce, Snowflake Flower (Stephanie Rhoades), 6¾″ high, 1985; bowl, Seferina Ortiz, 8½″ diameter, ca. 1965; cowboy figurine, Ivan Lewis, 8½″ high, 1990*

MIDDLE ROW: *Seated figure, Virgil Ortiz, 5″ high, 1993; bowl, R. Romero, 5¼″ diameter, ca. 1970; Cochiti rain god, Virgil Ortiz, 5½″ high, 1994; wall sconce, Louis and Virginia Naranjo, 4¾″ high, 1992*

BOTTOM ROW: *Owl figurine, Joseph Suina, 5″ high, 1992; figurine with camera, Dorothy Trujillo, 4¾″ high, ca. 1965; angel figurine, Seferina Ortiz, 3¾″ high, 1994; box, April Arquero, 1¾″ high, 1993; bear figurine, Louis and Virginia Naranjo, 4″ high, 1994; bathing beauty figurine, Seferina Ortiz, 6¼″ high, 1995*

At Cochiti, even the bowls are fun. The chicken in R. Romero's bowl and the lizards on Seferina Ortiz's bowl have a cartoony friendliness that other pueblos seldom offer.

The two sconces describe modern Cochiti. The one on the right is pure Louis and Virginia Naranjo, and the one on the left is Snowflake Flower doing an homage to grandmother. (She didn't sign this one, and Al paid far too much for it, thinking he'd snagged a rare 1920s piece. He'd have gone on thinking it, too, if he hadn't later met Stephanie and showed it to her, and if she hadn't laughed and told him when she made it.)

Back in Helen Cordero's heyday, Cochiti potters were still kidding the Anglos. Dorothy Trujillo shows what tourists look like from the other side of the lens. Thirty years after she made the bowl in the top row, Seferina Ortiz gives us an airheaded bathing beauty and a grumpy angel. Ivan Lewis makes a nineteenth-century cowboy with removable hat. And Virgil Ortiz creates strange and wonderful figures. The "Cochiti Rain God" is an inside joke. Tesuque rain gods catch the rain in a pail between their legs. At dry Cochiti, buckets don't help.

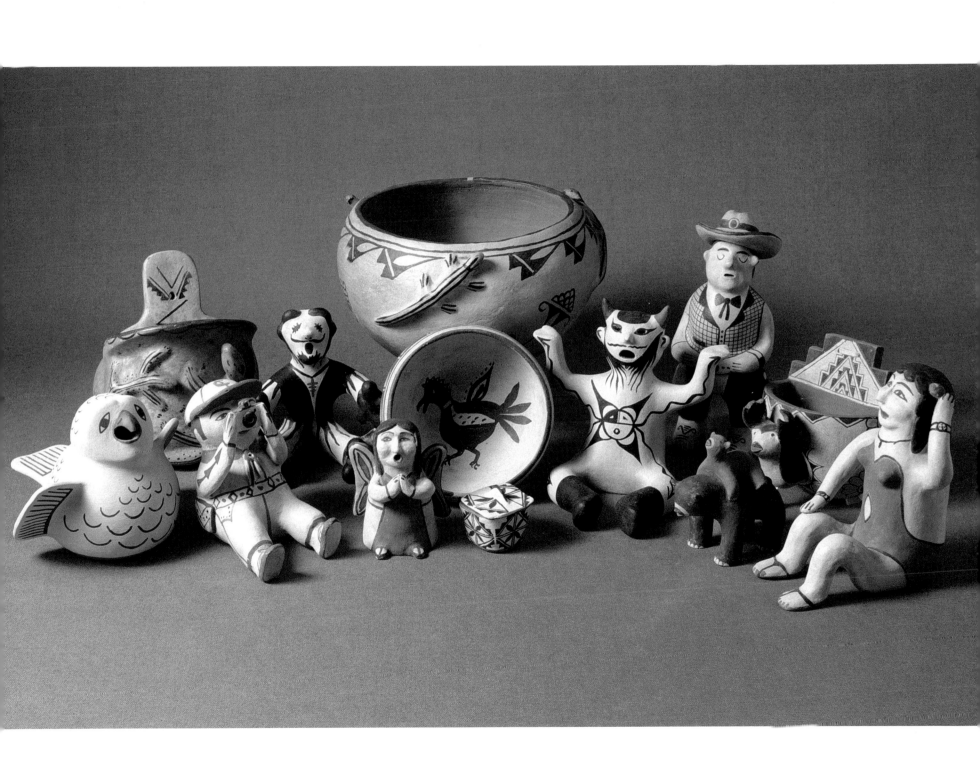

Hopi

➤ *Multicultural, yes. Diversified, no.* The three Hopi mesas have nine villages, but First Mesa and the village of Hano have dominated Hopi pottery since the 1890s. First Mesa potters use Hopi's unique clay to make great quantities of some of the finest of all pueblo pottery.

But Hopi pottery history goes back more than a thousand years, not a hundred. At Acoma, you'll be told that the Sky City Pueblo is the oldest continually inhabited city in the United States. At Hopi, you'll hear the same about the Third Mesa village of Old Oraibi.

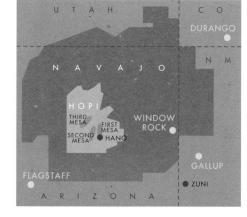

Oraibi goes back to the twelfth century, and a look down at its unpaved streets confirms its age. With every step, you'll see tiny Anasazi sherds, broken and rebroken through the centuries.

The Hopi reservation lies about eighty miles northeast of Flagstaff as the crow flies. Thanks to bureaucrat-created geography and Navajo growth, the Hopi now live in a three thousand-square-mile island within the giant Navajo Reservation. Land disputes between the tribes have led to years of prickly relations, with each other and especially with the government that drew the boundaries.

The Hopi's Sinagua and Anasazi ancestors probably spoke different languages, a condition that seems to persist throughout Hopi history. The Hopi now speak an Uto-Aztecan tongue, like many other Southwestern tribes. But the histories and religions of Zuni and Hopi are

intertwined, and the Zunis speak their own language. A Zuni and a Hopi understand each other's belief systems, but these days they only communicate in English. After the Pueblo Revolt of 1680, Tewa-speaking fugitives from the Rio Grande fled Spanish retribution and hid out at Hopi. They established the village of Hano on First Mesa and have been a wrong-language minority ever since.

The Hopi's ancestors traded yellowware from the 700s on, but under pressure from Spanish, Apache, and Navajo, the wandering and trading diminished, and pottery production had almost disappeared by 1800.

Outside influence brought Hopi pottery back to life. In the early nineteenth century, drought and epidemic caused a large number of Hopis to take temporary refuge at less-afflicted Zuni, and these transplants relearned pottery there. When the railroad came through Arizona in the 1880s, so did the traders, who wanted to fill the demands of an exponentially enlarged tourist market.

The Hopi style of the day was Polacca Ware, named for a town at the base of First Mesa. This ware was characterized by a less-than-perfect white or yellowish slip that tended to craze into fine black hairlines over the entire surface. It was the Hopis' nineteenth-century-long attempt to make pottery the way the Zunis taught them, and it became the first important Hopi trade pottery since the sixteenth century.

In 1880, Thomas Keam, the local trader,

asked potters to reproduce archaic forms from the abandoned First Mesa pueblo of Sikyatki, and Hopi pottery hasn't been the same since.

By 1900, Nampeyo of Hano had become the first celebrity potter, and what she and her family achieved defined twentieth-century Hopi pottery. The style was called "Sikyatki Revival," but the term has long been obsolete. Now, it's just "Hopi Pottery," or more precisely, "Hopi-Tewa Pottery," because most Hopi pottery still comes from the Tewa potters in Nampeyo's wrong-language village.

TOP ROW: *Polacca moccasin bowl, 5¾″ long, ca. 1895; Polacca bowl, 7″ diameter, ca. 1905; Polacca jar, 7″ diameter, ca. 1890; Hano vase, 6¼″ high, ca. 1925*
MIDDLE ROW: *Sichomovi bowl, 6″ diameter, ca. 1945; Hano bowl, 8⅛″ diameter, ca. 1910; Sichomovi canteen, 4¼″ high, ca. 1935; Polacca bowl, 6½″ diameter, ca. 1880*
BOTTOM ROW: *Hano duck effigy, 9¼″ long, ca. 1910; Walpi moccasin, 2½″ long, ca. 1920 (?); Hano tile, Sadie Adams, 6⅛″ high, ca. 1970*

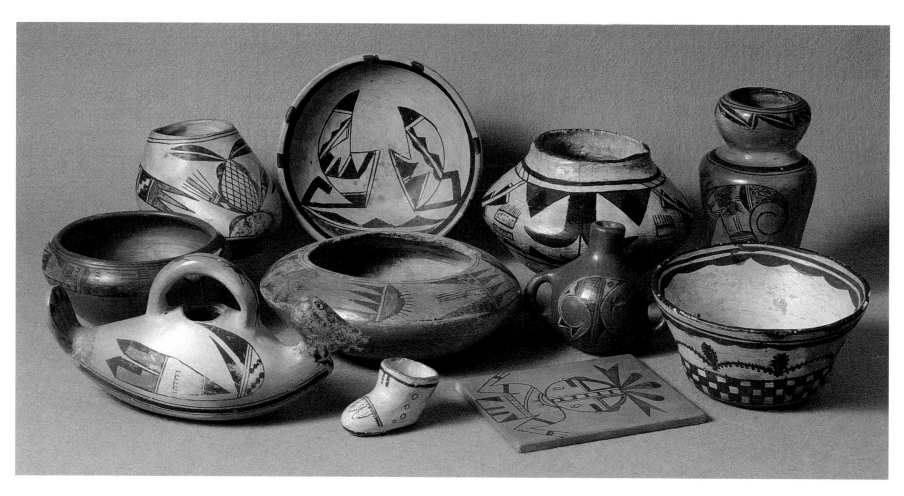

This picture gives a mini-history of the first hundred years of modern Hopi pottery. The dark-red-on-white bowl with the Grecian-looking corn garlands at the right represents pre–Sikyatki Revival Polacca. Its mutton-bowl shape is unique to Polacca, although it's really too small to be a mutton bowl. One expert dismissed it by calling it a "cereal bowl." The first tourist who saw this probably snapped it up. In 1880, Grecian Revival was a hot style. Like "Santa Fe" is now.

The jar at center right, top row, is from the latter days of Polacca, its post–Thomas Keam phase. Its painted design comes from prehistoric Hopi rather than from eclectic Zuni, while the bowl to the left of it is pure Sikyatki Revival.

The wonderful moccasin-shaped piece at middle left deserves special attention. When a Polacca Sikyatki Revival piece is this good, it's tempting to attribute it to Nampeyo herself. Nampeyo or not, it's a marvelous early Revival example: Polacca slip, now yellow instead of white, and shaped like a prehistoric Hopi food-warming bowl. You stick the toe of the moccasin toward the fire and hold the cooler heel.

The flat jar in the middle has a characteristic Hopi shape and is undoubtedly by a potter who knew and worked with Nampeyo. Here, the Polacca slip is replaced by the self-polish that distinguishes Hano ware after 1900.

Once Hopi potters left the Polacca slip behind, most work continued in a lineal direction: Sikyatki ornament on polished yellow. The duck from 1910 and the vase from 1925 (Carol Hayes says it's a "hyacinth vase") show a Nampeyo-imposed continuity. So does Sadie Adams's tile from 1970. Tiles have been part of Hopi pottery ever since Keam suggested that tourists might buy them a century ago.

After 1900, a few Hopi potters started making red-slipped ware, and a small amount of redware production continues to the present. The bowl at the left and the little canteen are examples of Sichomovi Polychrome, as opposed to the polished yellow Hano Polychrome.

White-slipped post-Polacca Hopi ware is called Walpi Polychrome. It came later (after 1925, some authorities say, but others disagree and the little moccasin looks older). Although scholarly type names like these usually designate different periods or different regions, that's not the case here. Walpi, Sichomovi, and Hano are all First Mesa villages, just a few steps from each other.

Hopi · Tourists

Make whatever they want, but make it Hopi.
Like the potters from most other pueblos in the first half of the twentieth century, Hopi potters fell under the trader's spell. In the 1920s, Tom Pavatea ran a trading post at Polacca and had a price list for Hopi works, starting at fifteen cents for small pieces and ranging up to an astronomical seventy-five cents for a twelve-inch bowl by Nampeyo.

Since Nampeyo's pieces commanded a premium, and since the photographs identified as "Nampeyo" don't all seem to show the same person, modern-day cynics have accused Pavatea of trotting out any competent resident potter to serve as the Nampeyo-of-the-day. If true, it would have been a practical answer to the marketing needs of the times.

Through the 1950s and beyond, Hopi potters made (and still make) tourist souvenirs, from unassuming little cowboy hats to ambitious table lamps. But, because they were Hopi potters, they made them with the stubborn integrity that all Hopi pottery seems to exhibit. Where Acoma potters over the years have resorted to decorating precast ceramics fired in kilns, Hopi potters have steadfastly kept to the traditional ways. In the face

of commercial pressure, and despite the pedestrian, "un-Indian" nature of the teacups, ashtrays, and salt and pepper shakers the Hopis turned out by the hundreds, the manufacture and decoration of their tourist pottery remained pure Hopi.

Even the most prestigious potters weren't above making the occasional tourist piece. The little cup in the picture is by Grace Chapella (1874–1980), fourteen years younger than Nampeyo and her next-door neighbor. She may not have made the top seven, but she's important enough to be one of the matriarchs in Rick Dillingham's *Fourteen Families in Pueblo Pottery*.

In *Hopis, Tewas and the American Way*, (1983), Katherine L. McKenna might have had Tom Pavatea in mind when she wrote, "It is not at all clear to me that Anglo commercialism has corrupted, manipulated or exploited the 'naive' Indian artists. Hopi-Tewa artists can be as shrewd as any Anglo dealer; and the Indian art business serves their interests as well as those of the dealers, perhaps because these canny Hopi-Tewa traders, like really good traders the world over, have been so successful in identifying themselves to Anglos as guileless romantics."

TOP ROW: *Wall sconce, Lorraine Shula, 5½″ high, 1990; vase, 6″ high, ca. 1925; table lamp, Sadie Adams, 11⅝″ high, ca. 1950; turkey effigy jar, S. C. C., 6½″ high, ca. 1975*
MIDDLE ROW: *Ladle, 8½″ long, ca. 1950; cowboy hat, 5″ diameter, ca. 1925; basket, 3⅜″ long, ca. 1925; cup, Grace Chapella, 2⅛″ high, ca. 1940; salt and pepper shakers, 3″ high, ca. 1925*
BOTTOM ROW: *Bird ashtray, 4″ diameter, ca. 1930; scoop with mudhead, 4″ long, ca. 1940; bird ashtray, 4¾″ long, ca. 1960*

Sadie Adams (lamp) was one of the more important non-Nampeyo potters, active from the 1920s into the 1980s. Her table lamp represents the high end of tourist ware, and it probably sold for what seemed to be a high price when it was new.

The turkey effigy jar wasn't cheap to begin with either, and Lorraine Shula's wall sconce is new enough to command the premium that any Hopi pottery calls for. We'd be very surprised if any of the other pieces sold for more than ten dollars when they were new, however, and most of the older ones probably went for a dollar or less.

The vase in the back row is easy to date. It has to be after 1920, because before that time, Hopi potters didn't make this European art-pottery shape. And it has to be before 1930. Around that time, Mary-Russell Colton, who with her husband Harold founded the Museum of Northern Arizona in Flagstaff, laid down the law to Hopi potters: "Clean up the color of your red paint, or we won't include your work in our annual shows." Almost immediately, Hopi reds changed to the richer color on the lamp and the turkey.

The rest of the pieces speak for themselves. In other pueblos in other times, square baskets like the one at middle right are called "ceremonial." There's little ceremony here. This one has a pencil graffito on the bottom reading "T. P. 35." Somebody probably paid Tom Pavatea thirty-five cents for it.

With tourist pottery, utilitarianism generally fell by the wayside. Ashtrays stained instantly, and it's a rare cork that fits the bottom of the salt and pepper shakers.

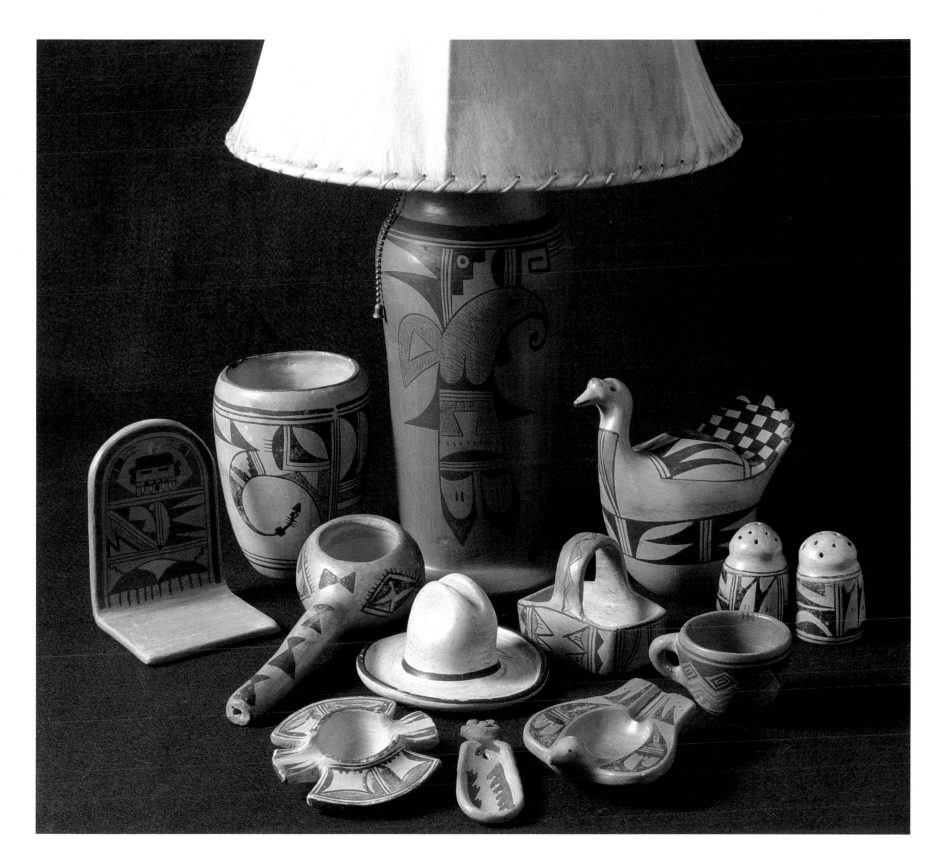

Hopi · Nampeyo

The Seven Families #3: Nampeyo. In 1896, the Smithsonian sent ethnologist J. Walter Fewkes to excavate the Sikyatki ruin on First Mesa. He later wrote that he showed the sixteenth and seventeenth century pottery he'd unearthed to a Hano Tewa potter named Nampeyo (1860–1942), the wife of one of his workmen.

More than a few books date the beginnings of modern Hopi pottery design to that 1896 meeting. By legend, the sight of these fabulous relics so impressed Nampeyo that she single-handedly created the Sikyatki Revival and all of Hopi followed. Actually, trader Thomas Keam had potters reproducing archaic pottery in 1880, and the then-twenty-year-old Nampeyo could well have been one of Keam's potters. By 1896, the Sikyatki Revival was sixteen years old.

The first Revival pieces put Sikyatki designs on Polacca slip, but by 1905, Nampeyo had dropped the slip and converted to an unslipped style more like the old ware. Fewkes became concerned her work might appear to be forgery, but Keam (and later on, Tom Pavatea) had no such qualms. Nampeyo found herself launched on a career that brought her celebrity until her death at eighty-two.

In the 1900s, the Fred Harvey Company brought her to the Grand Canyon, where she demonstrated Hopi potterymaking for the hotel guests. She must have put on a good show, because they later took her all the way to Chicago for the United States Land and Irrigation Exposition in 1910, where she introduced Southwestern pottery to the world at large.

Meanwhile, Nampeyo's daughters—Annie, then Nellie, and finally Fannie—became accomplished potters working in their mother's style, and in turn gave birth to successive generations of potters.

In the picture, there's work by Annie's daughter Rachel Namingha. She gave birth to Dextra Nampeyo (whose work is so expensive we've never found a piece we could afford) and Priscilla Namingha, who in turn gave us Rachel and Jean Sahmie. There's a piece by Annie's daughter, Daisy Hooee (who studied at L'Ecole de Beaux Arts in Paris and knew Charles Lindbergh) and Shirley Benn, Annie's granddaughter.

By the time the family tree reached Cheryl Naha and Jake Koopee, it had spread over six generations.

Fourteen Families in Pueblo Pottery has genealogical charts for each family, and each family member merits a dot—black dots for non-potters, red dots for the potters. The Nampeyo chart shows sixty red dots, and that's not enough to cover all the potters in the John & Al Museum collection. Ellsworth shows up as a black dot, and Jake isn't mentioned at all.

In answer to the question, "Who's the Number One Hopi potter," the answer has just about always been "_____ Nampeyo." At any given time, you could fill in the blank with the name Annie, or Fannie, or Dextra, or Daisy, or whomever, or you could leave the blank empty, and from the 1890s on, you'd have been right. If, instead of being artists unstained by commerce, the Nampeyo family were a manufacturing corporation, *Fortune* magazine might run a cover story about how it managed to stay on top of an entire market for a full century without changing its product design.

TOP ROW: *Jar, Priscilla Namingha, 4½″ diameter, ca. 1980; jar, Rayvin Nampeyo, 5¼″ diameter, 1992; bowl, Jake Koopee, 9″ diameter, 1994; bowl (down), Adelle Nampeyo, 6″ diameter, ca. 1985; bowl, Fannie Polacca, 5¼″ diameter, ca. 1950; jar, James Nampeyo, 5½″ diameter, 1994*
MIDDLE ROW: *Jar, Miriam Nampeyo, 5″ high, 1985; jar, Rachel Namingha, 4½″ diameter, ca. 1980; jar, Nampeyo, 4¾″ diameter, ca. 1910; bowl, Daisy Hooee and Shirley Benn, 5½″ diameter, 1988*
BOTTOM ROW: *Jar, possibly Nampeyo and Annie Healing, 3½″ diameter, ca. 1910; jar, Rachel Sahmie, 3¼″ diameter, 1987; bird figurine, Cheryl Naha, 2⅜″ high, 1992; salt shaker, Nellie Douma, 2¾″ high, ca. 1960*

Nampeyo left us two designs that occur over and over in family pottery. The eagle pattern shows up four times in this picture, or five if you count the salt shaker. The jar in the middle row, second from right, and the one second from left in the top row are eighty years apart, the first attributed to Nampeyo by super-authority Francis Harlow, the other by her great-granddaughter Rayvin.

Harlow also attributed the jar at lower left to Nampeyo, but other experts disagree, pointing out that it has a line break at the rim, a device they insist Nampeyo never used. Some authorities maintain that at Hopi at the start of the twentieth century, the line break was only used by potters hopeful of bearing children. Nampeyo's eldest daughter Annie painted for her mother during this period, and we vote for her, at least for the painting.

Whether or not Annie did the bowl, Nampeyo's middle daughter Nellie made and signed the salt shaker, and Fannie, the third daughter, made and signed the bowl at right in the middle row.

Fannie's granddaughters did the pieces that demonstrate the other ubiquitous family design, the "migration" pattern. Adelle Nampeyo's bowl beneath the big bowl typifies the pattern, and the pieces at far left and far right show it in modified form. Almost every book on Hopi pottery written between 1970 and 1990 had a migration bowl on the cover.

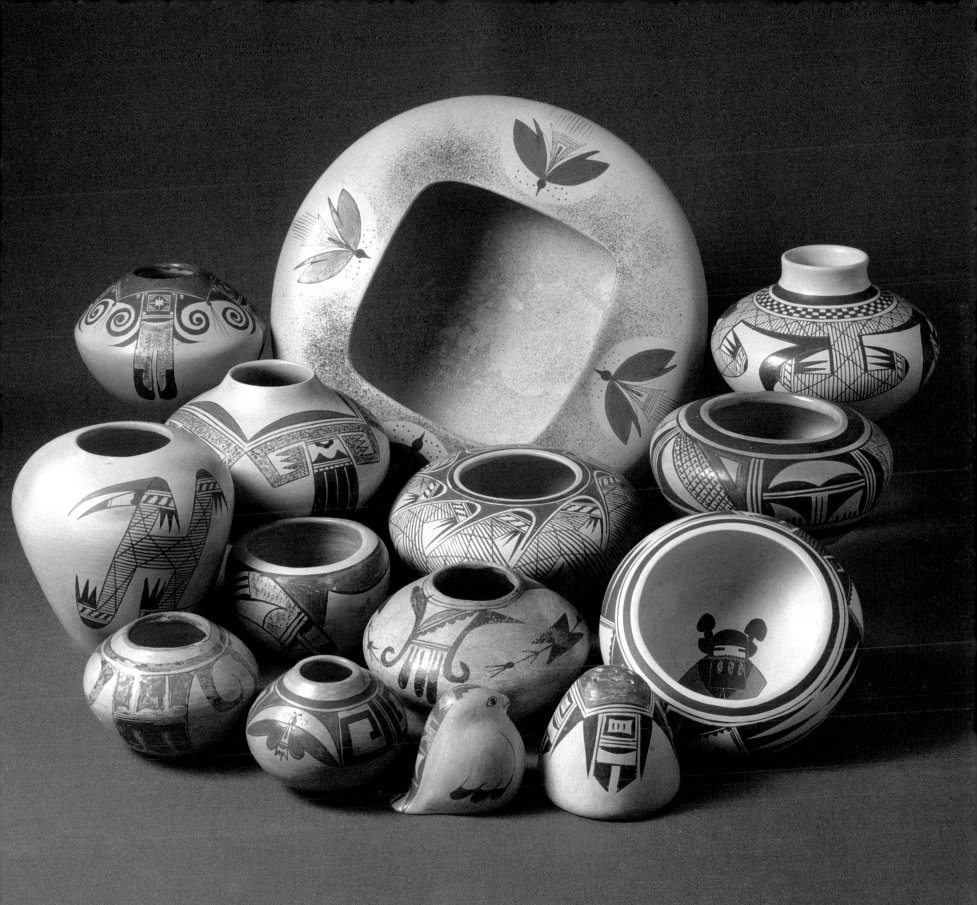

Hopi · Naha

Frogs and Feathers. You could argue that the worst injustice of the *Seven Families* exhibit was omitting the Nahas.

Each of the pueblos in the exhibit had work by a dominant family: Martinez from San Ildefonso, Tafoya from Santa Clara, Lewis from Acoma, and Nampeyo from Hopi. But the other three pueblos each had a second family: Gonzales, Gutierrez, and Chino. Where was the other Hopi family?

Unquestionably, the Nahas would have been it, then as now. Paqua Naha, who died about 1956, was active and respected by the 1920s. *Paqua* means "frog" in Spanish, and, late in her career, she signed some of her pieces with a crude frog symbol. (The bowl in the picture at right, attributed to her, has no signature.) Somewhere along the line, she became known as "Frog Woman," but after her death, the name and the frog signature passed to her daughter, Joy Navasie (b. 1919), and has stayed there ever since.

According to Joy, Paqua made yellow pieces for most of her career, but began experimenting with white slips late in life. After some trial-and-error of her own (there's a very rare frog-signed redware piece on page 175), Joy Navasie settled on whiteware, and from the 1960s on, the Naha/Navasie look evolved into a permanent institution.

Meanwhile, Paqua's son Archie married Helen (1922–1993). She too concentrated on whiteware, but worked out her own ornamentation style, borrowed from earlier prehistoric pieces rather than from the Sikyatki Revival patterns that inspired Joy. Helen also devised her own signature. Since Joy had appropriated the frogs, she signed her pieces with a feather.

Ever since, Frog Woman and Feather Woman and their children and grandchildren have dominated whiteware, the other important Hopi pottery. (The classifiers call it "Walpi Polychrome.") As in the Nampeyo family, younger potters have stayed within family design conventions. No matter when they were made, for the last twenty-five years, frog pots have looked like frog pots and feather pots have looked like feather pots.

TOP ROW: *Plate, Maynard and Veronica Navasie, 9⅛″ diameter, 1994; wedding vase, Joy Navasie, 10¼″ high, 1985; vase, Marianne Navasie, 6¾″ high, 1993; dish, Lucille Naha, 6″ diameter, 1990*
MIDDLE ROW: *Wedding Vase, Marianne Navasie, 6″ high, 1992; bowl, Paqua Naha, 5¼″ diameter, ca. 1940; jar, Helen Naha, 4¼″ diameter, ca. 1980; vase, Sylvia Naha, 3¼″ high, 1995; seed jar, Burel Naha, 4½″ high, 1992; wedding vase, Gail Navasie Robertson, 6¼″ high, 1993*
BOTTOM ROW: *Vase, Rainelle Naha, 6″ high, 1994; bowl, Lana David, 3″ diameter, 1993; jar, Marianne Navasie and Harrison Jim, 1⅝″ diameter, ca. 1980; bowl, Joy Navasie, 4¾″ diameter, 1993; seed jar, Sylvia Naha, 5¾″ diameter, 1993*

The scratched yellow bowl with the odd-looking bird is unsigned, but we think it's by Paqua. There's a jar at the Arizona State Museum with this same bird that seems to have been done by the same hand. If we're wrong, it's probably still in the family. We have a signed piece with the same bird by Sadie Adams, Paqua's cousin.

Right or wrong on Paqua, we can speak with assurance about the rest of the photo: frogs and feathers scattered throughout. Frog Woman, Joy Navasie, made the big wedding vase, and Feather Woman, Helen Naha, made the jar below it. Joy's children and grandchildren have stayed close to her style, and any one of the frog pieces in the picture looks as if it could have been made by Joy herself.

Helen's children and grandchildren have stayed almost as close to home. Sylvia is the ranking potter among her children, and many of her pots, like the seed jar at the right, feature lizards. Her brother Burel favors spiders, and he may be heading in yet another name direction. People have taken to calling him "Spider Man."

These explorations beyond Helen Naha's pure geometrics aren't really design defections. Rainy's narrow-necked vase at bottom left and Sylvia's little vase to the right of her mother's jar remind us just how strong Feather Woman's influence remains.

FROGS

Joy

Marianne

Maynard & Veronica

Gail

Lana

FEATHERS

Helen

Sylvia

Burel

Rainy

Lucille

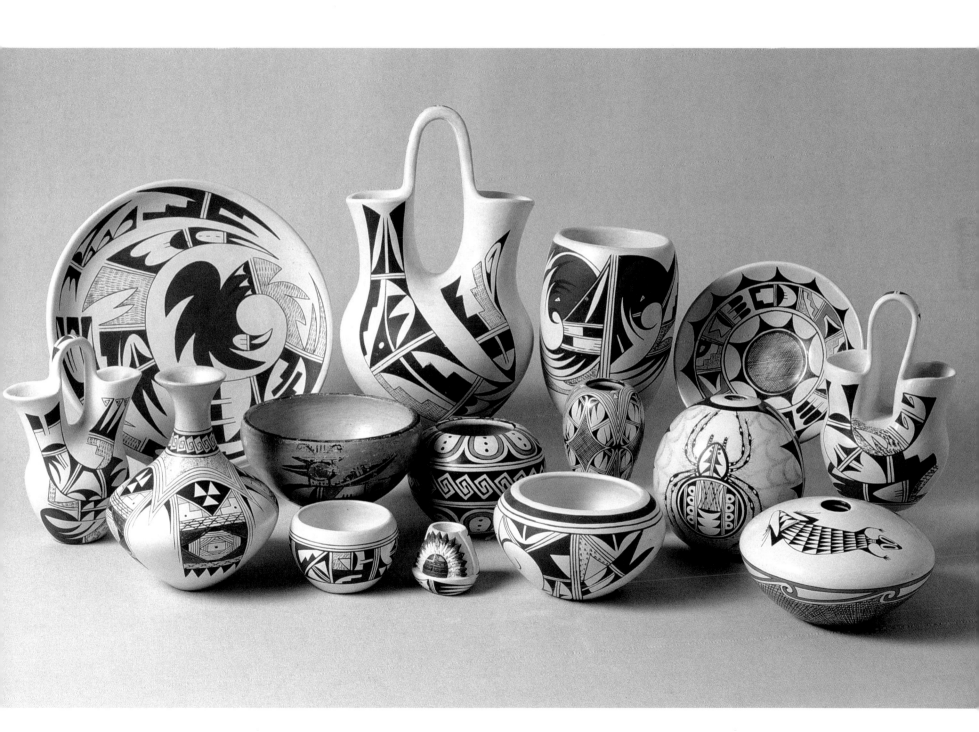

Hopi · Other Directions

Do anything you want, but don't break the rules. Over at Acoma, potters wrestled with the temptations of greenware and the kiln. Not so at Hopi. Despite Hopi's size (fifty-five hundred people, almost twice the population of Acoma) and struggling population of potters, none that we know of have followed the quick-money path.

The social pressures that kept Hopi potters pure in the tourist-ware days of the first half of the century seem to have been equally strong in the pottery-as-art days of the last half. If any piece in the picture at the right wasn't traditionally fired, at least part of the way, we've been fooled.

An aside on "traditional firing" and "part of the way": Black-and-sienna pieces, like the turtle and incised seed jar at bottom left by Robert Homer, require a double firing. On any given pot, the potter may have fired the piece to black with scrupulously traditional outdoor firing techniques; then, in the second firing, created the sienna highlight by doing something completely unauthorized, maybe even with a blowtorch. Since we weren't there watching the potters fire the black-and-sienna pieces in the book, we can't say for sure how any of them were done.

Several factors keep Hopi potters from taking shortcuts. Weight of tradition, especially if it's combined with family pressure, counts for a lot. But so does market pressure. Where even a faint fire cloud mars Acoma white to the point of unacceptability, buyers expect and actually prefer a little burnished discoloration on Hopi yellow.

But here, even under all these heavy influences, we see all kinds of variety and exploration. The Sahmie sisters and Iris and Nolan Youvella are in the Nampeyo family, and Tom Polacca is Fannie's son, so far up the Nampeyo family tree he's in sight of the top, only two generations removed from Nampeyo herself.

(An interesting footnote: Tom Polacca shares the same name as his great uncle, Nampeyo's older brother—a dashing figure, and one of the first Hopis to welcome Anglo contact. A town grew up around his home at the base of First Mesa, and, in the 1890s, Anglos named it after him—then, unaware of the irony, named nineteenth-century Hopi pottery that had little to do with Nampeyo after the town.)

Mark and Dianna Tahbo, brother and sister, represent another illustrious line. They're great-grandchildren of Nampeyo's neighbor Grace Chapella. They're also two of the very few potters in Hopi who challenge the leading Nampeyo-family potters for prestige.

The late Garnet Pavatea achieved star status by doing redware jars with triangular punctuations (we're told she made them with an old-style beer-can opener) from the 1970s into the 1990s.

Iris Youvella's sensitive sculptured plainware follows in a tradition begun by Elizabeth White thirty years before, and her son Nolan continues the style. The incised seed jars in the bottom row by Robert Homer and Lawrence Namoki are remarkable only in that they come from Hopi. They look like Santa Clara.

Experimentation at Hopi moves from just off center to all the way out to the edge. Although Lawrence Namoki's seed jar with the kachina figures is almost totally traditional, it doesn't look it.

Antoinette Silas (top right) and another super-expensive potter, Rondina Huma (not pictured), make beautifully designed jars that qualify as innovative only because their painted geometric patterns are so wonderfully intricate. The same can be said of Mark and Dianna Tahbo's work (lower center): traditional pots, exceptional painting. It's less a matter of changing the rules than it is of raising the standards.

Other pieces on the page stretch the bubble. Jean Sahmie's tile shows a sense of humor that seldom surfaces in Hopi pottery, and her sister Rachel's Navajo chief's blanket on a jar doesn't look like anything else we've ever seen. Robert Homer's turtle is an original.

Tom Polacca's jar (top center) is a full-blown example of a sculptured style he created himself, one that others, including Lawrence Namoki and Tom's daughter Carla, have adopted. In only two generations, the Nampeyo family has traveled far afield.

Finally, the Kim Obrzut mudhead sculpture shows how far we've actually stretched the definition of Hopi pot. Granted, Kim doesn't live on the reservation (her home is in Flagstaff), and granted, she's been exposed to the big, wide art world, but this is real Hopi pottery, beautifully made. The tradition ever widens.

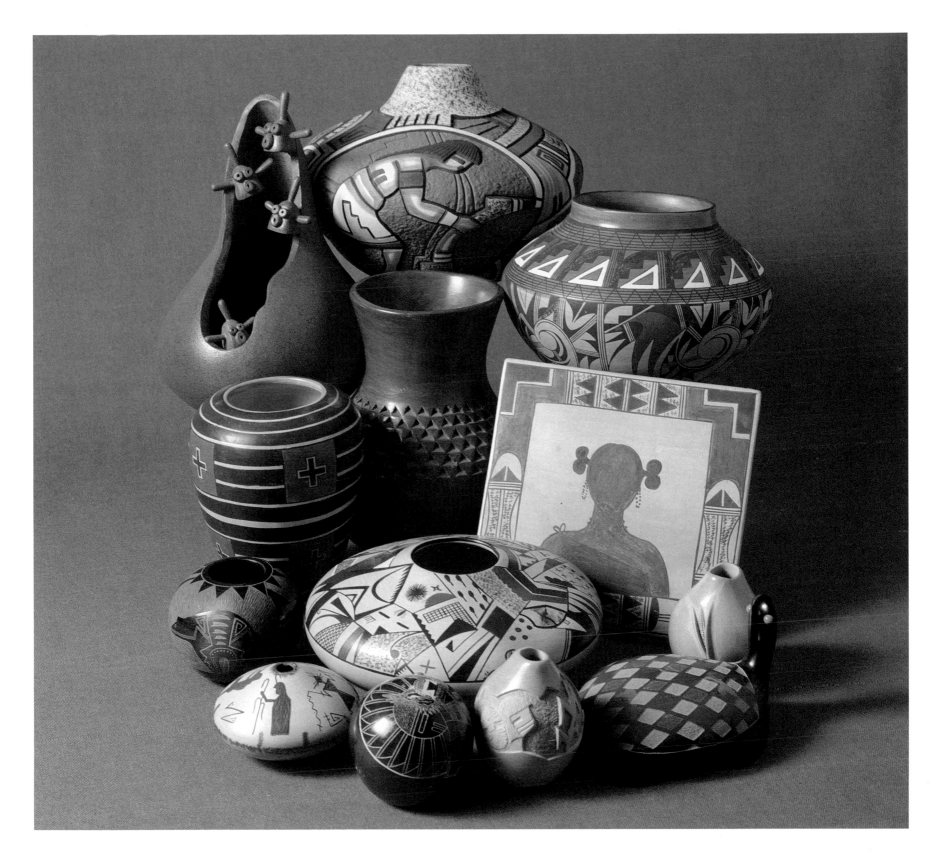

Isleta

▶▶ *Just go down the road from Albuquerque. It's right there on I-25.* The guidebook we're using to check the populations and areas of the various pueblos doesn't hesitate to name Isleta's most admirable craft achievement: baking bread. It even called out an eminent baker by name. Once Al got a different answer. He asked an Isleta native to tell him what the people of Isleta were known for, and she answered unhesitatingly, "Working in Albuquerque."

More than most of the larger pueblos, Isleta (it's pronounced Iz-LET-ta) seems to have had its identity diluted by the affairs of the outer world. This is true today, and it was true three hundred years ago. Isleta was first settled around 1200 as part of the Anasazi western movement. In 1581, the Spanish counted fifteen hundred residents, and today the pueblo's population is three thousand, although the reservation covers thirteen hundred square miles. Some of that land is lush farmland in the Rio Grande basin, but much of it has only marginal use.

Isleta has always suffered from its proximity to Albuquerque and the army. The padres built their first mission at Isleta in 1613. In 1680, Isleta didn't—or couldn't—participate in the uprising, and the Spanish governor hid out there after he escaped Santa Fe. The next year, he returned with a troop detachment and found the mission burned and the main structure used as a livestock pen. A quick about-face took him back to El Paso, but not without taking 385 Isleta natives

with him. They settled below El Paso in Isleta South. (Down there, it's *Ysleta del Sur*, with a "Y.")

The 1692 reconquest found Isleta burned and empty. Governor de Vargas ordered it resettled, and started it off with three hundred residents, some returned from Ysleta del Sur and some relocated from Taos and Picuris.

A note on languages: The Zunis speak their own language, but the other seventeen New Mexico pueblos all belong to one of two major language groups, Keresan and Tanoan. Acoma, Laguna, Santo Domingo, Cochiti, Santa Ana, and Zia speak Keresan. The rest speak one of three confusingly named Tanoan dialects: Tewa, Tiwa, and Towa. Today, Isleta and Sandia speak Tiwa (pronounced TEE-wah), the language of Taos and Picuris in the north. Jemez is the only remaining Towa-speaking pueblo, and the other six pueblos north of Santa Fe speak Tewa (TAY-wah).

By 1720, Isleta had a new, grander mission and a culture tied to the ever-growing Hispanic populations of Albuquerque to the north and Belen just to the south. Today, Isleta continues quietly on its way, largely ignored by those tourists who look for things other than good bread and old churches.

Isleta pottery has a diffident history. In the nineteenth century, the Tiwa-speaking natives produced a plain redware, similar to San Juan's but paler, mostly the large bowls you'd expect in a community devoted to baking. In the late nineteenth century, a group of disaffected Lagunas

moved to Isleta and started making tourist pottery using a chalky white slip imported from Laguna. This ware dates from 1890 to 1930, and the old Tiwa redware potters never learned to make it.

You can see seven examples in the picture to the right. Nothing was large, nothing was ambitious, everything was made solely to be eyecatching. In the beginning, it was mostly bowls like the one in the lower middle, but later on, little pitchers, little ashtrays, and especially little baskets with twisted handles became more and more common.

The demand for these trinkets apparently dried up during the depression, but not until after it had submerged whatever pottery tradition Isleta had. When the tourist ware itself disappeared, it left no trace of its own tradition behind.

Even in today's Golden Age, Isleta potters still work in styles derived from other pueblos.

TOP ROW: *Triangular dish, Stella Teller, 10 ¼″ diameter, ca. 1980; bowl, Louise Jojola, 4″ diameter, ca. 1960; bowl, Stella Teller, 5 ¼″ diameter, ca. 1975; jar, 4 ⅝″ diameter, ca. 1955*
MIDDLE ROW: *Basket, 4 ⅜″ high, ca. 1925; bowl, 5 ½″ diameter, ca. 1920; pitcher, 4 ¾″ high, ca. 1930*
BOTTOM ROW: *Bowl, 3 ¼″ diameter, ca. 1910; dish, 4 ⅛″ diameter, ca. 1920; bird effigy coin bank, Stella Teller, 3 ½″ long, ca. 1980; dish, 4 ¾″ diameter, ca. 1930; basket, 4″ high, ca. 1925*

JEMEZ
ZIA
SANTA ANA
SANDIA
COCHITI
SANTA FE
SANTO DOMINGO
SAN FELIPE
N E W M E X I C O
ALBUQUERQUE
ISLETA

The seven 1930-and-before pieces in the picture to the right pretty well describe the Isleta tourist pottery industry as it existed for forty years: bright little bowls, pitchers, baskets, dishes, and ash-trays, made to be sold at the railroad station in Albuquerque.

They stopped making these in the 1930s, but the Louise Jojola bowl at the upper left seems to be a rare lineal descendant. Isleta pottery from this period is almost non-existent.

The whimsical jar at the upper right doesn't fit anywhere in a nice, orderly historical flow chart, but it looks as though it, too, has Laguna antecedents. It's unsigned and was made at the end of the pre-greenware period of Isleta pottery.

In the 1970s, an Albuquerque hairdresser named Stella Teller started buying greenware and decorating it, not always as perfectly as she might have. The bowl in the upper middle is painted nicely enough, but it has an obvious plan-ahead-type mistake—the design didn't come out right when she got back to the beginning, so she faked it.

The big triangular dish is green-ware done with a bit more assurance, and the coin bank indicates the transition to come. In a pueblo with a vanished pottery tradition, Stella and her children were about to start, if not a tradition, a style that, at least for now, pretty much represents the whole of Isleta pottery.

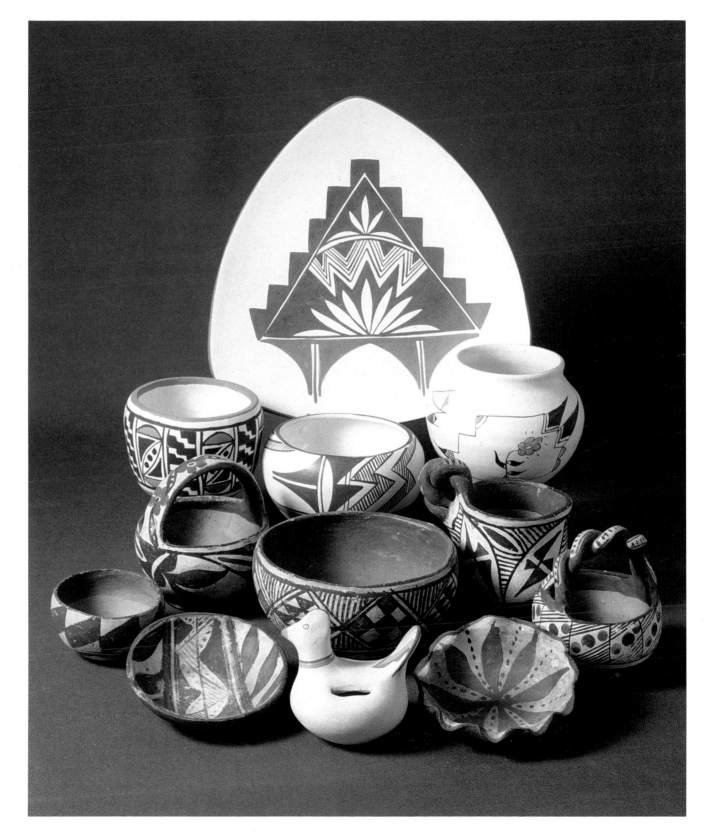

Isleta · Mostly Teller

The tourist still rules. As the 1970s became the 1980s, Stella Teller the hairdresser became Stella Teller the full-time potter, and she got better and better at her craft. By 1982, she'd improved her skills to the point where the bowl in the picture won a third prize at the New Mexico State Fair. She was now well past decorating somebody else's precast pots.

Also by the 1980s, Helen Cordero's storyteller pottery was at the height of its popularity. An obvious route to sales success was to start making storytellers. And if they could be made with a little personal twist, so much the better. Stella put all this together with just the right timing. By the late 1980s, she was considered one of the leading Southwestern potters, not just from Isleta but from anywhere. Her own twist came in her choice of colors—instead of the usual red and black, she painted hers in soft blue-grays.

Also by the 1980s, Stella's children had grown to become full-time potters in their own right. Very quickly, Isleta had a genuine high-production, market-driven family pottery dynasty. The Tellers —Stella, Chris, Mona, Lynette, Robin, and Leslie— now dominate Isleta pottery to the point that you have to look hard before you find anyone else.

There are still Jojolas. Doris is working, and there's a pair of moccasins by her at bottom left on page 177. And Deborah, who made the amazing ceramic water pitcher on the opposite page, has reached broader recognition as a painter and printmaker. But at the 1996 Indian Market, she showed wonderfully imaginative pottery masks as well.

The 1996 Indian Market also introduced us to Caroline Carpio (not shown), whose work ranks with the best. Isleta in the 1990s remains 90 percent Teller, 5 percent Jojola and 5 percent everyone else. But there are new stirrings. Watch this space.

TOP ROW: *Storyteller, Chris Teller, 6 ⅞″ high, 1994; sculptured water jar, 13″ high, Deborah Jojola, 1982*
MIDDLE ROW: *Storyteller bowl, Leslie Teller Velardez, 5″ diameter, 1993; storyteller, Stella Teller, 3½″ high, 1992; bowl, Stella Teller, 5¾″ diameter, 1982; storyteller, Mona Teller, 5″ high, 1993*
BOTTOM ROW: *Storyteller, Chris Teller, 3″ high, 1993; mudhead figurine, Chris Teller, 3″ high, 1994; storyteller, Chris Teller, 2¾″ high, 1993; storyteller, Robin Teller, 3″ high, 1992; storyteller, Lynette Teller, 2⅛″ high, 1993; bear figurine, Diane Wade, 3½″ high, 1993*

Here, an array of little Teller people, supervised by Deborah Jojola's amazing water serpent and protected by Diane Wade's little brown bear. After Stella began winning prizes for pieces similar to the bowl in the center, she turned to storytellers. The blue-and-gray theme runs through her daughters' work as well.

Her daughters aren't locked totally and inflexibly within the genre. Leslie's "story bowl," Chris's diapered mudhead, and Mona's singing mother/flower girl (it's in three pieces—she can set down her basket and take the flowers out) show some imagination, and Robin gave her singing mother a Hopi maiden hairdo.

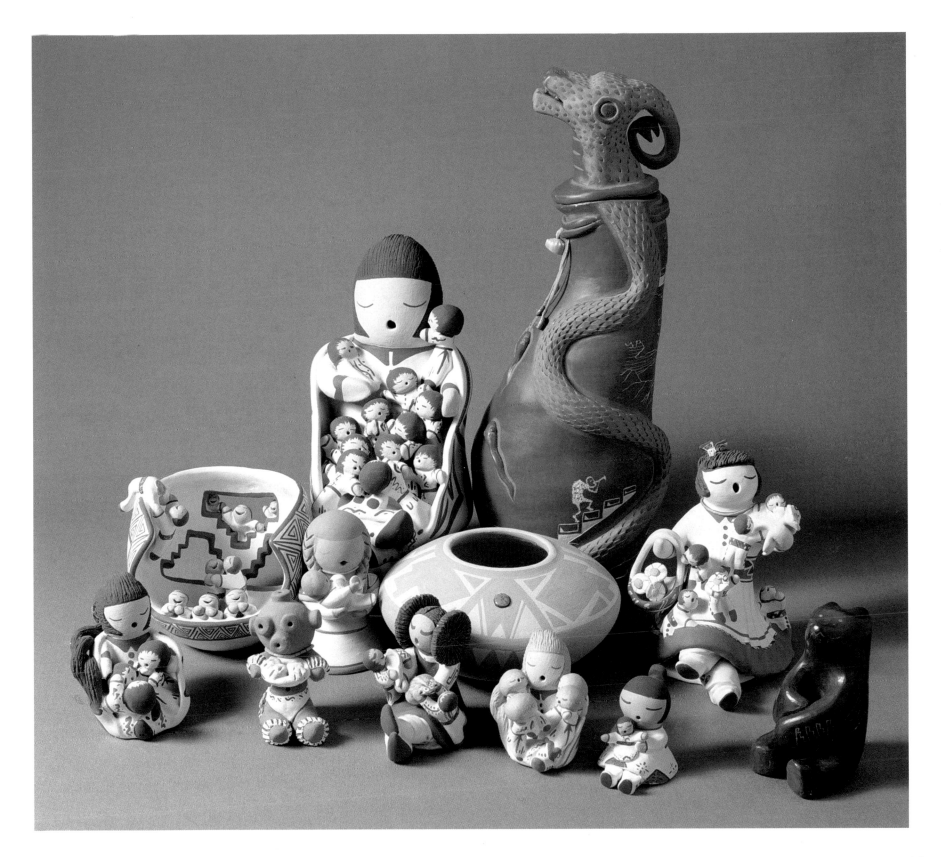

Jemez

⏵⏵ **What do you do when you lose a tradition?**
Build a new one. Between 1200 and 1400, potters
in the Jemez Mountains (detached square at the
upper left of this map) made some sharp-looking
black-on-white Anasazi pottery. After that, accord-
ing to the books, nothing
but a little plainware.

By the time the Towa-
speaking Jemez settled in
their current space, they
were farmers who used
their crops to buy pottery
from Zia. In 1598, Gover-
nor Oñate converted them
all to Catholicism with a
flourish of his pen, and by
1622, the padres reported six thousand faithful
attending the three missions at Jemez.

In 1680, however, their devotion wavered.
When General de Vargas returned in 1692 to
restore the rule of Spain, he had to search out
the people of Jemez (pronounce it HAY-mis,
the Spanish way). He found them hidden in
mountain strongholds and shot a lot of them
in order to renew their faith. Those he didn't
shoot, he rounded up and took south along the
Jemez River to build a new village where Jemez
Pueblo now stands. Today, Jemez real estate
covers 550 square miles between the Jemez and
the Salado rivers, sparsely populated by twenty-
one hundred people.

The history of pottery at Jemez is one of
absence and rebirth. You can look long and hard
in books and in museums without ever seeing
a Jemez piece from Spanish times. The late-
nineteenth-century olla on the next page is the
only old Jemez piece we've ever seen.

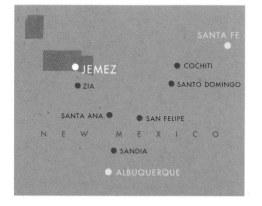

If a pueblo loses its pottery tradition (and
Jemez is by no means the only one that has),
pottery as a craft rarely reappears unless a potter
from another pueblo marries in. If a pueblo has
a strong tradition, the married-in potter will
almost always make pieces
in the style of the pueblo
where she lives. (There's a
wonderful example of this
on page 169—a pure Zuni
pot by Daisy Nampeyo,
who, at the time she
married Sidney Hooee,
was one of the most cele-
brated Hopi potters. She
learned to make Zuni pot-
tery and for years taught Zunis how to make it.)

On the other hand, if the tradition is gone,
potters feel free to make anything they want, either
work that resembles what they made at their
native pueblo or whatever else the market wants.

A handful of potters made an effort to revive
traditional pottery at Jemez in the 1920s, but
nothing came of it. However, during the depres-
sion, potters found they could make a little money
copying the unfired, poster-paint decorated pieces
they were turning out over at Tesuque. After World
War II, they discovered acrylics and yet another
form of lowest-common-denominator tourist
ware was born.

Pottery purists have our permission to check
out the 1890 olla to the right, then to avert their
eyes quickly and turn the page. At Jemez, the
pottery tradition hit absolute bottom, and only
those as perverse as the people at the John & Al
Museum enjoy looking at its depths.

TOP ROW: *Wedding vase, 5¼″ high, ca. 1960; vase,
4½″ high, ca. 1940; olla, 8½″ diameter, ca. 1890; jar,
7½″ high, ca. 1935*
MIDDLE ROW: *Cup and saucer, 3¾″ diameter saucer,
ca. 1965; salt and pepper shakers, 2¼″ high, ca. 1960;
jar, 3½″ diameter, ca. 1970*
BOTTOM ROW: *Canoe, 6¾″ long, ca. 1965, salt and
pepper shakers, 2″ high, ca. 1955; bowl, Chinana, 1¾″
diameter, 1973; pitcher, 3½″ high, ca. 1970; vase, 5″ high,
ca. 1970*

*The big olla speaks for itself. Since there's very little
else to compare it to, it has to stand as our total statement
about what they used to do at Jemez. We know its date
only because there's a similar one at the Denver Art
Museum.*

*The rest of the picture describes how low it sank.
The little gray vase with the black decoration might
echo revival efforts from the 1920s, and the poster-paint
jar to its right has really admirable decoration that later
pieces never approached, but everything else here
plummets downhill rapidly.*

*The other poster-paint pieces are garish and
banged out in a hurry, but manage to have a jaunty
charm. It's hard to hate them, and, at their best, like
the canoe and the eagle salt and pepper shakers, they
bring a smile.*

*The early Jemez acrylic painted pieces drop down
another notch. The vase at far right and the little bowl
in front are sad examples. The cup and saucer set is
even worse. It's so carelessly made that the cup can
barely stand upright on the saucer without tipping over.*

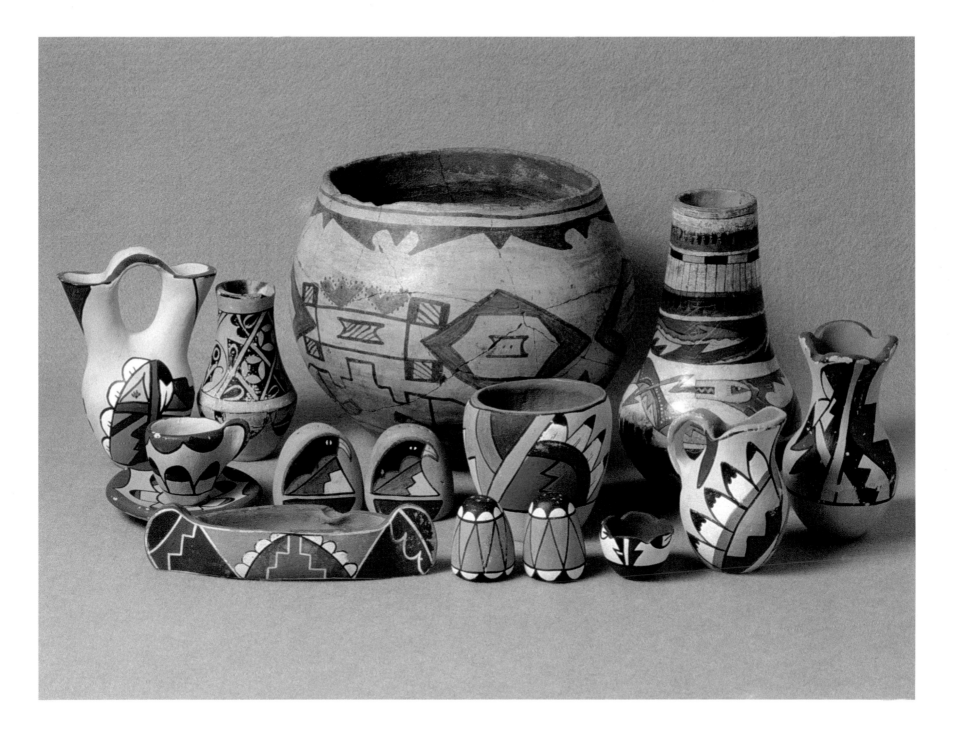

Jemez · Growing Pains

Figuring out what to do. Given the dreadful state of Jemez pottery in 1970, any change would have been an improvement.

Fortunately, during the hippie-dippy days of the late 1960s, general interest in anything Indian picked up dramatically, and the pottery market benefitted from the upswing. The citizens of Jemez may have been out of the pottery loop, but they weren't off the planet. They could see that higher-quality pottery was bringing much higher prices, and they set about learning how.

The easiest improvement was to switch to greenware, and some of today's fine potters started their careers with it. Others took a longer look, and artists like Mary Small and Mary E. Toya became champions of traditionally coiled, well-made pottery.

The 1970s and 1980s were a time of exploration, and not all explorations were successful. Lorraine Chinana and her relatives experimented with new slip colors, and although we personally give them high marks, they never caught on in the market-place. Mary Toya, Maxine Toya, and Maxine's mother Marie Romero made beautiful pieces, but soon switched to storytellers.

Others, though, found a path and led the way to the Jemez pottery of the 1990s.

Pecos Revisited. The search for a tradition ranged far afield, across the rivers to the ruins of Pecos, a Towa-speaking pueblo thirty miles southeast of Santa Fe. During prehistoric and historic times, Pecos produced Rio Grande glazeware, a generally well-made pottery featuring piled-on and often drippy glaze paint, sometimes in such a high relief that you hesitate to touch it for fear you'll chip it off.

Modern Pecos
Evelyn Vigil, 7″ diameter, ca. 1975

Evelyn Vigil traced her ancestry back to the last thirty-eight survivors who fled a ravaged Pecos for Jemez in 1828, victims of Spanish, Apache, and Comanche depredations. Evelyn and a few other Jemez potters spent much of the 1970s and 1980s attempting to recreate Pecos glazeware.

TOP ROW: *Wedding vase, Mary Small, 6½″ high, 1993; jar, Mary E. Toya, 7″ diameter, ca. 1975; vase, Geraldine Sandia, 6″ high, 1992; vase, M. Sandia, 4¾″ high, ca. 1980*
MIDDLE ROW: *Jar, B. J. Fragua, 4½″ diameter, ca. 1980; moccasin figurine, 6″ high, CA. 1985; jar, Mary Rose Toya, 4½″ diameter, ca. 1975; jar, Lorraine Chinana, 3¾″ high, 1993; jar, Flo and Sal Yepa, 4⅛″ high, 1995*
BOTTOM ROW: *Seed jar, Carol Pecos, 3⅞″ diameter, ca. 1980; seed jar, Dennis and Glendora Daubs, 3¼″ diameter, 1982; jar, Carol Loretto, 2¾″ diameter, 1993; seed jar, Vangie Tafoya, 3½″ diameter, ca. 1980; seed jar, R. Sandia, 3¼″ diameter, 1993*

Still not the greatest array of pottery, but it has its high points, and it shows a giant step forward. The date on Mary E. Toya's San Juan–looking jar at top center came from our number-one authority on things Jemez, Flo Yepa. She added that Mary made it at her kitchen table, and that she did the impressions around the neck with a butter knife.

Vangie Tafoya and Carol Pecos experimented with greenware (bottom row left, and second from right). A few years earlier, Mary Rose Toya wasn't quite as successful, but Blue Corn over at San Ildefonso was getting big prices for pots with odd colors on them, and the blue paint seemed like a good idea at the time.

M. Sandia (top right) and the anonymous potter who made the odd child in a shoe experimented with matte paint on matte pottery, and Lorraine Chinana (middle row, right) tried (and still makes) blue slips. Today, Flo and Sal Yepa (to the right of Lorraine) are experimenting with mixed clays and firing techniques, and they may be on the verge of the next breakthrough.

But back in the early 1980s, Glendora Daubs, with the incised jar in the bottom row, and her sister, B. J. Fragua, with the jar just behind it and to the left, guessed the future, and they still rank at the top of the ladder among Jemez potters. On pages 84 and 85, their prophecy is fulfilled.

Jemez · The Mature Voice

Skill and substance: the turnaround is complete. Hopi's pottery tradition built up over a thousand years, Acoma's took several hundred, and San Ildefonso's and Santa Clara's styles needed about a century. But the instantly recognizable look of fine Jemez pottery happened in barely more than twenty.

Today, most Jemez ware is red, and the best potters polish their pink clay to a brownish-red that doesn't quite look like anyone else's, or they leave it matte. Jemez pots often have largely or totally matte surfaces, and at Jemez, "matte" doesn't mean "soft eggshell luster" like it does at Acoma. It means dead flat matte, like on the owl or the Koshare clown in the picture.

Jemez potters use the forms that everyone else uses—large jars, seed jars, wedding vases, figurines, storytellers, and so forth. They use all the techniques of sculpture, appliqué, and incising, and they use tan and cream slips as well as red. But regardless of the combination they use, the work comes out looking like Jemez.

Al Anthony gives a lot of the credit for this new tradition to Mary Small, who insisted that Jemez potters should learn to make pottery right and taught them how to do it, back during the poster-paint-and-acrylic days.

If Mary Small started it, families like the Fraguas confirmed it. It's no coincidence that the pueblos strong in pottery can usually point to one or two families with transcendent skills and acceptance in the marketplace. It's difficult for a single potter to change the world. Thirty years later, it might seem like Helen Cordero changed Cochiti all by herself, but it never would have happened if her near and distant relatives hadn't jumped on the storyteller bandwagon right from the start.

On the previous page, there are two pieces, one by B. J. Fragua and one by her sister Glendora Daubs, that anticipate the best Jemez work of the 1990s as shown here. But it's a chicken-and-egg situation. Did they really anticipate, or did the rest of Jemez simply follow what the number-one pottery family was doing? The answers are yes and yes.

Here's Jemez in the 1990s. Redware, like B. Tafoya's and Terry Tafoya's incised seed jars (right of owl and far right) or Pauline Romero's swirl jar, predominates.

Instead of incising or sculpting her redware, Geraldine Sandia paints it, as on the odd little piece second from left in the front. She calls it a "Pueblo Lady," and if you stare at it for a moment, you'll see why.

Shapes can get creative. M. L. E. Teeyan's butterfly jar is unusual, and Laura Gachupin's owl isn't like anything else we've ever seen.

Some potters, like Marcella Yepa and Patricia Daubs, work with cream slips, and the color of Jemez creamware is almost as distinctive as the color of the redware.

Some potters combine the two, as on Roberta Shendo's wedding vase. Note the perfect elongated racetrack oval made by the arch of the handle and the space between the spouts. It's one measure of the quality of a wedding vase.

Jemez potters were among the first to convert to storytellers, like M. R. Lucero's seven-person effort (center). But Jemez is well beyond simple storytellers, as Rosalie Toya's corn maiden and Chris Fragua's Koshare clown attest. The watermelon-eating Koshare traditionally bedevils both performers and audience at kachina dances.

Laguna

The pueblo next door. Because of Sky City's spectacular attraction for tourists, and because Acoma's white pottery has had so much attention for so many years, Laguna remains something of a Rodney Dangerfield among pottery-producing pueblos.

Laguna is the new kid on the block. In 1699, refugees from Cochiti, Zia, and Santo Domingo, all Keresan-speaking pueblos, fled General de Vargas's reconquest after the 1680 revolt and headed for empty land near Keresan-speaking Acoma.

They didn't exactly escape. The Spanish let them form a village, but stood over them while they did it. The mission started going up immediately and was finished by 1701. Today, San Jose Mission in Old Laguna is one of the most lavishly decorated churches at any of the pueblos.

Laguna quickly filled with emigrants from Jemez, Sandia, Zuni, Hopi, and neighboring Acoma. By the early eighteenth century, it was a cosmopolitan town with a heavily Spanish tilt, and the influence remains. Today it has six thousand people, the Keresan language, and one of the largest pieces of pueblo land: 2,750 square miles.

Laguna's modern history has been shaped by two major events. In 1880, the railroad came through, and it stopped right at Old Laguna. In the 1950s, uranium fever infected the reservation. If you drive up north of I-40 from Old Laguna, you can see long, lifeless brown mountains, the tailings from now-abandoned mines, that the

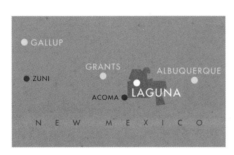

tribal and federal governments puzzle over what to do about. Both the railroad and the mines provided major sources of income for Laguna residents and diverted their attention from arts and crafts.

For the last hundred years, Laguna has had other things on its mind beyond pottery production. But even so, it has a clear pottery tradition, similar to but slightly different from Acoma's. The designs on Laguna ollas often have bolder geometric patterns than their fussier Acoma counterparts, and Laguna potters are more likely to temper the white clay with sand than with ground-up sherds. We've been told that this piece of information allows you to guess the identity of an older jar. You rub your hand inside on the unpolished part and if it feels fine-textured, it should be Acoma. If it feels sandpapery, it's supposed to be Laguna. (This should be a definitive test, but we're sorry to report that it's misled us so often that we have no faith whatsoever in its accuracy.)

Laguna's pottery tradition is hardly unbroken, however. From the 1920s on, good Laguna pottery gradually disappeared, to the point that, in 1929, Ruth Bunzel in *The Pueblo Potter* could quote the following Laguna attitude: "We don't make good pottery here any longer. Why don't you go to Acoma? When we want pottery, we buy it from the Acomas."

Potterymaking never completely stopped at Laguna, but by 1960, it was almost gone.

TOP ROW: *Olla, 8⅞″ diameter, ca. 1925; olla, 10½″ diameter, ca. 1920*
MIDDLE ROW: *Wedding vase, Statuwe, 10″ high, ca. 1975; bowl, 6¼″ diameter, ca. 1955; jar, 6½″ high, ca. 1930; bowl, R. Koyona, 5¼″ diameter, ca. 1975*
BOTTOM ROW: *Ashtray, 4″ diameter, ca. 1935; basket, 4¼″ high, ca. 1930; bowl, 3⅜″ diameter, ca. 1935; wedding vase, 4⅜″ high, ca. 1935; bowl, 3¾″ diameter, ca. 1930; wedding vase, 5¼″ high, ca. 1935*

The two ollas in the top row serve as reminders of the good old days of Laguna pottery, while the tall jar in front of the big olla shows some signs of the decay of the art. Its decoration is less fastidious, but not yet down to the level of the outright tourist pieces of the same period, such as the basket second from left and the bowl second from right in the front row.

We'd have called the basket "Isleta" except for two reasons: Its slip is yellower, like the bowl, and it has "Laguna" painted on the bottom, a clue that usually settles arguments.

Five years later, Laguna pottery had slid even further. The ashtray, the little bowl at bottom center, and the two small wedding vases all seem to be from the same period, and possibly even by the same potter. A wedding vase without a handle is almost always the product of a potter's mistake—it breaks off somewhere along the line, and the piece is finished without it.

The tall wedding vase at top left, the odd bowl with the dips in the rim (which could be an Acoma piece), and the greenware bowl at the right are post–World War II, and are better-than-average pieces from the lowest period of Laguna pottery.

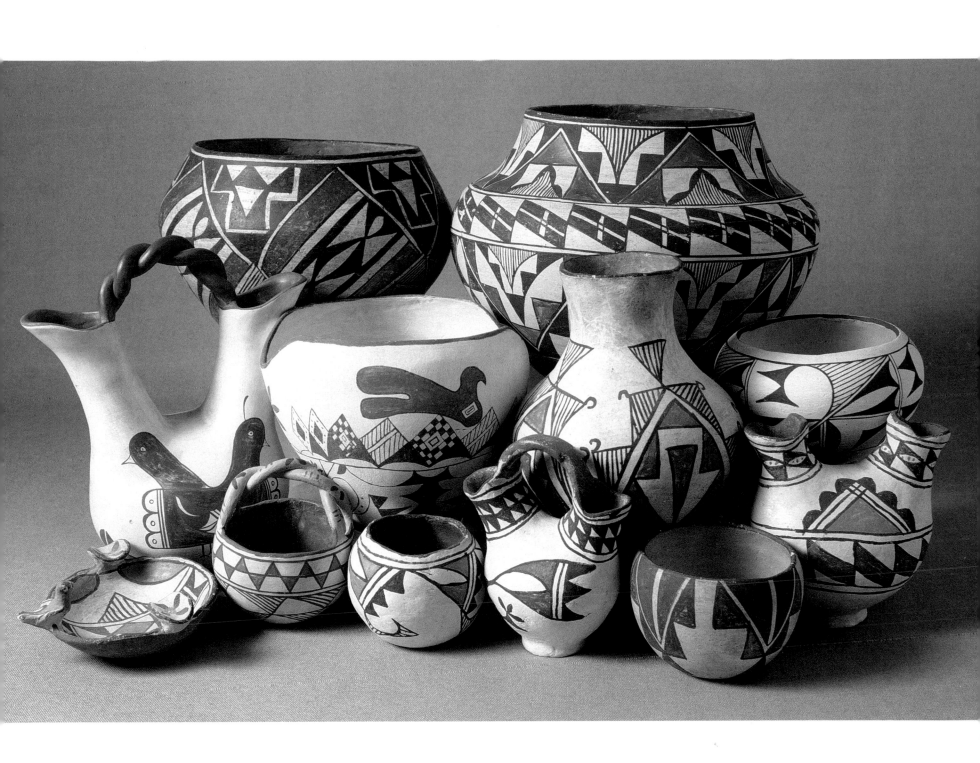

Laguna · Rebirth

Thank you, Evelyn. Much as Mary Small came forward at Jemez, Evelyn Cheromiah and her family started the move back to good pottery at Laguna in the 1970s. In *Acoma and Laguna Pottery*, Rick Dillingham quoted her as saying that after "looking at my mother's pottery-making tools, I got the urge of going back to making pottery."

This urge seems to be strong in pottery families. Jemez potter Flo Yepa, who was born in Laguna, resisted making pottery for years. She worked in the prison system and, familiar as she was with the underside of life, told us bluntly that she didn't want to become "just another potter working to support an alcoholic husband." But, when Flo married into Jemez, she told us she "heard her grandmother calling" and has worked full-time as a potter ever since.

During the 1980s, others got the urge. Laguna pottery got better and better and more and more traditional. Suddenly, there was not only the Cheromiah family, but new potters like C. Antonio doing traditional work. There was Gladys Paquin researching historic ollas and creating her modern versions of them. There was Myron Sarracino painting Tularosa swirls as well as they can be painted. And recently, there even was Max Early leaving the kiln behind and returning to pit-fired pottery, fire clouds and all.

There also was exploration way beyond Laguna's traditions. Like blackware. In the early 1990s, we'd seen some dreadful pre-cast ceramics painted black with commercial paint in matte and polish and signed by a Laguna. But until 1995, we'd never seen a piece like the one by Sally Garcia, a pot that would make any Santa Clara potter proud.

Andrew Padilla's white pieces combine his Santa Clara and Laguna heritage. Terence Cooka's micaceous ware looks like it came from the northern pueblos. And Andrew Rodriguez's sculptures move toward mainstream contemporary art.

Laguna is alive and well.

Evelyn Cheromiah and her daughters work within the old traditions—white-slipped coiled pottery, traditionally painted. M.W.'s 1985 effort has a striking design, but it's not too far removed from mainstream Acoma pottery of the period. Her 1994 effort is much more like Laguna.

Gladys Paquin's jars are deliberately traditional. She looks at pictures of old jars in books, then recreates their designs on new ones, and makes and fires them traditionally. You can see the 1880 jar that inspired the one at top left in Larry Frank and Francis Harlow's Historic Pottery of the Pueblo Indians, 1600–1880.

Myron Sarracino (pitcher), C. Antonio (jar above left of canteen), and Max Early (canteen) work in the old Laguna/Acoma tradition as well, but Andrew Padilla, Gladys Paquin's son, does heavier pottery that's more like the Santa Clara ware that gave him the impressed bear paw he used on his wedding vase.

The orange jar, the blackware jar, and the horse (bear? other?) at the bottom go far afield from Laguna. Terence Cooka got firing help for his micaceous jar (above ram) from Glenn Gomez in Pojoaque. Sally Garcia didn't learn how to make blackware like this from older Laguna potters. And Andrew Rodriguez's piece draws more inspiration from mainstream Anglo art pottery than it does from the tradition of any pueblo.

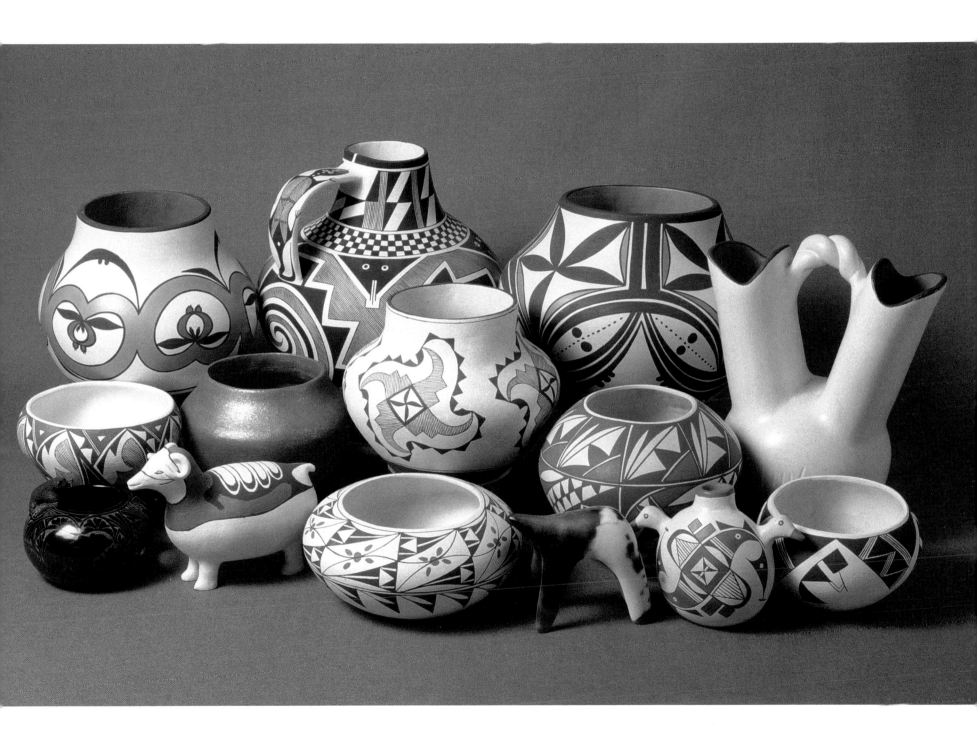

Maricopa and Pima

⫸ *If they weren't totally different, you couldn't tell them apart.* For the last 150 years or so, the Maricopa and the Pima (say PEE-ma) have been lumped together in the eyes of the outsider. Of course, they have different languages (the Maricopa speak Yuman, while the Pima, like the Hopi, speak an Uto-Aztecan language), different traditions, and a different craft emphasis (the Maricopa make pottery, the Pima make baskets), but none of that seems to matter to anyone who isn't a Maricopa or a Pima.

Unlike other linguistic groups, neither has its own reservation. Instead, they're split up between the Salt River Reservation just east of Phoenix, primarily Pima, and the Gila River Reservation to the south, where most Maricopa live.

Actually, the historic basis for the confusion predates the coming of the Anglos. Somewhere between the 1740s and the 1780s, the Pima and the Maricopa, the easternmost Yumans, formed their own version of NATO, promising to defend each other from all attack. At the time, they feared the western Yumans and the Apaches more than they did the Spanish. The Pima-Maricopa Federation became a force strong enough that not only the Spanish, but the Mexican and American governments had to deal with it as a major political entity. The Mexican War of 1846–1848 brought what is today Arizona and New Mexico under the American flag, and an alliance with the Pima-Maricopa Federation was one of the deciding factors. Until the Civil War, the federation's army was the strongest military force in Arizona.

Then the settlers arrived in greater and greater numbers. Originally, the Maricopa and Pima owned rich river basin farmlands in the Salt River and Gila River Reservations. They sold the early settlers their crop surpluses, and for the next century, they taught their children to get along with the settlers, a task that became increasingly difficult as politicians and developers siphoned off more and more of their water upstream.

By 1900, their populations were depleted by epidemics brought in by the settlers they once helped, and the once-proud Pima and Maricopa were hungry and dependent. The last general of the federation army died in 1908, and the Pima and Maricopa were so forgotten that the government that once depended on them didn't allow them to vote for another forty years.

Maricopa pottery (and a small amount of virtually identical pottery made by Pimas) has looked about the same from the mid-nineteenth century. In *Dirt for Making Things*, Janet Stoeppelmann and Mary Fernald tell of a thousand-piece Maricopa pottery collection gathered between 1885 and 1912 and acquired by two Phoenix museums, the Heard and the Pueblo Grande, in 1938. In 1971, Mary Fernald tried to locate the collection, and could only account for 272 pieces—262 between the two Phoenix museums and 10 on loan to the Museum of New Mexico.

Sadly, those other 700-plus pots were probably dumped into the market years ago. Some of them could even be in the picture to the right, but who's to know?

TOP ROW: *Snake effigy jar, 6¼″ high, ca. 1880; vase, Ida Redbird, 9¼″ high, ca. 1930; effigy jar, 5″ high, ca. 1870; vase, 9″ high, ca. 1900; cup, 5″ high, ca. 1890*
MIDDLE ROW: *Effigy bowl, 5½″ long, ca. 1925; basket, Ida Redbird, 3¾″ diameter; ca. 1930; snake effigy bowl, 3½″ diameter, ca. 1925; bowl, Lena Mesquerre (?), 5¼″ diameter, ca. 1925; frog effigy bowl, 3½″ diameter, ca. 1910*
BOTTOM ROW: *Candle holder, 4¾″ diameter, ca. 1925; bowl, 6¼″ diameter, ca. 1915; frog effigy dish, 4¾″ long, ca. 1910; dish (below), 5½″ diameter, ca. 1925; ashtray, 5″ diameter, ca. 1925*

The picture shows the three kinds of Maricopa pottery that have existed for over a century: black-on-red, black-on-cream, and black-on-cream-and-red. Rarely, potters will leave the black paint off, as in the effigy at top center.

Our compulsion to date everything in the book could get us into trouble here. There's so much published material on other types of Southwestern pottery that any mistakes we make in dating should be more than offset by the weight of other evidence. But there's so little literature on Maricopa that our mistakes might get more attention than they deserve.

So, for the record, every date we've put on every piece on this page is a guess, based on several factors: wear, fashions of the period, the presence of fire clouds (they don't seem to occur after 1900), and the fact that pre-1937 Maricopa pottery has a different look and feel from the revival pieces on the next pages. You can even see the difference in pre- and post-1937 work by the same potters, like Ida Redbird and Lena Mesquerre (Fernald and Stoeppelmann spell it "Meskeer").

The attributions on the two Ida Redbird pieces came from her cousin Wenima Washington, and the Lena Mesquerre call is based on a similar 1925 pot at the Amerind Foundation.

To us, the snake effigy jar at top left and especially the human effigy at top center seem to be products of an earlier time and way of looking at life, and the vase at top right, fire clouds and all, looks exactly like pieces collected at and before the turn of the century. The

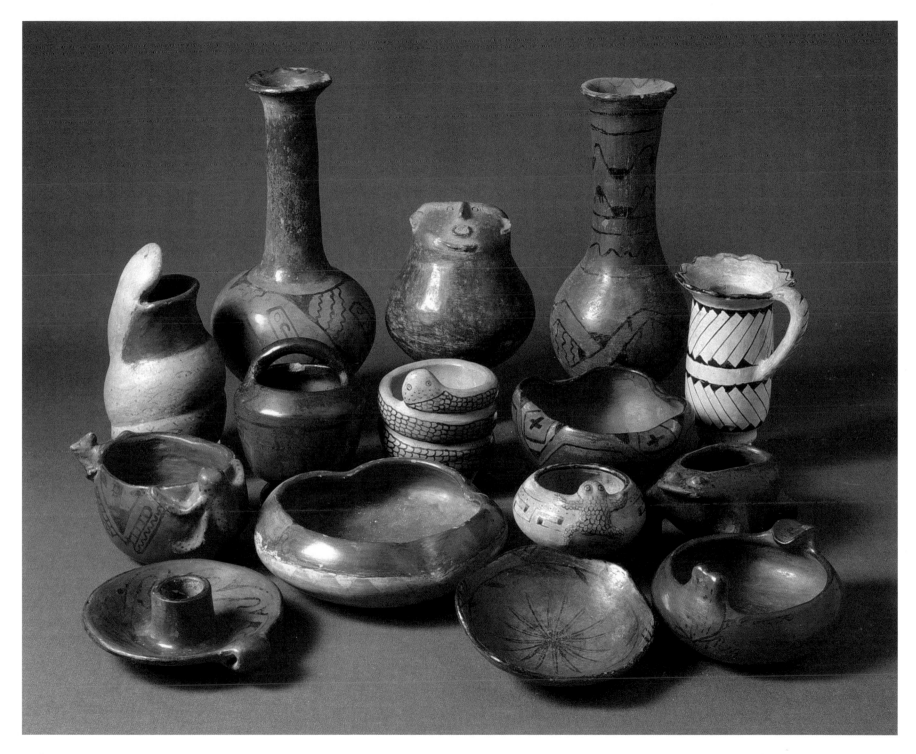

scalloped edge on the cup characterizes early tourist ware, and the double effigy bowl may be earlier than our 1925 guess. Carol Hayes, with her eye for antiques, suggests that the standing redware frog at the right may have been made as a pincushion, a standard Victorian/Edwardian souvenir.

To confuse the issue a bit, the polychrome bowl in the bottom row was sold as "Pima." This may or may not be correct, but the rule of thumb is, in the absence of hard evidence, any given pot is 99 percent more apt to be Maricopa than Pima.

Maricopa & Pima · Revival

Here comes Elizabeth Hart. In 1937, the United States Indian Service Home Extension Agent, Pima Jurisdiction, Sacaton, Arizona, wrote letters to the three major Southwestern museums—the Heard and the Pueblo Grande in Phoenix and the Museum of New Mexico in Santa Fe.

Elizabeth Hart felt that if Maricopa potters could improve the quality of their work, they'd be able to get higher prices, thereby improving their economic status, and she thought the museums might help. She had precedent for her crusade. Mary Colton of the Museum of Northern Arizona had pointed out market realities to Hopi potters in the late 1920s. Kenneth Chapman of the Museum of New Mexico had done the same for San Ildefonso potters ten years earlier.

By 1937, Maricopa pottery needed improvement. The art had been drying up for twenty-five years as the number of potters diminished and the pendulum swung away from carefully made, carefully painted pieces and towards unimpressive, dashed-off tourist pieces.

Within a few months after she sent the letters, Elizabeth Hart and Odd Halseth of the Pueblo Grande Museum had organized the seventeen-member Maricopa Pottery Association, with the charismatic Ida Redbird as president.

Halseth arranged for them to have weekend showings at Pueblo Grande, where they were supposed to dress in native costume, do demonstrations, and sell pottery. As Ida Redbird later recounted to Mary Fernald, they could have done without the costumes, but for once, they got to set their own prices and keep the money.

By 1938, Maricopa pottery was alive, active, and better than ever. Elizabeth Hart's ten-point quality standard (borrowed from what Mary Colton had given the Hopis in 1930) was working exactly as she'd hoped.

But four years later, the explosion was over. Phoenix was a long way away over dirt roads, and there was no retail outlet on either reservation. None of the potters had cars, Elizabeth Hart died in 1941, and World War II turned everyone's attention elsewhere.

TOP ROW: *Pitcher, Ida Redbird, 7″ high, ca. 1940; vase, Ida Redbird, 10″ high, ca. 1955; pitcher, Mary Juan, 9¾″ high, ca. 1940*
MIDDLE ROW: *Wedding vase, Lena Mesquerre, 6″ wide, ca. 1940; Lizard bowl, 5″ diameter, ca. 1955; bowl, Lena Mesquerre (?), 5⅜″ diameter, ca. 1940*
BOTTOM ROW: *Bowl, Mary Juan, 4¾″ diameter, ca. 1950; shoe ashtray, Claudia Kavoka, 5½″ long, ca. 1940; tripod bowl, 5⅛″ diameter, ca. 1950; bowl, 5″ diameter, ca. 1955*

The Maricopa Pottery Association's influence had dramatic effect. Now the polish was mirror bright and the paint strong black. If we're right in thinking that she did all three, the difference between the Lena Mesquerre bowl on the previous page and the two pieces on this page (middle row, left and right) is obvious. (The wedding vase has a museum collection attribution inked on the bottom.)

The Ida Redbird and Mary Juan pitchers once looked that way, too, but they've been handled much more. The Ida Redbird, Mary Juan, and Claudia Kavoka attributions came from Wenima Washington, Ida and Mary's cousin and Claudia's daughter. The tall vase with handles is signed by Ida, which pushes it back to a later date, perhaps contemporary with the unsigned bowl at bottom right and the appliquéd lizard bowl, which looks like a 1970s revival piece. Only the lack of signature makes us push its date this far back.

The three-legged piece is another sold-as-Pima, but as we said on the previous page, we have trouble with Pima attributions based on anything other than hard knowledge. In Dirt for Making Things, *Mary Fernald quotes a grouchy Mabel Sunn saying in 1970: "Maricopa are always lumped together with the Pima, and they call Maricopa pottery Pima pottery. But Pima don't make pottery now."*

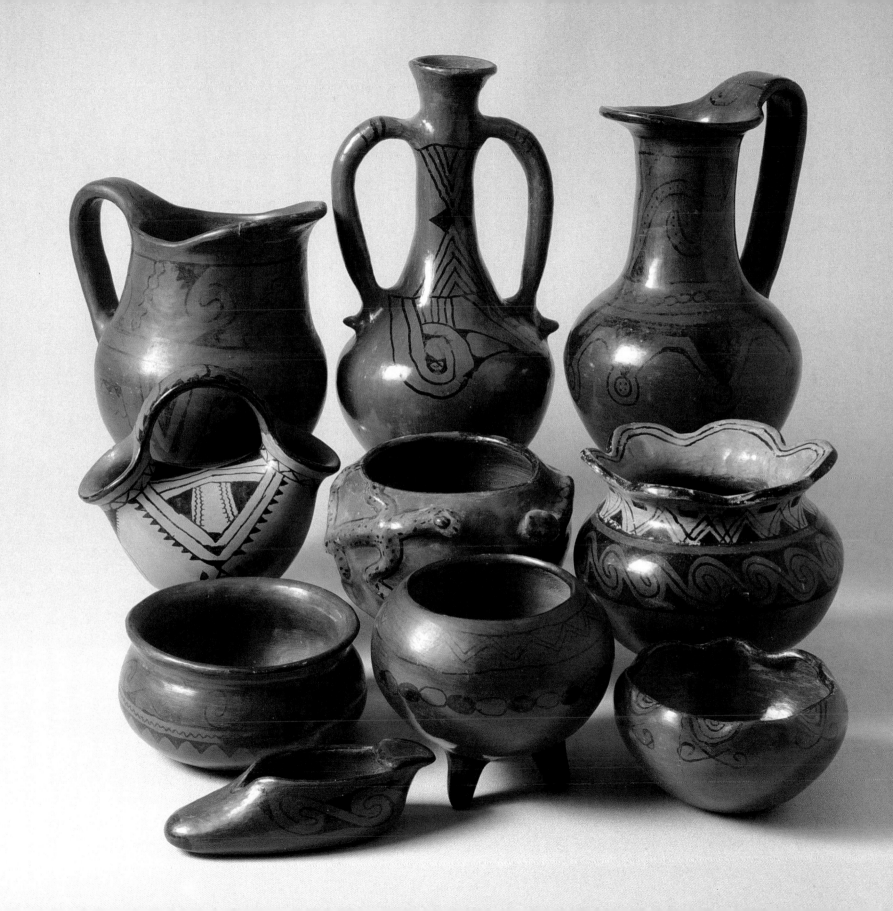

Maricopa & Pima · Revival Again

Here comes Mary Fernald. And Phyllis Cerna. In 1938, Elizabeth Hart lived with the Maricopa and took matters into her own hands. In 1970, Mary Fernald was writing a master's thesis, and she came to Ida Redbird, Mabel Sunn, and Barbara Johnson with hat rather than matters in hand, just hoping for a little acceptance and instruction.

Mabel, Ida, and Barbara gave her her thesis, which lay buried at the University of Arizona until Mary and Janet Stoeppelmann made a book out of it in 1995. But Mary gave Mabel, Ida, and Barbara a great deal as well: pictures and information about earlier Maricopa pottery and encouragement to continue and to stretch the art. Whether it happened because of Mary Fernald's visit or coincidentally, Maricopa production turned upward in the early 1970s, to the point that Stoeppelmann's book, *Dirt for Making Things,* can talk about "the 1970 revival."

Pieces from this second revival have the sharpness and polish of the 1940 pieces, but they're easy to identify because almost all have signatures. Unfortunately, so little has been written about the Maricopa that we have no idea of what some of the signatures mean. It took us years to learn that the "G. Stevens" on two of the pots in the picture (one seemed to read "Storena," which threw us way off) was actually Gertrude Stevens, Mabel Sunn's younger daughter.

After its early-1970s flurry, Maricopa pottery went into another long downward slide. By the early 1990s, Ida Redbird and Mabel Sunn were gone. Barbara Johnson, Phyllis Johnson Cerna, and Theroline Bread were still around, but only a handful of potters, almost all of them elderly, still practiced.

Then, in 1994, Phyllis Cerna started teaching at the Salt River Reservation, and new potters began to learn the art. In 1995, we saw examples of student work in a showcase at the Hoo-Hoogam-Ki Museum at Salt River, and some of the pieces approached the quality of the best of the 1940 revival.

Five years later, Barbara Johnson was gone and Phyllis Cerna was less active, but Theroline Bread, Wally Oliver and Mabel Sunn's granddaughter, Dorothea Sun (she dropped one of the n's) were keeping the flame flickering. Maricopa pottery may yet resurrect itself one more time.

TOP ROW: *Effigy bowl, Gertrude Stevens, 6¾″ diameter, ca. 1975; effigy, Theroline Bread, 8″ high, 1969; bowl, Barbara Johnson, 9″ diameter, ca. 1980; effigy, Phyllis Cerna, 6¾″ high, ca. 1985*
MIDDLE ROW: *Effigy bowl, Gertrude Stevens, 7″ diameter, ca. 1970; bowl, Barbara Johnson, 3¼″ diameter, ca. 1970; effigy bowl, Mabel Sunn, 7″ diameter, ca. 1970; bowl, Phyllis Cerna, 4¼″ diameter, 1992; owl effigy, Antoinette Pinon, 4″ high, 1994*
BOTTOM ROW: *Bowl, Wally Oliver, 4″ diameter, 1993; vase, Ida Redbird, 3¼″ high, ca. 1970; frog figurine, Mabel Sunn, 4″ long, ca. 1970; effigy bowl, Wally Oliver, 5¼″ diameter, 1993*

The Ida Redbird, Mabel Sunn, and Gertrude Stevens pieces date from Mary Fernald's thesis period. Barbara Johnson was Mabel Sunn's daughter and was around and participating when Mary Fernald was working with her mother.

The effigy at top by Theroline Bread, another still-active potter, is a latter-day Maricopa phenomenon. Red-on-matte-buff effigies like this are in frank imitation of Mojave effigies. We've seen these by both Theroline and Barbara Johnson sold as Mojave more often than we've seen them sold as Maricopa. This isn't surprising. If they were now-rare Mojave, they'd bring double the price. If you see one of these, look for a "T. B." or a "B. J." on the back or the bottom. Both potters have been scrupulous about signing these pieces.

Phyllis Cerna (effigy, top right, and bowl below it) brings Maricopa into the present and beyond. She's now teaching, and she's instructed her daughter Antoinette Pinon (owl) so thoroughly that we can't tell Antoinette's work from her mother's.

Finally, having questioned all the other Pima attributions in this section, we can tell you that Wally Oliver (bottom row, left and right) is a Pima, is currently working, and seems to be making every type of pottery in the Maricopa/Pima repertory.

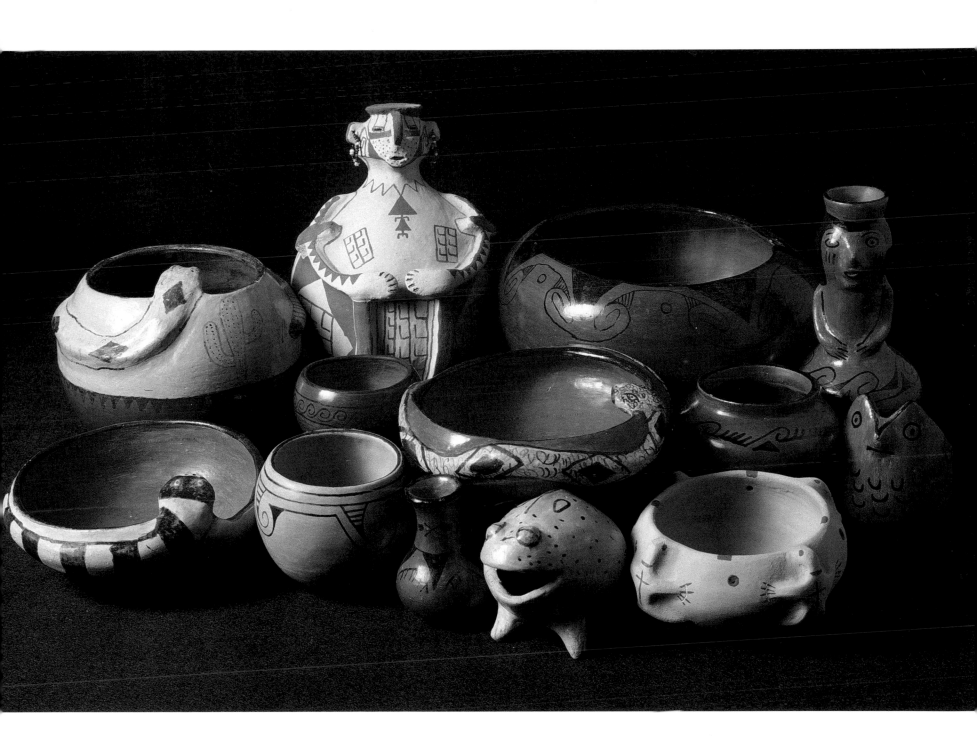

Mojave

▶▶ *Not all Southwestern pottery is alive and well. This one seems barely quivering.* In the early twentieth century, the western Yumans—the Mojave, the Cocopah and the Quechan—cranked out a lot of pottery for tourists, and the Mojave sold it at the railroad station in Needles.

Their eastern relatives, the Maricopa, split off from (or were chased out by) the western Yumans in the seventeenth century and allied themselves both politically and pottery-wise with the Pimas.

But the western Yumans remained along the Colorado River. They also remained, at least in their pottery, the only heirs of the Hohokam, who may have passed over the Yuma Crossing of the Colorado on their way to and from California in prehistoric times. The resemblance to Hohokam Red-on-buff is strong in Mojave, Cocopah, and Quechan pieces alike.

In 1970, two famous Mojave potters still worked in Parker, Arizona, where the Hohokam had traded a thousand years before, but the tradition seemed to have disappeared by 1990. Then, in 1998, Betty Barrackman (not shown) surprised us by telling us she was still active. She lamented that no young people were taking up the craft, but in 1999, we saw the work of two potters tentatively approaching the old traditions. There's still hope.

Despite the heading, it's not really correct to label all this pottery "Mojave." (Or "Mohave." California has the Mojave Desert. A few miles

east, Arizona has Mohave County. We went along with the spelling Elmer Gates put on the bottom of his pottery.) We should simply call these pieces "Yuman." However, there are two reasons why we didn't.

First, the word "Yuman" causes confusion. Until recently, writers used "Yuman" to mean "Quechan." Since the Quechan actually live in Yuma, it's hard to object, but you have to figure out whether the writer is talking about the Quechan in Yuma or the Yuman-speaking peoples as a whole.

The temptation to credit the Mojave and forget the others is further encouraged by the fact that Cocopah and Quechan potters remained anonymous to the outside world, while Elmer Gates and Annie Fields got quite a bit of publicity for the Mojave. Today, this habit of mislabeling is almost universal. Just bear in mind that, if it's pre-1960, red-on-buff, and looks mildly Hohokam, it could be Mojave but it's even money that one of the other Yumans made it.

How do you tell Quechan from Mojave from Cocopah? A 1960 *Arizona Highways* article gave us dubious help. It told us that Cocopah pottery "is perhaps the crudest made by these river Yuman tribes," while Quechan and Mojave pottery was "rather crudely decorated, but it was better done" than Cocopah wares.

Look at the picture, then make your own call.

As with Maricopa, there's not a lot of published material we can turn to for help. We did look over the collection at the School of American Research in Santa Fe, one of the few existing arrays of Mojave/Quechan/Cocopah pottery of any size. We showed our pictures to Christy Hoffman, the collection specialist, and compared them to what we saw and what she knew.

So we have some basis—if not a whole lot of assurance—about our dates and attributions here.

We could be hundreds of years (and hundreds of miles) off with the plainware pot at the upper right. But it did come from the flatlands west of Phoenix, toward Mojave country.

We're surer of the pitcher and the two baskets. They had pieces much like them in Santa Fe. The cup, the basket with the bird, and the polychrome bowl at lower left, Christy felt, were Quechan/Cocopah. The bird basket has brown poster paint along with the fired-on red. The wedding vase is either Yuman or it's not telling the truth.

Elmer Gates (jar, top left, and top effigy) and Annie Fields (frog) were two of the last Mojave potters, and the only famous ones. The three signed pieces are all typical of their work, but Annie's frog misses one of her most-beloved touches: On some, the frog has a cigar in its mouth.

In 1995, we were told that Matt Brenner was apparently the last surviving Mojave potter, but Betty Barrackman put us straight. Reports of the death of Mojave pottery were premature.

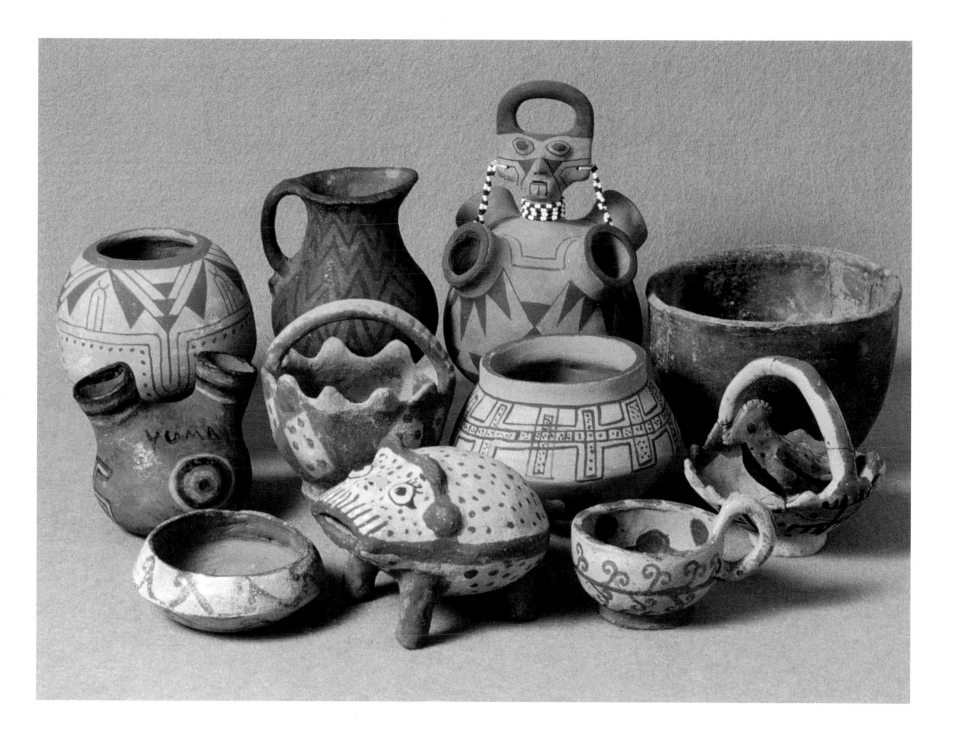

Nambé

▶▶ **It's more than oven-safe; it's the fastest-rising pueblo pottery.** Very few books have paid much attention to pieces from Nambé (say NOM-bay). Today, if you know the name Nambé, it's probably as a brand of metalware produced near the pueblo.

Historic Nambé pottery is either micaceous, blackware, or polychrome like San Ildefonso's and Tesuque's. All are rare enough so that no book shows a lot of examples, and undistinguished enough so that no authors felt they had to chase down the examples to show.

Nambé has been settled since the thirteenth century, and, as an ongoing reminder of that fact, Nambé farmers often turn up sherds of prehistoric pottery when they work the fields. When the Spanish came, the Nambé people lived in eight large villages, but the population dwindled over the years to its present four hundred.

A guidebook from the mid-1980s advises us that, if we wish to visit, we'll probably enjoy fishing at the Nambé Falls recreation area, but that the pueblo has little to offer in arts and crafts, and that its pottery is of "poor quality."

Actually, Nambé's pottery renewal was already under way when that guidebook was written. Pottery classes had happened back in the 1970s, Virginia Gutierrez was active in the 1980s, and Lonnie Vigil was beginning his work.

More than anyone else, Lonnie Vigil changed the pottery establishment's attitudes towards

Nambé and towards micaceous ware. High-fired and utilitarian micaceous ware, highlighted with bright flecks of mineral, has been Southwestern pottery's stepchild.

Pieces are seldom decorated. The micaceous surface is interesting enough in itself that additional painted designs seem unnecessary, and this lack of decoration may have kept it from receiving the attention it deserves.

Major juried Indian art exhibitions like the annual Santa Fe Indian Market and the Eight Northern Pueblos Show have a major influence in the market. As described in an article by Bruce Bernstein in the Winter 1994 *American Indian Art,* these exhibits tended to categorize pottery as either "decorated" or "utilitarian." Implied in the distinction, of course, is that the decorated pottery is the good stuff.

At the 1992 Santa Fe Indian Market, the jury selected a large Nambé micaceous piece by Lonnie Vigil as best pot in the show, which vaulted him into the ranks of the pottery elite. But they didn't award it the overall Best-In-Show prize because it wasn't "art." The reaction to this decision was enough to make everyone involved reexamine their attitudes towards micaceous ware.

In 1995, there was a major micaceous pottery exhibit in Santa Fe, with Vigil at the center. Today, micaceous pottery and Nambé are on the map.

TOP ROW: *Jar, 5¼″ diameter, ca. 1975; serving dish, 9½″ long, ca. 1930; seed jar, Pearl Talachy, 5¼″ diameter, 1993*
MIDDLE ROW: *Seed jar, Pearl Talachy, 3¼″ diameter, 1993; seed jar, Lonnie Vigil, 6″ diameter, 1992; seed jar, Robert Vigil, 5″ diameter, 1995*
BOTTOM ROW: *Bear figurine, Gloria Trujillo, 3⅞″ long, 1994; seed jar, Virginia Gutierrez, 3½″ diameter, 1994; bear figurine, Robert Vigil, 3½″ long, 1994; miniature vase, Lonnie Vigil, 2¾″ high, 1991*

Whenever we've seen deep-copper-red micaceous ware, it came from Nambé. According to Francis Harlow's 1977 Modern Pueblo Pottery, Nambé made micaceous pottery until the late 1940s, then production ended. The oval dish seems old enough to warrant the 1930 date.

The unsigned piece from the mid-1970s (top left) has the copper color, as does Robert Vigil's carved jar from 1995 (middle, right). Robert, Lonnie's cousin, managed several remarkable things on this piece. First, he achieved a high polish on the raised portions—always difficult, because the flecks of mica pick out during polishing, leaving little pits that look like flaws. He also made this into the thinnest deep-carved pot we've ever seen, and, just to prove he wasn't lazy, carved a Mimbres knife-blade pattern and another water serpent on the bottom (left). As long as young potters like Robert produce pieces like this, or like his little blackware bear in the bottom row, Pueblo pottery standards will keep improving, and the Golden Age will become more and more golden.

The pieces by Pearl Talachy, Virginia Gutierrez, and Gloria Trujillo all look like they could have come from Santa Clara or San Ildefonso across the highway. There's much intermarriage among the northern Tewa pueblos. Virginia Gutierrez is a sister-in-law of Minnie Vigil, a well-known Santa Clara potter, and of Thelma Talachy, equally well known as a Pojoaque potter.

The two Lonnie Vigil pieces are nice enough, but hardly summarize his current work or explain his influence. Major pieces by Lonnie might be as large as eighteen inches in diameter, undecorated, and beyond this museum's budget.

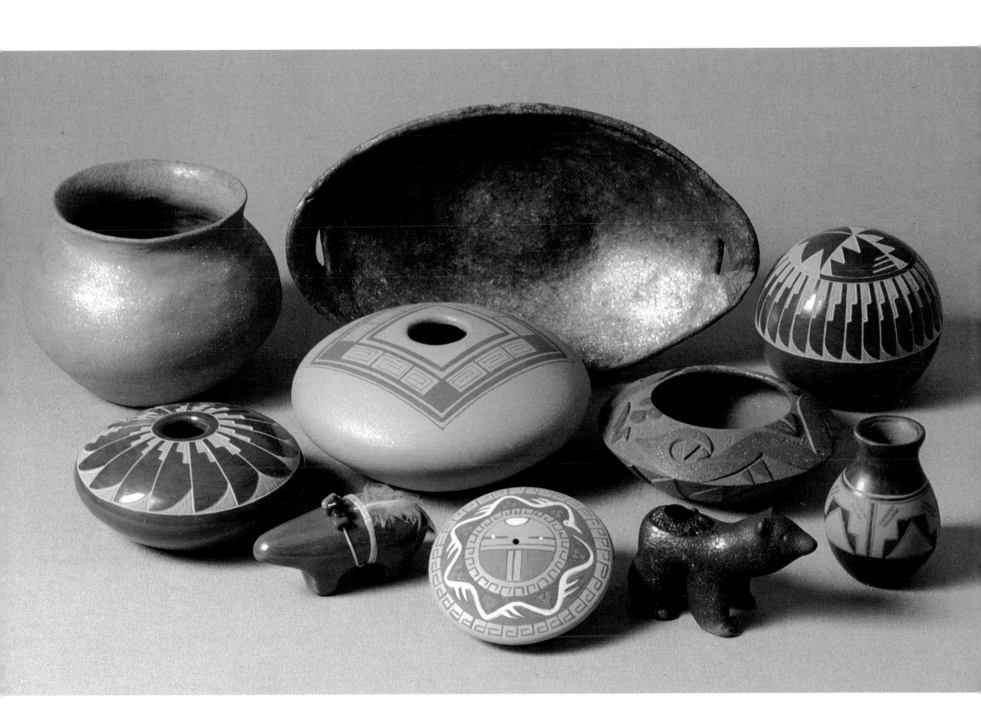

Navajo

⟫ *If it's brown, rough, and shiny, it's probably Navajo. In fact, it's probably from Cow Springs.* In the 1690s, while Governor de Vargas was mopping up all the pockets of resistance left over from the Pueblo Revolt, a group of Puebloans, probably from Jemez, met up with the Navajos at a remote spot east of Farmington called Gobernador Canyon.

At least, we assume that's what happened. What we know for sure is that a pottery that looked very much like Jemez plainware turned up in Gobernador Canyon about that time, and that it established the rounded and pointed-bottom shapes that distinguished Navajo plainware into the twentieth century. At the same time, a very Pueblo-looking polychrome pottery emerged from the same location.

The Navajo had come down from Canada perhaps 250 years before Gobernador Canyon, nomadic Athapascans who made life uncomfortable for the residents. "Anasazi," after all, meant "enemy ancestors," which pretty well explains the Navajo attitude on the subject.

Like other nomadic hunter-gatherers, historically, pottery wasn't important in their culture. Despite the interlude at Gobernador Canyon, it remained a slow-developing minor craft until the middle of the twentieth century. Subsequent Navajo potters pretty much left the polychrome to their Pueblo neighbors and concentrated on the plainware.

By 1950, Navajo pottery was an undecorated utility ware made by only a few families in the Shonto/Cow Springs area. It had two distinguishing characteristics: a lumpy fillet-rim decoration around the rim of jars (a design convention that had held for the whole nineteenth century) and a shiny piñon-pitch coating, applied after firing for the purpose of waterproofing. It's easy to distinguish from the high polish of a Pueblo piece. It looks and feels like a thick, slightly sticky varnish, and fills every indentation on the pot. Surface polishing doesn't get down into the crevices. It's hard to know exactly when Navajo potters started swabbing the melted-down pitch on their pots, but today, it's present on all traditional Navajo brownware.

After 1950, outsiders started noticing the Cow Springs brownware. Chuck and Jan Rosenak's *The People Speak* tells how Bill Beaver, who now owns the Sacred Mountain Trading Post north of Flagstaff, was working at Shonto, up the road from Cow Springs, and he and the wife of the trading post's owner started encouraging the potters. Back then, the pieces were either made for ceremonial use and didn't reach the marketplace, or were fillet-rim jars or pottery imitations of pieces normally made in metal, glass, or ceramic: perfectly serviceable frying pans, coffeepots, and the like. Beaver had to tell potter Louise Goodman to "make something different" before her pottery began to sell to the outside world. Today, her something differents—coiled jars,

pig banks and giant bears—bring high prices and reside as folk art in museums far more prestigious than this one.

Pottery still takes a back seat to rugs and jewelry among Navajo artists. However, the reservation has a quarter of a million people spread out over a plot of land larger than many states. In a big population base like this, even a secondary art has quite a few practitioners. It may be easy to recognize what's on this page as Navajo, but the art isn't standing still.

Two forces are tugging at Navajo pottery. On one hand, increasing interest in folk art is encouraging its ingenuous, humorous aspects. On the other hand, the sophistication level of Southwestern pottery in general is pushing it towards the mainstream. The next pages show what's happening in both directions.

TOP ROW: *Wedding vase, Betty Manygoats, 5½″ high, 1992; wedding vase, Aleta Bitsi, 21″ high, 1992; wedding vase, Elizabeth Manygoats, 6¼″ high, 1992*
MIDDLE ROW: *Jar, 4½″ high, ca. 1980; jar, Alice Cling, 5½″ diameter, 1992; wedding vase, Shirley Herder, 3½″ high, ca. 1980; bowl, Susie Crank, 7″ diameter, 1992*
BOTTOM ROW: *Jar, Stella Goodman, 2¼″ high, 1995; bowl, Arnold Spencer, 4½″ diameter, 1993; wedding vase, Silas and Bertha Claw, 4½″ high, 1978; jar, 4″ diameter, ca. 1970*

The jar at the far left and the even cruder one at bottom right are classic Navajo. The shape and the fillet rim with the ceremonial break (the missing lug in the circlet) are typical, as are the resin coating and the fire clouds. The little wedding vase in the middle is by Shirley Herder, who learned from her mother-in-law Helen, one of the first of the mid-century Cow Springs potters.

Betty Manygoats joined her relatives in Cow Springs in 1973. Wedding vases with appliquéd horned toads like the ones by Betty and her daughter Elizabeth and the gigantic one by clan sister Aleta Bitsi are a Manygoats family signature.

Silas and Bertha Claw make three spouted wedding vases. They too are Cow Springs potters, neighbors of Rose Williams, matriarch of yet another Cow Springs group.

Alice Cling, Rose's daughter, brought pitch-coated brownware to a new level (middle row, second from left). Her graceful polished jars rank in the top echelons of Southwestern pottery prestige. Susie Crank (middle row, right), another of Rose's daughters, works in the idiom, as does Arnold Spencer (bottom, second from left), an in-law.

Stella Goodman (bottom left) is Betty Manygoats's clan sister and daughter of Louise Goodman (next page). Louise turned stacked-coil pots like this one into a personal trademark. In fact, there's one on the cover of Hartman and Musial's definitive 1987 book, Navajo Pottery.

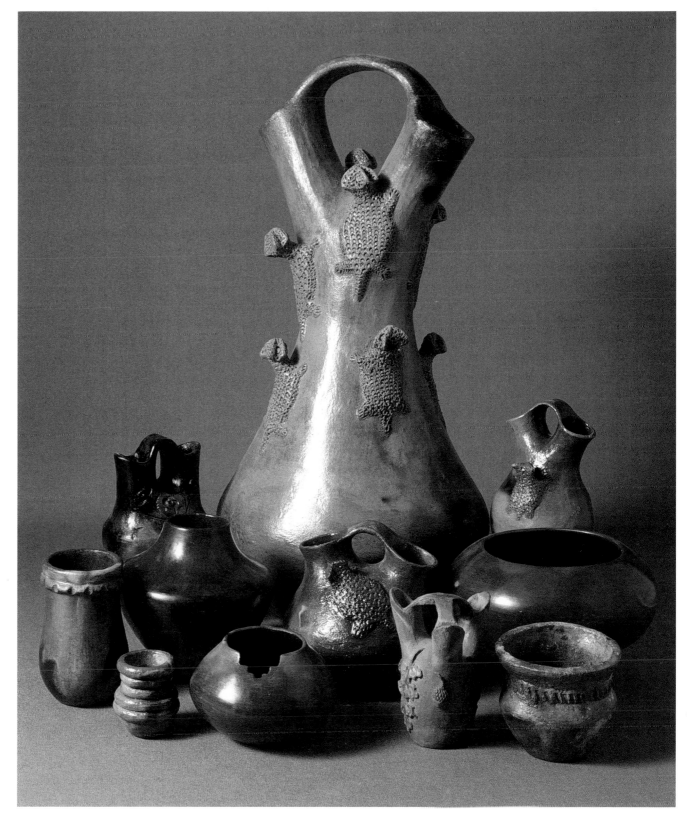

Navajo · Folk Art

To Cow Springs, add Sweetwater and Fruit-land. It was ever thus in the world of art, we suppose, but nobody outside the Southwest paid much attention to art from the backwaters of the Navajo Reservation until a couple of lawyers named Rosenak focused on it. In 1986, Jan Musial and Russell Hartman mentioned a few artists in their book, *Navajo Pottery*, but the book's main thrust was elsewhere. The Wheel-wright had a Navajo folk art show with a book-length catalog in 1987, but the craft still remained relatively low-profile.

Then Chuck and Jan Rosenak came along. Fresh from their impressively named 1990 book, *Museum of American Folk Art Encyclopedia of Twentieth-Century American Folk Art and Artists,* they set to work publicizing an enthusiasm they'd acquired in their general folk art research.

They showcased Navajo folk art in a traveling exhibition that appeared in museums in Missouri, New Mexico, and Arizona between 1987 and 1990. But their 1995 book, *The People Speak,* made it official. Navajo folk art had arrived.

The category includes weavers, painters, and carvers as well as potters, of course, but potters play a big part, and the potters of Cow Springs are as important as any. Potters from equally obscure places like Sweetwater and Fruitland, just west of Farmington, play important roles as well. The resin-coated brownware from Cow Springs has to share billing with an even older tradition: mud toys. These little, painted, unfired figurines make Cow Springs brownware seem downright sophisticated.

Mamie Deschillie makes mud toys, but she also makes, and may even be better known for, cardboard cutouts dressed in bits of fabric. She was born in 1920, so she knew mud toys as a child (according to the Rosenaks, mud toys had been written of as early as 1881, but the tradition of making them apparently died out by 1940).

Elsie Benally started making mud toys in the early 1980s, and her yarn-wrapped sheep seem to define the art. She reportedly speaks no English, and even the Rosenaks, for all their fero-cious pursuit, were never able to find her for an in-person interview. If, to be folk art, it has to come from unspoiled, out-of-the-way places, this qualifies without question.

TOP ROW: *Wedding vase, Silas and Bertha Claw, 8¾″ high, 1995; bear figurine, Louise Goodman, 21½″ high, 1995; pig bank, Lucinda Slick, 8″ long, 1992*
MIDDLE ROW: *Elephant figurine, Mamie Deschillie, 4¾″ long, 1995; steer figurine, possibly Ashie Bitsui, 6¼″ long, ca. 1990; pig bank, Louise Goodman, 6¾″ long, 1994; jar, Lorraine Williams, 3½″ diameter, 1993; buffalo figurine, Elsie Benally, 3⅞″ long, 1995*
BOTTOM ROW: *Sheep figurine, 3½″ long, 1994; jar, Irene White, 3¾″ diameter, 1995; sheep figurine, 3⅝″ long, 1993; sheep figurine, 3¾″ long, 1994; horse figurine, 3½″ long, 1994*

This is the pottery side of Navajo folk art, as defined by the Rosenaks in 1995. Louise Goodman's bear and piggy bank are right at the center of the movement, Silas Claw's 1995 wedding vase is much folksier than his (and Bertha's) 1978 one in the preceding picture, and Lucinda Slick's piggy bank outdoes Louise Goodman's for whimsy.

Lorraine Williams and Irene White made jars (middle and bottom rows, respectively) that hover on the outer edges of the category. Any Navajo pitch-coated brown-ware made these days qualifies, but these examples are almost too sophisticated to fit the genre comfortably.

On the other hand, that can't be said about the mud toys. These unfired little pieces radiate folk art. They're also so fragile that traders have to take extra precautions just to transport them over the reservation's rutted roads from places like Sweetwater and Fruitland.

We're sure of the attributions on Mamie Deschillie's yarn-tailed, pink-saddled elephant and Elsie Benally's somber-looking buffalo. The rest are anonymous. However, the spotted horse looks very much like it might have been done by the same person who did the elephant, and the three sheep show a definite kinship to the buffalo.

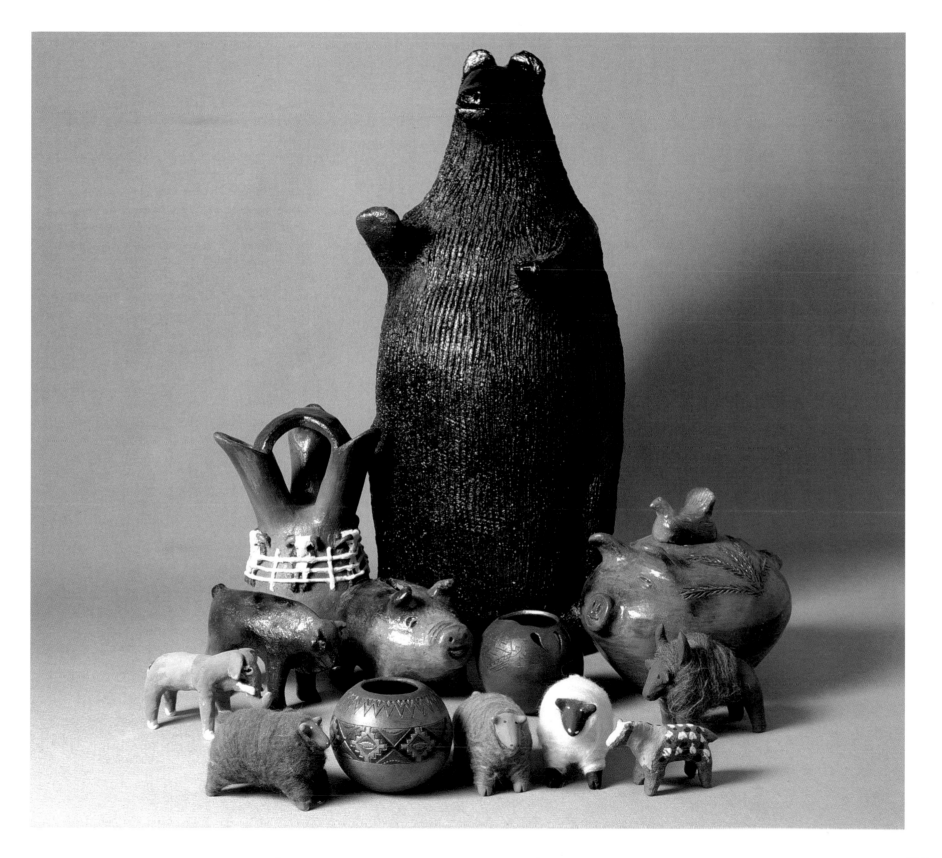

Navajo · Toward the Mainstream

The outside world intrudes. When you observe Southwestern pottery from a distance, it's comforting to think of it as a pure art, and pockets of consistent production like Cow Springs confirm that pleasant concept.

But it never has been pure art, which is a mixed blessing. Commercial pressure constantly keeps tearing at its integrity, but competition keeps pushing the standards higher. The picture to the right testifies to both sides of the issue.

The incised pot at the left of the middle row was manufactured by the Mesa Verde Pottery Company of Cortez, Colorado. It was precast and decorated on an assembly line in a pattern developed by Ute Mountain potters. Why is it on this page, or even in the book? Well, it was signed by a Navajo, it was sold as art, and E. Etsitty may someday be a serious potter. After all, Lorraine Williams, born in Sweetwater, wife of Cow Springs matriarch Rose Williams's son George, once worked at Mesa Verde Pottery. She made pots just like this one for a whole winter. Now she makes pots like the one on the previous page and gets written up in the fancy books.

Like it or not, machine-made Ute-design pottery is every bit as much a part of contemporary Navajo pottery as resin-coated brownware.

The picture to the right might be titled "influences from all over." There's pre-cast pottery painted to look like San Ildefonso blackware, one obvious and one so well done we're not really sure it's pre-cast. There's also beautifully made blackware that San Ildefonso and Santa Clara potters would admire.

There's incised redware as elaborate as anything Santa Clara's priciest potters might attempt. There's moderately successful pottery in imitation of Hopi ware, and there's pottery by a woman who learned her craft by watching Priscilla Namingha, Nampeyo's great-granddaughter.

And there's pottery-as-fine-art, both within the pitch-coated brownware idiom and outside of it.

The future is bright. But not wart-free.

At the high end, David John's matte masks and Arlan Dempsey's resin-coated sculpture show how far Navajo pottery has moved into the world of mainstream contemporary art. (Dempsey, by the way, is Laguna/Navajo. Experimental sculpture was no stranger to the Laguna of the mid-1990s, either, but we couldn't bring ourselves to put a resin-coated brownware piece anywhere but with the Navajo half of his heritage.)

Casha Blue Sky's redware (bottle and seed jar, bottom row) is superb, as fine-looking as work by the astronomically priced Lonewolf family of Santa Clara. Fabian deValenti Norberto's blackware (bottom row) is almost as good.

Ida Sahmie (cup) has already reached a celebrity plateau. She's sister-in-law to Rachel and Jean Sahmie and learned the lessons of the Nampeyo family well. She makes Hopi pots, but she paints them with Navajo motifs.

Gerry and Saressa Whitehorse, on the other hand, make pots that resemble those from Hopi, but without the finesse. Still, they have an individualism that caught our eye. The Whitehorses are on their way up, however, and better work may be coming.

The other pots in the picture are lower on the evolutionary scale. CBA's blackware is probably greenware, but if it is, it's a pretty good fool-the-eye piece, while Ad-Kai's pot is more obvious. And, of course, E. Etsitty's effort is factory-made all the way.

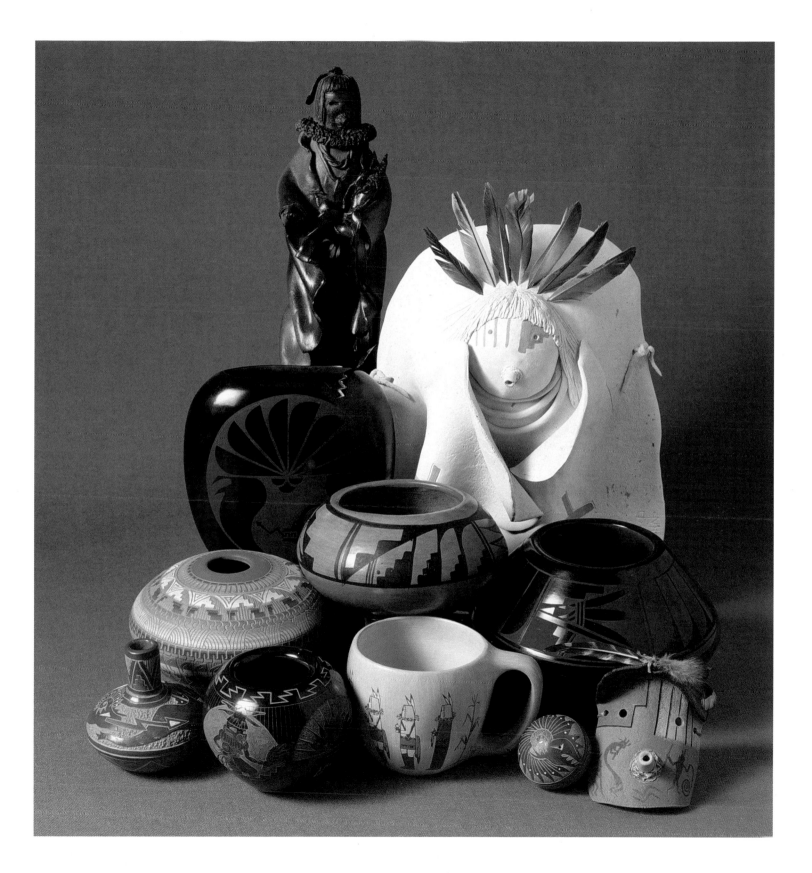

Pojoaque

►► *And now, the brand-new, shiny, totally reborn modern pueblo.* In the late nineteenth century, poverty and smallpox caught up with Pojoaque, and it went the way of Pecos.

By 1915, it was an abandoned pueblo, its adobe buildings dissolving in the annual rains. Then in the 1930s, the government restored the land, and eventually forty descendants of the original families resettled the pueblo. Some came from places like Chicago and Los Angeles, some from neighboring pueblos, and Pojoaque (its pronunciation is tricky—say "Pohockey" fast and you'll come close) began a second life.

It didn't happen overnight. A Comanche dance in 1973 was Pojoaque's first public ceremony in a hundred years. And it didn't result in a full restoration of pre-abandonment traditions. In fact, one guidebook written in 1985 dismissed Pojoaque out of hand, saying that it "exists in name only and has virtually ceased to function as a community."

This name-only community has managed, more than any other pueblo, to beat the outside world at its own game. Pojoaque was the first pueblo to build a casino, creating still more income for what had already become the highest per-capita income pueblo. When Pojoaque built a craft store, it built a polished retail outlet in the manner of Albuquerque's Pueblo Indian

Cultural Center and Sandia's Bien Mur. And when it built a cultural center, it built a monumental complex in the manner of the Anasazi master builders.

You can find a tiny amount of Pojoaque pottery mixed in with the Santa Clara, San Ildefonso, and Jemez work at the Pojoaque Craft Center. Until very recently, you could count the number of Pojoaque potters on the fingers of one hand without using your thumb, and their work has little or nothing to do with the historic Pojoaque pottery of the seventeenth and eighteenth century. Until the mid-1980s, Pojoaque potters were really Santa Clara potters. Lucy Year Flower (see page 137) married Joe Tafoya of Santa Clara. Although she signed her pots "Pojoaque/Santa Clara," she made them in Santa Clara with Santa Clara clay and in the Santa Clara style.

Joe and Thelma Talachy live in Pojoaque, but the polychrome style that the Talachys use is more often associated with Thelma's sister, Santa Clara potter Minnie Vigil. True, Thelma did make a few pieces in the eighteenth-century Pojoaque polychrome style, but only in the sense of an homage, similar to Evelyn Vigil's Pecos pottery from Jemez.

Cordelia Gomez is the closest thing to an established pure Pojoaque potter, but even here, it's hard to see the beginning of a Pojoaque

family tradition. Cordi's son Glenn considers himself a Taos potter and her son James does incised Santa Clara-style work. He normally signs his work "Pojoaque/Taos," but the Pojoaque part doesn't seem all that important to him. The one in the picture didn't have enough room on the bottom, so it just says "J. Gomez Taos."

Today, Pojoaque seems quite content to let neighboring San Ildefonso be the pueblo of dance, ceremony, and weighty pottery tradition. Pojoaque and its 250 people do just fine as the pueblo of new hotels and shopping centers.

TOP ROW: *Jar, James Gomez, 3½″ diameter, 1995; jar, Cordi Gomez, 6¾″ diameter, 1987; seed jar, Joe and Thelma Talachy, 3″ diameter, 1993*
BOTTOM ROW: *Seed jar, Joe and Thelma Talachy, 2⅛″ diameter, 1985; three bear figurines, Cordi Gomez, ¾″ long, 2″ long and 2⅞″ long, 1991; buffalo figurine, Cordi Gomez, 4″ long, 1993*

We met Cordi Gomez at the Santa Fe Powwow, and she graciously took us to her home, where we found the pieces (large jar, bears, and buffalo) in the picture. The micaceous jar is proof of the fact that pots can talk. She made it in 1987, sold it at the San Juan Crafts Center, and forgot about it. In 1994, she saw it again at a yard sale. As she put it, the pot called out, "Mommy, it's me." She had no choice but to buy it back and keep it until she found it a better home. Which, we suppose, was us.

The Joe and Thelma Talachy pieces (seed jars at right and lower left) are typical of the carefully decorated polychromes they've made since the 1970s, and the James Gomez piece is typical of his Santa Clara style.

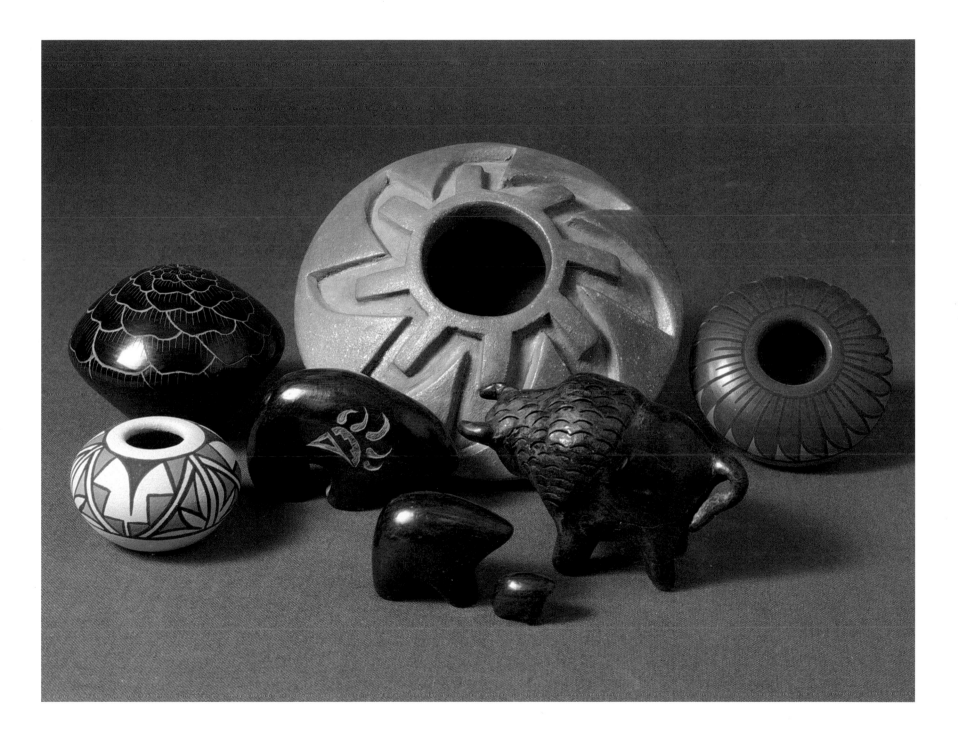

Sandia

▶▶▶ *From 1540 on, it's been a rough go.* Sandia sits on the edge of Albuquerque's urban sprawl, on the lower slopes of 10,678-foot-high Sandia Crest. If you stumble into Sandia, it's probably because you're on your way to enjoy one of Albuquerque's strongest tourist attractions, the tram ride to the mountaintop.

Sandia (the accent is on the second syllable: San-DEE-ya) has been there since about 1300, barely recognized, often stepped on. Its very names indicate the lack of respect and attention it has always been accorded. In the original Tiwa, it's *Nafiat*—"A Dusty Place." When the Spanish renamed it, they didn't pick a saint to honor it; they named it "Watermelon," because that's what they thought the local squash were.

Today, the town has 138 square miles of landscape that extend from the Rio Grande well up the mountain slope. It was one of the twelve Tiguex pueblos that Coronado visited in 1540, most of which were on today's Sandia land. Historians aren't sure whether Sandia itself was one of the ones Coronado burned down, or whether, by escaping the torch, it might have had one of its last strokes of good luck.

In 1598, the pueblo fell under Governor Oñate's heavy thumb, and the subsequent Spanish treatment of the pueblo was sufficient to make it an enthusiastic participant in the 1680 revolt. Poor Sandia couldn't even enjoy the success of the revolt. In 1681, Governor Otermín made an abortive attempt at reconquest, accomplishing very little beyond burning down Sandia and forcing the residents to flee all the way to Hopi. They built the village of Payupki on the Second Mesa and stayed there until the priests rounded them up in 1742 and brought them back to Sandia to rebuild the mission. Ever since, Sandia has been overwhelmed by Albuquerque, New Mexico's only true urban complex.

Today, Sandia has only two hundred people, a casino, one of the most impressive craft stores in the Southwest, and almost no artistic heritage. In *Pottery of the Pueblos of New Mexico, 1700–1940,* Jonathan Batkin reported two nineteenth-century observers, one of whom wrote about Sandia blackware while the other talked about black-on-white. In *American Indian Pottery,* John Barry told us that one woman was producing pottery in Sandia in 1931, and that he had seen one bowl of recent origin in 1978. Neither book showed any pictures.

When we went searching for Sandia pottery, we started at Bien Mur, the craft store at Sandia, a treasure trove of fine work from other pueblos. We asked about Sandia pottery, and the clerk said, "Well, Gina, the bookkeeper, used to make pottery, but since she got the job here, she doesn't have time to make it any more." A year later, we found a ten-year-old pot by Gina the bookkeeper at a store in Tucson.

There were and are others, and we found a few pieces. But there's no Sandia heritage or style. For the foreseeable future, Sandia pottery will consist primarily of work by potters from Jemez or Cochiti or wherever who marry in and continue to make the pottery they always made. One glimmer of hope: John Montoya's work improved rapidly in the late 1990s, and he may lead a Sandia resurgence much as Hubert Candelario and Daryl Candelaria are doing in San Felipe.

TOP ROW: *Jar, D. Montoya, 5½" diameter, ca. 1980; bowl, Gina Pecos, 4¼" diameter, ca. 1985; jar, John Montoya, 4⅞" diameter, 1992*
BOTTOM ROW: *Bowl, Helen Garcia, 4¼" diameter, ca. 1975; storyteller, Trinnie Herrera Lujan, 3¾" high, 1994; bowl, Helen Garcia, 3¼" diameter, ca. 1975*

The bowl at top center is by Gina the bookkeeper, who comes from a talented Jemez pottery family. From the look of her works, it's a good bet that Helen Garcia (bowls at left and right) was a Jemez potter as well. D. Montoya's jar at top left might be a little off-center and kiln-fired, but it's nicely designed, while John Montoya's jar at top right pretty well defines the purity of Sandia's pottery heritage. We're told it was done on a wheel, and its decorative elements include a Zuni heartline deer, a San Ildefonso avanyu, a Cochiti lizard, an Acoma butterfly, a Hopi bird, and Santa Clara cloud and rain designs.

Trinnie Lujan's storyteller is a nice storyteller. But, except for the signature, it's a Cochiti storyteller.

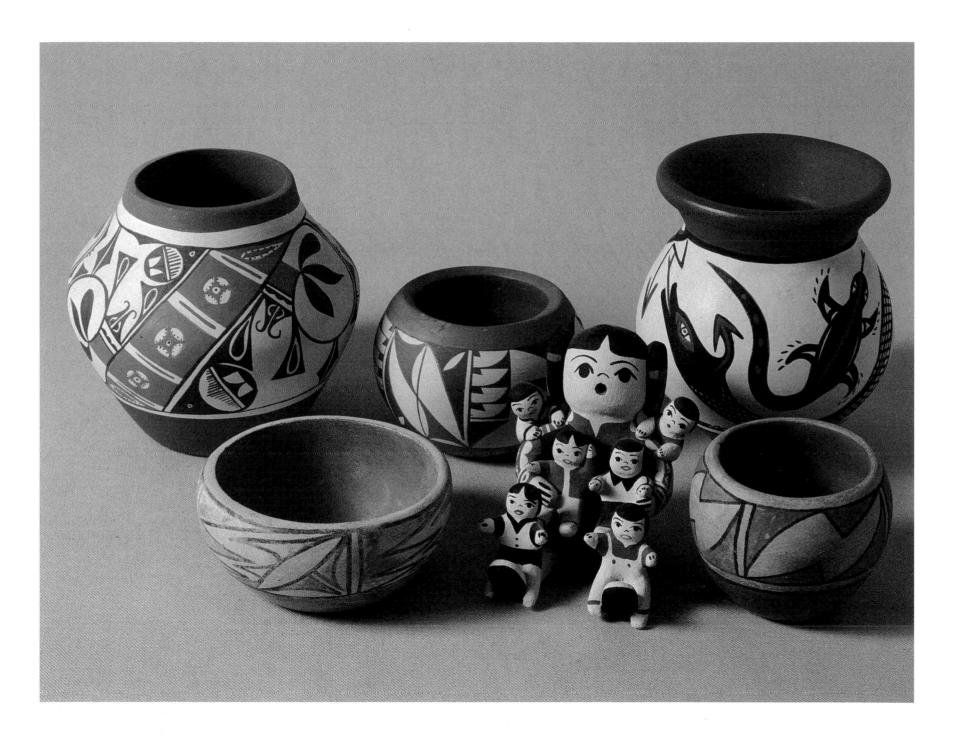

San Felipe

➤➤ Here, at least, we think there's a pottery heritage to recover. But it's so well hidden, it may never resurface. San Felipe itself is well-hidden. Not that it's located far off the beaten path—reservation lands cover three hundred square miles along a fifteen-mile stretch of the Rio Grande, and Interstate 25, the highway that connects Albuquerque and Santa Fe, runs right across it. But it's so little publicized that you'd think San Felipe is as small as Sandia.

Much of this lack of publicity is intentional. The pueblo has one of the most conservative tribal governments, offers little encouragement to visitors, and devotes most of its attention to agriculture.

If you've looked at the histories of the other Rio Grande pueblos, San Felipe's won't come as a surprise. It was probably settled by Anasazi before 1400; it was Christianized in 1598; it was punished by the Spanish cavalry for objecting a few years later; it participated eagerly in the 1680 revolt; its rebels were flushed out of their mountain hideaway by General de Vargas in 1692 and put to work building new missions in 1702. Over the years, the citizens of San Felipe were given plenty of reasons to decide they wanted little to do with Spanish or Anglo settlers.

San Felipe pottery is a puzzlement. As with Sandia, both Batkin's *Pottery of the Pueblos of New Mexico, 1700–1940* and Barry's *American Indian Pottery* dismiss it without a picture. Neither mentions what, based on the dozen or so examples we've seen, seems to us to be a genuinely distinctive pottery heritage: San Felipe brownware.

There are two examples in the picture on the next page, done more than fifty years apart. That time span alone indicates to us that brown pots from San Felipe were more than a minor aberration. Not that we've been able to find any evidence that anybody's still making them, or any evidence in any other book that anybody from San Felipe *ever* made them.

Modern San Felipe pottery certainly has nothing to do with brownware. It seems to have narrowed down to two transcendent potters, who, in the 1990s, found styles that pushed them into the inner circle of Southwestern potters. Hubert Candelario's orange micaceous wares are packed with theatrical appeal, while Daryl Candelaria has vaulted to the top of the ladder based on his late-1990s experimentations. Note the spellings—Daryl's name ends in "a" while Hubert's ends in "o." We assumed they were brothers until we looked carefully at the bottoms of their pots.

From what we can tell, there isn't much else currently happening at San Felipe. The picture on the next page tells a fairly clear story: an old tradition slowly abandoned, a mixture of traditionless work that could have come from Sandia or Isleta or Jemez or any other pueblo that lost the way, and intriguing work by two new potters that may inspire others.

Since there are twenty-five hundred people in San Felipe, we can only hope that pottery will find its way to new heights, as it did at Jemez and Laguna.

TOP ROW: *Seed jar, Hubert Candelario, 6⅛″ diameter, 1992; olla, 9″ diameter, 1986; bowl, Valencia Montero, 6½″ diameter, ca. 1975*
MIDDLE ROW: *Jar, 6″ high, ca. 1900; bowl, Hubert Candelario, 9¼″ diameter, 1989; swirl seed jar, Hubert Candelario, 6⅛″ diameter, 1993*
BOTTOM ROW: *Sculptured jar, L. L. Lucero, 4⅝″ diameter, 1978; dish, 1⅞″ diameter, 1964; bowl, B. Chavez, 6⅛″ diameter, 1984*

The jar with the bird on it at left and the tiny dish in the bottom row represent San Felipe brownware in 1900 and in 1964. Nobody we know of makes it now, but scratch the slip on the 1986 olla and on Valencia Montoya's 1975 bowl, and you'll find the same brown.

Other pots in the picture are search-for-a-tradition pieces. B. Chavez's bowl (bottom right) looks like D. Montoya's jar from Sandia, made about the same time, and L. L. Lucero's strange little jar (bottom left) looks like 1978 Jemez. The same holds true for Hubert Candelario's Santa Clara/San Ildefonso experiment from 1989.

But Candelario's orange balls from 1992 and 1993 are a different story. They're important enough to have attracted imitators—see Terence Cooka's Laguna piece on page 89—and to have found their way into some of the Southwest's priciest pottery stores.

Daryl Candelaria: rising star
12″ diameter, 1997

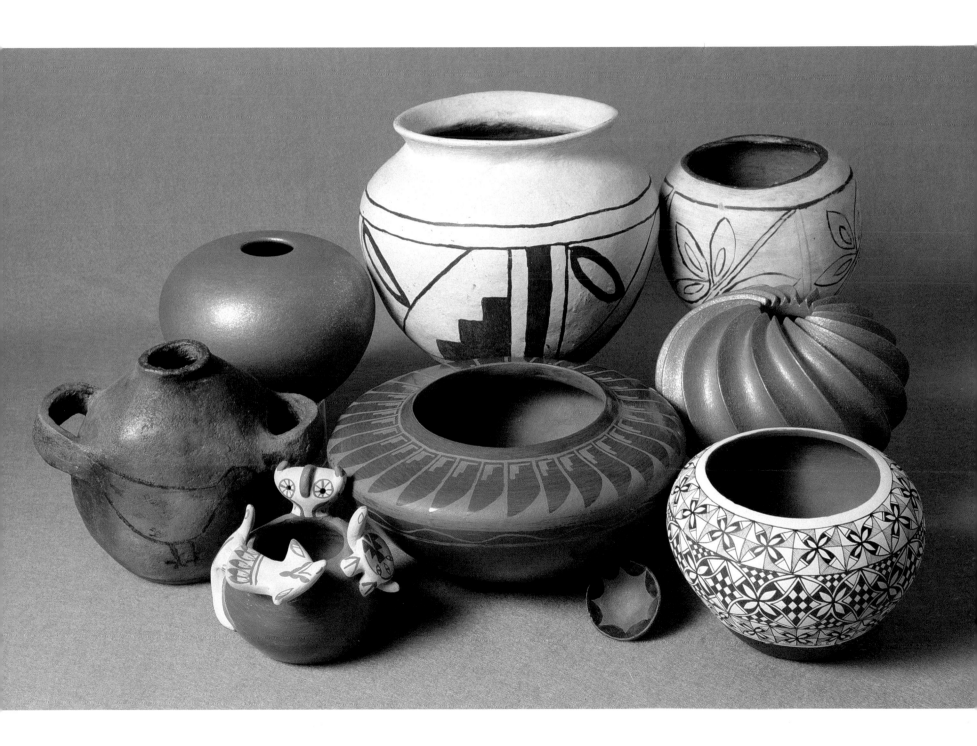

San Ildefonso

➤➤ Here, there's no question about the number one industry. You're looking at it. San Ildefonso's history is pretty much like the history of the other Rio Grande pueblos. Pretty much, but not entirely.

San Ildefonso's Anasazi ancestors settled what is now one of Santa Fe's premiere tourist attractions, Bandelier National Monument, adjacent to the lower left-hand corner of the reservation. Somewhere around 1300, they moved to a village a mile west of the current pueblo, where the Spanish found them in 1593. For the next eighty-seven years, they enjoyed the pleasures of mission-building and confiscatory taxation. Then, in 1680, they joined the rebellion and helped torch Santa Fe. They made their first divergence from the typical pattern that year— unlike their colleagues, they didn't burn their mission.

When General de Vargas restored the Spanish in 1692, San Ildefonso maintained a truce for two years, then rebelled and moved to a stronghold on Black Mesa, a table rock just north of the pueblo. They made their second departure from typical history in 1694. When the Spanish came after them with troops and a cannon, the Indians won the fight. The Spanish retreated, and ultimately San Ildefonso came off the mesa and wrote a truce on its own terms.

It lasted another two years, until San Ildefonso's patience finally broke. This time, they *did* burn the mission, sixteen years after everyone else had burned theirs. It was the last straw for de Vargas,

too. He sent a larger army to the Black Mesa and pacified San Ildefonso at gunpoint.

For the next three hundred years, San Ildefonso got better and better at making pottery.

Powhoge Polychrome (from *Powhoge-oweenge*—"Where the Water Cuts Down Through"— San Ildefonso's Tewa name) became the standard pottery form from San Ildefonso, Nambé, and Tesuque during the eighteenth and nineteenth centuries, but they made it just a little better at San Ildefonso.

In the second half of the nineteenth century, they added some red to the decoration on the upper body, and Powhoge Polychrome became San Ildefonso Polychrome. About 1905, they began using a grainy slip from Cochiti, and now it was Tunyo Polychrome. (Some experts lose patience with these hair-splitting classifications and say that it's all San Ildefonso, whether it's polychrome or black-on-red, Powhoge, Tunyo, or whatever.) Up to 1920, polychrome and, after 1900 or so, black-on-red remained the dominant San Ildefonso pottery colors. Even after 1920, the polychrome didn't totally disappear.

But everything else changed. Maria and Julian Martinez learned how to decorate blackware, and San Ildefonso pottery was no longer merely important among the Santa Fe pueblos. It became important to the world.

This array is one of the best one-of-each selections in the John & Al Museum. It's especially interesting because, despite the ages of these pieces, we have a pretty good idea of who did or (might have done) them. Only the Linda Dunlap piece (bottom left) is signed, but San Ildefonso pottery is so well documented and there are so few potters compared to the number in the larger pueblos that it's possible to make an educated guess and even some positive calls for every pot in the picture.

The double jar at bottom left is Powhoge Polychrome from its last days, and it's one of the crown jewels of our collection. Our attribution is a pure fluke. Charles Parker, who sold it to us, found an article in the Autumn 1991 issue of American Indian Art *that showed a pitcher that Marianita Roybal had written her name on before she presented it to a Colonel Green in 1881. It's now at the School of American Research in Santa Fe, and it has the same quirky bumps on the handle as well as other similarities to this piece. We made a pilgrimage to the SAR to check out Colonel Green's pitcher in the flesh, and bingo. If this little vase isn't by Marianita Roybal, we'll have hats for lunch.*

The Dolorita Vigil guess on the 1910 Tunyo Polychrome jar (top right) was suggested by Elvis Tsee-Pin Torres, our number-one expert on all things San Ildefonso and a fine potter in his own right (see page 117). Elvis also gave us some options for the larger black-on-red jar: possibly Dominguita Pino Martinez or Marianita Roybal again, painted by Maxmiliana Martinez. He thought the San Ildefonso Polychrome jar with the circular designs (deer hoofprints, we've been told), might be by Tonita Peña. Or might not.

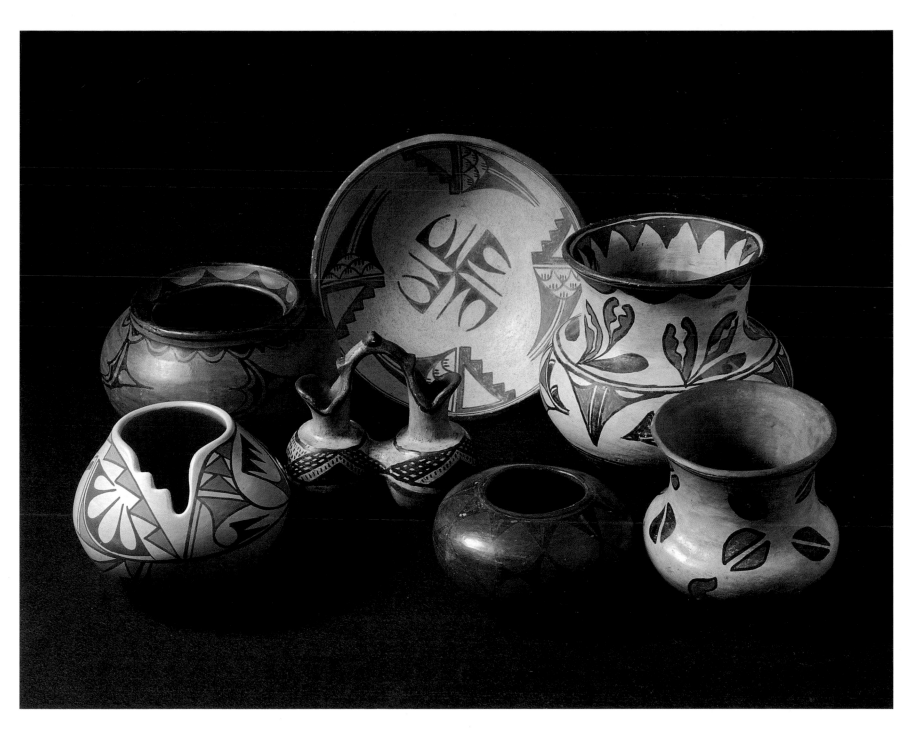

The Tonita Roybal call on the smaller black-on-red jar is a "Who else?" That was the sort of thing she was doing around 1920.

We found the Maria and Julian Martinez Tunyo Polychrome piece (top center) in a general antique store, where they were pretty sure it was "Indian." Every collector stumbles on a treasure like this once or twice in a lifetime, and this was our fifteen minutes of fame. Identifying it wasn't rocket science. It's right down the middle of what Maria and Julian did in the decade before Maria became the most famous potter in the world.

The one piece with a signature on it was done in 1993 by Maria's great-niece (Linda Dunlap), and it shows that they really do still make a few polychromes at San Ildefonso.

San Ildefonso · Maria Martinez

The Seven Families #4: Martinez. In 1908, Maria Montoya Martinez (1888–1980) and her husband Julian (1885–1943) were building a reputation for their Tunyo Polychrome. Maria could make big, graceful pots fast, and Julian painted their red-and-black-on-cream designs with a sure hand.

Then, history gets fuzzy. In *The Living Tradition of Maria Martinez,* Susan Peterson tells a clear story based on interviews with Maria. Edgar Lee Hewett, the Director of the Museum of New Mexico, needed a good, fast, San Ildefonso potter. His party had been excavating around the pueblo and they'd turned up some black sherds. Fascinated with the new discovery and driven by the same impulses that led Thomas Keam to ask Hopi potters to recreate Sikyatki ware almost thirty years before, Hewett asked Maria if she could make whole pots that looked like what these black pieces might have been.

Other accounts disagree emphatically. Equally credentialed authorities insist that Hewett asked Maria to reproduce black-on-cream ware, and that the pottery that made Maria famous was an unrelated discovery by Maria and Julian. In any event, in the winter of 1919–1920, they made the first black-on-black pieces. The Museum of New Mexico has two of these first large, black ollas.

They both have matte backgrounds decorated with polished *avanyus,* a traditional water serpent design. The matte backgrounds with polished images didn't last much beyond that first firing—they were too hard to make. Ever after, almost every piece of matte-and-polish has had a polished background with matte decoration. The avanyu, however, stuck hard, probably because Julian and Maria Martinez favored the design.

In turn, the fact that Julian and Maria favored them probably had a lot to do with Edgar Hewett and his eager assistant, Kenneth Chapman. In the Winter 1994 *American Indian Art,* Bruce Bernstein told how Hewett and Chapman favored "authentic" designs, and suggested that Maria and Julian decorate their blackware with motifs used on pottery excavated from the nearby Tewa pueblos of Puyé and Otowi. Julian's first avanyu, painted on a square redware basket ten years before, was copied without modification from a petroglyph that Chapman showed him.

Only one of the pieces in the picture to the right has an avanyu, but as soon as you turn the page, you'll see these feathered serpents wrapped around pot after pot, page after page, pueblo after pueblo.

Before long, Maria and Julian's black-on-black was turning into a commercial success, and she had to teach other family members how to make it. The hardest part of the teaching must have been how to create the silvery-black mirror polish that makes "Maria Pottery" just a little bit different from all other blackware. On later undecorated pieces, Maria achieved a true gun-metal gray, unique until 1990s Mata Ortiz potters figured out a way to do it.

By 1925, Chapman had her signing her pots. She signed them "Marie" because someone told her Anglo buyers would like it better. As her work became wider known, she was afraid her success would attract jealousy within the pueblo, so she got Julian's permission to show anyone in San Ildefonso how to make the blackware.

By 1930, Maria was world famous. And San Ildefonso was famous as the place where Maria Pottery came from.

TOP ROW: *Dish, Maria and Santana Martinez, 5¾″ diameter, ca. 1950; dish, Tonita Roybal, 10⅝″ diameter, ca. 1940; jar (below), Tonita and Juan Roybal, 7¼″ diameter, ca. 1935; jar, attributed to Popovi Da, 8¾″ high, ca. 1970*
MIDDLE ROW: *Jar, 5″ diameter, ca. 1925; jar, Maria and Julian Martinez, 4″ diameter, ca. 1940; jar, Desideria Sanchez, 4½″ diameter, ca. 1940; jar, Maria and Julian Martinez, 5″ diameter, ca. 1940*
BOTTOM ROW: *Jar, Tony Da, 3″ high, ca. 1965; dish, Lupita Roybal, 5¾″ diameter, ca. 1950; jar, Juanita Vigil, 4¾″ diameter, ca. 1930*

This is the ware that captured the world's attention and lifted the prices of Pueblo pottery from the under-a-dollar range into the rarefied atmosphere of hundreds and eventually thousands of dollars each.

Maria's sister, Desideria Sanchez, and in-law, Tonita Roybal, both achieved such prestige that first names were enough. Say "Maria," and everybody knows who you mean. To anybody who knows even a little about Southwestern pottery, "Tonita" and "Desideria" mean almost as much.

"Juanita" is an important signature, too, but two people used it: Maria's sister, Juanita Vigil, and her cousin by marriage, Juanita Wo-Peen. Fortunately, we learned how to tell their handwriting apart.

All were satellite to Maria and her lifetime of collaborations: with Julian until 1943, with her daughter-in-law Santana Roybal Martinez until 1956, and with her son Popovi Da until his death in 1971. The unsigned Popovi Da piece (top right) was attributed by the original owner who bought it directly from him.

By the 1970s, Popovi's son Tony Da (he pronounces his last name "Day" while Popovi said "Dah") was already internationally famous. His black-and-sienna pot is in a style his father developed and Tony helped popularize. Popovi's original ware required a difficult double-firing technique that the Das kept secret for years. But others figured out ways to achieve the look, and since the late 1970s, black-and-sienna has been a standard variant for any potter who makes blackware.

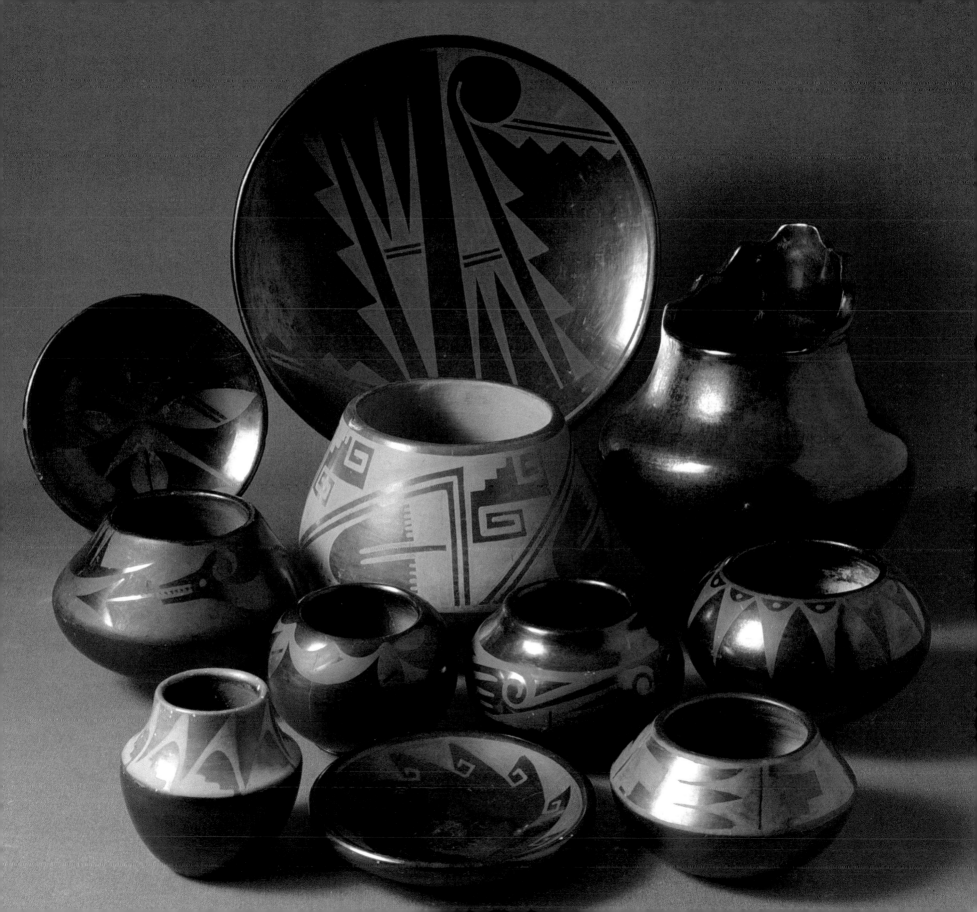

San Ildefonso · After Maria

Matte-and-polish evolves. After 1930, Maria was an institution, invited to fairs, expositions, museums, and universities, producing pottery that became the standard high-priced commodity of the Indian art market.

As the years passed, the torch had to pass as well. The post-Maria era really began in the 1950s as she began her collaboration with her son Popovi. She produced less and less for the remainder of her life, and potters other than her direct descendants were gaining fame.

But her shadow was huge. Since 1920 on, "Maria Pottery" has been at the center of San Ildefonso's economic welfare, and it probably will remain there for years to come. No matter how much restless young potters may experiment, Maria Pottery—matte decoration using traditional designs on a highly polished, unsculptured vessel —will continue, although it won't all be black-on-black. The surface might be red or cream, and the decoration might be almost any color.

The picture to the right includes pieces that look like Maria made them and pieces in styles her relatives developed. Maria's sister Juanita Vigil had two famous potter children. Carmelita Dunlap focused her interest on reviving polychrome, something Maria and Julian never totally stopped producing. There's a piece by Carmelita's daughter Linda on page 113.

Carmelita's younger brother Albert married Josephine Cordova, and they developed a new Martinez-family trademark pottery: white-on-red. Their son Doug and his wife Charlotte make pieces whose quality matches mom and dad's. White-on-red caught on, in and out of the family. Kathy and Geraldine Gutierrez are great-grand-daughters of Maria's aunt, Nicolasa Peña Montoya, way over on the other side of the family tree. Lorenzo Gonzales is off the tree entirely. His sister, Blue Corn, is San Ildefonso's most famous potter outside the Martinez and Gonzales families.

Blue Corn explored all the dimensions of matte-and-polish: conventional black-on-black, startling color combinations, and subtle effects. Note the unexpected mixture of matte-and-polish in the decorated center band of the cream-colored pot in the picture.

Maria's son Popovi Da's black-and-sienna caught on as well. Popovi's brother Adam and his wife Santana, Maria's collaborator from Julian's death in 1943 until the mid-1950s, experimented with it, as did Santana's daughter Anita and half the other potters at San Ildefonso and Santa Clara.

Black-on-black is going strong, too. Santana and Adam kept doing it, others are still doing it, and the craft is passing through the generations. In a generation leap, senior citizen Margaret Gutierrez, Tonita Roybal's daughter, and young Elvis Torres collaborated on as pure a "Maria" piece as you'll find anywhere.

TOP ROW: *Bowl, Kathy Gutierrez, 4″ diameter, 1995; bowl, Lorenzo Gonzales, 7″ diameter, ca. 1980; jar, Albert and Josephine Vigil, 4″ high, 1992; jar, Margaret Lou Gutierrez and Elvis Tsee-Pin Torres, 4¼″ diameter, 1995; seed jar, Blue Corn (Crucita Calabaza), 4″ diameter, 1992*
MIDDLE ROW: *Jar, Santana and Adam Martinez, 3″ high, ca. 1980; bowl, Santana and Adam Martinez, 4¾″ diameter, 1985; jar, Doug and Charlotte Vigil, 5″ diameter, 1985; jar, Anita Martinez, 3½″ diameter, ca. 1985; table lighter, Blue Corn, 2¾″ diameter, ca. 1970*
BOTTOM ROW: *Jar, Geraldine Gutierrez Shije, 2½″ diameter, 1994; turtle figurine, Louis Naranjo, 3⅛″ long, 1990*

"Maria Pottery" may have branched out over the years, but the basic form never branched very far. In the thirty years between the time Santana began painting for Maria and the time she and Adam made the little blackware jar at left, very little happened.

Very little happened in the next fifteen years as well, as Margaret Gutierrez and Elvis Torres demon-strated in the newest piece on the page. The little turtle by Louis Naranjo (not the same person as the better-known Louis Naranjo from Cochiti) may be a sculpture rather than a vessel, but there's nothing about it that would have surprised Maria.

Same with Blue Corn's cigarette lighter. It brings a smile today, but back in the 1960s, every coffee table had a Ronson table lighter, and one in San Ildefonso blackware must have seemed like a gracious, tasteful accessory.

The fact that five other potters besides Albert and Josephine worked on the white-on-red pieces in the picture indicates that it, too, has achieved the kind of ritual predictability that moves quickly to "tradition" status.

Black-and-sienna offers more possibilites, and has more variety. The two examples in this picture are refined but rather mild specimens, and potters from Santa Clara, Hopi, and even tradition-bound San Ildefonso have taken the genre much further.

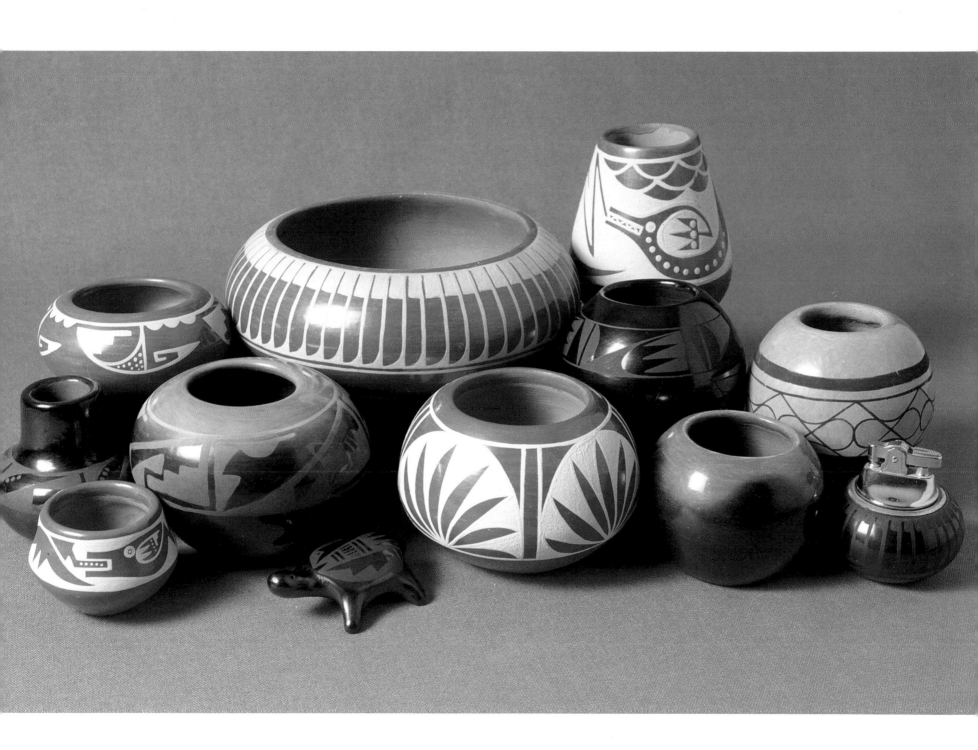

San Ildefonso · Rose Gonzales

The Seven Families #5: Gonzales. If Maria Martinez is the most celebrated of all the Pueblo potters, her cousin's wife Rose Gonzales (1900–1989) has to be the least-publicized of the seven matriarchs. A yellowed clipping we found in the bottom of the bowl on the next page indicates the extent of her anonymity. It shows her picture and says only, "Pottery making is popular among the women. It is taught by Rose, from the San Ildefonso pueblo near Santa Fe."

Both Rose and her son Tse-Pe had a heavy influence on San Ildefonso pottery, and their innovations have become standard in the San Ildefonso repertory. Where Maria built her reputation by making painted pots, Rose got hers by making carved ones.

Generally, carved blackware and redware are more a Santa Clara than a San Ildefonso thing, and Rose didn't have a problem with poaching a little Santa Clara turf, as the redware piece on the next page indicates (compare it with the 1940-vintage pieces on page 133). After all, she wasn't San Ildefonso by birth, she was married in, a Cata from San Juan. But Rose's carved blackware was an original creation, subtly different from Santa Clara's. A Santa Clara potter carves deep relief and creates a smooth matte indentation, but Gonzales-style carving is shallower, the surface edges can be rounded rather than sharp-cut, and the indentation is often intentionally textured and sometimes polished on the high points.

Tse-Pe followed his mother's direction, but wandered far afield. From the 1960s on, Tse-Pe and his first wife, Dora, experimented with odd shapes, double firings, inlays, and unusual slips.

Dora is a Gachupin, an important name in Zia pottery, but after she married in 1961, she learned San Ildefonso methods, was a major San Ildefonso potter by the 1970s and continued on after their divorce.

His second wife, Jennifer Sisneros Tse-Pe, came from an equally talented San Juan pottery family, and she too has become an important San Ildefonso potter. Jennifer S. Tse-Pe will keep the middle initial for the foreseeable future. It distinguishes her work from that of Tse-Pe and Dora's potter daughter Jennifer Tse-Pe, who died in 1998. Jennifer S. also experiments with unusual slips. The green on the jar on the next page is unusual, but not unheard-of. Blue Corn tried odd slip colors like blue and pumpkin orange in the 1970s and Tse-Pe himself currently does pieces with a metallic bronze slip.

Unfortunately, the Gonzales line isn't burgeoning. Beyond Tse-Pe and his two wives, there's just one highly active potter in the next generation. Tse-Pe has three living potter daughters, but only Candace Martinez has done important recent work. She also inhabits the center of San Ildefonso's pottery establishment. Her husband, Ray Martinez, is Maria's great-grandson, a potter himself, owner of a San Ildefonso gallery and student of San Ildefonso pottery history.

But there's a bit of life elsewhere. Juanita Wo-Peen's daughter Adelphia Martinez is Rose Gonzales's niece. In *Fourteen Families in Pueblo Pottery,* she appears in the Martinez pages, but much of her work owes more to her aunt Rose than it does to her second cousin Maria.

TOP ROW: *Inlaid jar, Tse-Pe, 5″ high, 1998; wedding vase, Adelphia Martinez, 7½″ high, 1994; bowl, Juanita Wo-Peen, 7½″ diameter, ca. 1935; egg, Tse-Pe, 3¾″ high, 1965*
MIDDLE ROW: *Bowl, Rose Gonzales, 4¾″ diameter, ca. 1965; inlaid bowl, Tse-Pe and Dora, 5″ diameter, 1973; lidded box, Rose Gonzales, 4⅝″ wide, ca. 1940; bear figurine, Tse-Pe, 5⅜″ long, 1993*
BOTTOM ROW: *Bottle with stopper, Jennifer Sisneros Tse-Pe, 4″ high, 1994; jar, Jennifer Sisneros Tse-Pe, 3½″ diameter, 1994; seed jar, Tse-Pe, 3″ diameter, 1997; bowl, Tse-Pe, 4¼″ diameter, 1990; inlaid jar, Candace Martinez, 2¼″. high, 1994; jar, Jennifer Sisneros Tse-Pe, 2¾″ diameter, 1994*

One of our regrets in gathering this collection is that the only Rose Gonzales pieces we found that we could afford weren't carved, or even typical. However, the large bowl at the top by her sister-in-law, Juanita Wo-Peen, could easily pass for an early work by Rose if it weren't for the signature.

Her family's work thoroughly defines the style as it evolved. Tse-Pe's pieces show all the carving variations: carving before firing, where the low part comes out black, carving after firing (the egg), where the low part comes out raw, and carving in the middle of a double firing (the black-and-sienna bowl), where the low part comes out a mottled tan. Tse-Pe and Dora's bowl not only has the carving, it has an inlaid turquoise stone. These days, an inlaid piece of coral or turquoise is standard show biz among blackware potters, but back in 1973, it was progressive stuff.

Tse-Pe's bear is a showpiece. Instead of the usual arrowhead or feather burden, it packs a turquoise surfboard.

And Tse-Pe and Dora's daughter Candace echoes their work in the inlaid jar down front. It looks like it popped full blown out of the bowl her parents made almost twenty years before.

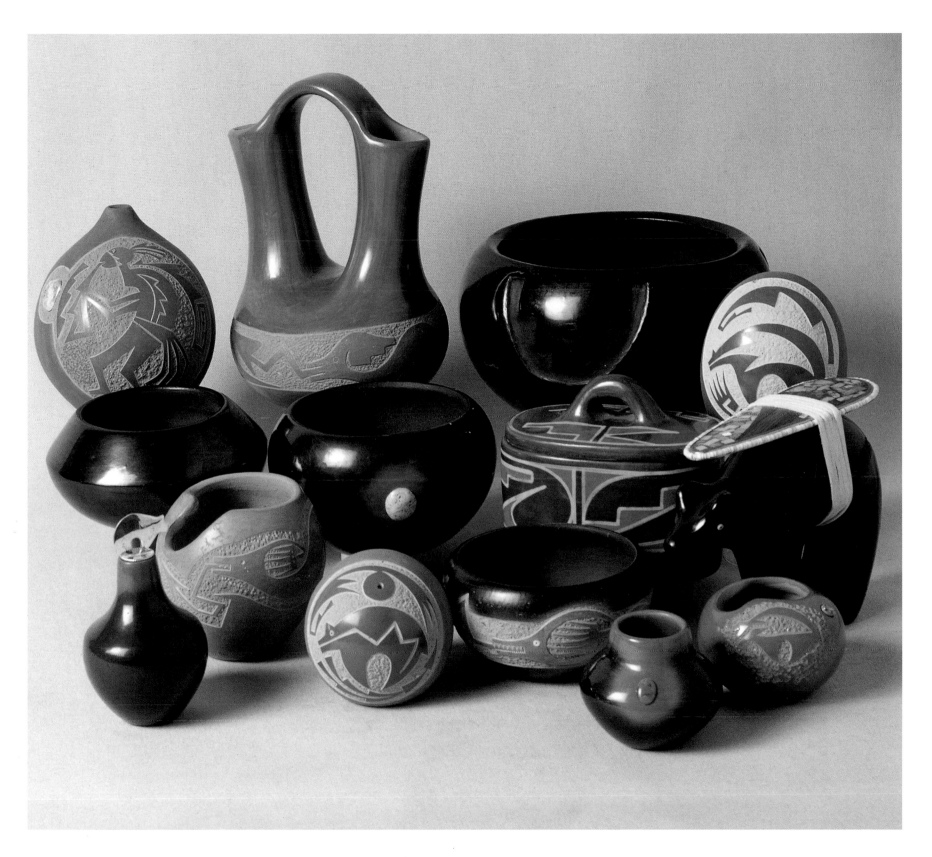

San Ildefonso · New Names, New Ideas

Quiet exploration. San Ildefonso may have gained world renown for its pottery, but it's really just a tiny town—about five hundred people in the mid-1990s. Perhaps forty artists provide the wares that keep Maria's legacy alive.

This places a heavy burden on any San Ildefonso resident who chooses to make pottery. There's no room for young potters who crank out inexpensive tourist pieces while they learn the craft. San Ildefonso's hundred-year-old reputation as the premier producer of quality pottery among the pueblos was hard-won and won't be surrendered without a fight.

By the same token, these circumstances would seem to leave little room for experiment. Because that reputation is based on a strong and highly recognizable design tradition, any San Ildefonso potter who leaves it behind risks the same heavy criticism. Susan Peterson stated that Maria hid her first blackware pieces because she felt they weren't true San Ildefonso pottery and therefore wouldn't be accepted. Family pressures make it even harder to stray from the path. The community is so small that almost everyone has a Martinez or a Gonzales or a Roybal on nearby branches of the family tree, either by blood or by marriage.

Despite all these constraints, careful experimentation continues. Here, twelve examples by San Ildefonso potters exploring the traditions: Maria pottery, Rose pottery, and pottery that doesn't quite fit either idiom. Missing: potters like Russell Sanchez, Gilbert Atencio, and Cavan Gonzales, who inhabit the rarefied upper end of the pottery world. They've escaped the John & Al Museum simply because we haven't yet found pieces of theirs we could afford within our buying rules.

But, in the ongoing confrontation between experimentation and tradition, there's no question in our minds which side has the upper hand. For us, the thirteenth pot in the picture settles the argument.

In 1995, Marvin Martinez sold pottery on the plaza in Santa Fe, just like his great-great-grandmother Maria did seventy and eighty years before. That's where we bought the blackware bowl in the picture that looks for all the world like something Maria and Julian made in 1925. Did we get a message from this little moment of living history? You bet we did.

TOP ROW: *Jar, Elizabeth Lovato, 5″ diameter, 1991; jar, Marie Gonzales Kaehela, 4¾″ diameter, 1994; seed jar, Elizabeth Lovato, 4¾″ diameter, 1992*
MIDDLE ROW: *Kiva sculpture, Peter Pino, 5½″ long, 1990; seed jar, Elizabeth Lovato, 3½″ high, 1993; bear figurine, Juan Tafoya, 4¾″ long, 1994; bowl, John Gonzales, 4½″ diameter, 1993; jar, Barbara Gonzales, 4″ diameter, 1993*
BOTTOM ROW: *Bear figurine, Kathy Sanchez, 2⅞″ long, 1993; seed jar, Barbara Gonzales, 3″ diameter, 1993; jar, Marvin and Frances Martinez, 4⅜″ diameter, 1995; jar with stopper, Nadine Baca, 2½″ high, 1994; turtle box with lid, Kathy Sanchez, 4″ long, 1994*

San Ildefonso isn't hopelessly locked in place. Even members of the Martinez family experiment: Kathy Sanchez, Peter Pino, and Barbara Gonzales are Adam and Santana's grandchildren, Nadine Baca is Tonita's granddaughter.

Nadine's little bottle with the bear stopper is a case in point. It's hard to imagine a more deft piece of Pueblo pottery, yet her work is so low-profile that she doesn't even rate the red dot that designates working potters in Fourteen Families in Pueblo Pottery. *Perhaps only in the Martinez family can such skill remain so unnoticed. Kathy Sanchez and Barbara Gonzales, on the other hand, are major figures.*

Elizabeth Lovato and her brother Juan Tafoya do some of San Ildefonso's finest and most under-publicized work. The four pieces in the picture speak for themselves: highly imaginative content, impeccable technique. Elizabeth's seed jar at the right of the top row was one of the very first pieces John bought, and it still remains one of his favorites. Peter Pino's kiva sculpture and Marie Kaehela's incised jar represent San Ildefonso pottery on the outer edge. On the other hand, John Gonzales's bowl proves that Rose's pottery continues unchanged. And Marvin and Frances Martinez's avanyu-circled bowl looks so much like one of great-great-grandmother's pieces that it's almost scary.

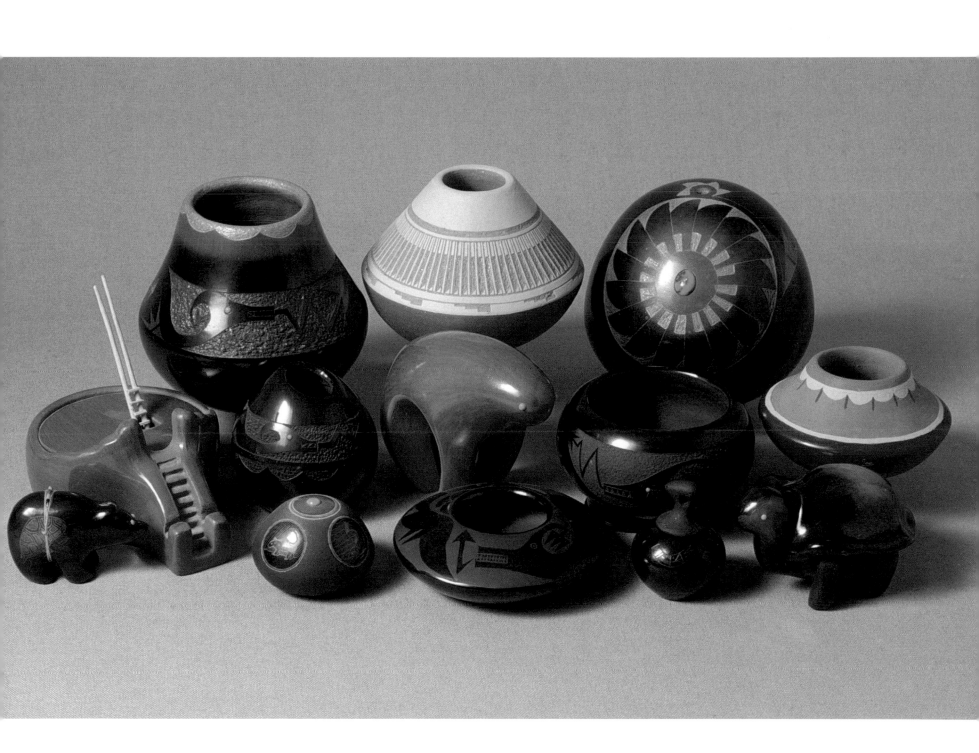

San Juan

▶▶ *Its Indian name is Ohkay, and we suppose that's accurate enough today. But there were a few rocky years along the way.* Coronado knew that Anasazi lived up the Rio Grande at Ohkay, but he spared them the pleasure of his company. San Juan saw its first Spanish in 1593, and, according to a contemporary account, the women were so frightened that they wept at the sight. Future events proved the appropriateness of their reaction.

Governor Oñate came to call in 1598, and he not only declared all its residents members of the Catholic church, he liked the village so much he kicked everybody out, declared it the capital of his new fiefdom, and renamed it San Juan de los Caballeros— St. John of the Horsemen. (Prepared-in-Santa-Fe literature tends to translate it "St. John of the Gentlemen," but there seems to have been little gentlemanly behavior towards the natives on Oñate's part.)

San Juan only lasted a month as Oñate's capital. He moved to a now-abandoned pueblo just across the Rio Grande and built the first mission in New Mexico. Eleven years later, the capital moved to Santa Fe, but San Juan had been the first pueblo to feel the full weight of Oñate's heel. Resentment toward the Spanish built early and strong. Ultimately, the Spanish made their big mistake. In 1675, they decided to quash heathen worship for good, and they tried forty-seven religious leaders from several pueblos for murder and witchcraft.

Popé of San Juan escaped with a flogging, and spent the next five years plotting with other victims of the purge. Today, he's generally credited with having been the leader of the brilliantly synchronized guerrilla uprising that burned the missions and drove the armed, mounted Spanish military machine all the way down to El Paso. Camelot only lasted twelve years, however, and, almost immediately after the reconquest, General de Vargas made sure that San Juan got the opportunity to build a brand new mission.

From that time on, San Juan has had a low profile, even though its current population of fifteen hundred makes it one of the larger northern pueblos. San Juan pottery is low-profile as well, although it has a distinctive tradition, demands great skill, and is highly recognizable.

San Juan pottery has a relative lack of market appeal compared to work from Santa Clara and San Ildefonso. For better or worse, Santa Fe drives the market for Southwestern art. Through the twentieth century, starting perhaps even before Edgar Hewett began working with Maria Martinez, the curators, critics, and dealers who comprise Santa Fe's art establishment have encouraged, influenced, directed, commissioned, and promoted the work of Santa Clara and San Ildefonso potters and paid much less attention to the work done a few miles north.

Before 1900, San Juan pottery was clearly different from that made by its Tewa neighbors to the south. After 1900, according to some sources, it went into eclipse, only to be revived around 1930 by potters with a new set of standards.

We find it difficult to accept such a big time gap, and we've assigned intermediate dates to some of the pieces in the picture. We can be sure of a few things, however.

Older San Juan pottery was thinner and harder (because of a higher firing temperature) than Santa Clara pottery, and it had a distinct break between the high polish of the upper body and the matte lower portion. San Juan pre-1900 pottery was either red or black, showed micaceous flecks in the slip and was normally undecorated; however, fire clouds on the redware are so prominent that they seem to be intentional. We hesitate to date the bowl at the upper right as pre-1900, but it fits the description.

The almost identical blackware bowl seems a little older. Except for the color, it could be the same pot. The boot is so Victorian that it has to be early. We're hedging our bet on this one—it could be a thinner-than-usual Santa Clara piece.

There's no question about the rest of the pieces in the picture. If a Victorian glassware curio inspired the 1880s boot, a Mexican pot inspired the jar with handle at the left, and we know when it was made because it's written on the bottom. The incised decoration on the moccasin foreshadows what was to become a San Juan trademark.

On the later pieces, the fire clouds are gone, and three of the four have painted matte surfaces, another component of the post-1930 San Juan pottery revival. But they don't really represent where San Juan pottery was headed. For that, turn the page.

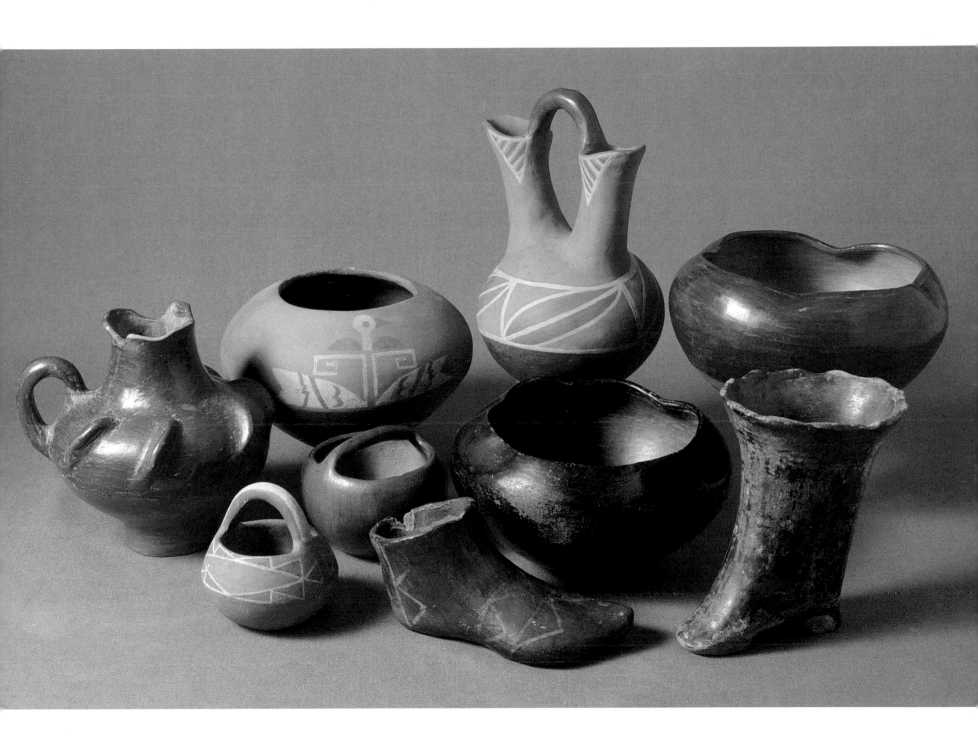

San Juan · Building a Style

An incisive approach. In the nineteenth century, San Juan made and traded a large amount of pottery. But Jonathan Batkin's *Pottery of the Pueblos of New Mexico, 1700–1940* points out that, according to the census, there were no potters in San Juan in 1910.

This doesn't mean, of course, that those potters vanished like their prehistoric ancestors. Census records of the pueblos have always been unreliable because Pueblo Indians haven't always shared the Census Bureau's compulsion to record every possible fact. However, it does suggest that there probably weren't a lot of highly visible potters working in San Juan in the first quarter of the twentieth century, and that one's chance of turning up San Juan pottery from that period is correspondingly slim.

Beginning about 1930, a whole new style emerged, led by seven potters working under the urging of Regina Cata, a married-in Spanish woman who in turn was urged either by the ubiquitous Kenneth Chapman or, more likely, by Chester Faris, the superintendent of the Santa Fe Indian School (and the man who told Maria

Martinez to change her name to "Marie"). The new group included Crucita Trujillo, Gregocita Cruz, Crucita Talachy, Reyecita Trujillo, Luteria Atencio, Tomasita Montoya, and one other whose name no one seems to remember.

Regina Cata's pottery had several characteristics that distinguished it from earlier San Juan work, and those characteristics persist today. It was heavier, more like Santa Clara pottery. It was almost entirely redware. There were no more fire clouds. The unpolished underbodies were now polished and the midbody had a matte band. And the pottery was no longer undecorated.

Those matte bands became a mural space, to be carved and painted with natural slips in a rich variety of design. You'll find stark whites, micaceous golds, dark, rich reds, and every color in between. Today, if you see a matte pinkish-red field on a piece of red pottery, and that matte field has incised designs filled with white, cream, and red, you can say "San Juan" and be right just about every time.

The new look took hold, and it never let go.

From the 1930s through the 1990s, what you see in this picture has been the essence of San Juan pottery. Only the Tomasita Montoya pot at top left differs from the pattern in the slightest, and she was certainly entitled to fool around a bit. After all, she was one of Regina Cata's original seven followers.

Dominguita Sisneros's bowl in the middle row, center, has geometric incising almost like the Mimbres hatching the Lewises and the Chinos loved at Acoma, but the design comes from Regina Cata rather than Lucy Lewis. She did geometrics like this from the outset. The micaceous slip is almost like gold paint. When modern San Juan pottery looks micaceous, it's intentional, well beyond the random flecks that show up in pre-revival pieces.

In Pueblo Pottery of the Indians of New Mexico, Betty Toulouse described how Cata and her follower studied Potsuwi'i sherds found near San Juan, a late prehistoric type featuring incised decoration. One can almost hear the helpful suggestions of Faris, Chapman, and their friends. In their relentless search for the authentic, they never missed an opportunity to encourage a Pueblo potter to switch over to historic or prehistoric decorative motifs, thereby making their art more "purely Indian" and less "debased" by European influences. The fact that this purity was obtained at the suggestion of a non-Indian didn't seem to bother them.

In any event, it didn't take long before Regina Cata's original eight and their followers started using any design they pleased on their pots, authentic pre-European or not.

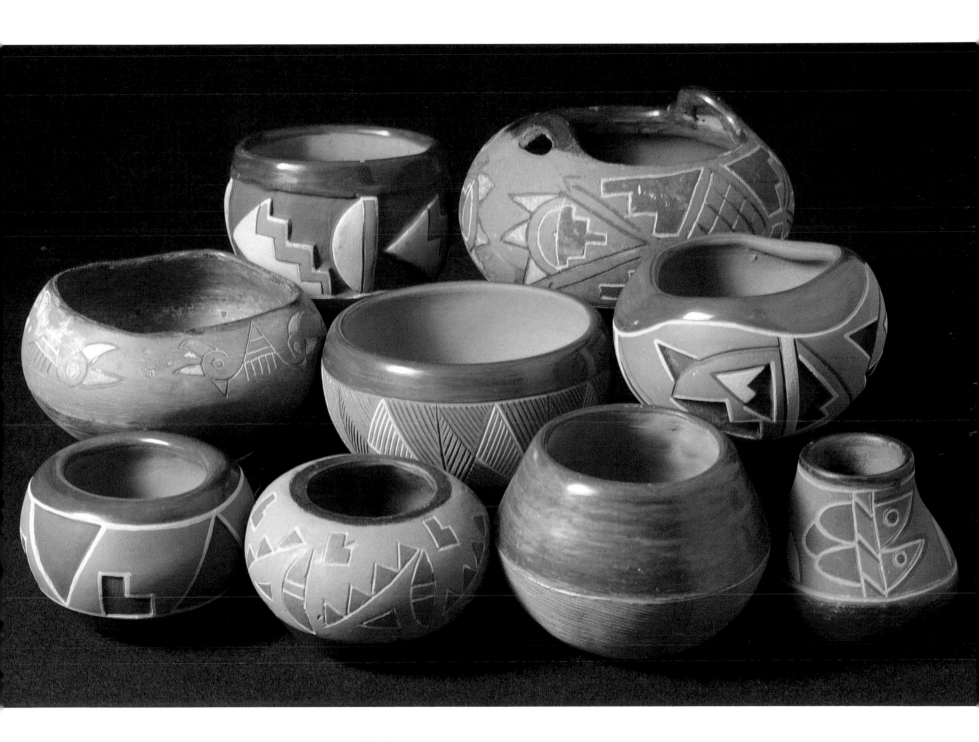

San Juan • Beyond the Style

More of the same. Only different. Regina Cata's legacy has endured far longer than most. Today's San Juan potters still work within the style she defined, more or less.

But most citizens of San Juan Pueblo have their minds on things other than pottery. Farming and sheepherding still occupy much of their attention, as does commuting to jobs in Española, Los Alamos, and Taos.

If you drive into the pueblo today, you'll find the impressive Oke Okweege Arts and Crafts cooperative by the road, but the last time we were there, in 1994, we didn't see work like the pieces in the picture. San Juan has taken note of the quick economic boost Pojoaque and Tesuque have experienced in recent years, and the lesson hasn't been lost.

The fact that there's little immediate evidence of top-level pottery at the pueblo doesn't mean it's not being done, it just means that pottery isn't as important to San Juan's overall well-being as it is, say, to San Ildefonso, Acoma, or Hopi. At those pueblos, you can park your car almost anywhere, walk two minutes, and find good pottery for sale. That doesn't work at San Juan. Instead, you have to go to Santa Fe or Albuquerque, find the better retail neighborhoods, walk two minutes, and see an array of beautiful work like the pieces in the picture.

You'll see that cream slips have joined the red and that, despite the work of Tom and Sue Tapia, blackware is scarce. Micaceous slips have reappeared and undecorated pottery still exists, as it has all along. Also, you'll see that a few potters are experimenting with non-traditional things like commercial paints, as on Dominguita Naranjo's micaceous piece in the picture.

This, after all, is Southwestern pottery's Golden Age, and San Juan's work is no exception. Its pottery is getting more and more refined, to the point where the pots to the right make the work by Regina Cata and her contemporaries look downright primitive by comparison.

TOP ROW: *Wedding vase, Lawrence Dili, 11 ½″ high, 1994; jar, Myrtle Cata, 11″ diameter, 1992; vase, Mary Maestas, 7¼″ high, 1992*
MIDDLE ROW: *Jar, Sue Tapia, 5½″ diameter, 1995; bowl, Dominguita Naranjo, 7⅛″ diameter, 1990; jar, Myrtle Cata, 6″ diameter, 1993*
BOTTOM ROW: *Bear figurine, Alvin Curran, 3⅜″ long, 1994; jar, Tom and Sue Tapia, 4¼″ diameter, 1995; frog figurine, Lawrence Dili, 2″ high, 1993*

The Mary Maestas jar and the Lawrence Dili wedding vase in the top row are direct inheritors of Regina Cata's legacy, brought into line with Golden Age demands for technical mastery and design skill.

Myrtle Cata shares Regina Cata's name, but her plainware (jars, top and middle right) in some ways echoes earlier times at San Juan. It's thin, graceful, and undecorated, a result of the ever-escalating sophistication among the best potters from all pueblos.

Dominguita Naranjo's bowl (center) departs from the Cata tradition, but she has inarguable credentials. She's Tomasita Montoya's granddaughter and mother of two important potters: Janet Teba, whose Cata-esque jar appears on the previous page, and the forever-inventive Jennifer S. Tse-Pe, whose work keeps moving San Ildefonso's Gonzales family in new directions.

Alvin Curran (bear figurine) underscores the cross-cultural nature of Southwestern pottery. His wife, Dolores, is every bit as famous as a potter. She lives at San Juan with Alvin and works in her native Santa Clara style, but strongly encouraged her husband to stay in the San Juan tradition. You'll see Dolores's miniatures on pages 141 and 175 (the black jar in the middle).

Tom Tapia's incised blackware has been widely known since the 1970s, and his wife Sue has developed her own carved style.

And Lawrence Dili is as versatile and imaginative as any potter in the Southwest. We've never seen another frog quite like this one.

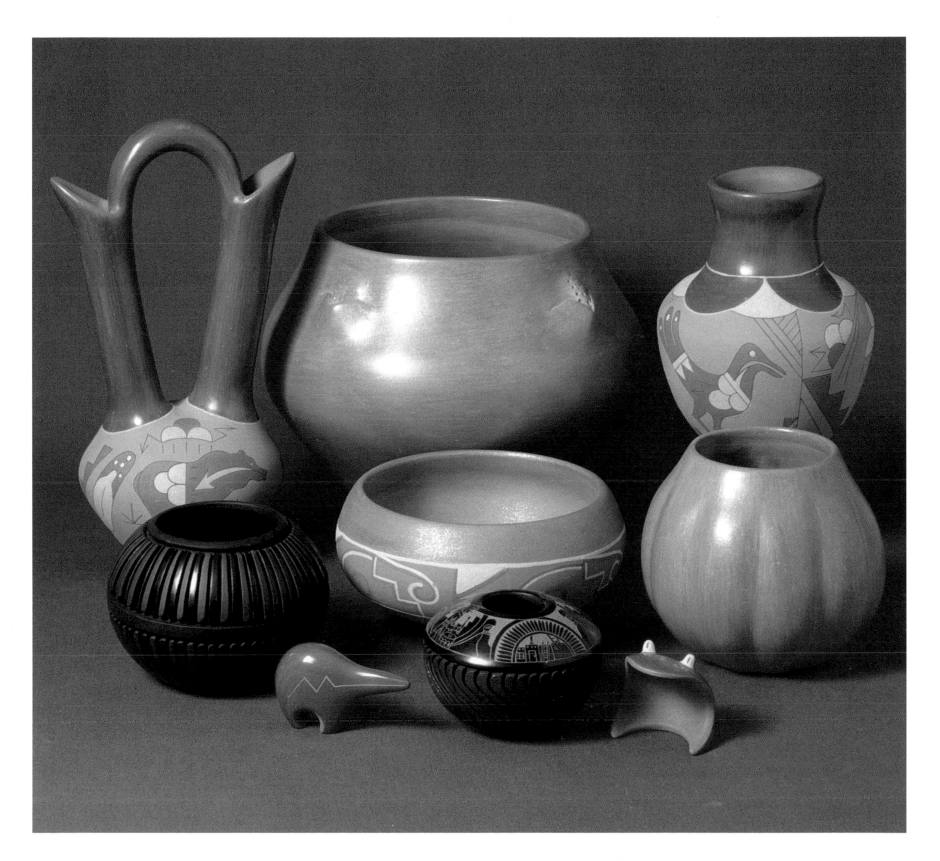

Santa Ana

▶ *Rare pottery from the pueblo of mystery.*
Old Santa Ana is closed to the public more than 350 days every year.

The barrier on New Mexico's Highway 44 helps make Santa Ana seem like the most remote and inaccessible of all the Rio Grande pueblos. Actually, the public isn't missing much activity. The old pueblo, a bit north and west of the current center of activity along Highway 44, has been reserved mainly for ceremonial use for more than a hundred years.

Santa Ana and Zia are kindred Keresan neighbors with a comfortable back-fence relationship. When Antonio de Espejo claimed them for the Spanish crown in 1583, he lumped them together as the "Province of the Punames." They suffered together for the next hundred years. In 1688, Spanish troops from El Paso inflicted the only significant punishment that occurred between the 1680 revolt and the 1692 reconquest: Both pueblos were destroyed and their populations scattered. The Santa Anas hid in the Jemez mountains, and, when they returned after the reconquest, looked around for better land. In the eighteenth century, they bought five tracts along the Rio Grande from the Spanish, farmland rich enough to encourage them to leave the old pueblo behind and establish Santa Ana II.

Ever since, the balance of trade has largely remained one of Zia pottery for Santa Ana crops; made–in–Santa Ana pottery has been correspondingly scarce. Today, Santa Ana prides itself on its organic farming agribusiness, but it's

become far more than a sleepy, private farming community. It also runs the upscale Prairie Star restaurant on the outskirts of nearby Bernalillo and the 27-hole Valle Grande golf course by the Jemez Dam, all administered from the "new" 200-year-old pueblo by the Rio Grande.

Historically, both Zia and Santa Ana potters made the same ware, Puname Polychrome. But when the Santa Anas moved east to the river, they substituted fine river sand for the black basalt temper the hillside-dwelling Zias used and still use.

This difference in temper serves as the easiest identifier between Santa Ana and Zia pottery. If you find a scratch or a nick in the slip, look at it through a magnifying glass. If you see black flecks of temper in the clay, you're looking at a Zia piece. The Santa Ana piece won't show black.

Because pottery was relatively unimportant at Santa Ana, it came close to dying out. Two people kept it alive: Eudora Montoya and an interested Anglo, Nancy Winslow of Albuquerque. Eudora learned pottery from her mother but didn't become serious about it until 1946, when she was in her forties. Back then, some of the older potters were still working, but by the early 1970s, she was the only Santa Ana potter.

In 1972, Montoya and Winslow organized a group of seventeen student potters. Ever since, pottery has trickled out of Santa Ana, all well made, all worth admiring, but there's never enough so that you'll find it without an effort.

TOP ROW: *Bowl, 6″ diameter, M. Montoya, 1994; jar, Rachel Medina, 6⅞″ diameter, 1990; jar, Elveria Montoya, 6″ diameter, 1993; bowl, 6¾″ diameter, ca. 1925*
MIDDLE ROW: *Canteen, Lena Garcia, 3″ wide, 1983; bowl, 7″ diameter, ca. 1900; bowl, Renee Montoya, 6⅜″ diameter, 1994; bowl, 7″ diameter, ca. 1935*
BOTTOM ROW: *Bowl, probably Eudora Montoya, 4″ diameter, ca. 1950; jar, 3¾″ high, ca. 1930; bowl, 3″ diameter, 1971*

The three large jars and the crimp-necked bowl summarize Santa Ana in the 1990s: three Montoyas and a married-in Medina from Zia. There's a creamy, almost waxy quality to the white slip that makes Santa Ana pottery recognizable even before you get out your magnifying glass to look for the black flecks of Zia basalt in the clay.

We're just about positive the bowl at the bottom center of the picture is Eudora's work, because of its quality and its age. The fact that it's unsigned pushes its date before the 1972 classes, and if it's before 1972, who else did it? Not the potter who made the little bowl at right in the bottom row. It has a 1971 graffito date on it, and it doesn't have the Montoya/Santa Ana look in the way that Lena Garcia's canteen does. She was one of the original seventeen students in Eudora Montoya and Nancy Winslow's classes.

The bowl at top right, the one just below it, and the jar in the bottom row represent an earlier period. They show that the Montoyas' Santa Ana colors of the 1990s look just like the colors of the 1920s and 1930s. The jar has another Santa Ana characteristic: what some books call the "Eiffel Tower" design. You can also see it on M. Montoya's bowl at the far left.

The old bowl in the bottom row is so deteriorated that you can barely make out the butterfly designs on the side. It's in such dismal condition it could even be Zia—the scratches are so dirty it's hard to tell if you're seeing basalt.

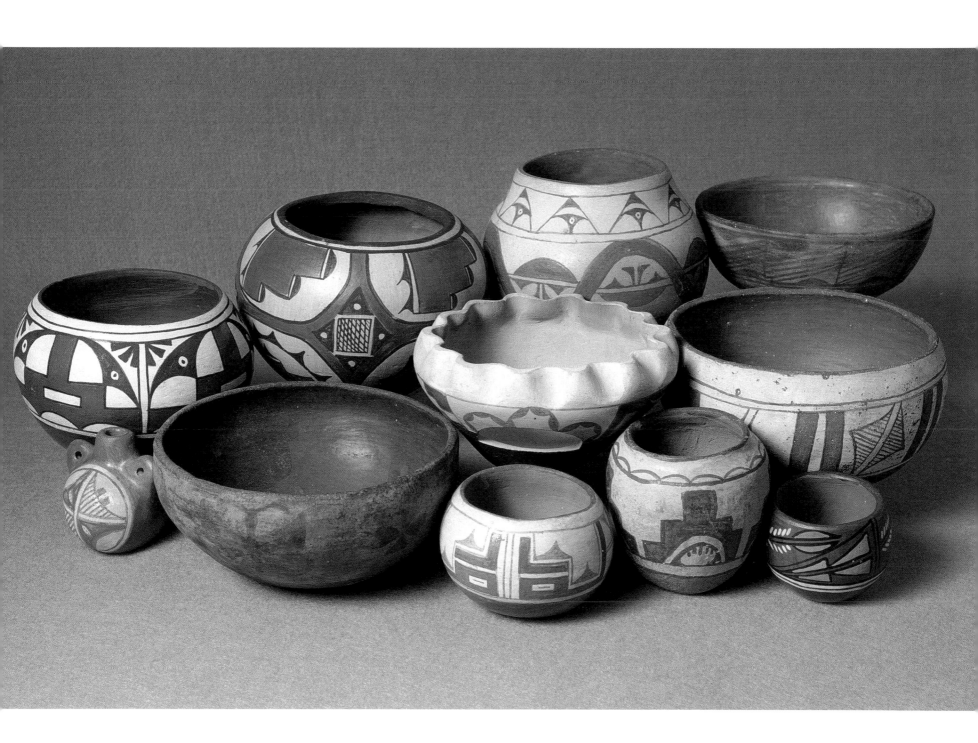

Santa Clara

▶▶▶ *Now it produces the fanciest pottery of all the pueblos. But it took a while getting there.* Santa Clara's early history was much like San Ildefonso's. The Anasazi probably built on Santa Clara land in the early 1300s, and you can visit the mesa-top ruins at Puyé today, right in the middle of the reservation. Some time around 1500, the Puyé dwellers joined their neighbors on the banks of the Rio Grande. They encountered Coronado's group in 1540, they had a mission by 1629, and, according to the fashion of the times, they burned it in 1680. After the 1692 reconquest, they joined the San Ildefonso people on Black Mesa and held off the Spanish until 1696. When Black Mesa fell, many Santa Clarans fled west to Hopi and Zuni, but by 1702, most of them were back and at work building a new and better mission.

Today, Santa Clara lives in easy cooperation with the heavily Hispanic population surrounding Española, and the pueblo's residents farm, work in Los Alamos, and make pottery.

They *really* make pottery. Perhaps 200 Santa Clara potters are turning out stylish blackware and redware, including some of the highest-priced pottery ever made. It wasn't always thus, however. When James Stevenson and Frank Cushing made the first Indian pottery-collecting expeditions for the Smithsonian in 1879, they gathered black, red,

and micaceous bowls and storage jars from Santa Clara, all undecorated. There's mention of a polychrome as well, but none seems to have survived. Early writers agree that most of the fine ceremonial polychrome pottery Santa Clara used at the beginning of the twentieth century came from San Ildefonso. Even the impressed bear paw, the most traditional design element on Santa Clara pottery, wasn't common until after 1900. One source dates the earliest documented piece with a bear paw at 1903, but others say the symbol goes back to the mid-nineteenth century.

What *did* happen early was traders and tourists. In 1880, the Denver & Rio Grande Railroad's legendary "Chili Line" connected Española to Santa Fe. Suddenly Santa Clara's undecorated blackware became small in size and varied in shape: cream pitchers, vases, cups, candlesticks, dishes, bird and animal figurines, and even a toy train. Bruce Bernstein suggests that, rather than being just for tourists, Santa Clara condiment jars and sugar and creamers became tableware staples in Hispanic and Anglo households during the later years of the century. Betty LeFree went so far as to call the years between 1880 and 1920 Santa Clara's "Period of Handles."

The Period of Greatness was to follow.

TOP ROW: *Water jar, 7½″ high, ca. 1910; bowl, 9″ diameter, ca. 1900; vase, 10¼″ high, ca. 1900; melon jar (below), 4¼″ diameter, ca. 1950*
MIDDLE ROW: *Teapot, 4″ high, ca. 1890; bowl, Frances Chavarria, 4⅞″ diameter, ca. 1960; swirl jar, Severa Gutierrez, 7″ diameter, ca. 1940; jar, 6¼″ diameter, ca. 1900*
BOTTOM ROW: *Sugar bowl and creamer, 3½″ diameter, ca. 1910; beaver figurine, 4¼″ long, ca. 1950; moccasin, 4½″ long, ca. 1920; turtle pin tray, 4¼″ long, ca. 1950; offering dish, Legoria Tafoya, 7¼″ diameter, ca. 1940*

There are several pieces here from the "Period of Handles." The eldest is the little teapot, with the unslipped bottom half that persisted in San Juan pottery but seems to have disappeared from Santa Clara ware by 1900. The wonderful big bowl with the bear paws is an almost-pure statement of the essence of early Santa Clara blackware.

The narrow-necked water jar has an indentation where the neck flares out to meet the body, a design element characteristic of early Santa Clara work. Santa Clara potters still use the indentation on traditional blackware jars.

Until the 1930s, well-made and well-fired Santa Clara blackware could hold water. Modern Santa Clara and San Ildefonso blackware is fired at a low temperature and is distressingly water-soluble, as we learned the hard way when our roof leaked during a winter storm. The sugar bowl and creamer could fall into the let-the-tourist-beware category. If you actually left cream in the pitcher, it might be all right, but it could melt out the bottom in a day or two. Yet Santa Clara made these for years. (Turn the page, and you'll see redware sets.)

The hands at the bottom of the handles on the big vase show up on pieces by the legendary Sara Fina Tafoya, but this one is a bit lopsided, probably not made by a master potter. The shape of the vase itself is traditional and is still being made.

Plain blackware with and without impressed designs has persisted to the present. The pieces in the lower part of the picture date into the 1960s and represent various stages of evolution. Little moccasins

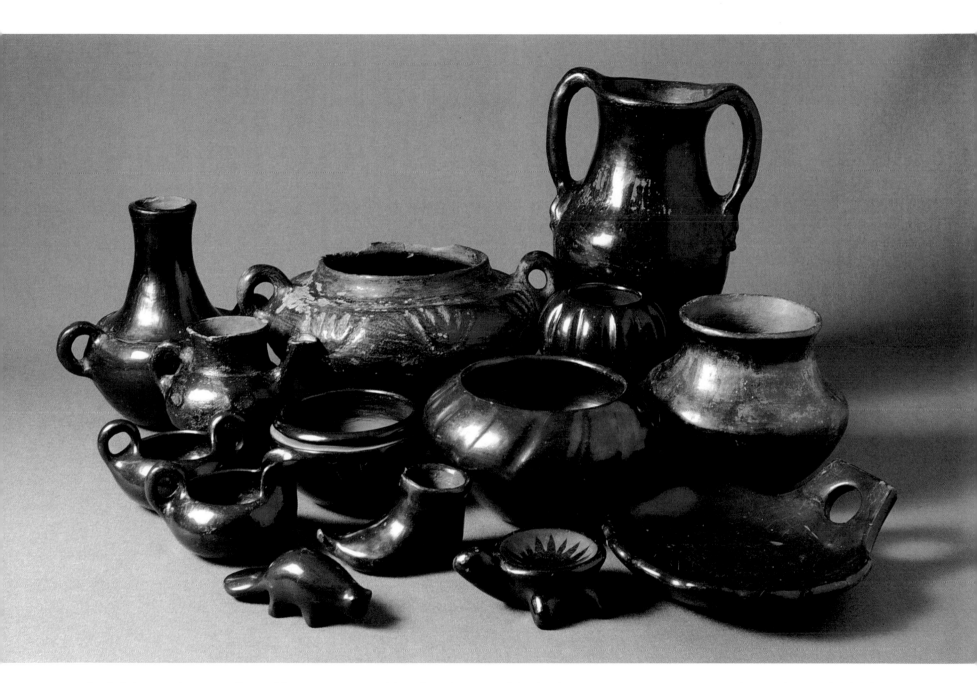

appeared early, before 1900, from Santa Clara and from most other pueblos as well. Animalitos, whimsical, small animal figurines, first showed up around 1910, supposedly made by little girls. Now Santa Clara potters produce so many of them that we're convinced they breed.

Melon jars, like the two bowls at right center, have been a part of Santa Clara pottery all through the twentieth century. As the years passed, they gained sophistication.

By 1940, Severa Gutierrez Tafoya was already taking the melon impression away from simple vertical lines and making swirl jars. She was a contemporary of Maria's and a major player.

Santa Clara · Redware

Black, we leave black. Red, we put colors on. In 1879, when Stevenson and Cushing wrote about Santa Clara redware, they pointed out that a Santa Clara potter would fire all her pots to a red color, then set aside the ones she intended to remain that way. The others, she'd smother in cow chips and refire, turning them into blackware.

The redware Stevenson and Cushing saw was utilitarian and undecorated but not necessarily primitive. Mary Ellen and Lawrence Blair's *Margaret Tafoya* shows a polished redware jar from 1865 that looks finished enough to pass for a modern polished piece. After 1880, redware, never all that common to begin with, moved into the background, but it resurfaced strongly around 1930 when potters started putting white paint on it.

Other colors followed, and in 1932 they even tried a commercial orange paint on blackware, but it scratched right off. In the 1930s, potters added a buff and what Betty LeFree called a "weak red." By 1940, they'd discovered a blue gray. The buff and weak red appear on San Juan pottery as well, but the blue gray was almost exclusive to Santa Clara.

White always outlined the other colors. "Always" isn't an exaggeration, as the picture demonstrates. At first, designs were geometric, but pictorials followed soon after, and even Bambi has a white halo.

These two-, three-, and four-colors-on-red polychromes hit their popularity peak between 1940 and 1960, but they never disappeared. The turtle in the front dates from 1994, and it displays some newer developments: matte surfaces and Belen Tapia's blue color that first showed up in the 1960s.

Although most Santa Clara redware is polychrome, plain redware is still around. The Baca family has made a niche for itself with melon jars (several experts have suggested Angela Baca for the unsigned black one on the previous page), and Alvin Baca's impeccable redware one from 1992 confirms his family's mastery of the genre.

TOP ROW: *Dish, Flora Naranjo, 10¾″ diameter, ca. 1945; bowl, Belen Tapia, 7¼″ diameter, ca. 1960; dish, Reycita Chavarria, 11¼″ diameter, ca. 1950*
MIDDLE ROW: *Engagement basket, 6″ high, ca. 1955; bowl, Belen Tapia, 6″ diameter, 1990; bowl, Anna Archuleta, 4¾″ diameter, 1990; bowl, 8¾″ diameter, ca. 1940; melon jar, Alvin Baca, 5½″ high, 1992*
BOTTOM ROW: *Bird ashtray, 5½″ long, ca. 1935; sugar bowl and creamer, 3¾″ diameter, ca. 1955; turtle figurine, Anita Suazo, 4½″ long, 1994, bird ashtray, 6½″ long, ca. 1950*

Santa Clara Polychrome redware ranges from serious work by serious potters, like Flora Naranjo's avanyu dish in the top row, to unashamed tourist pieces. The creamer probably wouldn't hold cream, the bird ashtray at the right of the bottom row says "Merry Xmas" on the rim, and the Navajo rug design on the large flat bowl may not have much to do with Santa Clara, but it sure looks Indian.

Flora Naranjo's avanyu and Reycita Chavarria's deer show how Santa Clara potters adapted these white-outlined polychromes to pictorial subjects.

The basket with the single-twist handle is called an "engagement basket." These hefty, five-inch-diameter pieces have become part of the Santa Clara potter's standard repertory, so well established that they've attained a status close to traditional.

Belen Tapia has remained a leading polychrome redware potter for more than thirty years. Her pure colors give her pieces a cheerful look that her daughter Anita Suazo has mastered and that newer potters like Anna Archuleta emulate.

Alvin Baca is one of the leading lights in the Baca family, and his melon jars are textbook examples of melon-jar perfection. These days, melon jars are carved rather than impressed. You can tell the difference by feeling the inside. If it's impressed, you'll feel the melon shape there.

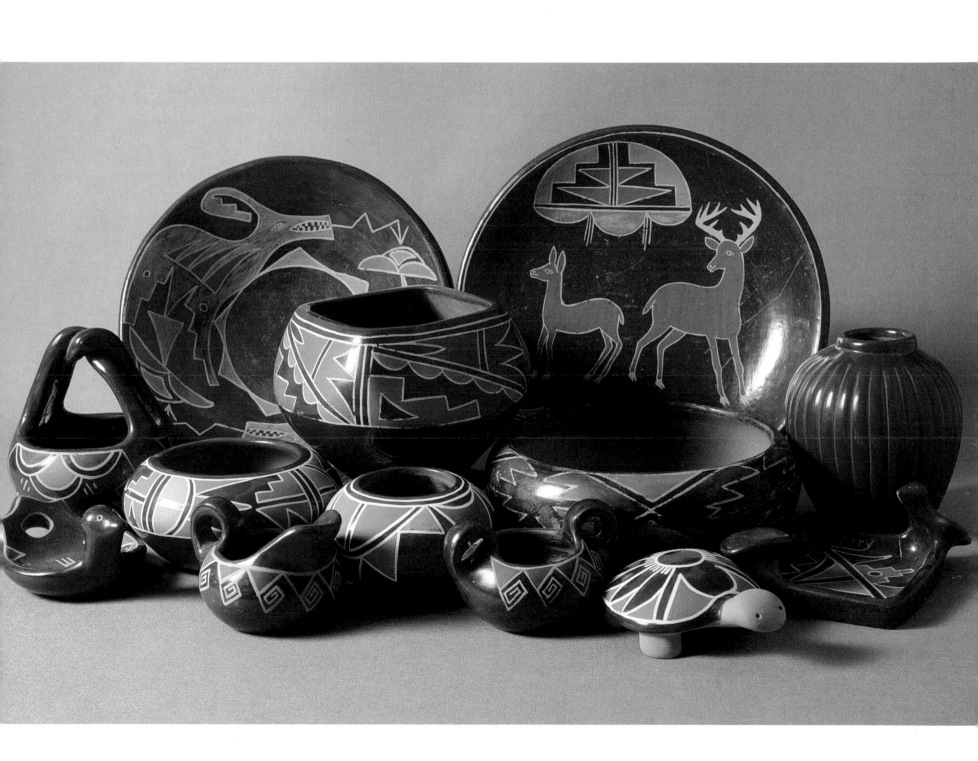

133

Santa Clara · Lela Gutierrez

The Seven Families #6: Gutierrez. In the hands of most Santa Clara potters, decorated redware achieved a predictable, ritualized presentation. This happened as well with Lela Gutierrez (1874–1966), but her predictability took an entirely different path.

She was among the first to experiment with the medium, predating most of her colleagues by five years or so, and she was the most adventurous in terms of color and design. Perhaps more precisely, her husband, Van, was the adventurer, since he did the painting, but the style they began in the 1920s continued unabated after his death in 1949.

Seven Families in Pueblo Pottery shows two polychromes by Lela that were supposedly made in 1907 and 1910, but most experts today dismiss those dates. In *Santa Clara Pottery Today*, Betty LeFree starts the Gutierrez's polychrome efforts in 1930. We've seen a polychrome vase that ostensibly has a provenance dating from 1928, and has a design that anticipates what they did from 1930 on. We believe that the Frank Lloyd Wright–looking jar in the picture dates from around 1930 or even earlier and is one of the earliest pieces in what was to become their trademark style.

After Van died, Lela continued working with their son Luther, and the large jar by Lela and Luther with the avanyu design is representative of basic Lela-Van-Luther-Margaret Gutierrez pottery. Almost every piece from 1930 on has a satin-finished, buff-colored band beautifully painted in slips that no one else has and that deliver color combinations no one else uses: yellow-orange, celadon green, warm gray, dark brown.

As Lela slowed down, her daughter Margaret took over, working first with Luther, then on her own, and now with her great-niece Stephanie. In the late 1990s, Margaret was still traveling all over the Southwest, from the Grand Canyon to Denver, to get her slips, and Margaret and Stephanie continue steady production of Gutierrez polychrome pottery. Today, however, Gutierrez polychromes are mostly *animalitos* and other little figurines rather than the stately jars that made Margaret's parents famous.

From the foregoing, it might seem like the dynasty will continue uninterrupted, but twenty-five years ago, the family tradition took a major sidestep. Luther's son Paul and his wife Dorothy began making little blackware mudheads and *animalitos* in quantities that defy belief. Today, Dorothy and Paul are better known than grandparents Lela and Van, or, for that matter, even Aunt Margaret, and their son Gary is following them as a blackware potter. Paul's sister defected from the polychrome ranks as well, making black-on-black pieces like the jar in the picture.

Lela and Van's buff bands with multicolored avanyus climbed high on the popularity charts, but their star is fading. Since 1980, buyers with the big money have been looking to the Seventh Family, the Tafoyas.

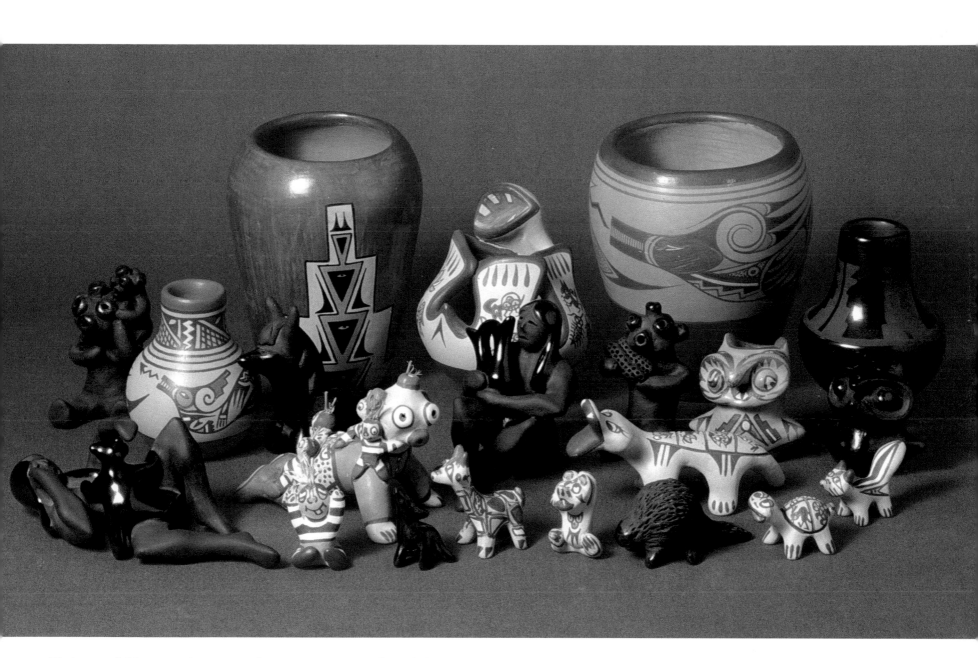

The jar at top left is a source piece, a very early Van and Lela and our earliest signed Santa Clara piece. Many experts might think our date is too early, but it has the scratched-in Lela signature without reference to Van (although he probably painted it) that appears on the earliest pieces and it doesn't have the band around the upper body that became their trademark.

She made the jar at top right years later with Luther, and if it were the only Lela Gutierrez piece you ever saw, you'd know what her work looked like.

Margaret and Luther continued making jars, but made more and more small figurines, each more grotesque than the last. The figures are about all Margaret makes these days, and Luther's granddaughter Stephanie continues the tradition.

Meanwhile, Dorothy and Paul started making little blackware figurines in the 1970s, and they haven't evolved one bit. You can pick up one that's twenty-five years older than the one next to it, and unless it's worn, you won't know which is which. Dorothy and Paul's son Gary also works in monochrome blackware and redware, specializing in sculptured figurines.

Santa Clara · Sara Fina Tafoya

The Seven Families #7: Tafoya. By 1900, Sara Fina Tafoya (1863–1949) was probably the leading potter in Santa Clara, master of large and small utilitarian forms, mainly in black, but also in red and micaceous clay. By "large," we mean *really big*. Some of her storage ollas approached thirty inches in their largest dimension.

She was also an open, friendly woman, and this combination of skill and temperament made her an early favorite of the new breed of curio dealers in Santa Fe. In turn, exposure to the outside world stimulated her to experiment with new forms unashamedly designed to appeal to the buying public's taste.

During the 1920s, her children were young adults, just the right ages to be swept into the rapidly developing market for better-quality Indian pottery created by the growing interest in Maria Martinez and San Ildefonso. In 1926, Fred Harvey Detours—luxurious limousine tours run from La Fonda Hotel in Santa Fe—began regular visits to Santa Clara, including ninety-minute layovers for lunch and serious pottery shopping.

As the 1930s unfolded, Sara Fina and her children were selling their work in Taos, in Santa Fe, and at the pueblo and won awards at the Santa Fe Indian Fair, the predecessor of today's Indian Market.

By the end of World War II, the Tafoyas had a family car and sold their pottery all over the Southwest. But Margaret and the Tafoya family's fame didn't really begin to grow until the 1960s, when it launched like a rocket. In today's marketplace, Sara Fina's children, grandchildren, great-grandchildren, and great-great-grandchildren have become the most prestigious, highest-priced group in all of Southwestern pottery.

Since the beginning, the Tafoyas have made all types of Santa Clara ware. Sara Fina stretched the definitions of size, quality, and form. Her pots were the biggest, roundest, best-finished, and best-polished. According to Mary Ellen and Lawrence Blair's *Margaret Tafoya*, she developed the first carved Santa Clara blackware in 1922. Later, her son Manuel (1895–1952), a part-time potter, did deeper carving, and by 1930, the two were doing carved ware that resembles modern Tafoya pottery.

Margaret continued raising the standards, and worked in all her mother's forms, including polychrome redware (although Belen Tapia's daughter questioned the experts' attribution on the large jar in the picture—she thought *her* mother probably made it, not Margaret). Margaret and Christina's carved work changed the general perception of Santa Clara pottery. If the arche-typical San Ildefonso piece is a Maria black-on-black, Santa Clara's counterpart is a Tafoya deep-carved piece.

In the 1960s, Margaret's brother Camilio and his son and daughter, Joseph Lonewolf and Grace Medicine Flower, developed a style of meticulously carved miniature pottery. It caught on so well it became the first super-high-priced Pueblo pottery, and Joseph's children continue the style.

The Tafoyas' imprint on Santa Clara pottery is so deep that it could well remain for most of the next century as well.

TOP ROW: *Jar, possibly Sara Fina Tafoya, 9¾″ diameter, ca. 1925; jar, Margaret Tafoya, 7½″ diameter, ca. 1960; jar, attributed to Margaret Tafoya (possibly Belen Tapia), 11¼″ high, ca. 1935*
MIDDLE ROW: *Basket, Christina Naranjo, 7″ high, ca. 1975; jar, Sharon Naranjo Garcia, 6⅞″ high, 1993; jar, Sharon Naranjo Garcia, 6½″ diameter, 1993; bowl, Mida Tafoya, 5⅛″ diameter, 1990*
BOTTOM ROW: *Incised egg, Susan Snowflake Romero, 1⅜″ diameter, 1993; jar, Lucy Year Flower, 4¼″ diameter, 1990; bowl, Myra Little Snow, 2″ diameter, 1983; bowl, Mary Cain, 5¼″ diameter, ca. 1985; incised egg (in front), Gregory Lonewolf, 1″ diameter, 1994; swirl seed jar, Linda Oyenque, 1⅞″ diameter, 1994; jar, Kelli Little Kachina, 3¾″ diameter, 1993; incised egg, Camilio Tafoya, 1¼″ diameter, ca. 1980; jar, Stella Chavarria, 4½″ high, 1994*

What isn't in this picture says almost as much about the Tafoyas as what we've shown. There are no signed or firmly attributed pieces by Sara Fina, Joseph Lonewolf, Grace Medicine Flower, Nathan Youngblood, Nancy Youngblood Yugo, Toni Roller, or Virginia Ebelacker, all Tafoya-family superstars. We couldn't find any we could afford, and the only reason we cold afford a signed Margaret is that it was broken and repaired.

Even so, this picture shows the Tafoya family's range. The big jars at the top illustrate the kind of skill and work that Margaret and her mother did before World War II, and the rest of the piece show what's happened since.

The carved blackware starts with an engagement basket by Margaret's sister Christina and continues through the generations. Mary Cain and Mida are Christina's daughter, and Sharon Garcia and Stella Chavarria are her granddaughters. Linda Oyenque is Margaret's granddaughter, Lucy Year Flower married Camilio's son Joe, and Kelli Little Kachina is Lucy's daughter.

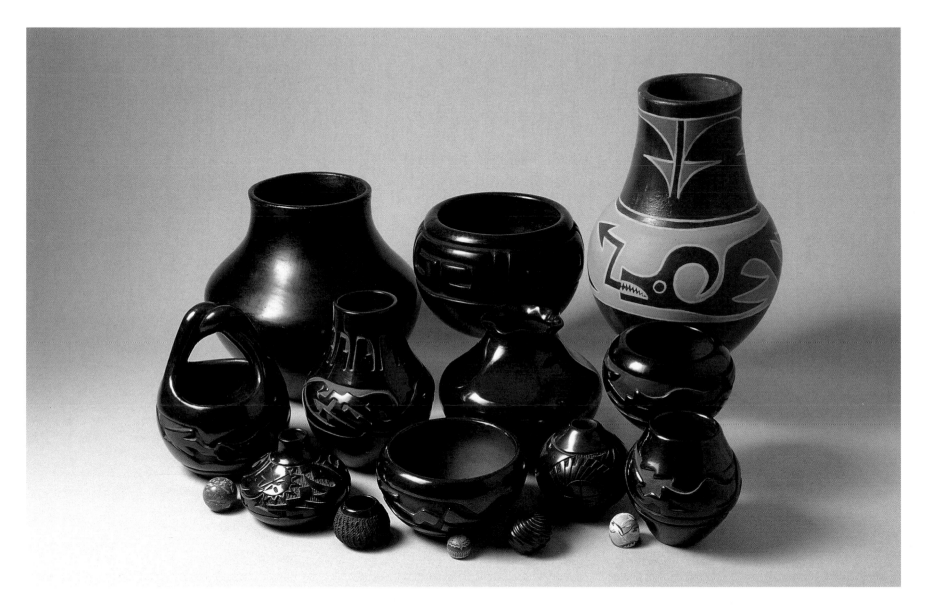

The three little polychrome pieces on the bottom (we called them "incised eggs" for want of a better name) represent Camilio's legacy. The one on the right is by Camilio, the other two are by his grandson Gregory Lonewolf and his granddaughter Susan Romero. Camilio's son and daughter, Joseph Lonewolf and Grace Medicine Flower, are conspicuous by their absence. Anything they do that looks like this now costs a fortune.

Santa Clara · The Sisters and the Cousins and the Aunts

The Tafoyas may have started slowly, but my, how they grew. Margaret and Camilio Tafoya and Christina Naranjo all married and had families, who had families, who had families.

The Tafoya genealogy in *Fourteen Families in Pueblo Pottery* shows 101 Tafoyas descended from Sara Fina. Seventy-one of them rate the red dots that identify them as working potters. Then, Rosemary Apple Blossom married Paul Speckled Rock, which puts her into the Gutierrez genealogy, with its sixty-four entries and thirty-one red dots. And Stella Tafoya married Loretto Chavarria, which connects with the Chavarria family and their forty-nine members and nineteen more red dots. Add a few dots for the young ones who have come into the field since the book came out, and you have 150 Santa Clara potters, all producing upper-level work. Tafoyas, Naranjos, Chavarrias, and Gutierrezes who don't fit in the official genealogies push the number over two hundred.

A great deal of the Tafoya and Tafoya-associated body of work is deep-carved and polished blackware. A proper Tafoya pot has an inky black polish and deep relief. The carved-out matte portion has very few tooling marks, and, on the best pieces, none at all. Even though the carving is deep, the pot itself will be thinner and lighter than you might expect, and certainly thinner and lighter than the same pot would be if it came from a pueblo with less exacting standards.

Some of these sisters, cousins, aunts, and namesakes have created distinctive niches in painting rather than carving. You can pick out non-relative Earline Youngblood's redware across the room because of her stylized traditional forms. You can recognize Shawn Tafoya's because he paints whatever he feels like and seldom bothers with traditional forms at all.

Others, like Linda Cain, Autumn Borts, and Tammy Borts Garcia, have built their reputations with carved pieces that follow all the rules, but somehow seem to have something extra. And still others—Virginia Ebelacker, Toni Roller, and Nathan and Nancy Youngblood—have created such an intense demand for their trademark pieces that collectors far richer than the proprietors of this museum stand in line for the privilege of buying them.

TOP ROW: *Vase, Tina Diaz, 7½″ high, 1994; jar (below), Sherry Tafoya, 3″ high, 1992; Tammy Borts Garcia, 4″ diameter, 1991; vase, Judy Tafoya, 7⅝″ high, 1988; jar, Denise Chavarria, 3¾″ high, 1992; jar, Greg Garcia, 5″ diameter, 1993; jar (below), Madeline Naranjo, 3½″ diameter, 1993*
MIDDLE ROW: *Jar, Sally Tafoya, 3¾″ diameter, 1992; jar, Autumn Borts, 3¾″ diameter, 1994; jar, Earline Youngblood, 4″ diameter, 1992; jar, Shawn Tafoya, 3″ high, 1989; jar, Sherry Tafoya, 3⅞″ diameter, 1990*
BOTTOM ROW: *Jar, Victor and Naomi Eckleberry, 3½″ diameter, 1984; seed jar, Denise Chavarria, 3½″ diameter, 1994; jar, Myra Little Snow, 2″ diameter, 1985; jar, Greg Garcia, 3″ diameter, 1994; jar, Laura Tafoya, 3¼″ diameter, ca. 1980*

If the painted water serpent became a likely identifier for San Ildefonso pottery, the carved serpent has assumed the same role on Santa Clara pottery. The picture includes nine of them, each as individual as the artist who carved it.

Denise Chavarria and Sherry Tafoya's avanyus are totally traditional, while Tina Diaz's redware serpent bounces around her jar, animated and jaunty. Judy Tafoya's is downright ferocious, Madeline Naranjo's looks sleepy, Laura Tafoya's is birdlike, and Tammy Borts Garcia gives us one almost lost in foam and waves.

Myra Little Snow offers us an avanyu with shallow carving, more like a Gonzales-family pot from San Ildefonso than like a Tafoya pot. Victor and Naomi Eckleberry have carved theirs so deep that we're almost afraid to handle the pot for fear of nicking off part of its nose. And Earline Youngblood paints her avanyus in graceful pale swirls.

The carved piece by Tammy Borts's sister Autumn shows the subtle creativity that is rapidly moving both sisters up the Santa Clara prestige ladder.

Shawn Tafoya marches to a different drummer. His pieces are fired in coal, which seems more non-traditional than it actually is. From prehistoric times, potters have used a variety of fuels, and Jeddito and Sikyatki ware from Hopi was often coal-fired.

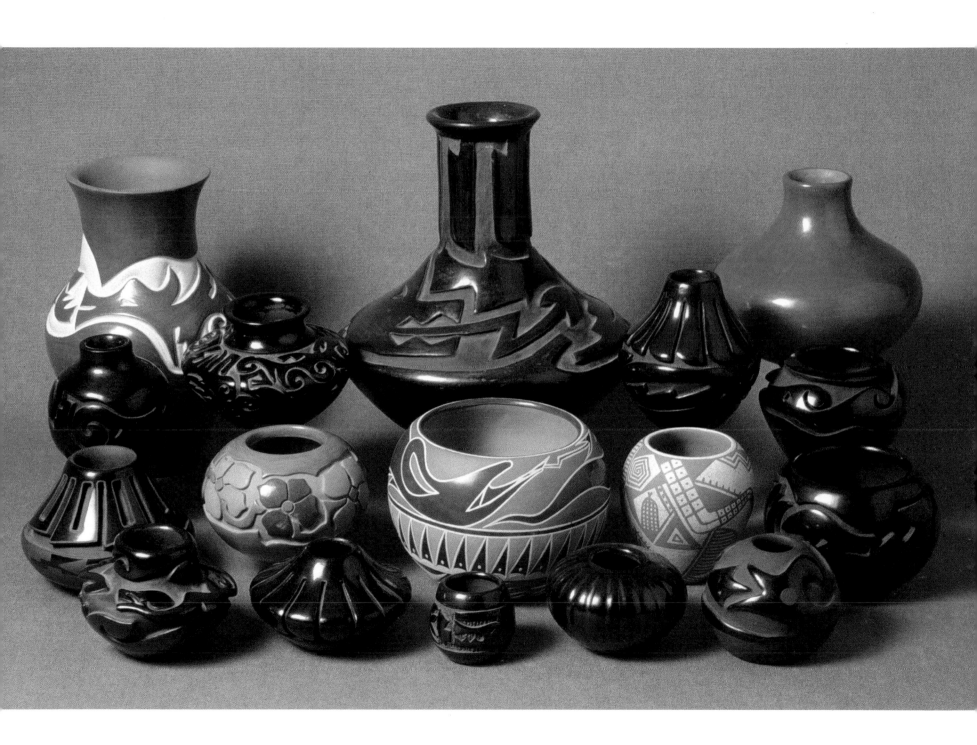

Santa Clara · Sgraffito and Sienna

Once you can make a good pot, why not make it even better? Sometime in the 1960s, a whole new style of decoration came into Southwestern pottery. Before then, the best work was big, and if a major piece had anything intricate about it, the intricacy would be confined to the accuracy and detail of the painting.

The Gonzales family at San Ildefonso and the Tafoyas at Santa Clara made an art form out of carving, but the carving was large in scale—avanyus and geometric forms that may have been striking but never fussy.

But then, Popovi Da began experimenting over at San Ildefonso in the late 1950s, accompanied by his son Tony and Tse-Pe and Dora. Right behind them, Joseph Lonewolf and Grace Medicine Flower started an entire parade of followers from Santa Clara. The movement started out slowly and tentatively, and the little pipe at left center of the bottom row typifies its modest beginnings. But during the 1970s and early 1980s, the watchword became "the more the better," and, among this subgroup of adventurous young potters, everything had to have inlaid coral and turquoise, double firing to create color changes on the pot and, above all, fineline sgraffito designs.

Out of all this, potters like Ron Suazo and Corn Moquino lifted the standards of this second generation to impressive heights. Now, as the picture demonstrates, the incised patterns have a deft precision that strains the eyes of anyone with less-than-perfect close vision. Even the naturalistic drawing is good—look at the flora and fauna scattered throughout the picture. Miniatures gave potters a chance to outdo each other. Elegant little pieces like Geri Naranjo's tiny jar and Dolores Curran's miniature tall vase seem almost commonplace these days.

An aside about Dolores Curran: she swims slightly upstream from tradition, in that she's married to San Juan potter Alvin Curran and lives there. Yet she resists the "married-in" designation and maintains her identity as a Santa Clara potter, while encouraging her equally talented husband to work in the San Juan idiom.

Experimentation with sienna firing raised interest in colors between black and red, and Stephan Baca, Bernice Suazo Naranjo, Karen Naranjo, Forrest Naranjo, Dusty Naranjo, and others have perfected an intermediate firing that produces a beautiful chocolate brown.

One look at today's work and it's obvious that it's gone far beyond show-off techniques. It's now a mature tradition, and is attracting so many young potters that it might well become Santa Clara's dominant tradition in the future.

TOP ROW: *Jar, Eric Tafoya, 5″ diameter, 1994; jar, Candelaria Suazo, 4½″ diameter, 1993; jar, Bernice Suazo Naranjo, 6¼″ high, 1994; jar, Corn Moquino, 4½″ diameter, 1991*
MIDDLE ROW: *Seed jar, Corn Moquino, 3¾″ diameter, 1985; jar, Stephan Baca, 2¼″ high, 1994; bowl, Susan Folwell, 4¼″ diameter, 1992; lidded jar, Ron Suazo, 4″ diameter, 1997; jar, Ron Suazo, 5″ diameter, 1992; seed jar, Dusty Naranjo, 5″ diameter, 1997*
BOTTOM ROW: *Jar, Dolores Curran, 2⅛″ high, 1985; seed jar, Forrest Naranjo, 3¾″ diameter, 1994; cloud blower, 4″ long, ca. 1975; jar, Kevin Naranjo, 2½″ diameter, 1994, bear figurine, Forrest and Karen Naranjo, 2¾″ long, 1993; seed jar, Karen Naranjo, 3¼″ diameter, 1994; bear figurine, Dusty Naranjo, 2¾″ long, 1993; miniature vase, Geri Naranjo, 1⅞″ high, 1993; jar, Lorenzo Puente, 2½″ high, 1993*

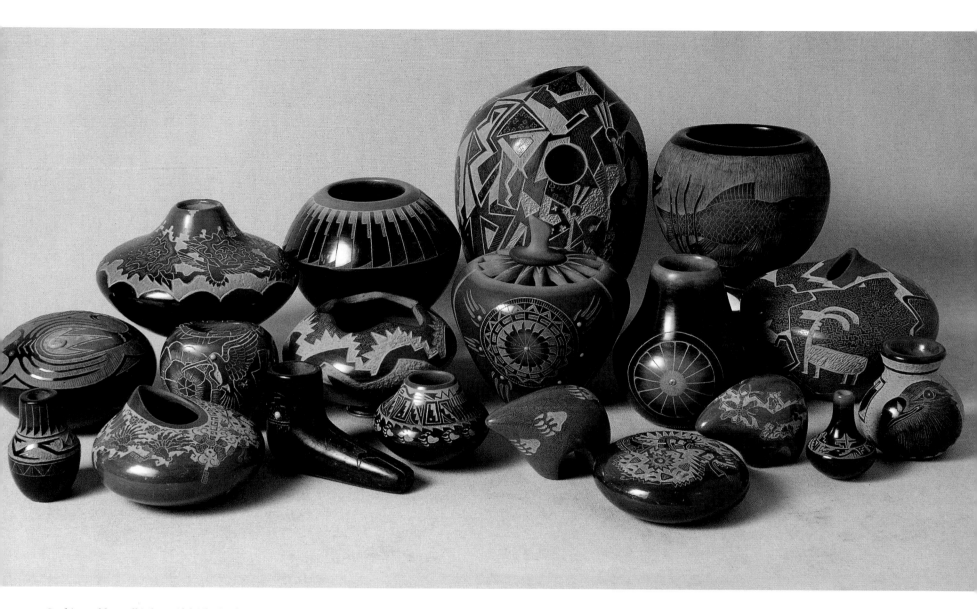

In this world, small is beautiful. The jar by Bernice Suazo Naranjo in the back row looms over the rest of the pieces in the picture like a giant, but it's barely more than six inches high.

One gets the feeling that people named Naranjo are good at this sort of work. The picture also features Dusty, Geri, Karen, Forrest, and Kevin. Karen and Forrest Naranjo have been established, important artists throughout the 1990s. Geri Naranjo has carved herself a niche as a master of sgraffito blackware miniatures, and Dusty's brownware is getting more and more attention.

However, Suazo is the biggest name in the style. Ron has been one of the leading exponents for years, Bernice is one of the best, and Candelaria, a married-in San Juan potter, does beautiful work too.

Corn Moquino is a senior citizen in this group, and a definer of the style. Susan Folwell is one of the best and most creative among Santa Clara's young potters. Her prices are escalating towards the stratosphere and are beginning to resemble the ones her superstar mother, Jody Folwell, receives. Eric Tafoya, despite the name, is from the other side of the Gutierrez family, a great-grandson of Van Gutierrez's sister Severa Tafoya.

Santa Clara · Surprises

If you think you know what to expect from Santa Clara, guess again. For a dozen pages, we've tried to describe the major styles and trends that influence Santa Clara potters, even to the point of describing "Tafoya pottery" and suggesting you simply look for a black pot with a deep-carved avanyu. But there's much, much more to Santa Clara.

In 1993, the Bloms and the Hayeses were checking out the exhibits at a fair at Santo Domingo, and Al stopped to talk to a young Santa Clara artist with an array of exceptionally off-center pottery. Al asked if it was tradition-ally made, and he answered, "Of course it's traditional. At Santa Clara, being non-traditional *is* the tradition."

We're not sure that Margaret Tafoya would have given the same answer, but the pottery in the picture corroborates his statement. The work ranges from slightly unusual to off the charts, and it indicates that non-traditional experimentation has been going on for quite a few years at Santa Clara.

It makes sense, if you think about it. Other major pottery-producing pueblos have continu-ing traditions of design that go back to the eighteenth century and before. Santa Clara, on the other hand, enjoys two liberating factors—

an explosion of young, restless potters and an earlier tradition of simple, utilitarian shapes, almost entirely undecorated. The boundaries are still being drawn.

The bizarre seed jar with the bouncing Bambi in the front row dates from the mid-1980s. Depending on which eye you're looking through at the time, you can either dismiss it as just another minor piece of carved Santa Clara red-ware, or you can look harder and say it's about the strangest little piece of pottery in the book.

Today, experimentation goes in all directions. Some surprises are quiet, as on the immaculately polished pieces at the lower left of the picture. They demonstrate the way an unexpected faceting or a simple sculpted detail can transform an utterly simple pot into one that's not quite like anything you've ever seen before.

Every piece here has something that lifts it out of the ordinary—a startling design, an unusual slip, exceptional incising, an eyebrow-lifting juxtaposition of matte and polish, or a painted design with no polish at all. And every piece here offers mute testimony to an indisputable truth: You can learn to recognize Santa Clara pottery, but you can't ever assume that you know what the next piece is going to look like.

The two pots by the Folwell sisters on the left of the top row seem far away from a typical carved black avanyu, but they actually hew more closely to the traditions of Santa Clara pottery than much of the work done by their famous mother. Many of Jody Folwell's (not pictured—too expensive for us) large works look more like contemporary mainstream fine art than like South-western Indian pottery.

Denny Gutierrez and Carol Velarde (jar, bottom row center and jar with stopper) surprise you with nuances of form. Harrison and Marie Begay (jar, top right, and seed jar, middle left) combine sophisticated stylization and contrasting surfaces. Paul Speckled Rock is a great-nephew of Lela Gutierrez and was married to Joseph Lonewolf's daughter, but his polished bear with a feather burden departs from the styles of both families. He hasn't totally escaped the Lonewolf orbit, however, as the incised golf ball in the bottom row testifies.

Minnie Vigil invented her own look, and other family members (such as her daughters Sunbird and Annette) follow, at Santa Clara and elsewhere. You'll see this elaborate geometry on seed jars by her sister Thelma Talachy over in Pojoaque. Her sister Lois Gutierrez, however, works in matte, like her sister-in-law Virginia Gutierrez in Nambé.

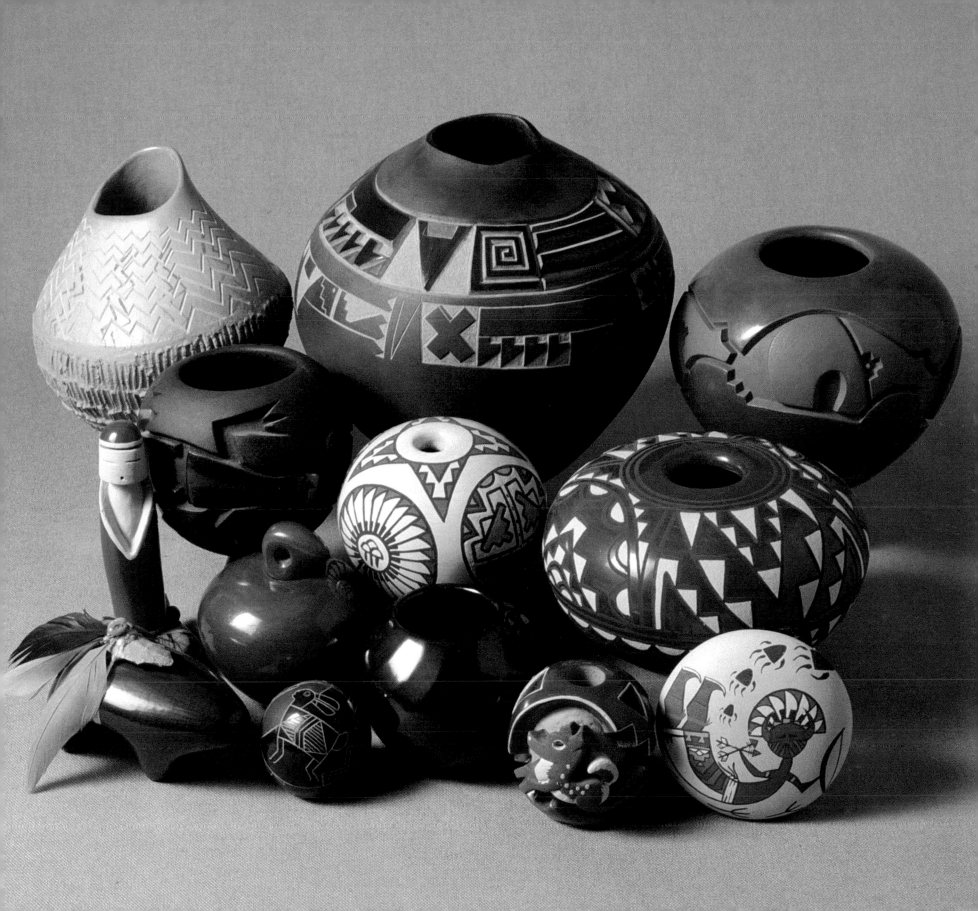

Santo Domingo

▶▶▶ *It's big, and it's big in the arts. But as far as pottery goes, it's still a small player.* Santo Domingo's real estate stretches out over one hundred square miles on both sides of the Rio Grande, and its twenty-five hundred people stay home, mainly farming or working in arts and crafts. The craft of choice is usually jewelry that tends to feature the Santo Domingo specialties: handmade heishi and turquoise beads and unusual inlay work with shell, turquoise, jet, and bone.

Santo Domingo's Indian name is *Guipi,* "The Unknown," and the pueblo remains unknowable to outsiders. Our guidebook doesn't recommend a visit, and bases that opinion on Santo Domingo's general conservatism and lack of interest in tourism. Not that Santo Domingo lacks reason to distrust Spanish, Anglos, and tourists—from Oñate's soul-saving proclamations in 1598 to the present, Santo Domingo has suffered one calamity after another.

The village of Guipi is relatively new. Floods destroyed it in 1606, 1700, and 1855, and each time it moved and rebuilt on higher ground. The 1680 Pueblo Revolt didn't help it either, and many of its citizens fled westward to establish the new pueblo of Laguna during the reconquest.

Nobody seems to know much about Santo Domingo pottery prior to 1880. That year, Adolph

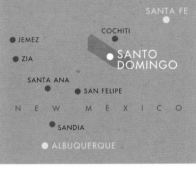

Bandelier praised their pottery as being of "very beautiful make," but James Stevenson collected few samples for the Smithsonian during his 1879 and 1880 excursions. From Stevenson's time to the present, Santo Domingo has made black-and-red-on-cream pottery in two basic styles. Kiua Polychrome has black-on-cream geometric patterns segmented into vertically separated panels, with the red confined to the underbody. Santo Domingo Polychrome has naturalistic flowers, leaves, and wildlife, and red appears in the upper-body designs. Kiua was an earlier style, but Santo Domingo Polychrome was well-established by the time Stevenson visited in 1880.

News of the commercial value of blackware reached Santo Domingo by the 1930s, and it's been around ever since. It's easily recognizable as Santo Domingo work because it's almost always decorated with Santo Domingo flowers and leaves rather than San Ildefonso or Santa Clara geometric shapes.

It's also easily recognizable as Santo Domingo because, with very few exceptions, Santo Domingo potters never quite got the hang of blackware. Examples tend to be clunky, streaky, and not very black.

Santo Domingo kept making pottery through the 1940s, and nobody paid much attention to it. But things were about to change for the better.

TOP ROW: Wedding vase, 7½˝ high, ca. 1935; jar, Robert Tenorio, 8½˝ high, 1982; pitcher, 5¾˝ high, ca. 1930
MIDDLE ROW: Teapot, 6¼˝ diameter, ca. 1935; pitcher, 4⅛˝ high, ca. 1930; jar, 4⅝˝ high, ca. 1930; basket or double pitcher, 7½˝ diameter, ca. 1935
BOTTOM ROW: Candleholder, 5˝ diameter, ca. 1925; bowl, 4⅝˝ diameter, ca. 1920; pitcher, 5½˝ high, ca. 1935; footed pitcher, 6½˝ high, ca. 1920

Here, an array of pre–World War II Santo Domingo ware, including a late example that fooled us. We dated the fine large jar at the top as ca. 1920 in the book's first printing, but Robert Tenorio actually made it in 1982 in frank appreciation of older pieces. It did a few years of service under a downspout at his home, hence the look of age.

The big jar on the top, the bowl at bottom, and especially the pitcher on the top describe Kiua geometric design, while the rest were done in the floral/naturalistic Santo Domingo Polychrome style.

Some of the pieces are only–in–Santo Domingo examples. The double-spouted basket at the right of the middle row is characteristic, as is the footed pitcher for the tourist trade.

Early-century Santo Domingo was big on pitchers. Also dough bowls. The Kiua bowl at the bottom is a miniature of the twelve- to eighteen-inch monsters that high-end collectors search out. It also has another characteristic that the big collectors want: the red band. Before 1930, potters from Cochiti, Santo Domingo, Santa Ana, and Zia left the bottoms of bowls and jars unslipped and smoothed to a dull red. They then painted a quarter- to one-inch-wide band of red slip at the top of the underbody and polished it. This produced a red-on-red stripe around the underbody. It serves as a date indicator, since the red band was almost universal before 1930 and almost never there afterwards.

The blackware wedding vase at the top left may seem pitiful by San Ildefonso or Santa Clara standards, but it's actually quite good for Santo Domingo in the 1930s. The slipper-shaped candleholder in the next picture shows the other extreme.

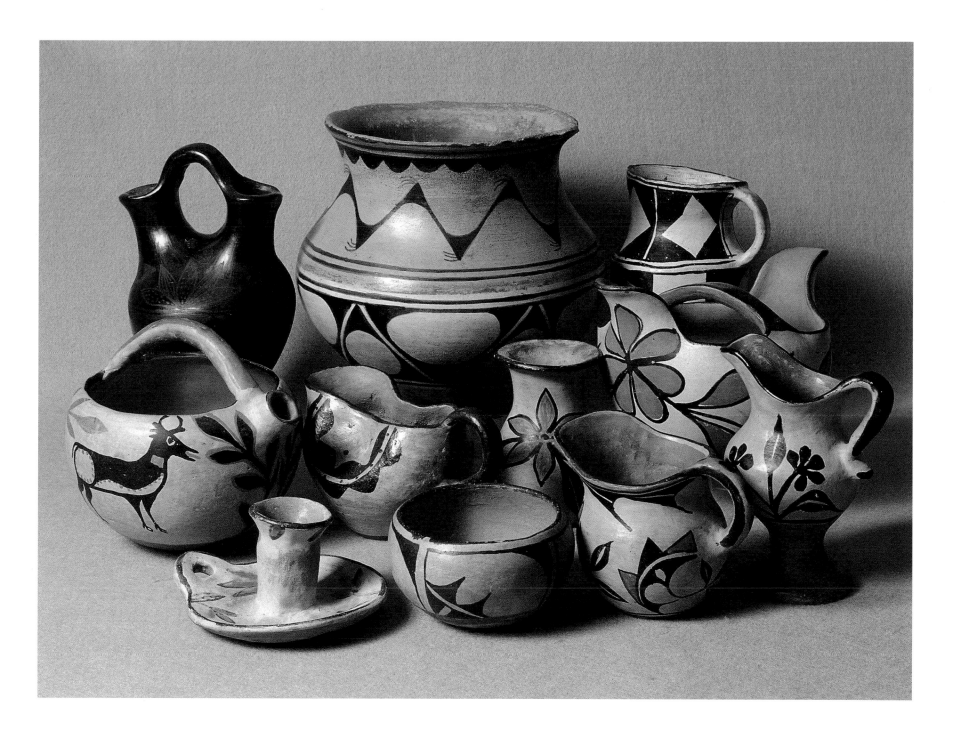

Santo Domingo · Back to the Source

Major players enter the scene. After World War II, fewer and fewer potters worked at Santo Domingo. Production dried up and quality dipped. Things spiraled ever downward as the Indian jewelry craze of the 1970s lured artists away from pottery.

But down didn't mean out. Some of those who kept going held to high standards, and strong pottery families emerged. Santana Melchor (d. 1978) learned from her mother, began making small pieces in the 1920s, and by 1930 had established herself as an important Santo Domingo potter. By 1945, she was *the* most important Santo Domingo potter. She worked continually until her death, and her daughters and grandchildren continued the family pottery tradition. Crucita Melchor was decorating pottery by 1950, and the Melchors have been around ever since.

Others learned. In fact, the pottery from the 1990s in the picture competes with the finest work from the finest pottery pueblos. Helen Bird learned how to polish redware at San Ildefonso.

Mark Wayne Garcia makes fastidiously painted ware. And Josie Martinez has made some of Santo Domingo's best blackware for years.

These days, blackware by the Aguilar family gets more attention. Rafaelita Aguilar's large jar in the back row of the photograph holds its own when you put it against a good piece from San Ildefonso or Santa Clara.

"Aguilar Pottery" didn't always mean blackware, however. Around 1910, three Aguilar sisters took the prompting of a merchant in Bernalillo (the town nearest the pueblo) and began producing a variant Kiua geometric ware that covered the cream-colored slip almost entirely with black and red. The style had largely disappeared by 1920, but it didn't vanish forever.

This reverse-painted Aguilar pottery reappeared as part of the repertory of yet another important Santo Domingo pottery family. Turn the page for the story of Robert and the rest of the Tenorios, the family that, in the 1990s, dominates Santo Domingo pottery.

TOP ROW: *Bowl, Crucita Melchor, 9½″ diameter, 1992; Olla, Rafaelita Aguilar, 11¾″ diameter, ca. 1975; bowl, Alvina Garcia, 9¼″ diameter, 1992*

MIDDLE ROW: *Basket, Andrea Ortiz, painted by Anacita Pacheco, 6″ diameter, ca. 1950; jar, Santana Melchor, 5½″ diameter, ca. 1965; bowl, 8¼″ diameter, ca. 1950; jar, 6½″ diameter, ca. 1950; kachina figurine, Alvin Lovato, 6″ high, ca. 1980*

BOTTOM ROW: *Effigy bowl, Santana Melchor, 8½″ long, 1972; jar, Josie Martinez, 4″ high, 1990; candleholder, 6″ long, ca. 1965; jar, Mark Wayne Garcia, 4″ diameter, 1992; jar, Helen Bird, 3″ diameter, 1993*

The carelessly made polychrome jar half-hidden at the right of the middle row typifies the state of the art at Santo Domingo at mid-century. Dropping to the bottom row, the two pieces at the right are emblematic of the improvement in the level of work by unheralded Santo Domingo potters over the last thirty years. The slipper-shaped candleholder is a poor piece of blackware by even the most charitable standards. The little red jar by Helen Bird is right at the top of the quality ladder.

Crucita Melchor's painted bowl at upper left is pure family work, much like the polychromes her mother Santana did all her life. The kachina figurine at the right is a relatively rare example of Santo Domingo pottery-as-art. It's by Alvin Lovato, the son of Charles Lovato, a well-known Santo Domingo painter.

Most of the other pieces represent work of the potters' times. The older, unsigned pieces never seem to combine good potter's craft with good painting; you seldom get much of either in this work.

The newer pieces give you both, whether in blackware, polished redware, or matte polychrome. The reason is easy to understand. In 1995, Santo Domingo potters have the message. The bar is higher.

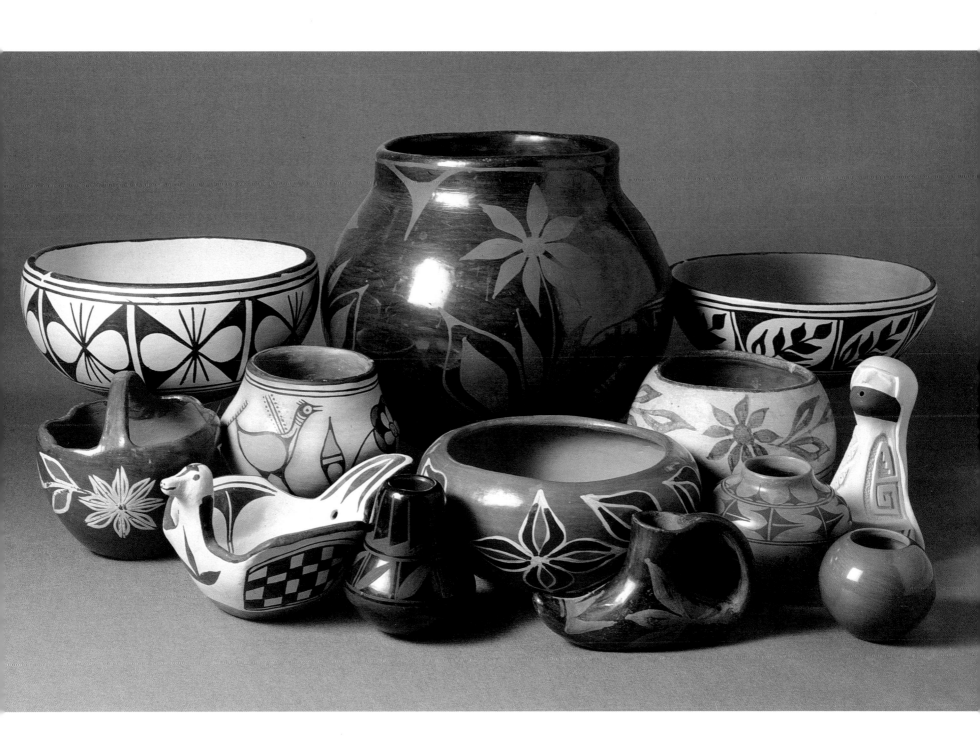

Santo Domingo · Tenorio

Another family emerges. Andrea Ortiz was a potter in a family of jewelers, and she occasionally had her jeweler daughter Juanita paint designs on her pottery.

She also let Juanita's son Robert work with the clay, but there were few thoughts in the family of letting him stay with it. As expected, he went to the Institute of American Indian Arts to learn the jeweler's tradition. However, he kept wandering into the pottery classroom to get his hands back in the clay.

When he decided he wanted to be a full-time potter, his grandmother and a great aunt, Lupe Tenorio, came to his support, and Lupe showed him how to boil down the Rocky Mountain bee plant to make his paint.

By the 1970s, Robert's work was attracting attention. In 1980, John Barry noted that Santana Melchor had died two years earlier and wrote in *American Indian Pottery,* "Robert Tenorio is the only potter today making large traditional pots at the pueblo."

In the 1980s, Robert coaxed his sisters into the pottery world. First, Hilda and her husband, Arthur Coriz, made pieces, and Robert decorated them. That didn't last long. Arthur and Hilda became full-time, award-winning potters, second in rank to Robert only because of longevity. Arthur and Hilda's daughter Ione is doing fine work today as well.

Next, Paulita Pacheco entered the ranks and quickly built her skills up to the family level. Now her son Andrew Pacheco is winning his own awards with his dinosaur designs. Mary Edna was the last to join in. Robert is still painting for her, but her fireplace corners are drawing attention.

The emergence of the Tenorios might be the best thing that could have happened to Santo Domingo. Every twentieth-century pottery renaissance in every pueblo has been led by a family that mixed tradition, innovation, and marketing acumen in equal measure. The Tenorios seem to have the skill and energy to bring Santo Domingo pottery back to life.

TOP ROW: *Jar, Lupe Tenorio, 9½" high, ca. 1965; bowl, Arthur and Hilda Coriz, 10½" diameter, 1992; dough bowl, Paulita Pacheco, 13½" diameter, 1991; jar, Arthur and Hilda Coriz, 10¾" diameter, 1992*
BOTTOM ROW: *Double canteen, Robert Tenorio, 8" long, ca. 1980; fireplace corner, Mary Edna Tenorio, painted by Robert, 4¾" high, 1994; jar, Andrew Pacheco, 5¼" high, 1993; pitcher, Hilda Coriz, 2½" high, 1992*

By the 1990s, all the Tenorios were making large traditional pots at the pueblo, just as Aunt Lupe had done thirty years before. Paulita Pacheco's dough bowl at top center is big enough to qualify as large by anyone's standards.

Robert's 1980 double canteen dates from a period when he was just beginning to become known. It's signed "Robert Tenorio Santo Domingo in America"— evidence that his confidence level in his own and in Santo Domingo's celebrity was considerably lower than it is today.

The large jar at the right by Arthur and Hilda displays the "Aguilar pottery" reverse-painted style of the 1910s. Robert is primarily responsible for reviving the heavy paint coverage of this distinctive approach.

Arthur and Hilda's bowl at top left shows an early 1990s Tenorio aberration, present on many of Robert's pieces from the period: blurred edges on the black paint. Collectors and dealers didn't much care for it, and newer pieces don't have it.

Andrew Pacheco's trademark dinosaurs are climbing rapidly in popularity and price. And Hilda's little pitcher in the front is a reminder of the early days of Santo Domingo tourist pottery.

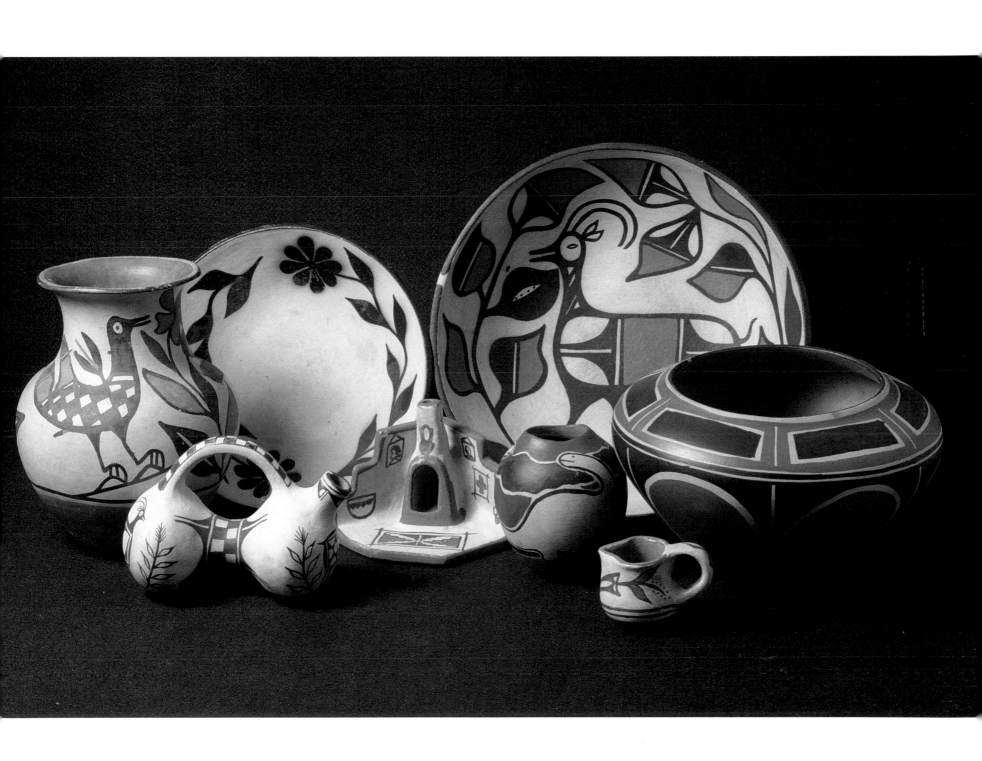

Taos and Picuris

➤➤ Yes, micaceous pottery comes from all over. But if you guess "Taos" or "Picuris" on any given piece, you'll be right much of the time. The two northernmost pueblos, both Towa-speaking like Sandia and Isleta, are distinctly different from each other, but until recently, it's been difficult to separate their pottery.

Neither pueblo enjoyed much benefit from European contact. When Oñate Christianized Picuris (say PICK-ur-eese) in 1598, his lieutenants described it as a warlike community with three thousand inhabitants. Picuris warriors were among the fiercest rebels in 1680, and they rebelled again four years after the 1692 reconquest, ultimately fleeing to join a band of nomadic Apaches in southern Colorado. After ten years of disease and intertribal warfare, they returned to Picuris, their population down to five hundred. Now, Picuris has a population of barely more than two hundred. When you visit, Picuris seems sleepy and impoverished, but it owns and operates the stylish Santa Fe Hotel in Santa Fe.

Taos (it's slurred into one syllable, sounding like "Touse") gives the opposite impression. Its five-story apartment complex makes it the most architecturally spectacular of all the pueblos, and its almost-in-the-city-limits location helps make it the most tourist-oriented.

Today's amicable coexistence is surprising in light of history. In 1628, the priests wrote smugly that twenty-five hundred Taos Indians were now good Christians. Eleven years later, the people of Taos were so disgusted with their lot that they fled en masse to Kansas, where they would still

be if Spanish soldiers hadn't tracked them down and herded them back two years later.

In 1680, Taos helped lead the revolt, and Popé of San Juan lived there while he planned it. During the reconquest, the people of Taos fled again, and it took Governor de Vargas four full years to subjugate them. They didn't get along with Mexicans or Americans, either. In 1837, the Mexican governor took it upon himself to arrest the *alcalde* (roughly equivalent to a mayor) of Taos, thereby triggering a new revolt. The rebels captured and killed the governor and set up a Taos Hispanic, José Angel Gonzales, as his replacement. Mexican troops threw him out a month later and the Mexican government ultimately executed him.

In 1846, the American flag went up, and, repeating the pattern, Taos warriors rebelled and murdered Governor Bent the next year. When American troops arrived to restore order, seven hundred Indians barricaded themselves in the mission, and the American commander blew the walls and many of the occupants apart with a cannon. All the pueblos have a troubled history, but Taos seems to have had the least tolerance for oppression.

Until very recently, Taos and Picuris pottery has been made for utility, not for art. The micaceous ware with its glittery flecks is strong and safe enough for cooking, and it's said that you can't really appreciate Southwestern pottery until you've eaten beans cooked in a Picuris pot.

TOP ROW: *Taos or Picuris bowl, 5½″ diameter, ca. 1970; Picuris bean pot, 9½″ high, 1990; Picuris pitcher, Anthony Durand, 7″ high, 1992*
MIDDLE ROW: *Picuris bean pot, 5¼″ high, 1993; Picuris bowl, Cora Durand, 5″ diameter, 1992; Taos jar, 4¼″ high, ca. 1915; Picuris jar, Anthony Durand, 8″ diameter, 1990*
BOTTOM ROW: *Picuris or Taos bowl, 6½″ diameter, ca. 1975; Taos jar, Yellow Flower, 5½″ diameter, ca. 1975; Picuris pitcher, Romita Martinez, 6″ high, 1957*

This array of pots and pitchers covers eighty years, shows little stylistic evolution, and was made strictly for utility. The old pot in the middle has been well used, as has the bowl-with-handle at top left.

One thing that makes Taos and Picuris pottery so serviceable is its high firing temperature. We got a lesson in firing when Brenda bought the bowl at the left of the middle row from Cora Durand. She told us the reason that Picuris pottery was superior to all others (including, of course, similar pottery from Taos) was that Picuris potters fired their work hotter than anyone else. She told us you could test firing temperature by ringing a pot—the higher the tone, the better the firing. She was out of good pots that day and hesitated to sell us this less-than-perfect little example, but she proved her point about firing by pulling out all the throwaways she had lying around the house and tapping them. Even if they had big cracks or, in one case, a large hole in the bottom, they rang like chimes.

Picuris pottery, such as Anthony Durand's (pitcher and jar, right) and Romita Martinez's (pitcher, bottom right) pieces, often has a greenish-gold cast that's unique to the pueblo. Taos pottery, like Yellow Flower's piece in the front row, tends to be a tan or yellow gold.

Traditional Taos and Picuris pieces have no painted decoration, but they gain interest from sculpted detail. Whether a piece is crudely made (the bowl in the bottom row) or finely finished (Anthony Durand's pieces), a Taos or Picuris bowl or jar is almost certain to have some sculptural element that gives it extra character.

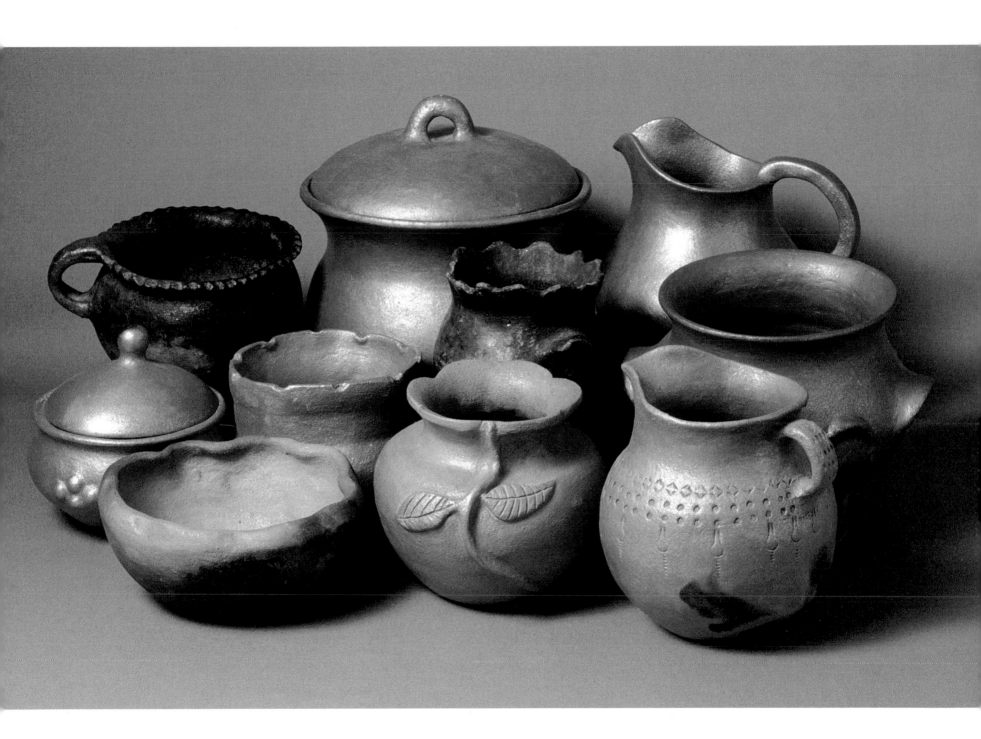

Taos and Picuris · Explorations

Looking backward, you know what to expect. Looking ahead, all bets are off. In 1980, John Barry wrote "Lack of participation by [Taos and Picuris potters] at the 1979 and 1980 Indian Market suggests that their tradition is declining. One explanation for this decline is lack of customer interest. . . . If an effort were undertaken to produce and market quality pottery at Taos and Picuris, in all probability collectors would welcome these pieces to their collections."

On the opposite page, you see some evidence of that effort, all from Taos. By and large, Picuris potters have kept their traditional forms, making thin-walled, undecorated, greenish-gold bean pots with discreet sculpted detail. There's not one surprise in the Picuris work from the 1990s on the previous page. Taos in the 1990s, however, is something else.

Here, traditional micaceous work takes new shapes and forms. When Juanita Dubray makes a tan micaceous jar, its sculpture is so individual that it identifies the artist across the room. When Glenn Gomez and Mead Concha make micaceous pieces, they fire them as blackware. And when Angie Yazzie makes one, its shape has nothing to do with Taos and bean pots.

But Taos has gone way outside the boundaries of micaceous ware. While other pueblos such as Nambé are rediscovering micaceous clay, Taos is using everything else. Pam Hauer makes elegant miniatures; the seed jar at far left is big for her. In the scramble of miniatures on page 176, you'll see a couple of her pieces that are barely a half-inch in diameter. Alma Concha's trademark mudhead figurines remind you that she came there from Jemez. Henrietta Gomez makes storytellers that cause you to think of Cochiti as well as storytellers that couldn't be from anywhere else but Taos. And Jevi gives us the church at Taos—the new one, not the one American cannons shot holes through in 1847.

What all this means is that Taos potters have taken John Barry's words to heart, but with results no one could have anticipated. Today, Taos does anything and everything, and Picuris remains traditional.

TOP ROW: *Taos storyteller, Henrietta Gomez, 7″ high, 1993; Taos bowl, Glenn Gomez, 5¼″ diameter, 1993; Taos wedding vase, Angie Yazzie, 10″ high, 1993; Taos mudhead storyteller, Alma Concha, 6½″ high, 1992* MIDDLE ROW: *Taos mudhead figurine, Alma Concha, 3½″ high, 1993; Taos church model, Jevi, 9¼″ long, 1990; Taos jar, Juanita Dubray, 8½″ diameter, 1991; Taos lidded bowl, Glenn Gomez, 5⅜″ diameter, 1994* BOTTOM ROW: *Taos seed jar, Pam Lujan Hauer, 2¾″ diameter, 1992; Taos buffalo figurine, Jason Mondragon, 2½″ long, 1993; Taos relish bowl, Mead Concha, 9½″ long, 1992; Taos bear storyteller, Henrietta Gomez, 3¾″ high, 1993; Taos mudhead figurine, Alma Concha, 2½″ long, 1994*

Glenn Gomez's blackware jar with turquoise inlay is a departure for Taos, but not nearly as much of a departure as his lidded jar with the matte top, polished bottom, and sienna highlight on the stem. We were struggling trying to describe it, but the technician at John's photo lab had no problem at all—she told us it was a candy kiss.

We had similar problems with Mead Concha's shallow dish, and John's rather desperate call of "relish dish" was about the best we could do. Carol had no confusion about it. She took one look and said, "It's a duck."

Jason Mondragon's bear, Alma Concha's mudheads, and Henrietta Gomez's storytellers are all unusual for Taos, where potters almost never made figurative pieces before the mid-1980s, but Jason Mondragon's buffalo evokes an older tradition. Taos animalitos go back a hundred years or more. There's an old one at the far right of the grouping on page 178.

Angela Yazzie and Juanita Dubray's elegant vessels raise the critical standards for Taos micaceous ware. They provide a subtly changed emphasis—instead of "useful pieces with nice sculptured details," we now look for "beautiful pieces that can also be used."

Jevi's church speaks for itself. It's the only complete building in the John & Al Museum.

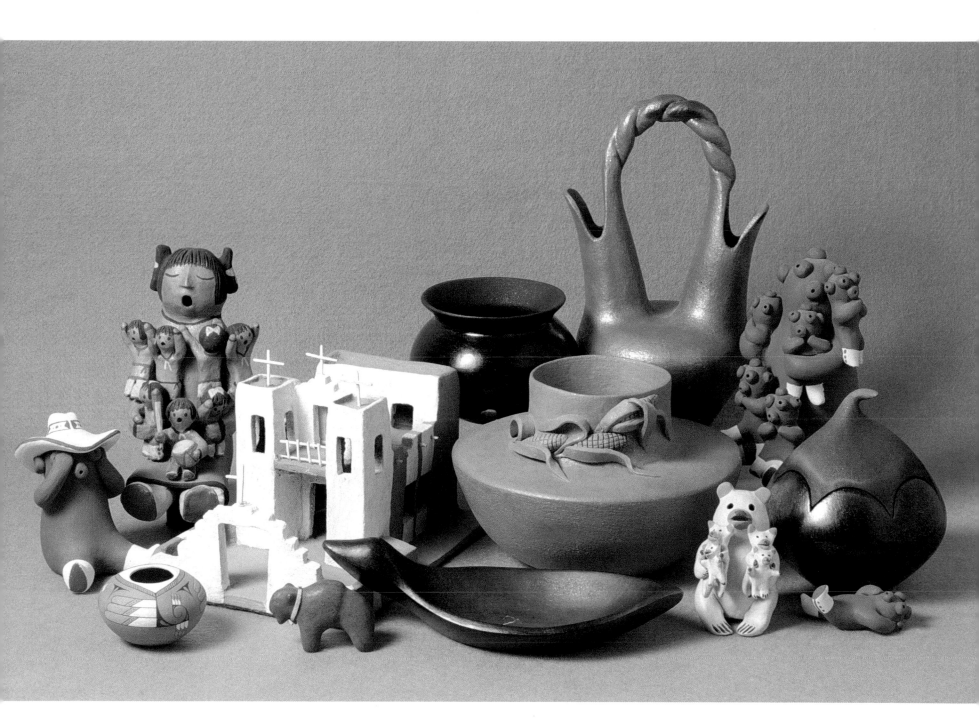

Tesuque

▶▶ *If it's going to happen, it'll probably happen at Tesuque first.* One reason for that phenomenon is that Tesuque (say Te-SOO-ky) is barely outside Santa Fe's city limits, a proximity that has never seemed to be of much benefit to Tesuque.

The current village was established about 1700. The date isn't surprising. The old Anasazi village was about three miles away, and that's where Coronado's army found it in 1540. It was still there in 1680 when Tesuque struck the first blows of the revolt. They were the first to kill a public official and the first to do in a priest.

Apparently, the Spanish had a long memory. By the time the citizens of Tesuque finished struggling against the reconquest, their old village was destroyed, and they had little choice but to build a new pueblo with a nice new mission.

During the eighteenth and nineteenth centuries, the little pueblo of Tesuque was one of the three main makers of fine painted pottery. Tesuque's work equaled San Ildefonso's for quality and was perhaps a little dressier than Nambé's, since Nambé pieces had more micaceous flecks showing through. But it didn't last.

First in line as always, Tesuque potters were in deep collaboration with the Santa Fe traders by 1880. Not that the traders were much interested in continuing a fine pottery tradition—in Jonathan Batkin's *Pottery of the Pueblos of New Mexico, 1700–1940*, there's a circa-1880 photo of trader Jake Gold with an array of Tesuque pottery, and it's clear that the righteously decorated Powhoge

Polychrome ollas were already almost entirely in the past. Instead, Tesuque potters were turning out quirky little figurines much like the monos being made at Cochiti. Gold's eye was on commerce rather than on art, but in his pursuit of the dollar, he created a market.

By 1920, traditional pottery was history at Tesuque, and production had switched over to mass manufacture of rain gods, strange little creatures that look like space aliens holding buckets between their legs. Anglo merchants sold them as sacred ceremonial items, but they were the furthest thing from them.

How many rain gods did Tesuque potters produce? The Gunther Candy Company of Chicago gave them away as promotional items, and Gold and John Candelario sold them by the barrel, for six dollars and fifty cents per hundred.

One by one, the pottery traditions evaporated. It was quicker, easier, and more predictable to paint a rain god after firing than before, and they decorated fired pieces with ink as early as the 1880s. Then they found out it was easier not to fire it at all, but just to let it dry in the sun or heat it on the kitchen stove. And, of course, it was also easier to buy your paint at the store than it was to make it yourself.

By 1930, the rain god's popularity was waning, but Tesuque potters were happy to switch over to little bowls that were even easier to make. Poster paints came on the market in the late 1920s and acrylics appeared in the 1940s. As always, Tesuque potters were first to use them.

TOP ROW: *Rain god, 5¾" high, ca. 1915; rain god, 6¼" high, ca. 1920; rain god, 6½" high, ca. 1920; basket, 6⅜" high, ca. 1890; see-hear-speak-no-evil rain god set, 6½" high, 1912*
MIDDLE ROW: *Bowl, 3¾" diameter, ca. 1950; salt and pepper shakers, 2¾" high, ca. 1950; bowl, 4" diameter, ca. 1940*
BOTTOM ROW: *Bird figurine, 3¼" high, ca. 1955; double canteen, 6¼" long, ca. 1910; bowl, 4¼" diameter, ca. 1950*

The two oldest pieces show the transition from the old days of beautiful large ollas to Jake Gold's brave new world populated entirely by rain gods. Their quirky shapes show Gold's influence. In fact, they'd both look right at home in that 1880 photo of Jake standing next to his merchandise.

The six rain gods were probably all made within ten years of each other, and vary in quality. The smallest one holding a basket instead of a bucket is crude, quick, and unfired, while the one with the scorched nose (probably because someone used it as a candleholder) is much more carefully made.

The ink decorated see-no-evil, hear-no-evil, speak-no-evil set speaks volumes about how seriously everyone regarded the "sacred" nature of the rain god. Back in 1912 when these were made, the usual postcard portrayal showed three monkeys lined up in this pose.

Poster-paint quickies started appearing in the late 1920s, and, as usual, Tesuque was first. Identifying tip: Tesuque pieces are more apt to have gray clay and blue paint; Jemez pieces usually have pink clay and brighter colors.

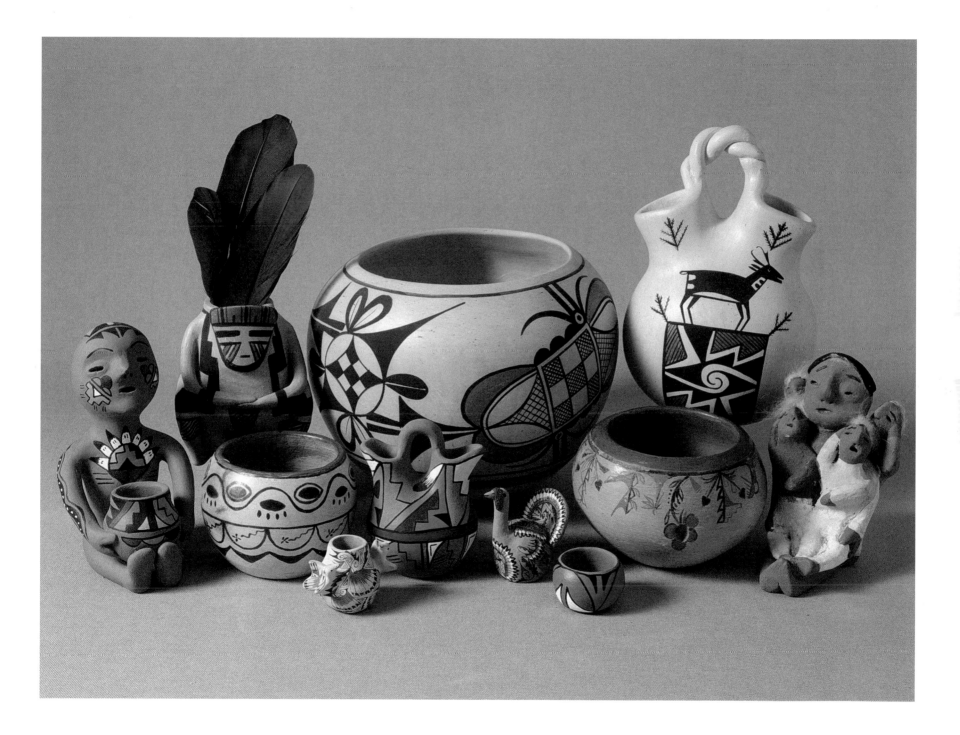

Tohono O'Odham

Three hundred years ago, the Spanish garbled their name. It's about time to correct the mistake. Until the 1980s, all books referred to the people who occupy the huge reservation

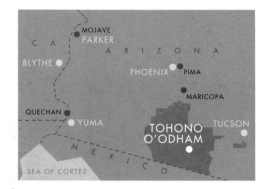

west of Tucson as the Papago, a Spanish mispronunciation of the name the Pima called them. Unlike the Navajo, who have been working with less than total success to convert their name back to their own *Diné*, the name Papago wasn't so deeply buried in the American consciousness that conversion couldn't be accomplished quickly.

They speak a Piman language, and like the Pima, they're better known today for basketry. Despite the name conversion, you'll see far more Papago baskets than you will Tohono O'Odham baskets in Indian stores. It's as if we think that everything made before 1985 was made by Papagos, and only things made after that date could have been made by the O'Odham.

By whatever name, the O'Odham have been making pottery for a long time. A 1698

*Storage jar, 18″ high, ca. 1850
with Angea friendship vase*

manuscript tells of Gila River Indians carrying water in jars. Of course, there had already been pottery in the area for a thousand years—this was Hohokam land—but few are willing to suggest that the O'Odham are descendants of those disappeared Hohokam.

Now that we've read the literature, we're sure of this much: the O'Odham are either descended from the Hohokam, or the Salado, or the Trincheras branch of the Casas Grandes culture, or the Sinagua. Or someone else.

Until the mid-nineteenth century, and perhaps as late as 1880 or so, Gila River pottery probably meant mostly Tohono O'Odham and Pima storage jars. These were big and ungainly—the late-nineteenth-century jar in the inset picture is really rather small as specimens go, and you can get an idea of its size by comparing it with a softball-sized piece from the picture at the right. These huge vessels were either red on tan or undecorated red. Black-on-red is rare or non-existent prior to the tourist age.

After 1880, O'Odham pottery quickly switched over to Maricopa/Pima-like tourist ware. In fact, some accounts suggest that the characteristic Maricopa black-on-red pottery is really nothing more than O'Odham pottery, copied and improved upon.

The Maricopa did in fact improve on it. O'Odham tourist pieces from the twentieth century usually show obvious polishing striations, where the best Maricopa pottery has a much

more even surface. The O'Odham also made whiteware, but not until after 1930. O'Odham whiteware can be really white, much cleaner than the dirty tans and grays of Maricopa White, but older pieces may also be tan because mid-century potters sometimes mixed white and red clays to produce intermediate colors.

Since the 1980s, O'Odham potterymaking seems to have been confined to a handful of families. The Angeas from Hickiwan are in the lead, by as wide a margin as the Tellers at Isleta. The Angeas make white polychromes, a non-existent Tohono O'Odham pottery type until they came along. Their most tourist-pleasing contribution is the "Friendship Vase," a ventilated jar surrounded by dancers holding hands, and it's definitely given Tohono O'Odham pottery a boost.

There's one in the picture on this page, and we're paying attention. After all, look what the storyteller did for Cochiti.

TOP ROW: *Wedding vase, Manuel, 10¼″ high, 1989; canteen, 6¾″ high, ca. 1960; jar, 9½″ high, Joe Angea Jr., 1990*
UPPER MIDDLE ROW: *Double-spouted vase, 5¼″ high, ca. 1920, canteen, 7½″ high, 1980; jar, 3¾″ high, ca. 1960; friendship vase, Angea, 4¾″ high 1992; wedding vase, 8¼″ high, ca. 1960*
LOWER MIDDLE ROW: *Jar, 3½″ high, ca. 1975; bowl, 5⅞″ diameter, ca. 1960; jar, 5¾″ diameter, ca. 1935; jar, Angea, 5¼″ diameter, 1990*
BOTTOM ROW: *Pitcher, Sally Havici, 3¼″ high, ca. 1950; dipper, R. Angea, 5¾″ diameter, 1985; effigy bowl, Rosa Antone, 5″ high, ca. 1950; jar, 4½″ high, ca. 1930*

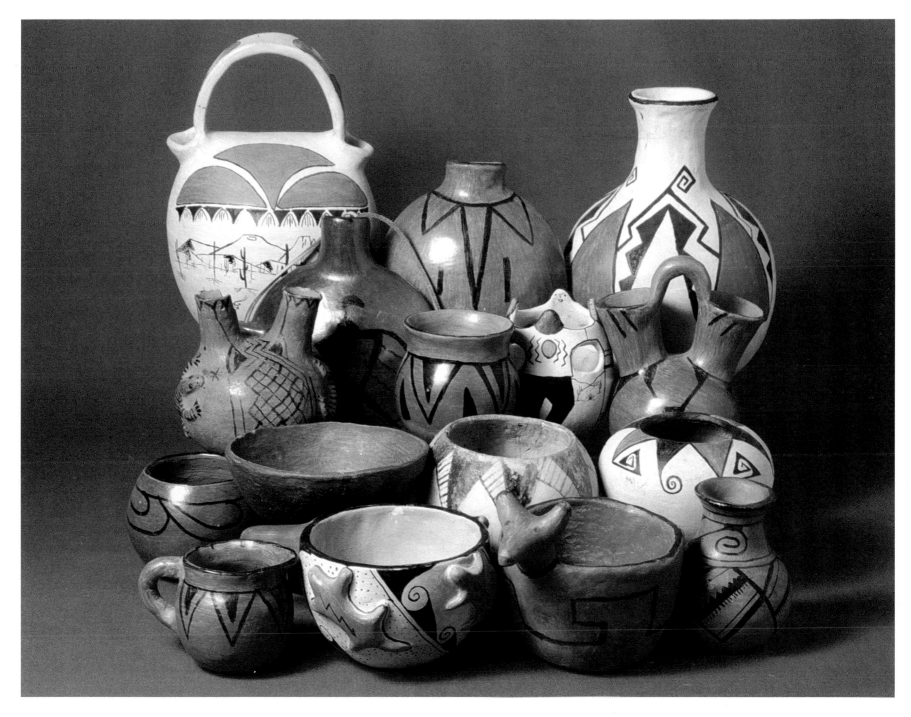

The undecorated bowl at middle left is basic Papago red-ware—the ware that, if you stuck it in the ground for a few years, could pass for prehistoric Salado with no effort at all.

The white jar next to it is early whiteware; the tan jar at lower right is an early mixed-clay piece. The two canteens, Rose Antone's duck bowl, Sally Havici's pitcher, and the other little black-on-red pieces are typical, with the polishing striations that signal the difference between O'Odham and Maricopa ware.

Current O'Odham ware comes from very few families, most of whom live in Hickiwan. The Manuel family did the large wedding vase in the back, but the Angeas are really the only ones who produce in any quantity, and much of that is friendship vases. However, they also do distinctive polychromes that look every bit as good as much of the work from the high-priced pueblos.

Zia

▶▶▶ Bad land plus bad luck equals good pottery. In 1540, Coronado's men reported that the village of Zia (say ZEE-ya) was sparkling and whitewashed and that many of its thousand or so houses were decorated in bright colors.

It didn't take the new administration long to correct that impression of well-tended gaiety. In 1598, Oñate estimated its population to include twenty-five hundred soon-to-be Christians, all in urgent need of a large mission. Zia's oppression was early and thorough.

Zia's participation in the 1680 revolt was typical, but the reprisals and outcome weren't. In 1688, Domingo Cruzate came up from El Paso in an unsuccessful effort to recapture New Mexico for the Spanish, but before he retreated, he managed to break Zia's spirit. Cruzate launched a major attack on Santa Ana and Zia, and three thousand Indians chose to make a stand at Zia. A few days later, six hundred of them were dead, seventy more were on their way to El Paso as slaves, the remainder of the force was hiding in the mountains, and the village itself was torched and destroyed.

When de Vargas returned in 1692, Zia capitulated quietly, and Zia warriors helped him in several battles against other pueblos—a collaboration that, according to some historians, continues to haunt Zia's relationship with its neighbors.

Today, the mission built after the reconquest still stands, and even if it isn't whitewashed and trimmed in bright colors, Zia remains one of the most attractive pueblos to approach. But despite

the postcard setting, Zia's history for the last three hundred years has been hard. Where next-door Santa Ana had negotiated with the Spanish for land along the Rio Grande in the eighteenth century, Zia made do with what it had—lots of acreage and little water. What had been a pueblo of three thousand people is now a water-poor community of fewer than one thousand, most of whose residents work away from the pueblo.

What Zia *has* had, however, is pottery. For at least two hundred years, the balance of trade was food from Santa Ana, Jemez, and San Felipe for pottery from Zia, and pottery remains Zia's number one home-grown cash crop.

Zia pottery is Keresan, and as such, shares design characteristics with other important Keresan pottery, especially Acoma and Laguna ware. They all have their favorite geometric patterns, stylized birds, rainbows, and flowers, but you'd never for a minute confuse an Acoma pot with a Zia pot.

Where Acoma and Laguna's bird is a parrot, Zia's is a roadrunner, often startled, sometimes taking off with jets roaring and sometimes skidding to a stop with afterburners going full blast. Acoma's parrot-and-rainbow is Zia's roadrunner-and-rainbow, Acoma's black-and-orange-on-stark-white is Zia's dark brown-and-brownish red-on-creamy white, and Acoma's hard, paper-thin, white-clay ollas are Zia's sturdy, slightly granular, basalt-tempered red-clay jars.

Zia pottery is unique unto itself, and you can spot it from twenty feet away.

This assortment spans two-thirds of a century, but it's hard to tell the oldest from the newest. The roadrunner scurrying around the bowl in the center could have appeared on a bowl made fifty years before or fifty years after. You can't date these pieces based on style. From the late nineteenth century to the 1970s, Zia potters remained stubbornly resistant to the pressures of fashion.

They really only made one adjustment—like potters from the other Rio Grande Keresan pueblos, they stopped using the red band around the underbody about 1930 (it's there, faintly, on the red-and-orange jar at the top and on the old bowl at middle left). Little else changed. For the last hundred years, most Zia pottery has been brown, white, and red. But not all of it. Every so often, a tan piece like the 1915-vintage bowl at bottom right or the 1940 version at bottom left shows up, and if your antenna isn't 100 percent tuned in, you'll miss it. In fact, several experts misidentified the one at bottom right before one was alert enough to take a magnifying glass to a patch of clay that peeped through a nick in the slip and saw the black flecks of temper that confirm the piece as Zia.

Occasionally during the 1920s, Zia potters substituted orange for the white, like on the jar at the top. These are scarce, too, but some of the most glorious multi-thousand dollar ollas are of this red and orange variety.

But tans and oranges are the exceptions. The rest of the pieces in the picture are basic, easy-to-identify Zia. The bowl at the right of the middle row looks like one pictured in Generations in Clay *over a caption that says it's "almost identical in design to many bowls of its type." You could say something much like that about the rest of the brown, white, and red bowls in the picture, and you wouldn't be far off the mark.*

Zia · Evolution

At Zia, change takes its own sweet time.
In most pueblos, pottery history shows a slump in the first quarter of the twentieth century, with revival beginning in the 1920s, gaining momentum until the 1960s, and then exploding in many directions.

Zia's pottery history is much more stable. It follows the same pattern of development, but the peaks and valleys are more like slight lifts and dips. Odd Halseth made Edgar Hewett/Kenneth Chapman–type inspirational visits over several months in 1923, and, according to his own account, got more insults than attention. He visited the nearest trading post and tried to encourage the trader to promote better, more "traditional" pottery, and evidently accomplished very little on that front either.

Despite their conservative insularity, a few Zia potters achieved celebrity relatively early. Although potters almost never signed their work before 1950, Jonathan Batkin, in *Pottery of the Pueblos of New Mexico, 1700–1940*, tells of a documented storage jar from 1922 signed by Isabel Torrebio (modern family members usually spell it Toribio).

Trinidad Medina toured the country between 1930 and 1946, demonstrating pottery. She appeared at the Century of Progress Exposition in Chicago in 1933 (the little bowl at bottom center in the picture came from there) and at the Golden Gate International Exposition in San Francisco in 1939. In the 1950s and 1960s, most observers probably would have named Seferina Bell as Zia's number one potter.

At Zia, however, rising to number one is no guarantee of wealth and fame. None of the number ones over the years—Isabel Torrebio, Trinidad Medina, Seferina Bell, or today's Sofia Medina—ever had the marketing push that comes automatically to the leading potters from San Ildefonso, Santa Clara, Hopi, and Acoma.

The same names occur over and over on Zia pottery—Pino, Gachupin, Medina, Toribio. This shouldn't come as a surprise. The pueblos with a strong pottery tradition have that tradition because a few strong families keep it that way.

And, at least at Zia, they keep evolution so gradual that, at times, it's barely perceptible.

By 1980, orange was gone from Zia's mainstream, and Zia whites were pure white, Zia dark-browns were almost black (or were just plain black), and Zia reds were deep and rich.

But Zia design was basically unchanged: a bit of geometry, a flower here and there, a red underbody and a red rim, and birds everywhere—standing, trotting, taking off, landing, and skidding to a halt. If the road-runner was common on Zia pottery prior to 1980, it was omnipresent afterwards.

Most of these pots look as though they could have been made by the same potter. This is art from a genre discipline, not a collection of personal expressions by a group of far-reaching artists.

Lois Medina's bear figurine is the only surprise on the page, yet, even though we've never seen another Zia piece like it before or since, we knew at a glance that it was Zia. There's something about the heft, surface, degree of finish, and decorative style of a Zia pot that gives it away every time.

Especially the decorative style. Don't ask us to explain how or why, but the bear, dragonflies, flowers, and paws on that bear seem to have sprung full-blown from the same mold that produced all those energetic roadrunners.

Zia · Experimentation

Even at Zia, change creeps in. And when change does show up, it's apt to come within the family that leads the way.

Sofia Pino married Trinidad Medina's grandson Raphael, who studied art at the Santa Fe Indian School. Back in the 1950s, Sofia encouraged him to paint. He started with acrylics on paper and got pretty good at it. Ten years later, grandmother Trinidad finally got Sofia interested in pottery. Sofia, according to her account in *Fourteen Families,* found it emotionally rewarding. Trinidad, perhaps made a bit less sentimental by age, pointed out that she could depend on it financially. The lessons took, and by the 1970s, Sofia Medina was as good as anyone in the pueblo.

Also in the 1970s, the inevitable happened. Raphael tried painting on a few pots. He used natural pigments on two of them, but he'd spent twenty years painting with acrylics, so he shifted over.

He wasn't the first to use acrylics on pottery. Jemez potters had used acrylics for years, almost entirely on low-end pieces knocked out for the tourists. But as far as we can tell, he was the first established, talented painter to use acrylics on pottery, and his efforts brought legitimacy to a practice that makes purists shudder.

Because Raphael led the way, Zia is the only pueblo that produces high-quality acrylic-painted pottery. Today, two artists have built considerable reputations with acrylics: Sofia and Raphael's son Marcellus Medina, who works with his wife, Elizabeth, and Ralph Aragon, who married Raphael's cousin Joan. Their styles are entirely different. Marcellus's work is like his father's—realistic figures on otherwise traditionally colored pottery—while Ralph paints traditional elements in non-traditional arrangements and colors. Marcellus Medina's pots look like "Indian art," and Aragon's look like "modern art."

Beyond acrylics, contemporary Zia pottery experimentation is a short stretch. The rest of the Medinas, Pinos, Gachupins, and Toribios still do pretty much the same thing. It's a little crisper, a little different perhaps, but it's still pure Zia pottery, as beautifully made and as easy to recognize as ever.

Marcellus and Elizabeth Medina's little jar in the bottom row shows the style of figure painting that Marcellus's father began putting on his mother's jars twenty years before.

Ralph Aragon's two pieces describe his work: individual, unmistakable and uncomfortable to purists who can't conceive of a Zia pot in anything other than Zia colors.

The rest of the pieces show how closely other Zia potters have held to the established idiom. Roadrunners still run the roads, but individual artists now contribute their own smile-provoking, animated-cartoon movement to the figures. Eusebia Shije's struts, Elizabeth Medina's hops, Reyes Pino's waddles, L. Negale's stops in bewilderment, and Kathy Pino's brakes to a screeching halt.

Eusebia Shije and Reyes Pino make pieces in untraditional shapes, Elizabeth Medina puts a turtle on the lid of her jar, and Kathy Pino plays with Zia design elements to create a piece that wanders slightly away from the middle of the road. The key word for all of this is "slightly." Zia pottery remains Zia pottery, now and for the foreseeable future.

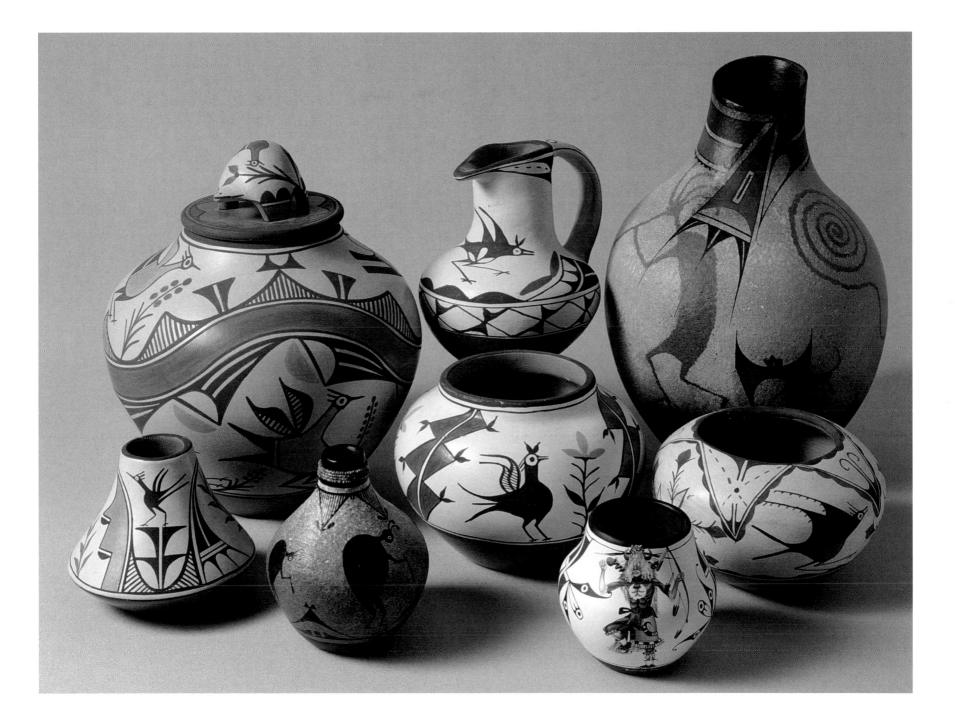

Zuni

➤➤ *It all began here.* On the day in 1539 that an annoyed Zuni warrior dispatched Estebán the Moor and sent Fray de Niza scurrying back to Mexico City with tales of the gold of Cibola, the fate of the Southwest was sealed. Coronado came, saw, and conquered Zuni in less than an hour, and foreigners have ruled pottery country ever since.

Zuni tried its own pueblo revolt in 1632, doing in two resident priests and fleeing to the hills to avoid retaliation, but a new set of priests coaxed them back down until the revolt of 1680, when they went back into the hills along with the rest of the pueblos. Zuni capitulated quickly during the reconquest—it had problems even worse than the Spanish. In 1670, Apache raiders had destroyed the village of Hawikuh, burned the mission, and killed most of the inhabitants. In 1692, the protection of armed Spanish troops seemed preferable to slaughter by Apaches.

Today, Zuni is in the modern age. Highway 53 cuts through a town that shows no evidence of age or permanence. The government in far-off Santa Fe barely acknowledges its existence, displaying a faint contempt in the way they spell the highway signs within the pueblo: a Hispanic "Zuñi." (The accent over the n tells you to pronounce it "Zoon-yee," an unthinkable mangling of the name. It's "Zoony" now and forever.)

But there's far more to Zuni than you see at first. If you walk around in back of the Turquoise Village Trading Post and wind through a snail track of alleys, you'll find yourself face-to-face

with the seventeenth-century mission and the homes of Old Zuni. And if you duck your head and walk through the little door at the side of the mission, you'll see the most amazing juxtaposition of old and new, Indian and Spanish, Kachina and Catholic, in the whole Southwest. Alex Seotewa's Sha-lako procession murals surround the walls, right above the Stations of the Cross in a mission restored through a joint effort of church and tribe.

Zuni is unique, and, in subtle ways, so is its pottery. To the untutored eye, the better examples look like Acoma or Laguna, and the lesser examples just look crude. But when you know what to look for, you become more and more appreciative of the differences.

Much of the clay used at Zuni is pink where Acoma's is white, and the thinnest white Zuni olla can show pink through a scratch. Zuni black paint is apt to be brown, and since 1800, Zuni jars have black or dark brown underbodies rather than red. This might seem like a minor divergence, but if you look at the more than a hundred jars and bowls with a dark base in the pages of this book, you'll find they're all red until you get to Zuni.

Zuni potters like sculpture and appliqué and water symbols and hunting symbols. Frogs, tadpoles, heartline deer, and dragonflies may show up from time to time on pottery from other pueblos, but they're Zuni designs.

Fine pre-1930 Zuni pieces are rare, highly prized, highly priced, and highly publicized. But not all pre-1930 Zuni ware was all that fine.

Zuni potters made a broad range of ollas, baskets, jars, and odd little ceremonial pieces at many levels of quality. On the opposite page, you'll see an assortment of older Zuni pieces of the type that books about historic pottery usually ignore.

In the picture, there's really only one example of fine turn-of-the-century Zuni Polychrome—the moccasin in the bottom row. It has the polish and the hard finish that typifies the most prized Zuni ollas. Much early Zuni ware, however, was quite a bit rougher in execution. The bowl with the appliquéd frogs at top left is less carefully made, but it's a masterwork compared to some of the others. The little jar at bottom right and the two jars in the top row are quick, rough, and fascinating. Older Zuni redware is scarce, and pieces like the jar at top right don't seem to have been made after 1920 or so.

As the years went by, quality deteriorated. The 1930 jar at the right of the middle row isn't half bad, but the later examples get worse. The jar in the center and the two pieces at the left of the bottom row come from the dark ages of Zuni pottery—1935 to 1960. Part of the problem was simple: Zuni jewelers were becoming world-famous for their painstaking, finely crafted inlays, settings, and carvings. The opportunities in jewelry were obvious, and the best artists quit making pottery.

The last and latest piece in the picture is a latter-day execution of a traditional Zuni shape: the prayer-meal basket, decorated with tadpoles and dragonflies.

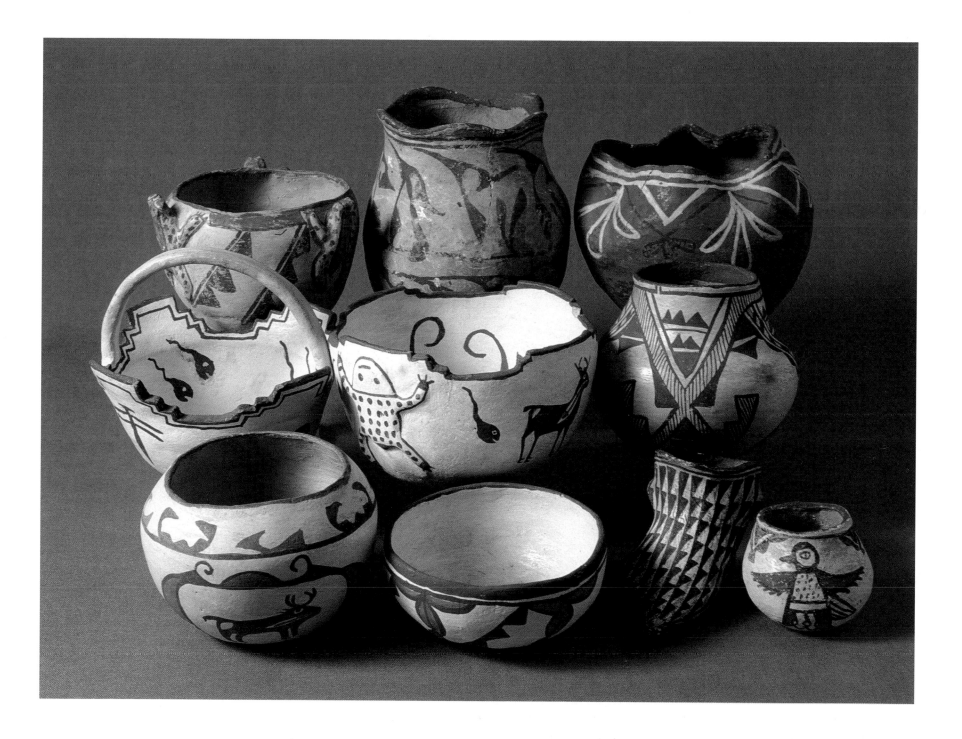

Zuni · Comeback at Zuni High

All it takes is a couple of good teachers and thirty years of intense effort. By the 1950s, Zuni pottery was in a slump. It wasn't quite as near death as Mojave pottery is in the 1990s, but vital signs were fading rapidly. Almost every artist at the pueblo was in the jewelry business.

There had been a few fine potters at Zuni between 1920 and 1950—Tsayutitsa, the great potter, whom Anglo collectors knew as "Mrs. Milam's mother" because they couldn't pronounce her name, and Catalina Zunie, the great teacher. But they were gone, and only Nellie Bica kept the tradition alive.

Then an amazing lady—Daisy Hooee, Nampeyo's granddaughter, one of the great Hopi potters, graduate of *L'Ecole de Beaux Arts* in Paris—married a Zuni man. She moved to Zuni, taught at Zuni High School, and became a conscientious and competent Zuni potter and teacher.

Later, another accomplished married-in potter, Jennie Laate from Acoma, took over the pottery classes at Zuni High. She knew the old designs and taught her students to do them right.

It took a while for the results to show, however. In 1980, John Barry's *American Indian Pottery* told us that, "Through the years, various individuals and institutions have tried to encourage the Zunis to revive pottery making. These attempts have not been successful for the reason that there must be pueblo support and individuals with an interest in making pottery. . . . At the 1979 Santa Fe Indian Market only one potter, Jennie Laate, displayed Zuni pottery."

But Jennie Laate's students kept at it, and others encouraged family members to turn back to pottery from jewelry. In 1983, Margaret Hardin and the Heard Museum worked with Zuni to put together a show that rekindled interest in the art. In 1985, Josephine Nahohai received a fellowship from the School of American Research to teach Zuni women traditional pottery. Quanita Kalestewa got tired of breathing the dust from grinding shells, and when the price of silver went up, quit jewelry-making for pottery. In 1986, James Ostler wrote in *Zuni Pottery* about what happened when the Zuni Tribal Arts & Crafts Enterprise sent six potters to the Smithsonian: "I had thought that the results of seeing historic Zuni pottery by the Zuni potters would be diffused and slow in taking effect: in fact, they were almost immediate. No less than a month after the museum visit, I was seeing pots of different shapes and older designs. . . ."

In the 1990s, Zuni High continues. Daisy Hooee and Jennie Laate are gone, but Noreen Simplicio had over a hundred students in her classes in 1990 and 1991, and Gabriel Paloma has almost as many today. There are strong Zuni pottery families: the Nahohais, the Kalestewas, and the Peynetsas foremost among them. And there are pieces coming out of Zuni that no one has made for more than half a century. There are large, thin, beautifully finished rainbird and deer-in-house-ollas, the kind whose nineteenth-century versions can bring five figures at today's auctions. There are prayer-meal baskets and un-slipped redware jars and turquoise-covered fetish jars.

Perhaps even more important, there are fanciful new extensions of the art that make everyone take notice. The new group of Zuni potters isn't merely re-creating the old, it's building a new, strange, and wonderful pottery tradition.

As much as any group picture in the book, this one tells a complete story. Start with a Zuni traditional piece that goes back more than a hundred years: the owl figurine. The larger one in the bottom row was made by Quanita Kalestewa's mother Nellie Bica, one of the last of the old-time potters, who concentrated on owl figurines in her later life. The smaller one was made by Nelson Vincenti, a novice potter, in 1994, and it's every bit as satisfyingly traditional as the fine old pieces that inspired it.

At the lowest point of pottery production, Daisy Hooee arrived. The little jar at bottom center shows how serious she was about becoming a real Zuni potter. This is a loving representation in miniature of a classic deer-in-house olla with rosette (the name comes from the decoration around the standing deer, always depicted with a heartline, the red line that runs from its mouth to its heart). Jennie Laate did them, too—late in life, she did the slightly larger version to its right, and you can see a full-size specimen on page 1.

Jennie Laate did other traditional pieces as well, like the prayer meal basket in the middle, and she taught students how to do them. Anderson Peynetsa, a star pupil, did the beautiful big rainbird olla at the top. This is the other major nineteenth-century design, and its square-winged bird is so stylized that, on most examples, you'll probably need help before you see the bird's beak. (By the way, if you see an old pot in a

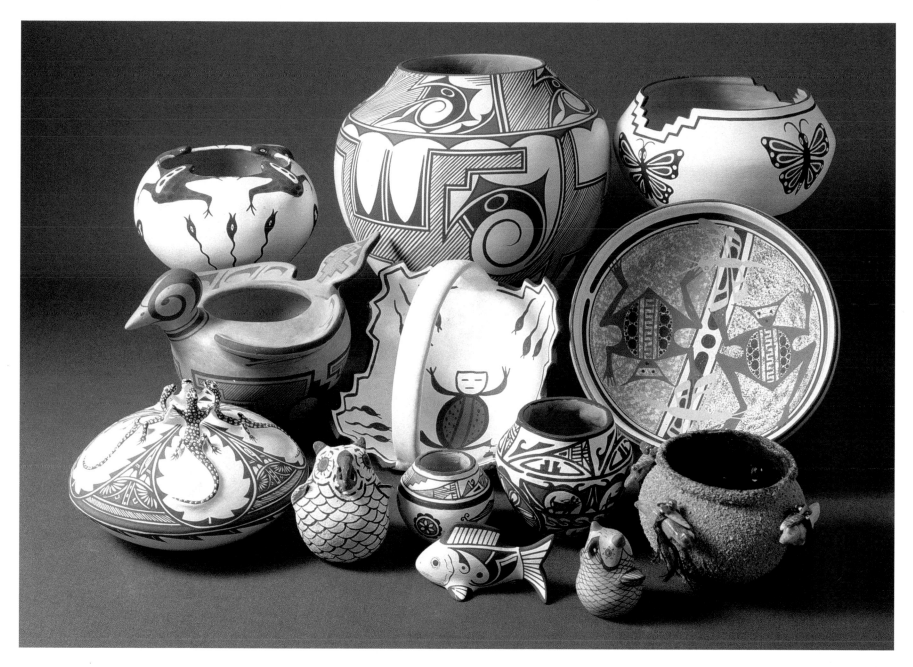

junk store with either of these designs, grab it. You may have a treasure.)

Other potters found other traditions. Erma Kalestewa's frog jar at top left is the direct heir of the old ones on the preceding page, and her mother's kiva jar at top right comes from an older tradition as well. The Kalestewas steadfastly resist the electric kiln, which makes them unlike many Zuni potters.

Merely recreating the old wasn't enough. Josephine Nahohai's son Randy and his wife Rowena Him became the best-known Zuni potters of the early 1990s by experimenting; now a young potter like Chris Nastario can make something like this fish and nobody questions it.

Noreen Simplicio makes some of the most elegantly detailed and imaginative pieces of any Southwestern potter anywhere, and even fetish carvers like Edna Leki are deco-

rating fetish jars covered with crushed turquoise in the traditional way. This one came with its four fetishes tied to the outside and two more resting within, properly fed on a bed of blue corn meal.

Thanks to Daisy Hooee, Jennie Laate, and a bump in the price of silver, Zuni pottery is in full bloom.

Zuni • Fun with the Peynetsas

Jennie Laate's legacy: the creation of a great pottery family. The picture on the right shows an array of important work by five different family members: Anderson Peynetsa, his sisters Priscilla and Agnes, his wife, Avelia, and his brother-in-law Darrell Westika. The important thing about it is that it all started with Jennie Laate and Zuni High, not from learning through the family.

When you stop to think about it, this is unusual in itself. In *Zuni Pottery,* Jennie Laate commented that she didn't know why so few of her students kept up with the craft. The answer, of course, is that it's easier not to. It's a sad fact that in all the arts, everywhere in the world, a high percentage of talented young people drop out and do other things with their lives, and the people in Jennie Laate's classes at Zuni High were no exception.

Anderson Peynetsa, however, was an exception. He kept at it and never stopped, building a body of work that in the mid-1990s probably established him as Zuni's premier potter. His long suit is sculpture and appliqué.

In the beginning, Priscilla's career path was more typical. She took the pottery classes in high school but wasn't particularly interested. But after she had an accident and couldn't work, she went back to night school and took the classes in earnest. That began a ten-year career as one of Zuni's finest potters. In an ironic twist, a career that began with an accident was again altered by one. In early 1995, Priscilla lost an arm in a car crash, and her return to pottery production has been slow and difficult.

Agnes came next. At first, she worked with Anderson, and has worked with Berdel Soseeah since Anderson married Avelia, whose name often appears (mistakenly) as "Aurelia." There are a lot of pots signed "A. A. Peynetsa." The older ones are Anderson and Agnes, the newer ones are Anderson and Avelia. Avelia, by the way, *does* have a family heritage. She's a direct descendant of the great teacher of the 1920s, Catalina Zunie.

At Zuni High, young potters learn about greenware, commercial paints and the kiln, and many don't leave them entirely behind. The Peynetsas dig their own clay and make their own paints, but, like most Acoma and Zuni potters, they use the electric kiln. Anderson tried outdoor firing once, failed, and gave up.

The brilliant Noreen Simplicio, who also uses a kiln, offered an eloquent defense for the practice in Milford Nahohai's and Elisa Phelps's *Dialogues with Zuni Potters:* "Over at Indian Market, when you try to enter your work, they'll downgrade it because it's fired in a kiln. I think it's good that they have that for people who are totally traditional, but they should have room for people that, like myself, are both traditional and contemporary."

Traditional and contemporary describes the Peynetsas perfectly. All Peynetsa work is excellent: excellently decorated, excellently sculpted, often with a quiet sense of humor, never with an inflated sense of importance. Where else can you see major, museum-quality pieces right alongside a refrigerator magnet, all done with the same loving care?

TOP ROW: *Olla, Priscilla Peynetsa, 8½″ diameter, 1991; bird effigy, Anderson and Avelia Peynetsa, 11″ high, 1994; olla, Anderson Peynetsa, 8½″ diameter, 1991*
MIDDLE ROW: *Canteen, Anderson and Avelia Peynetsa, 6¼″ high, 1994; jar, Anderson and Avelia Peynetsa, 5″ high, 1993; jar, Priscilla Peynetsa, 6½″ diameter, 1990; jar, Priscilla Peynetsa, 5¾″ diameter, 1989; bird effigy, Darrell Westika, 7″ high, 1993*
BOTTOM ROW: *Bird figurine, Agnes Peynetsa, 3½″ high, 1991; cloud blower, Priscilla Peynetsa, 8″ long, 1994; seed jar, Anderson and Avelia Peynetsa, 3¼″ diameter, 1992; turtle figurine, Priscilla Peynetsa, 7″ long, 1993; refrigerator magnet, Priscilla Peynetsa, 2⅜″ high, 1993; seed jar, Anderson and Avelia Peynetsa, 3″ diameter, 1993*

Anderson Peynetsa loves sculpture, and you can appreciate it in the way his lizards and frogs clamber about his jars and canteens. Agnes shares his affinity for sculpture, as the little bird at bottom left demonstrates. (After much contemplation, John decided it was a loon.)

However, it's not nearly as loony as the effigy jar by Priscilla's husband Darrell Westika at the right. Al is convinced that if you pinch its beak together hard enough, it'll honk out of the horn on the top of its head. We were told this was inspired by a book on pre-Columbian art, and it must be so. Even a Peynetsa couldn't think this one up without some external input.

The looniness is more controlled on other pieces, like Priscilla's cloud-blower pipe at bottom or her annoyed-looking turtle, or Anderson and Avelia's monumental dovelike creature.

And sometimes the looniness is absent altogether, as on Anderson's carefully recreated rainbird jar on the previous page or on Priscilla's painstakingly correct deer-in-house and rosette jar at middle right—or on her equally correct refrigerator magnet.

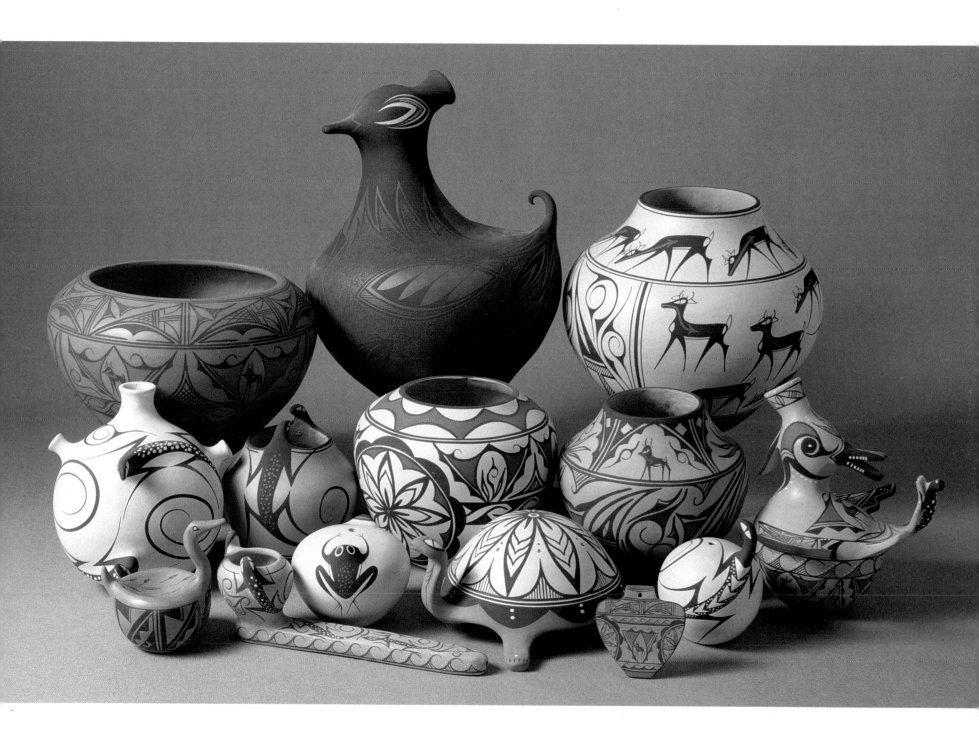

The Others

▸ *You'd think that in this many pages, we could cover it all. Well, we couldn't.* In traveling through the alphabet from Acoma to Zuni, we've stopped in twenty-six different places in the Southwest where Indians make pottery. Each place has, or has had, its own style, its own traditions, and its own recognizable pottery.

There are others as well. To the west and a bit north of Taos, the Jicarilla Apache make a micaceous ware that ranges from crude, like the bowl that could pass for prehistoric in the front row, to sophisticated, like the micaceous ware to its right.

Down by El Paso, those 385 prisoners of war who left the scene of the Pueblo revolt and founded Ysleta del Sur in 1681 never made much pottery. But, with the resurgence of interest in Indian arts that occurred in the 1970s, there was a brief revival down south. It was all cast pottery and not very inspiring, but it is in fact pottery from yet another pottery-producing pueblo.

The Yaqui Indians, whose main population is across the border in northern Mexico, overlap into southwestern Arizona. They made a small amount of exceptionally fine, high-fired, eggshell-thin blackware, more like prehistoric Ramos black than like anything from Santa Clara or San Ildefonso.

And then, there are individual potters who don't seem to fit in anywhere. The little micaceous storyteller in the front is by Margaret Quintana. She's a Cheyenne married to a Cochiti who lives in San Juan and uses Taos clay. Where does that put her? According to tradition, if it's Taos clay, it's a Taos pot. Maybe the pot is. But, considering who she is, it's hard for us to put Margaret Quintana in Taos.

Same with Dalewepi (Ergil Vallo). His finely made blackware decorated with non-traditional colors is easily recognizable, and we've seen his work sold as Santa Clara. Like Taos for Margaret Quintana's little storyteller, that's easy enough to accept. But Vallo himself is Acoma/Hopi, so where does that leave him? Here with The Others, until further notice.

If Jicarilla Apache ware keeps improving, it may get its own space in the next book like this that comes along. Tammie Allen's cousin Felipe is working to revive the art among the Jicarillas, Tammie herself is beginning to get some recognition, and other potters are coming up.

Yaqui ware seems to have disappeared with even less trace than Mojave ware, and Ysleta del Sur closed down the craft shop and put in a restaurant. The last we heard, they'd put in a casino, and they had things other than pottery on their minds.

Which leaves us with Margaret Quintana, Dalewepi, and others like them. As long as there are people, people will move, and people will become interested in doing things that the people across the street are doing. So, at any given time, there will always be square pegs who don't fit anywhere in a neatly organized presentation.

Like the mysterious Pecos Rose and her huge, Medina-style greenware pot. Is she Navajo? Is she from a Rio Grande pueblo? Or maybe she isn't Indian. We have no idea, and we may never learn. We know that if we dig deep enough, we'll probably find out. But we'll find three more equally mysterious people in the process. For the moment, we'll leave her simply as the symbol of all we have yet to learn.

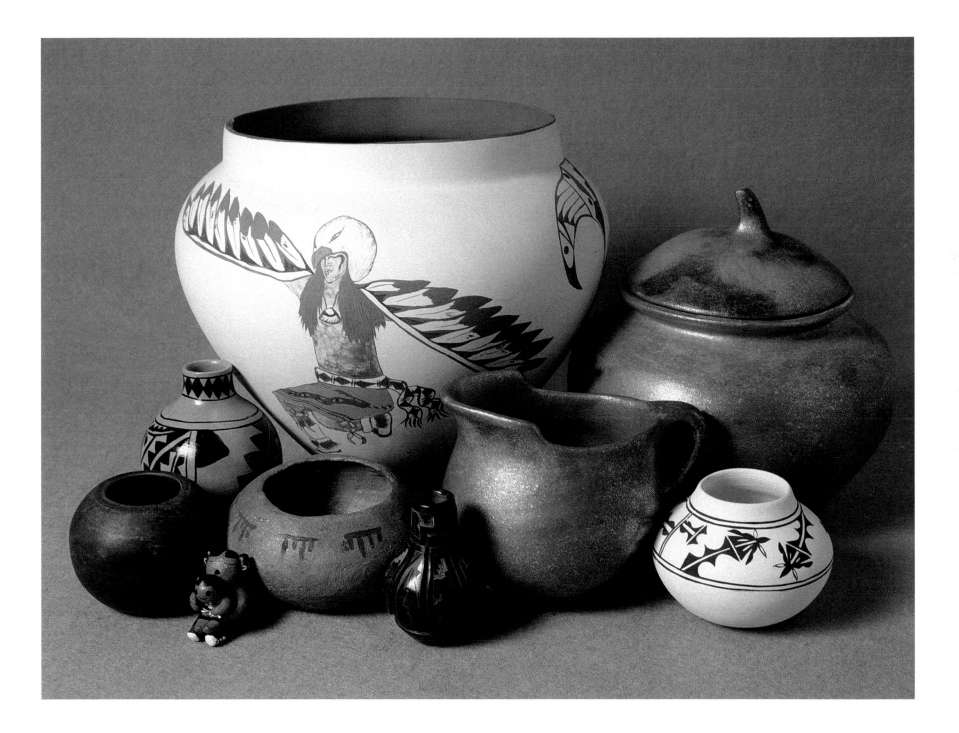

Collections

Hopi, Santo Domingo, Cochiti, and Isleta moccasins, ca. 1900–1925

➤ **This book happened because four collectors got together. Al's weakness is tourist stuff.** The tackier and funnier it is, the more points he gives it. Not everything in the picture is Al's—all of us have a bit of everything, and each of us has bought more than our share of these guilty pleasures.

Some of these pieces are quite well made, like the Santa Clara duck bowls or the Angel Coriz Santo Domingo necklace on the opposite page. Some were made by prestigious potters—Carol Velarde of Santa Clara did the blackware basket at far right, opposite, and Joy Navasie did the little red pitcher in the middle of that page, the only redware piece we've ever seen by Frog Woman, the master of whiteware.

Some of this is unexpected, like the Maricopa bowl below with the caricature Indian chief, copied off of a Wild West show poster or a penny, but with no resemblance to any Indian that ever lived within five hundred miles of Maricopa.

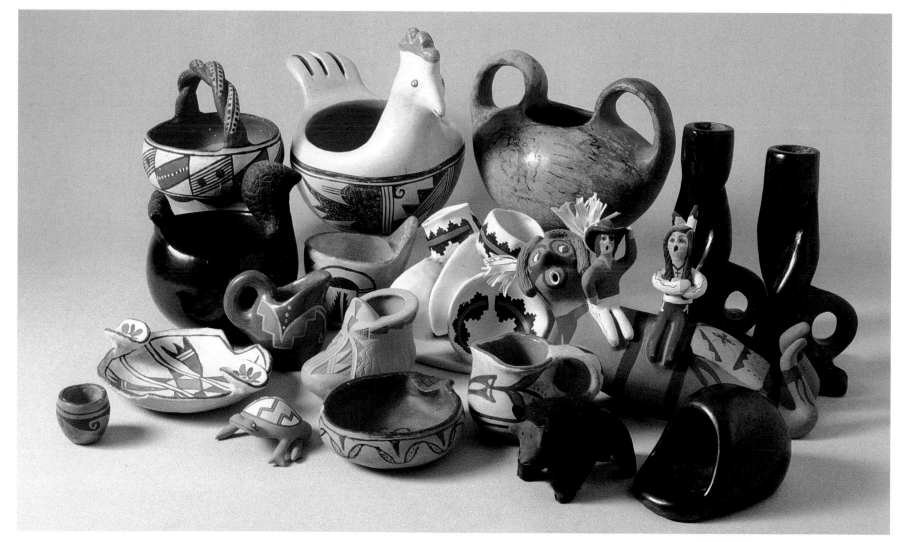

Or the blackware horno, one of the few pure tourist pieces we've seen from San Ildefonso.

Some are flagrantly touristy, like the Jemez Santa Claus storyteller or the poster-paint salt and pepper shakers, also from Jemez. And some are just plain awful, like the blue shoe from Acoma or the Navajo piled-basket thing behind it (Carol calls it a "paper-clip holder"), the turquoise-covered wedding vase that the dealer thought looked like something you found on a back shelf in the chicken coop, or the most unspeakable of all, the night-light to the left of it that brings to mind a line from a current souvenir postcard: "These Indians are Taiwans. It says so right on their pottery."

Al's favorite? This beautifully done Santa Clara bowl made in 1992 by Fidel and Tonita Naranjo. It has N E W · M E X I C O deeply and fastidiously carved around its perimeter. Al's sons are currently fighting over who he leaves it to in his will.

New Mexico

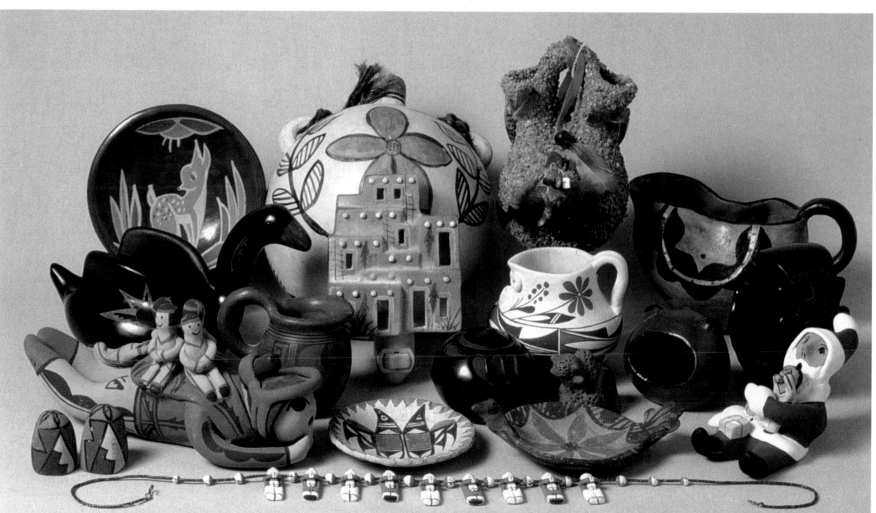

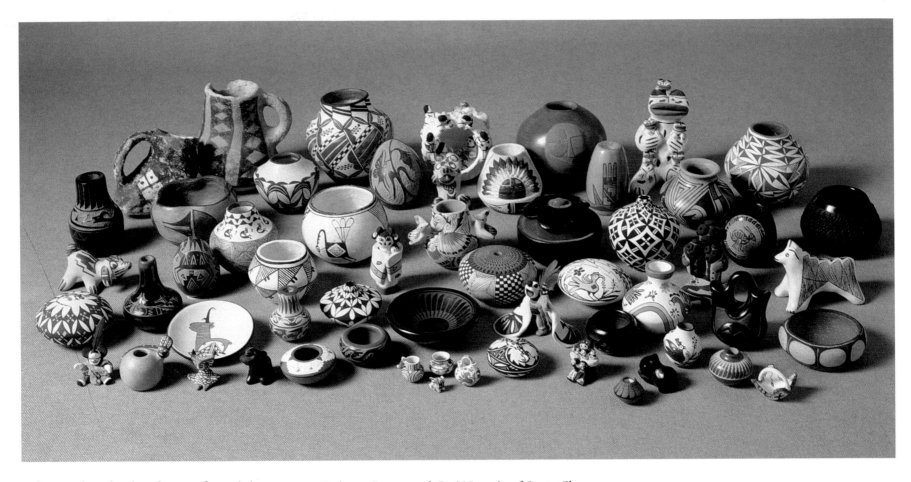

John, on the other hand, goes after miniatures.
Miniatures have been around forever. The Mogollon
Reserve Black-on-white pitcher and sipper at the
upper left date from around A.D. 1000.

Some are small pots, like the Acoma seed
jars scattered through the picture. Some are
true miniatures, like the olla by Acoma's Wanda
Aragon at top center, a reproduction of a
nineteenth-century masterpiece. There's work
here by masters—Dorothy Torivio, Adrienne
Roy Keene, and Dolores Aragon of Acoma;

Dolores Curran and Geri Naranjo of Santa Clara;
and Iris Youvella of Hopi. But, as with everything
else, just "miniature" isn't enough in this Golden
Age. In the 1990s, there's a whole new class of
subminiatures, with Thomas Natseway of Laguna
currently the leading exponent. You can see
some of his tiny ollas at front center. Along
with the winner so far: a polychrome pig loaded
with attitude by Judy Shields of Acoma. It's
three-eighths of an inch long.

*The pig (two and a half times its
actual size)*

And Carol likes moccasins. For reasons we can't fully explain, miniature pottery moccasins have been very popular all over the Southwest.

The prehistoric infant's water-sipper on the opposite page is a moccasin with a handle, and the nineteenth-century Polacca Polychrome shaped like a prehistoric warming-bowl on page 67 looks like a moccasin. With these, however, there's no "looks like." The big nineteenth-century Zuni one at top right even shows the ankle bones, as does the red San Juan one below it. We think the little Isleta one and the worn-out Maricopa one next to it in the front row go back to 1900 or before, and it's probably true of the Santo Domingo one behind the Maricopa.

These come from all over—you're looking at Jemez, Cochiti, Santa Clara, Hopi, and Laguna examples as well—and from all times up to the present. The blue thing from Acoma on page 174 was probably made last week.

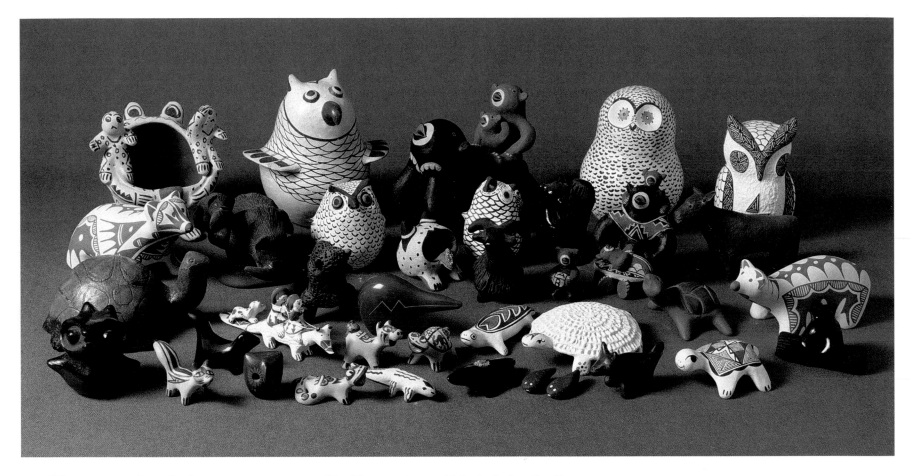

Small beasts appeal to all of us. They also appeal to a great number of Pueblo potters. Certain pueblos have traditional pieces, like Zuni with its owls, but they make a lot of them at Acoma as well.

This array represents most pueblos, and you've probably noticed quite a few more of these charming creatures on the earlier pages of the book. All kinds of animals get all kinds of treatments. Since we mentioned owls, look what Dorothy and Paul Gutierrez of Santa Clara did with one at bottom left. And what Cordi Gomez of Pojoaque did a couple of pieces to the right of it in the bottom row. Stephanie Rhoades's and Martha Arquero's Cochiti frogs get your attention, as do the Cochiti bear families by Louis and Virginia Naranjo and their daughter Edna.

Is there a favorite among all these? That's impossible to answer. But there's a hands-down winner for the most unexpected. Check out the black tadpoles by Lucy Lewis in the bottom row.

Collections · People Named Vigil

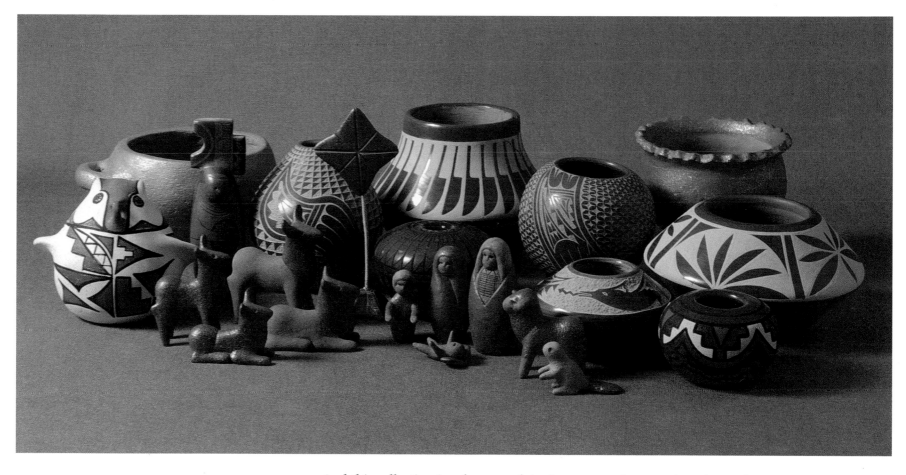

And this collection just happened. As the John & Al Museum grew, we started seeing names again and again: Tafoya, Garcia, Naranjo. But the name Vigil got our attention. It's uncommon over most of the nation, yet we had pots by Vigils from all over the Southwest.

Just in this picture, we have Albert, Josephine, Doug, and Charlotte from San Ildefonso. Minnie and Annette from Santa Clara. Gloria and Carol from Jemez. Priscilla and Ka'Ween (Claudia) from Tesuque. Robert from Nambé. Darlene from Hopi. And a pot from Picuris just signed "Vigil." Elsewhere in the book, you'll find pots by Lonnie from Nambé, Evelyn from Jemez, Dolorita and Juanita from San Ildefonso, Sunbird from Santa Clara, and Manuel from Tesuque.

Nineteen Vigils from seven pueblos, some famous, some almost forgotten, some with their fame still ahead. All of whom remind us why we started this in the first place: with Southwestern pottery, no matter how much you learn, there's always a surprise waiting around the corner.

museums & bibliography

MUSEUM COLLECTIONS

The collections of Southwestern pottery in many of America's museums aren't all on open display. So when we say any given museum has a pottery collection worth checking out, it doesn't mean you'll necessarily be able to see it just by walking in and looking. But if you're seriously interested, ask about an appointment for a collection tour. Also, when museums put together pottery exhibits, they may travel. Watch the museums and universities in your area. These museums all have especially significant Southwestern pottery collections.

THE ARIZONA STATE MUSEUM, *Tucson (University of Arizona)*
THE BROOKLYN MUSEUM, *Brooklyn*
THE DENVER ART MUSEUM, *Denver*
THE FIELD MUSEUM, *Chicago*
THE HEARD MUSEUM, *Phoenix*
THE MAXWELL MUSEUM, *Albuquerque (University of New Mexico)*
THE MILLICENT ROGERS MUSEUM, *Taos*
THE MUSEUM OF NEW MEXICO, *Santa Fe*
THE MUSEUM OF NORTHERN ARIZONA, *Flagstaff*
THE NATIONAL MUSEUM OF THE AMERICAN INDIAN, *New York*
THE PEABODY MUSEUM, *Cambridge (Harvard University)*
THE PHILBROOK MUSEUM, *Tulsa*
THE SAN DIEGO MUSEUM OF MAN, *San Diego*
THE SCHOOL OF AMERICAN RESEARCH, *Santa Fe (by appointment)*
THE SOUTHWEST MUSEUM, *Los Angeles*
THE TAYLOR MUSEUM, *Colorado Springs*
THE UNIVERSITY MUSEUM, *Philadelphia (University of Pennsylvania)*

BIBLIOGRAPHY (*suggested reading)

Ambler, J. Richard and Alan P. Olson. *Salvage Archaeology in the Cow Springs Area.* Museum of Northern Arizona Technical Series No. 15. Flagstaff: Museum of Northern Arizona, 1977.

Appleton, LeRoy H. *American Indian Design & Decoration.* Reprint with new materials. New York: Dover Publications, Inc., 1971.

Arnold, David L. "Pueblo Pottery: 2,000 Years of Artistry." *National Geographic* 162 No. 5. Washington DC: National Geographic Society, 1983.

Ashton, Robert Jr. "Nampeyo and Lesou." *American Indian Art* 1 No. 3. Scottsdale, AZ: American Indian Art, Inc., 1976.

* Babcock, Barbara A., Guy Monthan, and Doris Monthan. *The Pueblo Storyteller: Development of a Figurative Ceramic Tradition.* Tucson: University of Arizona Press, 1986.
———. "These, They Called Them Monos: Cochiti Figurative Ceramics, 1875–1905." *American Indian Art* 12 No. 4. Scottsdale, AZ: American Indian Art, Inc., 1987.

* Bahti, Mark. *Pueblo Stories and Storytellers.* Tucson: Treasure Chest Publications, 1988.

* Bahti, Tom. *Southwestern Indian Tribes.* Las Vegas: KC Publications, 1968.

Barnett, Franklin. *Excavation of Main Pueblo at Fitzmaurice Ruin.* Flagstaff: Northern Arizona Society of

Barnett, Franklin. *(continued)*
Science and Art, 1974.

* Barry, John W. *American Indian Pottery, 2d Edition.* Florence, AL: Books Americana, 1984.

Bartlett, Katherine, Kathleen E. Gratz, and Ann Hitchcock. "Hopi and Hopi-Tewa Pottery." *Plateau* 49 No. 3. Flagstaff: Museum of Northern Arizona Press, 1977.

* Batkin, Jonathan. *Pottery of the Pueblos of New Mexico, 1700–1940.* Colorado Springs: Taylor Museum of the Colorado Springs Fine Arts Center, 1987.
———. "Three Great Potters of San Ildefonso and Their Legacy." *American Indian Art* 16 No. 4. Scottsdale, AZ: American Indian Art, Inc., 1991.

Bee, Robert L. *The Yuma.* New York: Chelsea House Publishers, 1989.

Bernstein, Bruce. "Potters and Patrons: The Creation of Pueblo Art Pottery." *American Indian Art* 20 No. 1. Scottsdale, AZ: American Indian Art, Inc., 1994.
———. "Pueblo Potters, Museum Curators, and Santa Fe's Indian Market." *Expedition* 36 No. 1. Philadelphia: University of Pennsylvania Museum, 1994.

* Blair, Mary Ellen, and Laurence Blair. *Margaret Tafoya: A Tewa Potter's Heritage and Legacy.* West Chester, PA: Schiffer Publishing, 1986.

Blinman, Eric. "Anasazi Pottery: Evolution of a Technology." *Expedition* 35 No. 1. Philadelphia: University of Pennsylvania Museum, 1993.

Bloom, Maurice M. Jr. "In Appreciation: Daisy Hooee Nampeyo, 1910–1994." *The Indian Trader* 26 No. 2. Gallup, NM: The Indian Trader, Inc., 1995.

* Brody, J.J. *Beauty From the Earth.* Philadelphia: The University Museum of Archaeology and Anthropology, University of Pennsylvania, 1990.

* ——— *Mimbres Painted Pottery.* Santa Fe: School of American Research, 1977.

* Brody, J.J., Catherine J. Scott, and Steven A. LeBlanc. *Mimbres Pottery: Ancient Art of the American Southwest.* New York: Hudson Hills Press in association with The American Federation of Arts, 1983.

Bronson, Oscar T. *Fetishes and Carvings of the Southwest.* Tucson: Treasure Chest Publications, 1976.

Brugge, David M., H. Diane Wright, and Jan Bell. "Navajo Pottery" *Plateau* 58 No. 2. Flagstaff: Museum of Northern Arizona Press, 1987.

* Bunzel, Ruth L. *The Pueblo Potter: A Study of Creative Imagination.* New York: Columbia University Press, 1929.

Cahill, Rick. *The Story of Casas Grandes Pottery.* Tucson: Boojum Books, 1991.

Cleland, Charles F. "Yuma Dolls." *American Indian Art* 5 No. 3. Scottsdale, AZ: American Indian Art, Inc., 1980.

Chapman, Kenneth M. "Indian Arts: America's Most Ancient Art." *Indian Arts (Pueblo and Navajo).* Worcester, MA: The Davis Press, Inc., 1932.

* Cohen, Lee N. *Art of Clay: Timeless Pottery of the Southwest.* Santa Fe: Clear Light Publishers, 1993.

Collins, John E. *Hopi Traditions in Pottery and Painting, Honoring Grace Chapella.* Alhambra, CA: NuMasters Gallery, 1977.

Colton, Harold S., Robert Euler, Henry Dobyns and A.H. Schroeder. *Pottery Types of the Southwest* Museum of Northern Arizona Ceramic Series No. 3D. Flagstaff: Northern Arizona Society of Science and Art, 1958.

Congdon-Martin, Douglas. *Storytellers and Other Figurative Pottery.* West Chester, PA: Schiffer Publishing, 1990.

Crown, Patricia L., and Ronald L. Bishop. *Ceramics and Ideology: Salado Polychrome Pottery.* Albuquerque: University of New Mexico Press, 1994.

Cunkle, James R. *Talking Pots: Deciphering the Symbols of a Prehistoric People.* Phoenix: Golden West Publishers, 1993.

* Cushing, Frank H. *My Adventures in Zuni.* Reprint with new materials. Palmer Lake, CO: Filter Press, 1967.

Dedera, Don. "In Praise of Pueblo Potters." *Exxon USA* 12 No. 2. Houston: Exxon Company USA, 1973.

* Dillingham, Rick, and Melinda Elliott. *Acoma & Laguna Pottery.* Santa Fe: School of American Research Press, 1992.

* Dillingham, Rick. *Fourteen Families in Pueblo Pottery.* Albuquerque: University of New Mexico Press, 1994.

* Dittert, Alfred E., and Fred Plog. *Generations in Clay: Pueblo Pottery of the American Southwest.* Flagstaff, AZ: Northland Publishing, 1980.

Dobyns, Henry F. *The Pima-Maricopa.* New York: Chelsea House Publishers, 1989.

Downum, Christian E. "Southwestern Archaeology: Past, Present and Future." *Expedition* 35 No. 1. Philadelphia: University of Pennsylvania Museum, 1993.

Eaton, Linda B. "The Hopi Craftsman Exhibition." *Expedition* 36 No. 1. Philadelphia: University of Pennsylvania Museum, 1994.
———. "Tradition and Innovation: The Pottery of New Mexico's Pueblos." *Plateau* 61 No. 3. Flagstaff: The Museum of Northern Arizona, 1990.

Eight Northern Indian Pueblos: 1994 Official Visitor's Guide. San Juan, NM: Eight Northern Indian Pueblos, Inc., 1994.

Elliott, Melinda. "Indian Arts Collection Helps Tribes to Maintain Cultural Continuity." *New Mexico* 72 No. 8. Santa Fe: *New Mexico Magazine,* 1994.

Fane, Diana. "Curator's Choice: Indian Pottery of the American Southwest." *American Indian Art* 11 No. 2. Scottsdale, AZ: American Indian Art, Inc., 1986.

Fewkes, J. Walter. *Prehistoric Hopi Pottery Designs* (Papers from 1895–96 and 1911–12, reprinted with new materials). Mineola, NY: Dover Publications, Inc., 1973.
———. *The Mimbres: Art and Archaeology.* Reprint with new material. Albuquerque: Avanyu Press, 1989

Fontana, Bernard, William C. Robinson, Charles W. Cormack, and Ernest E. Leavitt, Jr. *Papago Indian Pottery.* Seattle: University of Washington Press, 1962.

* Frank, Larry, and Francis H. Harlow. *Historic Pottery of the Pueblo Indians, 1600–1880.* West Chester, PA: Schiffer Publishing, 1990.

Fritz, Gordon L. *The Ecological Significance of Early Piman Immigration to Southern Arizona.* Tucson: unpublished thesis, 1977.

* Gault, Ramona. *Artistry in Clay.* Santa Fe: Southwestern Association on Indian Affairs, 1991.

Giametti, Victor Michael, and Nancy Greer Reichert. *Art of a Vanished Race: The Mimbres Classic Black-on-White.* Silver City, NM: Dillon-Tyler Publishers, 1975.

* Graybill, Florence Curtis, and Victor Boesen. *Edward Sheriff Curtis: Visions of a Vanishing Race.* New York: American Legacy Press, 1976.

Hammack, Laurens C. "Effigy Vessels in the Prehistoric American Southwest." *Arizona Highways* L No. 2. Phoenix: Arizona Highway Dept., 1974.

Hardin, Margaret Ann. *Gifts of Mother Earth: Ceramics in the Zuni Tradition.* Phoenix: the Heard Museum, 1983.

* Harlow, Francis H. *Matte-Paint Pottery of the Tewa, Keres and Zuni Pueblos.* Santa Fe: Museum of New Mexico, 1973.

———. *Modern Pueblo Pottery, 1880–1960.* Flagstaff, AZ: Northland Press, 1977.

* ———. *Two Hundred Years of Historic Pueblo Pottery: The Gallegos Collection.* Santa Fe: Morning Star Gallery, 1990.

* Hartman, Russell P., and Jan Musial. *Navajo Pottery: Traditions & Innovations.* Flagstaff, AZ: Northland Publishing, 1987.

Hawley, Florence M. *Field Manual of Southwestern Pottery Types* Bulletin No. 291, University of New Mexico. Albuquerque: University of New Mexico Press, 1936.

Hays, Kelley Ann, and Diane Dittemore, "Seven Centuries of Hopi Pottery: Yellow Ware from the Arizona State Museum Collections." *American Indian Art* 15 No. 3. Scottsdale, AZ: American Indian Art, Inc., 1990.

Hedges, Ken, and Alfred E. Dittert, Jr. *Heritage in Clay.* San Diego Museum Papers No. 17. San Diego: San Diego Museum of Man, 1984.

Hering, Michael J. "Zia Matte-Paint Pottery: A 300-Year History." *American Indian Art* 12 No. 4. Scottsdale: American Indian Art, Inc., 1987.

Houlihan, Patrick T., Barbara Cortwright, John E. Collins, Mike Tharp, Maggie Wilson, and Anita Da. "Southwestern Pottery Today." *Arizona Highways* L No. 5 Special Edition Phoenix: Arizona Highway Dept., 1974.

Howard, Richard M. "How Old Is That Acoma Pot?" *American Indian Art* 12 No. 4. Scottsdale, AZ: American Indian Art, Inc., 1987.

Jacka, Lois Essary *Beyond Tradition: Contemporary American Indian Art and Its Evolution.* Flagstaff, AZ: Northland Publishing, 1988.

James, H.L. *Acoma: People of the White Rock.* West Chester, PA, Schiffer Publishing, 1988.

Johnson, Ginger. *Exploring the Past: A View of Southwestern Prehistory.* Prescott, AZ: Ginger Johnson, 1994.

* Kramer, Barbara. *Nampeyo and Her Pottery,* Albuquerque: University of New Mexico Press, 1996.

LeFree, Betty. *Santa Clara Pottery Today.* Albuquerque: University of New Mexico Press, 1975.

Leskou, Stephen H. "Chaco, Hohokam and Mimbres: The Southwest in the 11th and 12th Centuries." *Expedition* 35 No. 1. Philadephia: University of Pennsylvania Museum, 1993.

* Lister, Robert H., and Florence C. Lister. *Anasazi Pottery.* Albuquerque: Maxwell Museum of Anthropology, 1978.

MacCallum, Spencer Heath. "Pioneering an Art Movement in Northern Mexico: The Potters of Mata Ortiz." *Kiva* 60 No. 1. Tucson: Arizona Archaeological and Historical Society, 1994.

Markley, Max C. "Distribution of Pueblo Pottery in Southeastern New Mexico." *The Minnesota Archaeologist* VII No. 2. Minneapolis: Minnesota Archaeological Society, 1941.

* Marriott, Alice. *Maria: The Potter of San Ildefonso.* Norman: University of Oklahoma Press, 1948.

Mays, Buddy. *Indian Villages of the Southwest.* San Francisco: Chronicle Books, 1985

McChesney, Lea S. "Producing Generations in Clay: Kinship, Markets, and Hopi Pottery." *Expedition* 36 No. 1. Philadephia: University of Pennsylvania Museum, 1994.

Mera, H.P. *Style Trends of Pueblo Pottery, 1500–1840.* Reprint with new material. Albuquerque: Avanyu Publishing, 1991.

Mercer, Bill. *Singing the Clay: Pueblo Pottery of the Southwest Yesterday and Today.* Cincinnati: Cincinnati Art Museum, 1995.

Minnis, Paul, and Michael Whalen. "Casas Grandes: Archaeology in Northern Mexico." *Expedition* 35 No. 1. Philadephia: University of Pennsylvania Museum, 1993.

* Nahohai, Milford, and Elisa Phelps. *Dialogues With Zuni Potters.* Zuni, NM: Zuni A:shiwi Publishing, 1995.

Nampeyo of Hano (Exhibition catalog with introduction by Joseph Trangott.) Albuquerque: Adobe Gallery, 1983.

Naranjo, Tessie. "Pottery Making in a Changing World." *Expedition* 36 No. 1. Philadephia: University of Pennsylvania Museum, 1994.

Olson, Alan P. *Archaeology of the Arizona Public Service Company 345 KV Line* Bulletin No. 45, Museum of Northern Arizona. Flagstaff: Northern Arizona Society of Science and Art, 1971.

* Oppelt, Norman T. *Earth, Water and Fire: The Prehistoric Pottery of Mesa Verde.* Boulder: Johnson Publishing, 1991

* Parks, Walter P. *The Miracle of Mata Ortiz: Juan Quezada and the Potters of Northern Chihuaha.* Riverside: The Coulter Press, 1993.

Patterson, Alex. *Hopi Pottery Symbols.* Boulder: Johnson Books, 1994.

* Peckham, Stewart. *From This Earth: The Ancient Art of Pueblo Pottery.* Santa Fe: Museum of New Mexico Press, 1990.

* Peterson, Susan. *Lucy M. Lewis, American Indian Potter.* Tokyo: Kodansha International Ltd., 1984.

* ———. *The Living Tradition of Maria Martinez.* Tokyo: Kodansha International Ltd., 1989.

Pilles, Peter J., Jr., and Edward B. Danson. "The Prehistoric Pottery of Arizona." *Arizona Highways* L No. 2. Phoenix: Arizona Highway Dept., 1974.

* *Prehistoric Cultures of the Southwest: Anasazi, Hohokam, Mogollon, Salado and Sinagua* (Series of five pamphlets.) Tucson: Southwest Parks and Monuments Association, 1992.

* Rodee, Marian, and James Ostler. *Zuni Pottery.* West Chester: Schiffer Publishing, 1986.

* Rosenak, Chuck, and Jan Rosenak. *The People Speak: Navajo Folk Art.* Flagstaff: Northland Publishing, 1994.

Ryerson, Scott H. "The Potters of Porvenir: The Lesser-Known Artisans of Mata Ortiz." *Kiva* 60 No. 1. Tucson: Arizona Archaeological and Historical Society, 1994.

Scully, Vincent. *Pueblo: Mountain, Village, Dance.* Second edition. Chicago: University of Chicago Press, 1989.

* *Seven Families in Pueblo Pottery.* (Exhibition catalog.) Albuquerque: Maxwell Museum of Anthropology, University of New Mexico, 1974.

Sommer, Robin Langley. *Native American Art.* New York: Smithmark Publishers, 1994.

* Spivey, Richard L. *Maria.* Flagstaff: Northland Press, 1979.

* Stoeppelmann, Janet, and Mary Fernald. *Dirt for Making Things: An Apprenticeship in Maricopa Pottery.* Flagstaff, AZ: Northland Publishing, 1995.

Tanner, Clara Lee. "Crafts of Arizona Indians." *Arizona Highways* XXXVI No. 7. Phoenix: Arizona Highway Dept., 1960.

Toulouse, Betty, *Pueblo Pottery of the New Mexico Indians.* Santa Fe: Museum of New Mexico Press, 1977.

Traditions in Clay: The Technology Behind the Art of Ancient Southwest Ceramics (Pottery from the Martin Collection). Exhibition catalog. San Francisco: The Museum of Ancient Civilizations, San Francisco State University, 1994.

* Trimble, Stephen. *Talking With the Clay: The Art of Pueblo Pottery.* Santa Fe: School of American Research Press, 1987.

Underhill, Ruth. *Indians of the Southwest.* Garden City, NY: Nelson Doubleday, Inc., 1966.

———. *Pueblo Crafts.* Washington DC: U.S. Department of Interior, Bureau of Indian Affairs, 1944.

Wade, Edwin L., and Lea S. McChesney. *Historic Hopi Ceramics: The Thomas V. Keam Collection of the Peabody Museum of Archaeology and Ethnology.* Cambridge: Peabody Museum Press, 1981.

Walker, Steven L. *Indian Cultures of the American Southwest.* Scottsdale, AZ: Camelback/Canyonlands Venture, 1994.

* Walker, Willard, Lydia Wyckoff, Lea S. McChesney, Katherine L. McKenna, and Robert E. Cleaves. *Hopis, Tewas and the American Road.* Middletown, CT: Wesleyan University, 1983.

Washburn, Dorothy K., Ben Elkus, John Adair, Joe Ben Wheat, and J.J. Brody. *The Elkus Collection.* San Francisco: The California Academy of Sciences, 1984.

Westheimer, Duffie. "The Annual MNA Indian Art Exhibitions." *Expedition* 36 No. 1. Philadephia: University of Pennsylvania Museum, 1994.

Wood, J. Scott, *Checklist of Pottery Types for the Tonto National Forest.* Phoenix: Arizona Archaeological Society, 1981.

Wormington, H.M., and Arminta Neal. *The Story of Pueblo Pottery.* Museum Pictorial No. 2, 4th edition. Denver: Denver Museum of Natural History, 1974.

index

Page numbers in *italics* refer to photographs.

185

afterword

⯈ AT THE END OF THIS JOURNEY, we're rather stunned by what's happened. We don't think we ever really believed that our benighted quest to cover the subject from A to Z—from Anasazi (or Acoma) to Zuni—could come so close to the mark.

We also wouldn't have believed that people who have devoted their lives to the study of the subject could have taken two amateurs seriously enough to help with the project.

But perhaps our green enthusiasm was our strong point. Certainly, a large number of those serious students of the field took interest in our work, almost to the point of adopting us. Al Anthony and Claire Demaray stood over us from the beginning. People like Greg Hoffman in Zuni, John Hill in Scottsdale, and Mark Sublette in Tuscon set things aside for us and sold them to us for less than they should have.

What happened to us proves one of the main propositions of the book: that Southwestern pottery is not only one of the world's important art forms, it's the most accessible. To underscore the point, think of it this way: Two beginners with full-time jobs in other fields and a cheapskate buying policy started from ground zero and in less than four years put together a collection that describes more than fifteen hundred years of development—a collection strong enough to attract three thousand visitors when just a quarter of it went on exhibit in early 1995 at the Marin Cultural Center and Museum.

Southwestern Indian pottery is a national treasure, but it's not locked up in a vault. It's there for anyone to touch and hold.

—JOHN & AL
Marin County, California, 1996

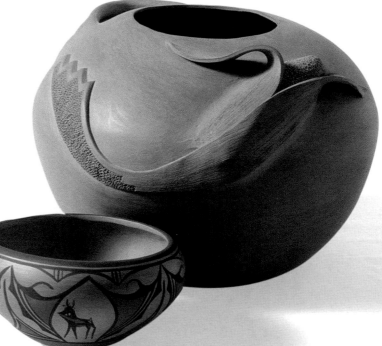

A to Z:
Acoma, Wilfred Garcia, 1992,
and Zuni, Priscilla Peynetsa, 1992

Footnote to the First Printing. Within days after our book appeared, we were surprised to learn that, despite an "expert" consensus, the stately Kiua Polychrome jar from Santo Domingo at top left on the front cover wasn't what it appeared to be. It didn't date from 1920 at all and it had a far more colorful history than we could have imagined.

At the 1996 Indian Market, we showed our book to Robert Tenorio, the great contemporary Santo Domingo potter, and he pointed out that he had actually made the pot for himself in 1982 in homage to the older styles. He didn't sign it because, at the pueblo, it's inappropriate to sign things you make for your own use. It spent four years under a downspout catching water, accumulating nicks around the rim whenever he pulled it out to empty it, and gaining an appearance of age consistent with its design. Then, about 1986, somebody swiped it, and it floated around until we bought it from a reputable dealer in 1995.

The whole experience illustrates one of the perils of buying any antique: it might be stolen, and the seller can be as unaware of the fact as the purchaser. Our deep thanks to Robert for his help, support, and generosity of spirit in resolving what could have been a genuinely sticky problem.

—DECEMBER 1996